DESIGNS ON THE LAND
Exploring America from the Air

DESIGNS ON THE LAND

Exploring America from the Air

Photographs by
Alex S. MacLean

Text by
Alex S. MacLean, James Corner
Gilles A. Tiberghien and Jean-Marc Besse

with 432 color illustrations

Thames & Hudson

To Kate

French texts translated by Ruth Taylor

First published in paperback in the United States of America in 2003 by
Thames & Hudson Inc., 500 Fifth Avenue, New York, New York 10110

thamesandhudsonusa.com

Designs on the Land was created by Editions Carré with Editions Textuel
Original edition © 2003 Editions Textuel, Paris

Library of Congress Catalog Card Number: 2002114688
ISBN 0-500-28414-8

Printed and bound in Italy

Contents

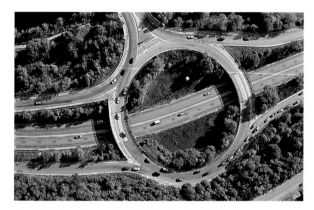

Lowell, Massachusetts. Route 3, circular interchange.

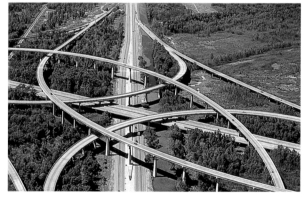

Kenner, Louisiana. Inverted interchange over swampland.

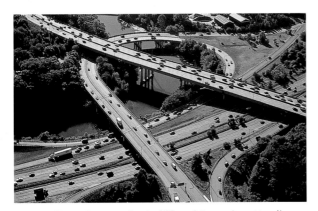

Weston, Massachusetts. Route 128 and Massachusetts pike.

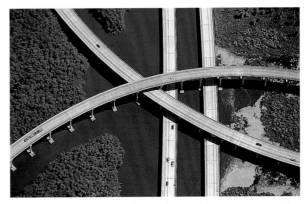

Kenner area, Louisiana. Elevated interchange over wetlands.

THE AERIAL AMERICAN LANDSCAPE

James Corner

→ James Corner is Chair and Professor of landscape architecture at the University of Pennsylvania, Graduate School of Fine Arts. He is the co-author with Alex MacLean of the award-winning book Taking Measures Across the American Landscape (Yale, 1996), and editor of Recovering Landscape: Essays in Contemporary Landscape Architecture (Princeton, 1999).

→ A medium of ideas and imagination as much as of material substance, the larger American landscape pervades almost every aspect of daily life for its occupants. As many American poets, painters, and filmmakers have recognized, the sublime omnipresence of the American landscape is difficult to escape. This pervasive quality derives not only from the sheer immensity and physical splendor of the land but also from the multitude of ways Americans have encountered, constructed and represented it over time. These cultural processes, most often inspired and informed through direct and practical engagement with the land, are also embodied in the workings of literature, painting, movies, planning and advertising. Consider, for example, the inseparable relationship between Thomas Cole's painting and the Hudson River Valley, or between Thoreau's writing and the New England woods, or—at a popular, subliminal level—between contemporary advertising images and the romanticization of postindustrial derelict landscapes on the one hand and the sentimentality of suburban lifestyle on the other. After all, landscapes are not so much "real" or given as they are invented and produced.

Photographs in particular—especially aerial photographs—continue to exercise great influence upon how the American landscape is both received and projected. Indeed, the aerial view is perhaps the best viewpoint to gain perspective and insight across the vast scale of the American landscape. From the air, America's geometries and spaces are revealed, appearing as a huge patchwork of geometric regulation: a grid of squares within squares highlighted by clusters of settlement, farming patterns, circular irrigator fields and transversal lines of infrastructure. Meandering rivers, hills, mountains, forests and desert break the geometrical framework. Since the

Land Ordinance Act of 1785 and the subsequent National Lands Acts, nearly all four million square miles of the United States have been visibly marked in one way or another. Given that many of these same geometries and spaces were produced aerially (through survey and planning and other activities informed by the aerial imagination), the view from above potently reveals the peculiarly American space of extension, order and repetition, only locally modified by topographical or environmental variation.

From the cockpit window of his small airplane, Alex MacLean continues to produce some of the most remarkable aerial images of this great landscape. Typically low and oblique with flattened depth and scale ambiguity, MacLean composes stunningly abstract images of the larger landscape. His pictures burn surprising and unforgettable images of land development into the imagination. MacLean's pictures possess an internal eloquence and beauty while revealing aspects of the land that would otherwise remain hidden or unseen. Although MacLean's photographs are often strange and enigmatic, they are less abstract than they are matter-of-fact, extracting sections of the landscape and re-presenting them for scrutiny. MacLean's lens does not seek to obscure or distort; he rarely uses a filter and never does he manipulate the photograph in its printing. Instead, his pictures present the land *just as it is*, albeit under particular and rarely replicable viewpoints, circumstances and moments of light. This momentary realism is complemented by the contemplative and slow manner in which a viewer must subsequently apprehend the actual photograph. It is very difficult to turn away from these pictures: the imagination roams across their surfaces in search of answers to what, where, who and how. Cumulatively,

MacLean's collection paints a picture of a landscape that is paradoxical: a terrain that is at once coherently chaotic, singularly diverse and brutally elegant. There is a particularly emphatic double reading on the perverse expansionism of modern development and infrastructure across otherwise endless territory. Here, MacLean's images of suburban tract homes, shopping malls, development sites in deserts or farm fields, parking lots and freeway interchanges point to a capacity to turn the absurd logic of American real estate and economy into pure spectacle. These oddly beautiful photographs prompt one to see a productive potential in an otherwise hugely destructive and wasteful process—the potential of a spectacular instrumentality.

There is a beautifully obscene straightforwardness to such images. Unlike the complex palimpsest of the elusive European landscape, where layers upon layers of accretive development over time sediment a more complex social-historical terrain, American space is simpler and direct, the result of rational expediency and modern production. Forged through large-scale instrumental techniques of development, the landscape is insistently autonomous, at once resilient and yielding to changing patterns of use, and capable of endless modification and replacement. Grids of interconnection, lines and arcs of pure circulation, endless circles and geometries of irrigation, cultivation, and abandonment; dams, mines, strip fields, silos, fields of windmills, hydroturbines, bomb test sites, airfields, radio-telescopes, levees, swales, woodlots, landfills, pilings, and plots of seemingly infinite dimension and possibility—this is a landscape at work, a spectacular infrastructure of activity and production.

Linking this world of objects are transportation and distribution systems, communication networks, schedules, production lines and other such measures of activity that make American life as efficient and accessible as possible. Speed and availability collapse the physicality between space and distance, making the remote seem near and lending to the individual a sense of participation within national and global processes. Consequently, the American landscape is perhaps less a scenic and spatial phenomenon than it is a highly active and temporal medium, an *economy*, the construction of which is fluid, mobile and transient.

The transmutative vibrancy of the working landscape reflects the American dream. The measure of what is moral and ideal for the American belongs less to the intellect than to the world of material action, to "getting the job done" bluntly, directly, and without pretension. Productivity and invention are, in turn, rewarded by material freedom, success, and wealth. Such is the American way, sustained by the effervescent buzz of material accumulation and the optimism of dreams. The instruments and results of this material utility are inscribed all across the land, ceaselessly producing, circulating, consuming, moving, hauling, draining, transforming. With matter-of-fact directness, the American landscape presents itself as an immense expression of a pure and inexorable pragmatism that is spectacular in its banality, spectacular in its idealized realism.

What one sees from the air, then, are not merely attractive patterns and forms but great metabolic scaffoldings of material transformation, transmission, production and consumption. The country is an enormous working quarry, an operational network of exchange and mobility. To appreciate the essential character of the

American landscape, it is first necessary to understand how its appearance is less an evolving *expression* than it is an activating *agent* of American ways of life and other material practices. To detach the landscape from culture as an object of scientific or aesthetic contemplation—to objectify it—is not only to fail to recognize the constitutive power of representation in the forming of reality but also to be distanced from the various reciprocities and differences that are structured between the land and its occupation by people. The implicit subjectivity in the content of Alex MacLean's photographs reveals not only the strange working beauty of this busy, ongoing inhabiting of America, but also the potential for modern design and planning to create even more spectacular environments—this time for on-the-ground reception and effect as well as from the air.

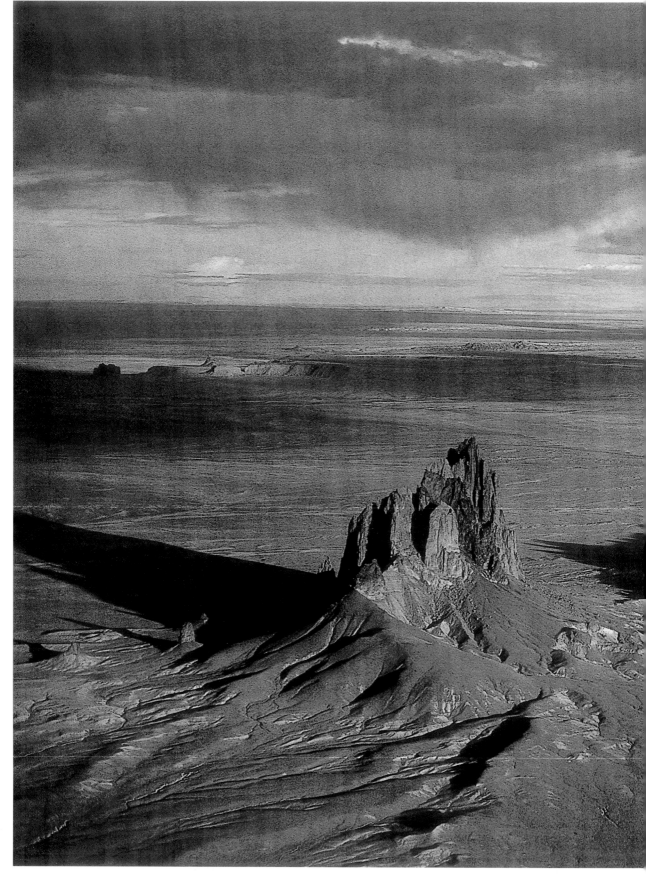

Shiprock, New Mexico. The extinct Shiprock volcano.

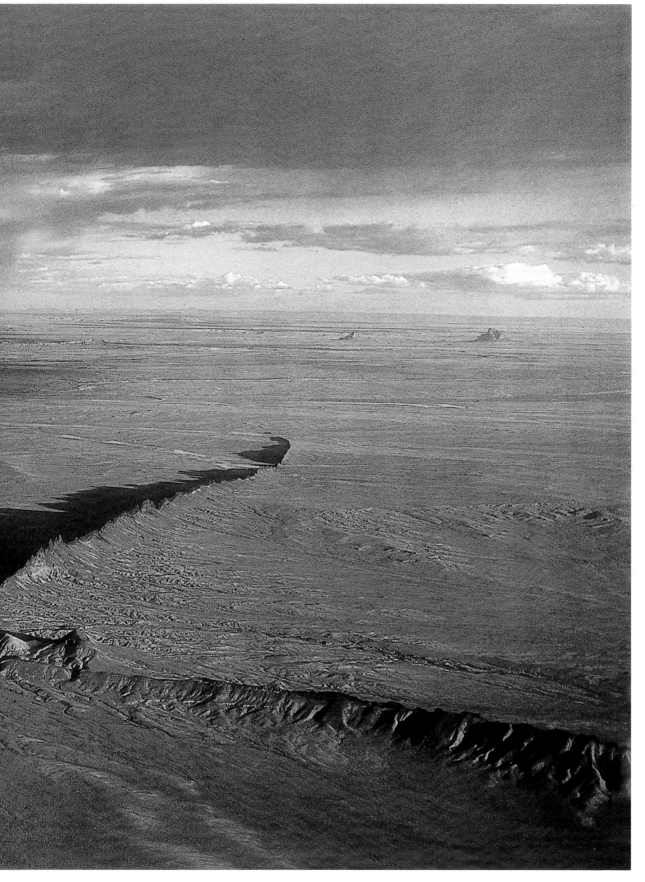

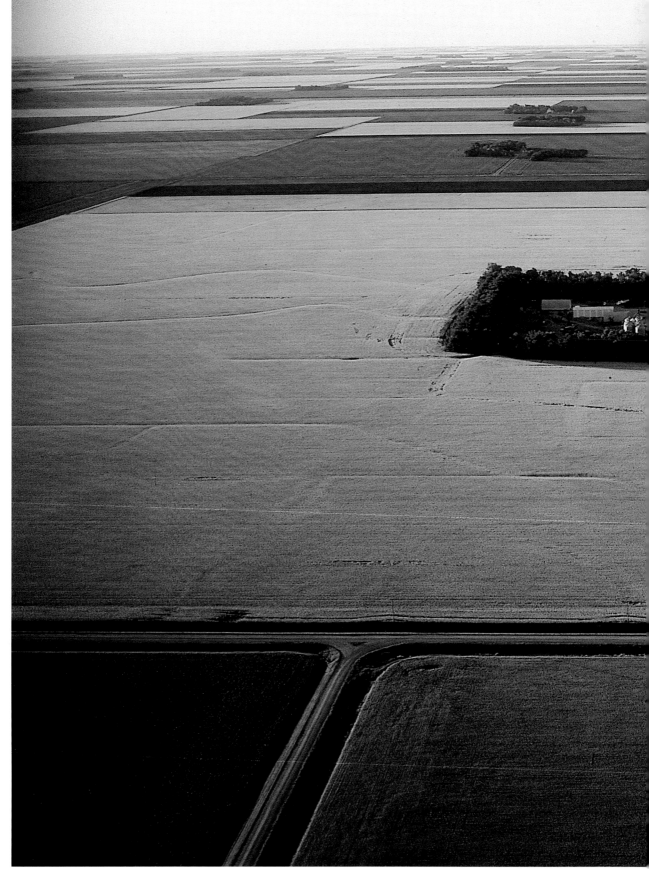

Castleton, North Dakota. Grid correction in Red River Valley.

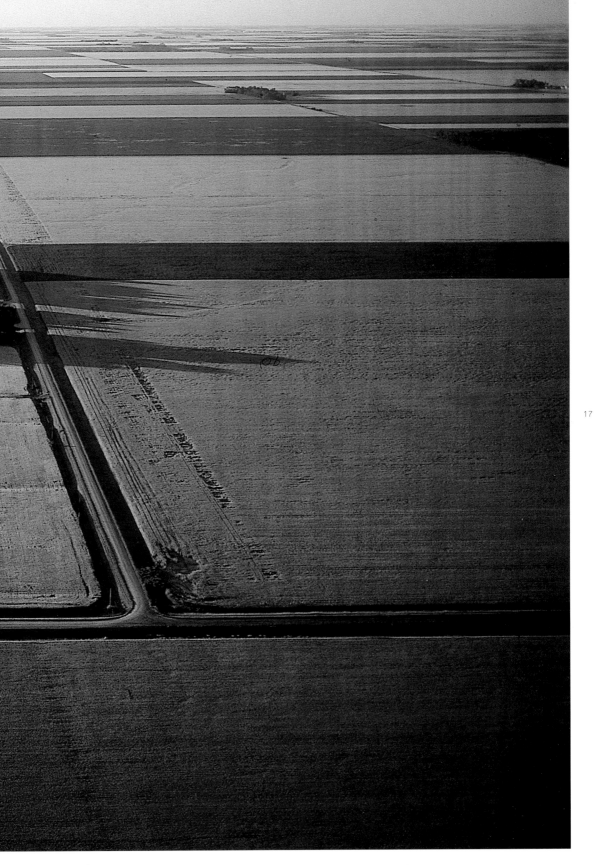

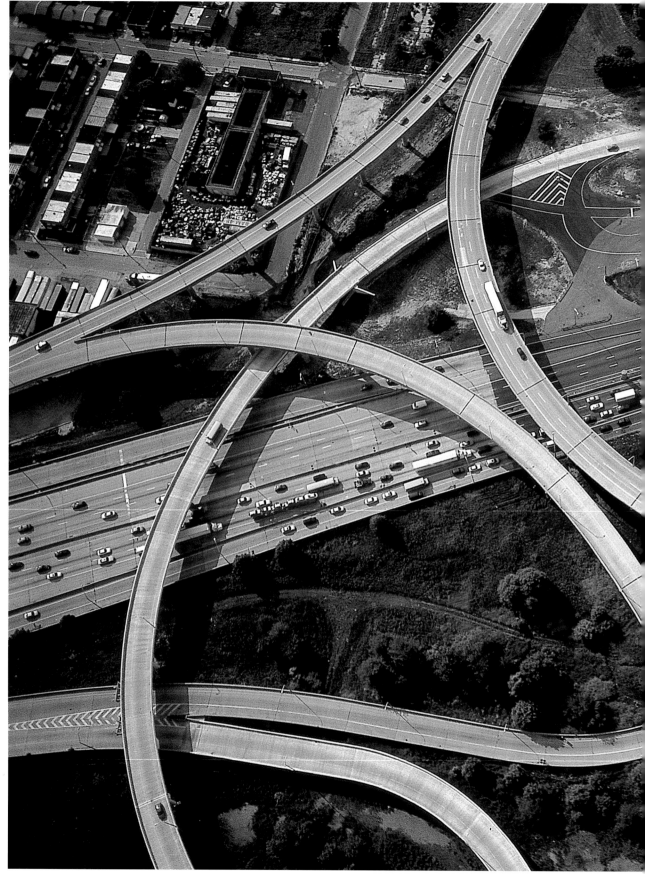

Philadelphia, Pennsylvania. Betsy Ross Bridge and I-95 intersection.

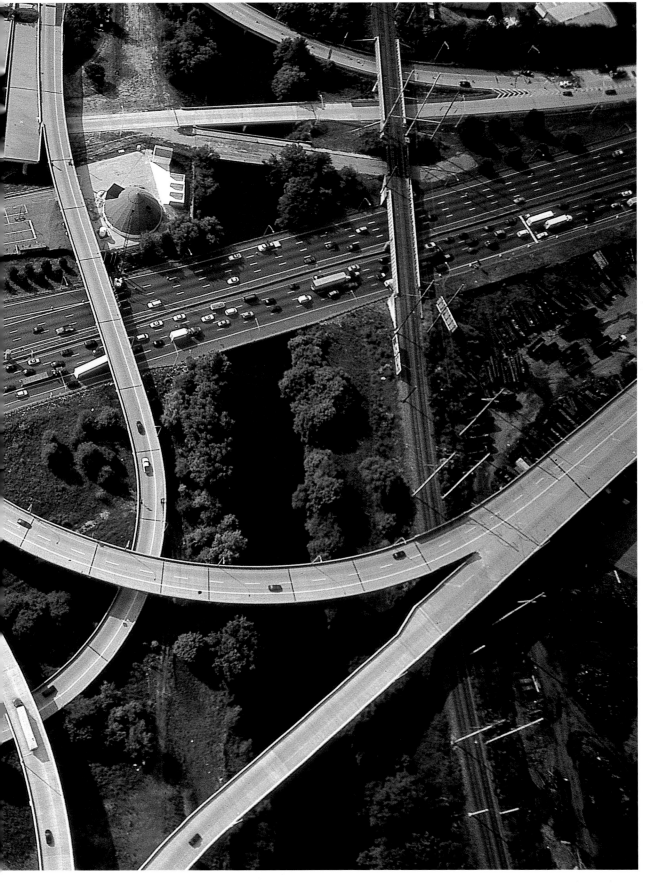

THE AMERICAN GRID

→ The simplest way to divide, subdivide and measure land areas is in the form of squares and rectangles. It was this template that Thomas Jefferson followed when he encouraged settlement of lands in the west through the Land Ordinance of 1785. The Ordinance was a simple and expedient measure to distribute land in a democratic, fair, and equitable way. When one flies out of New England, either to the Midwest or to the South Atlantic states, a grid of evenly divided land lies below.

The grid is visually apparent and defined by crisscrossing roads outlining the square mile sections. Usually, the grid is then further subdivided into quarter sections often seen in the pattern of numerous square and rectangular farm fields. The extent of the American grid is remarkable as it spreads seemingly without end until it reaches the west coast, interrupted only by natural features. So ubiquitous and established is the grid that there are moments when one wrongly thinks that the natural features have penetrated it instead of the other way around.

From a visual point of view the grid is interesting both for its relentless monotony and its disintegration along the edges. The grid inevitably gives way as it approaches the curves of a meandering flood plain and its river course, or steep rolling hills and mountains. In addition to the natural features, new technologies and constantly shifting economic forces violate the organizational principles of the grid, thereby telling stories about our culture.

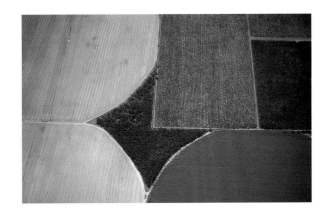

Macon, Georgia. Three pivot irrigators intersect
a rectangular field.

One example is the subsequent development of small towns along railway lines and highways that cut diagonally across the grid. Rather than aligning their own street grids with the north/south grid, such towns usually line up with the rail line or highway since it is the main route of transit in and out of town. The relatively new technology of pivot irrigators is another example. Trying to adapt this technology to the grid is like trying to fit a round peg into a square hole. However, farmers make pivot irrigators fit for financial reasons.

The American grid is a reminder that we live on a round surface. This is seen in the grid corrections that adjust the north/south grid lines as they imperceptibly converge as they run north. Depending on latitude, the north/south grid lines come to an abrupt stop approximately every seventeen miles and are corrected by being shifted a couple of blocks before resuming their track north. This keeps the square dimensions of the grid intact.

Above all else the grid is an incredible registration that defines the American landscape. It is an expression of one of the founding democratic principles that land is to be equally shared and divided. While this may have been a noble principle at the time of its inception, such divisional equality had little regard for both native inhabitants and natural environmental features, a fact that has had lasting ramifications.

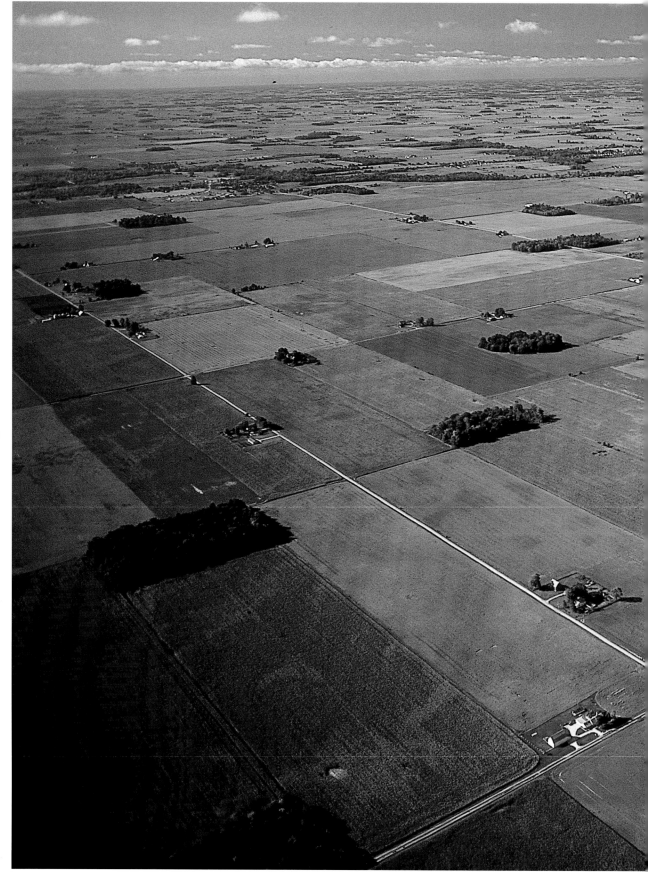

Rensselaer, Indiana. Farm grid.

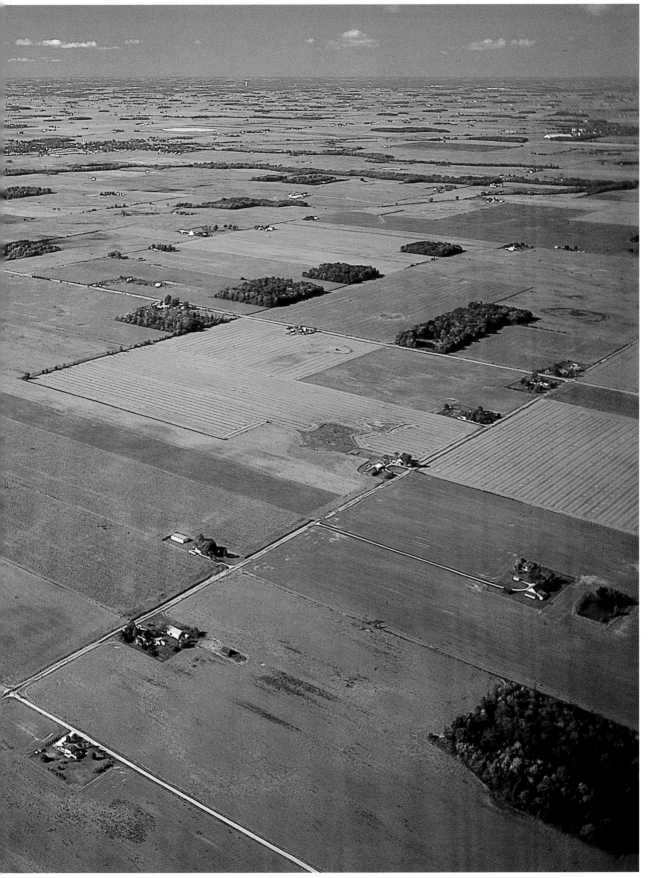

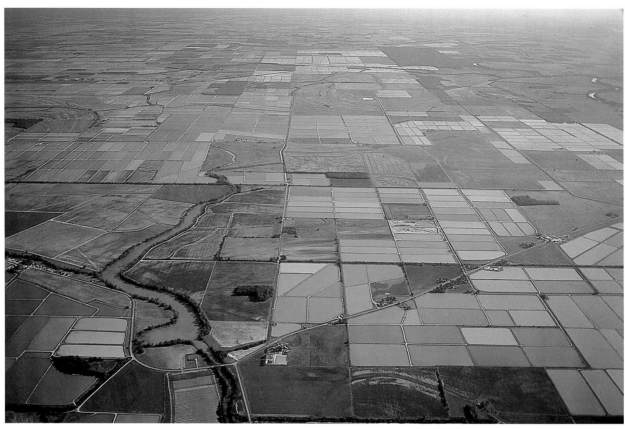

Yazoo City, Mississippi. Fish farms conform to the grid.

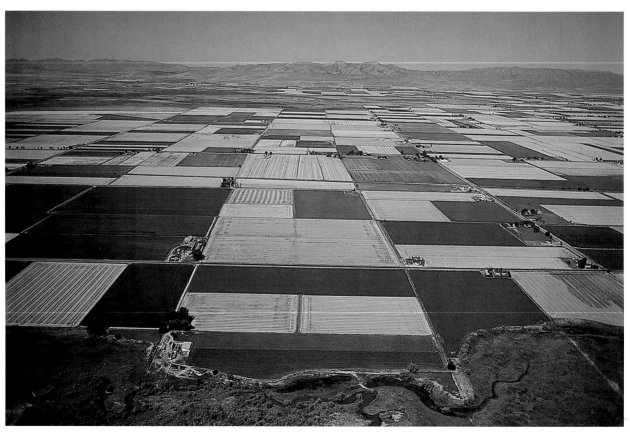

Fielding area, Utah. Beaver River against the farm grid.

Brigham City, Utah. A small town lines up with the grid.

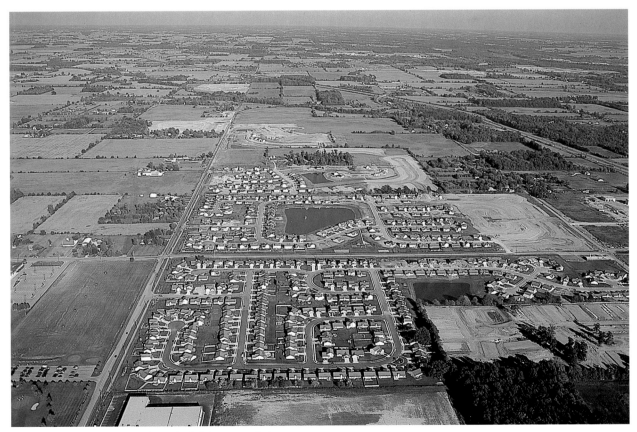

Indianapolis, Indiana. Housing sub-division east of city.

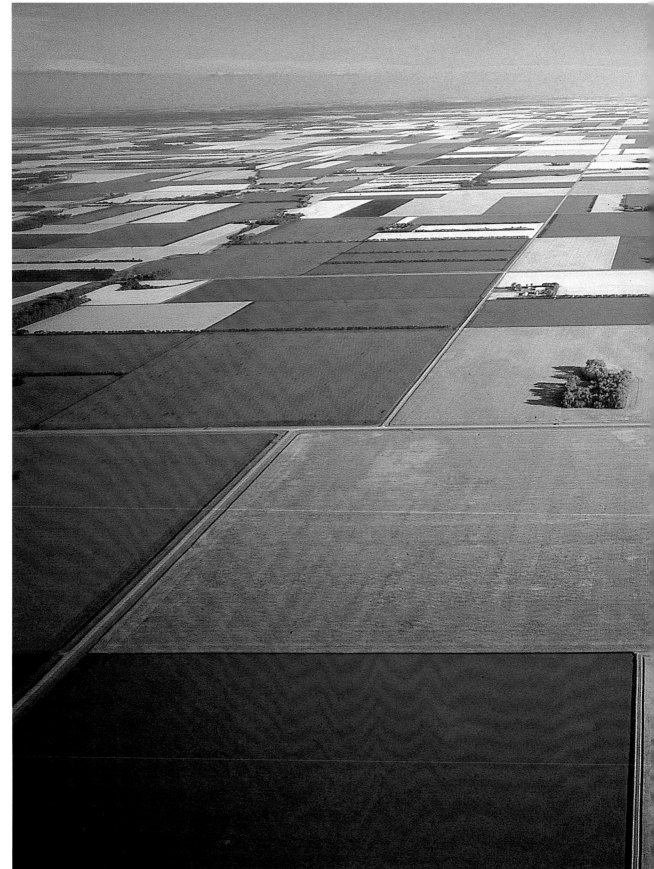

Red River Valley, North Dakota. Agricultural grid correction.

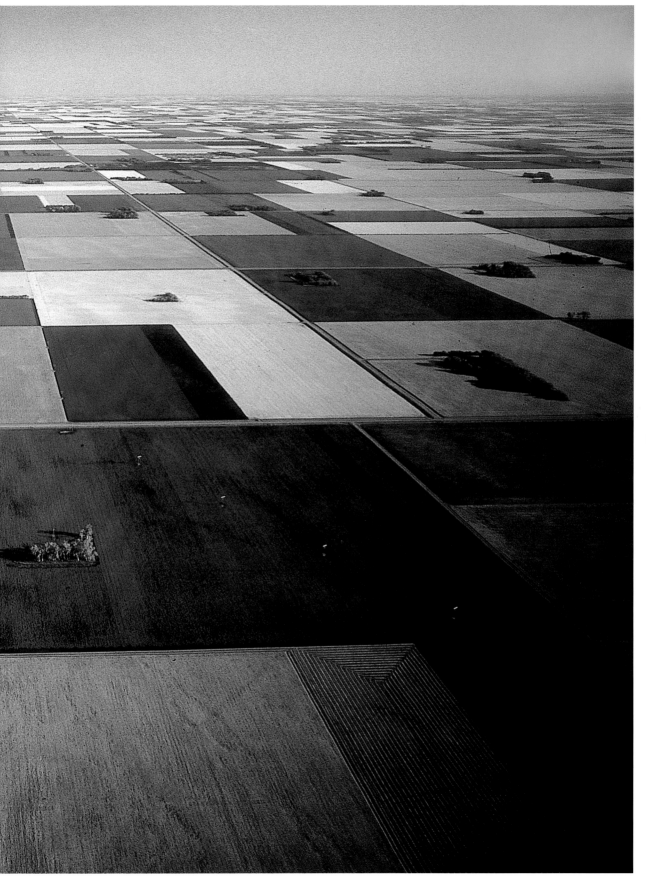

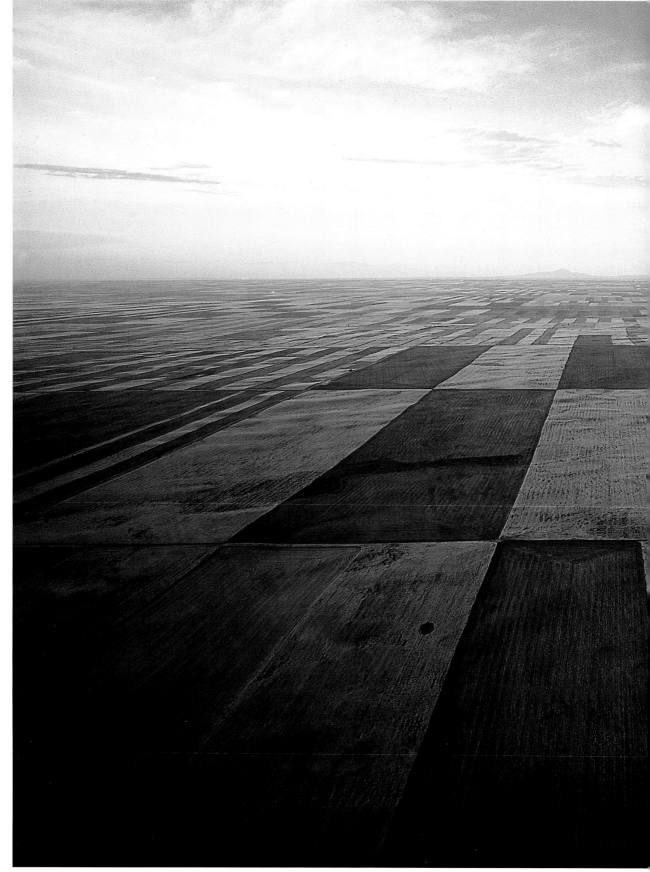

Havre, Montana. Dry-farming wheat strips.

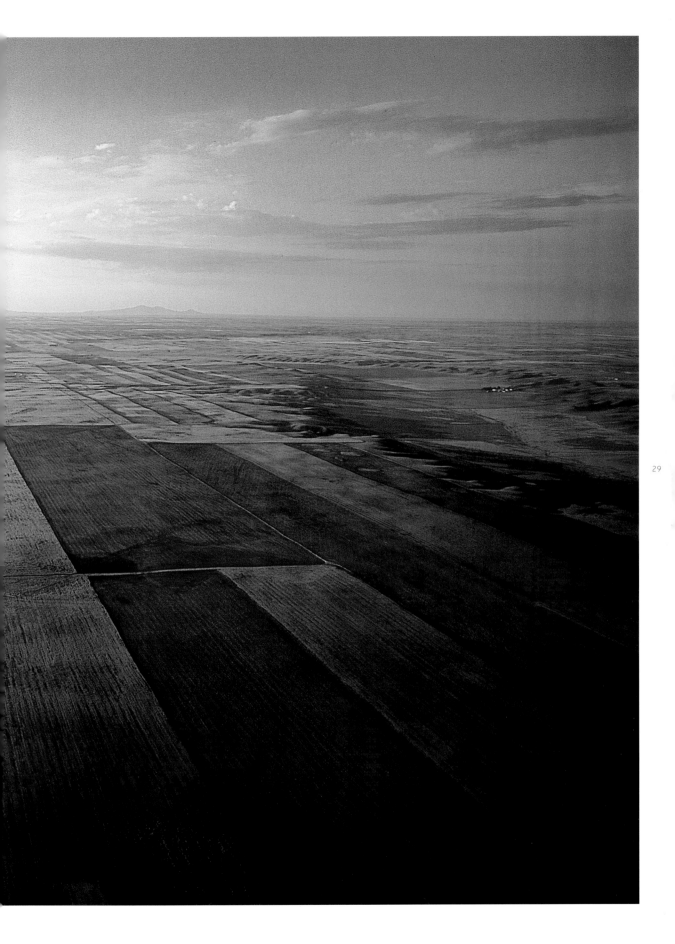

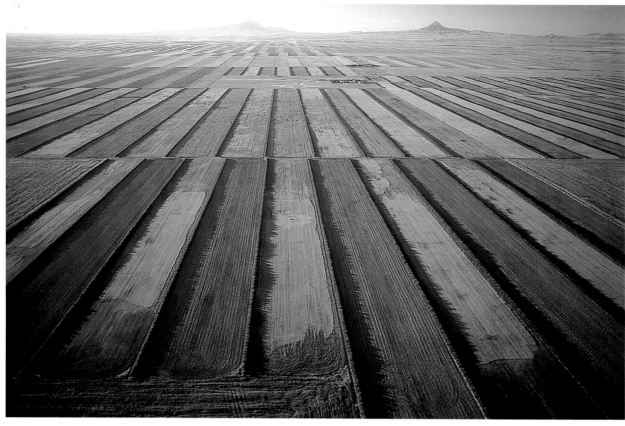

Conrad area, Montana. Wheat strips running perpendicular to the prevailing wind.

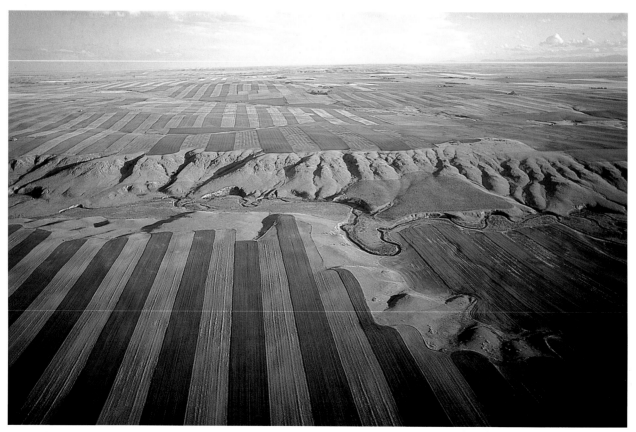

Cut Bank area, Montana. Dry land wheat strip fields abut the Marias River valley.

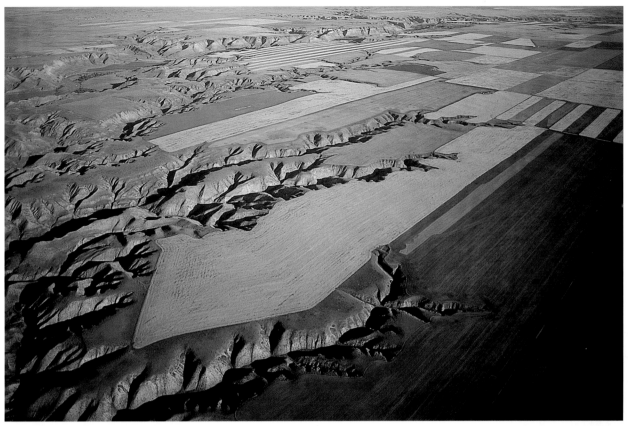

Cut Bank, Montana. Wheat fields on tablelands cut by the Marias River.

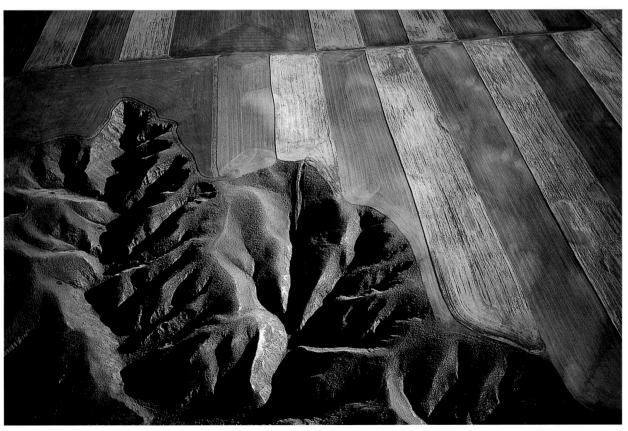

Floweree, Montana. Wheat fields along a deeply eroded stream bed.

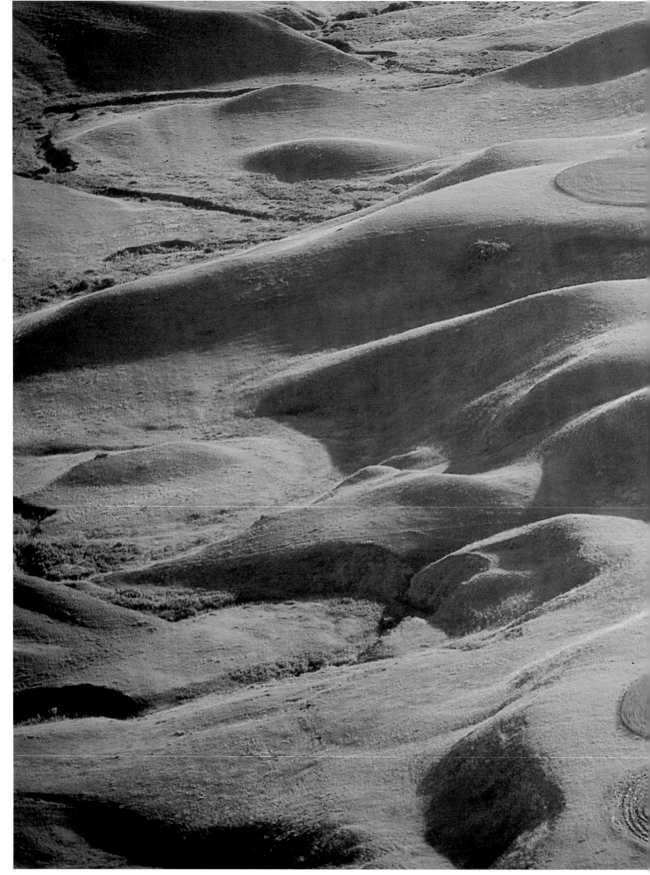

Cut Bank area, Montana. Field edge.

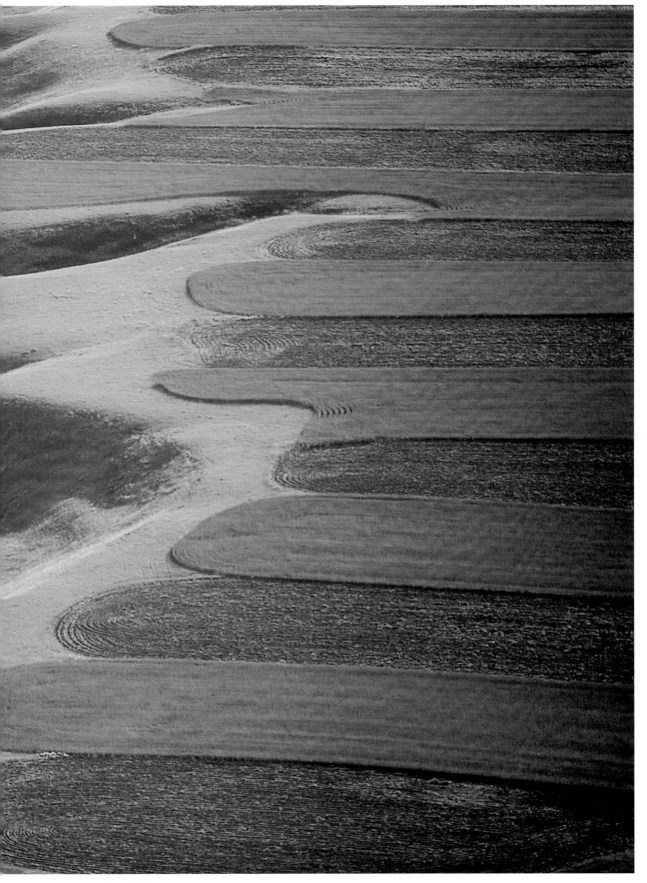

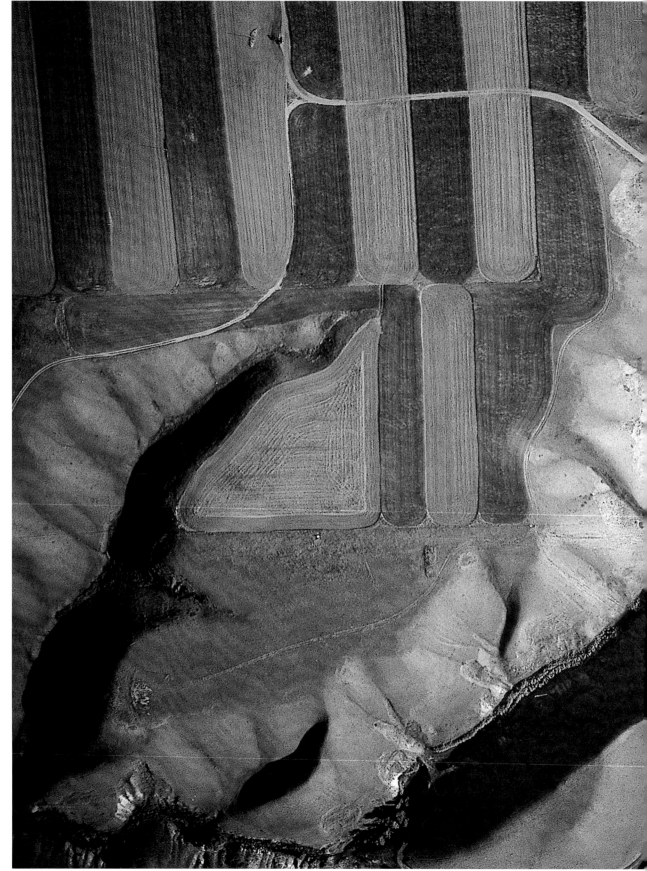

Cut Bank area, Montana. Wheat strips on top of a plateau.

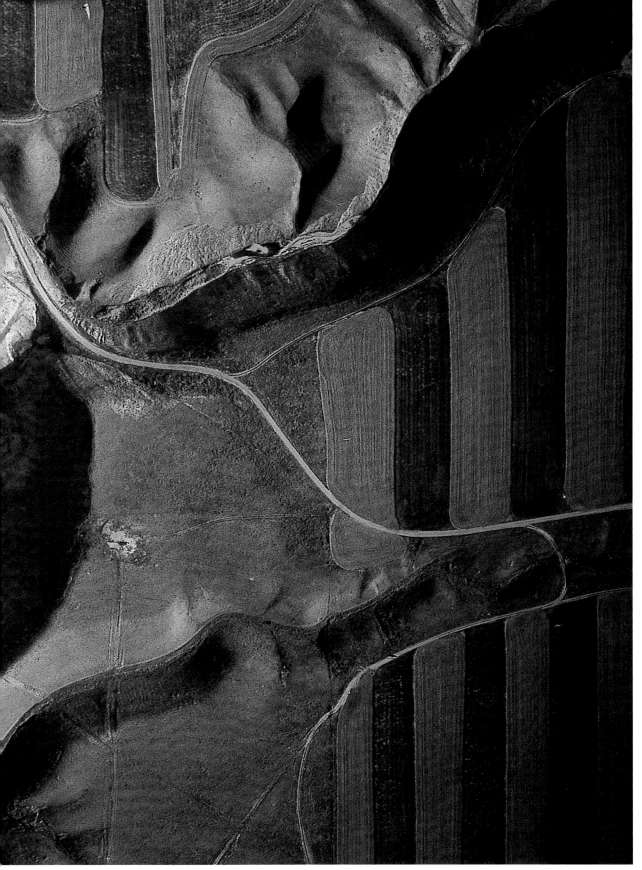

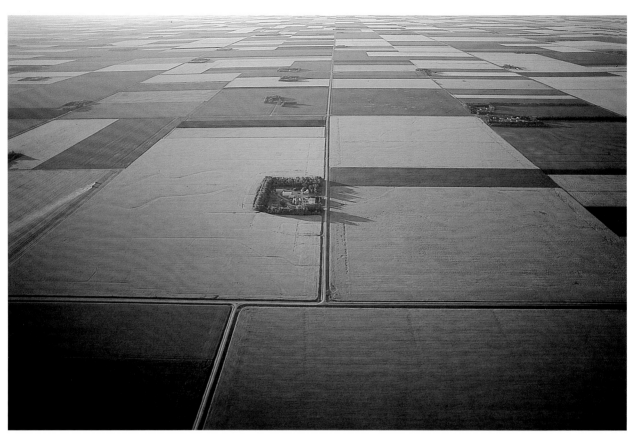

Red River Valley, North Dakota. Agricultural grid correction.

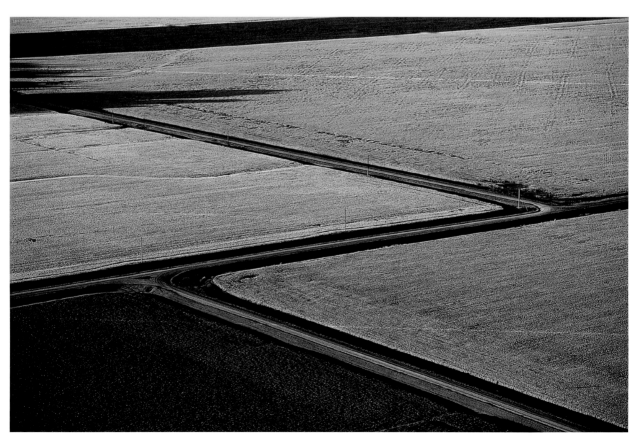

Red River Valley, North Dakota. Zigzag road grid correction.

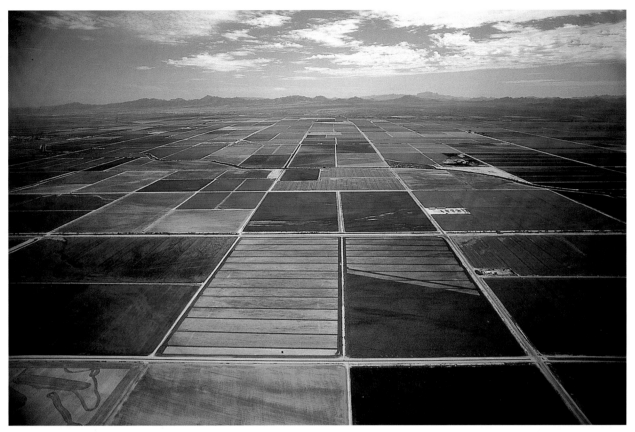

Blythe area, California. Agricultural fields in the Colorado River Valley.

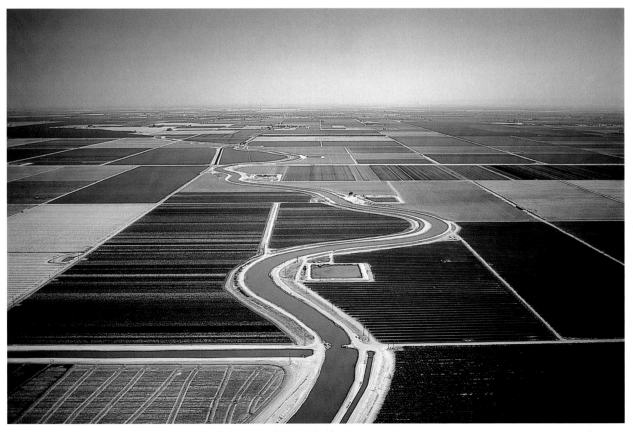

Bakersfield, California. An irrigation canal winds through flower fields.

CITY GRID

→ It is hard to think of many traditional American cities that are not laid out on a grid plan. Exceptions are found in the oldest sections of cities such as Boston and New York, but even the subsequent growth of these older cities gave way to the grid. The grid was seen as a more organized shape to accommodate development, allowing for efficient and equitable land distribution and administration through evenly divided rectangular or square blocks and land parcels. Ocean, lake or river waterfront areas on which cities were settled formed the starting line from which a north/south grid stretched out. There are many instances where grids of adjacent municipalities are out of alignment with one another since they do not share a common north/south axis.

For all the rigidity of the grid, it has successfully preserved open space in blocked-out parks. Oglethorpe's plan for Savannah created over two dozen square parks long before the housing and public institutions filled in around them. The grid has successfully reserved land for thousands of urban parks in this manner, including the large and spectacular open spaces of Central Park in New York City and Golden Gate Park in San Francisco.

The urban grid has brought most modern-day constructs into compliance. Modern skyscrapers dutifully fall into line. New sports complexes and convention centers likewise comply with the grid. The real impact of these

Santa Monica, California. Community garden plots.

buildings is in the size of their footprint, which cuts off cross-streets. Large urban renewal projects and public housing projects that have created rectangular super-blocks have also proven to be counterproductive as part of the urban fabric. Federal money is now being spent to remodel public housing with part of the funds going towards reintegrating older neighborhood cross-streets.

Complying least easily with the grid system, with the exception of insurmountable natural features such as mountainous rock outcroppings and water bodies, is the interstate highway. While the highway will do its best to line up with the grid, there are some unavoidable problems. The highway can bend and twist for natural features and it can skirt around political problem areas, but one of the many inherent problems with the highway in urban areas is that it cannot make sharp right-angle turns. This is a problem for highway ring roads around downtown areas. We see intersecting highways become elevated as they use expensive flyovers, inverted cloverleafs, and four-level stacked interchanges to save part of the thirty to forty acres of land normally consumed by a conventional cloverleaf interchange. The grid in the suburb becomes secondary to the highway which in itself is the predominant organizing force of the new "edge city."

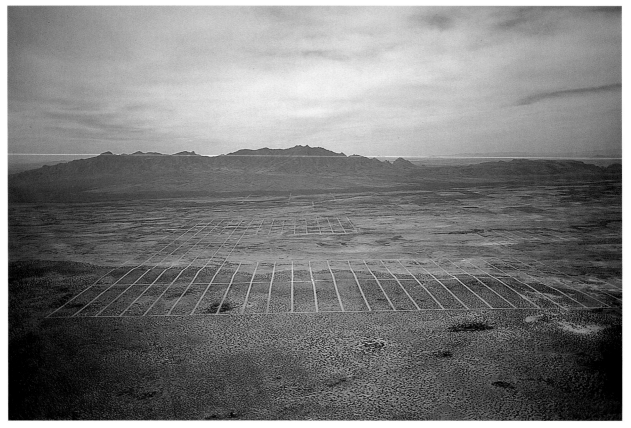

West Texas. Speculative housing grid.

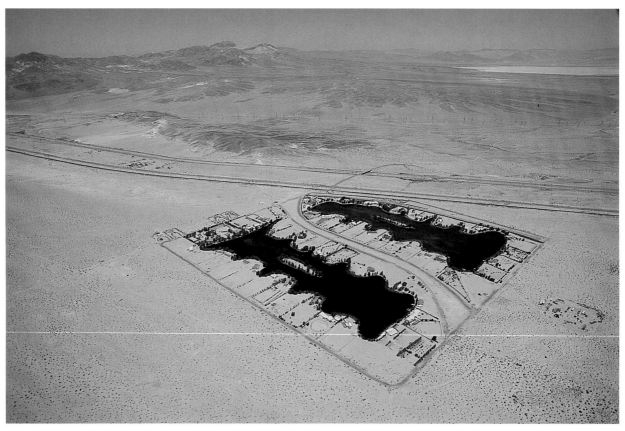

Mojave, California. Housing oasis in the desert.

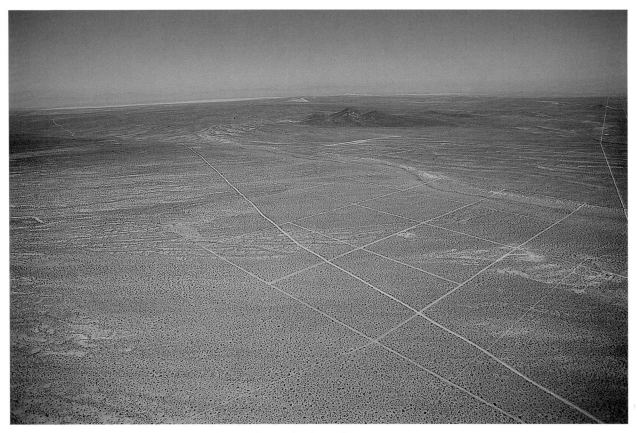

Mojave, California. Housing development grid etched onto the desert floor.

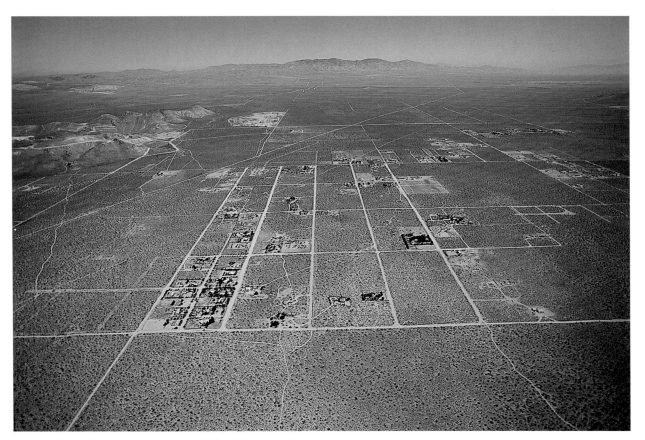

Mojave area, California. Grid and new housing.

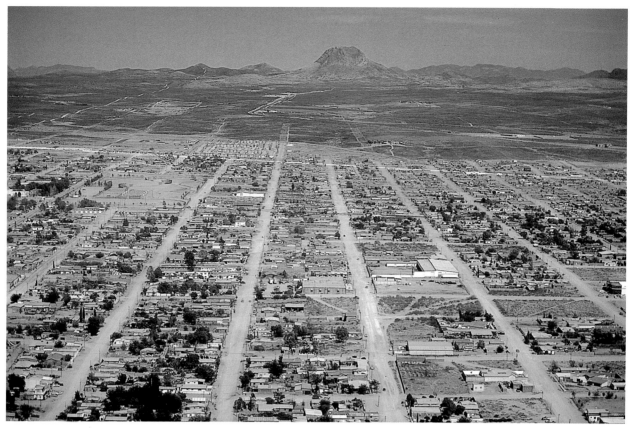

42 Douglas area, Arizona. Housing grid at the border, view south.

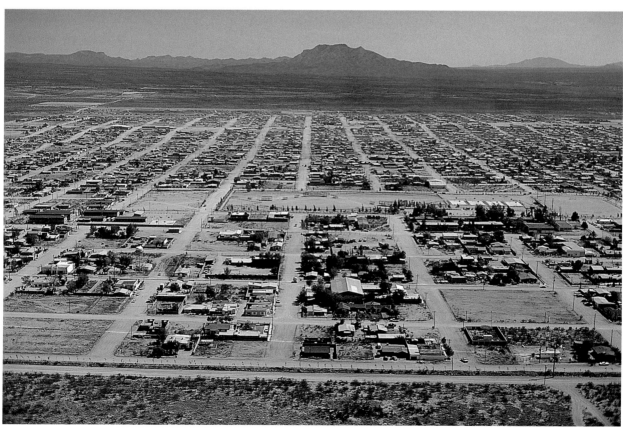

Douglas, Arizona. Town grid, view north.

Las Vegas, Nevada. Suburban housing grid filling in.

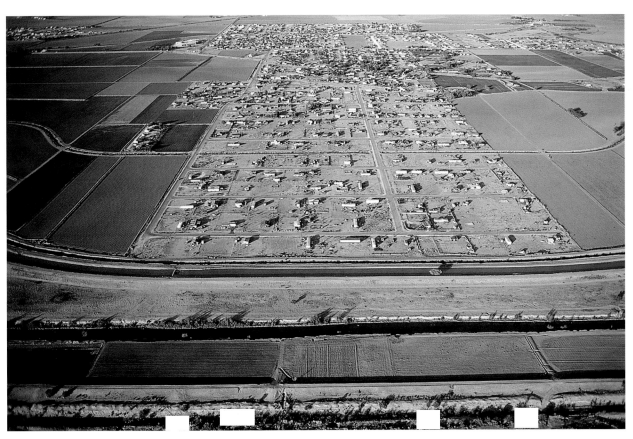

El Paso, Texas. Trailer lots follow the grid along the Rio Grande River.

44

Houston, Texas. Downtown parking blocks.

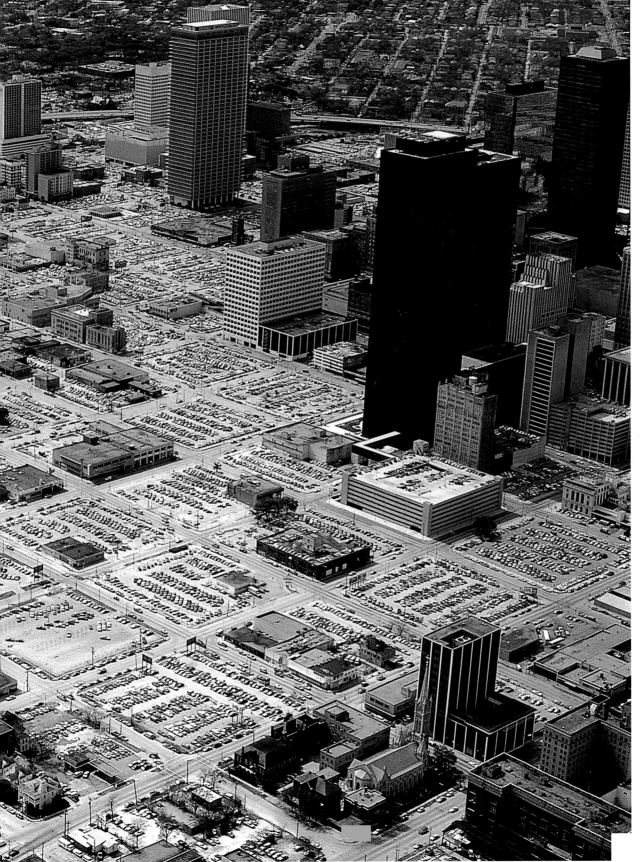

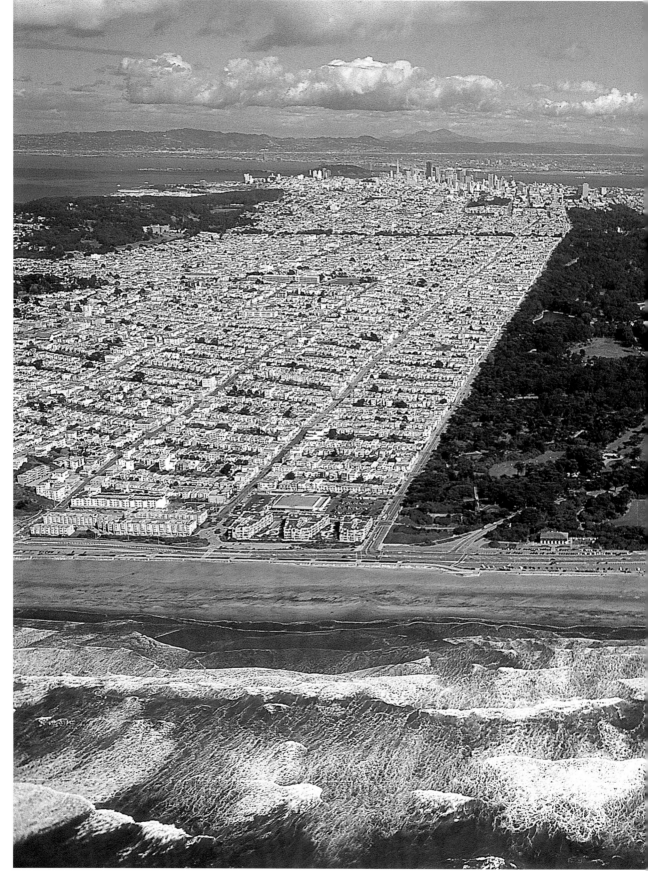

San Francisco, California. Golden Gate Park meets the ocean.

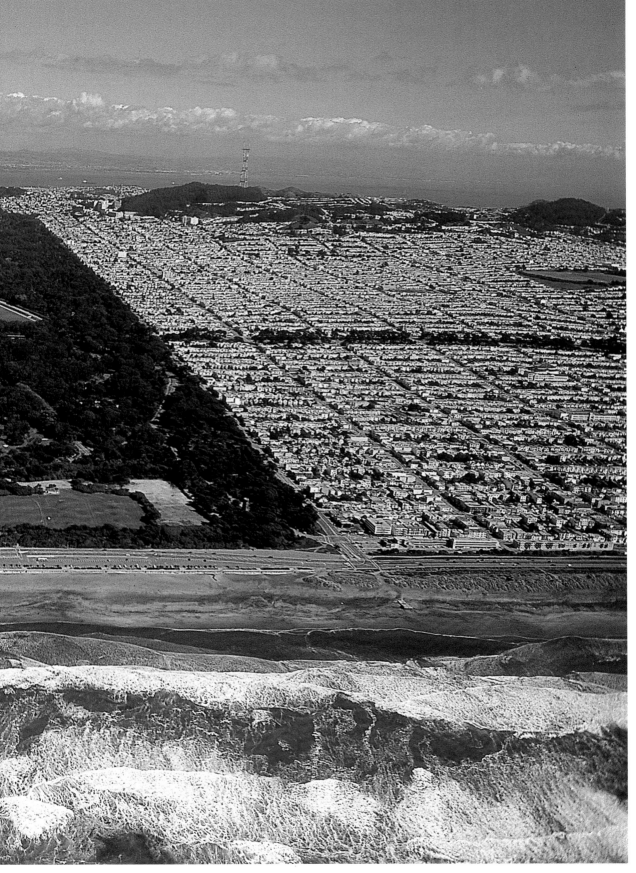

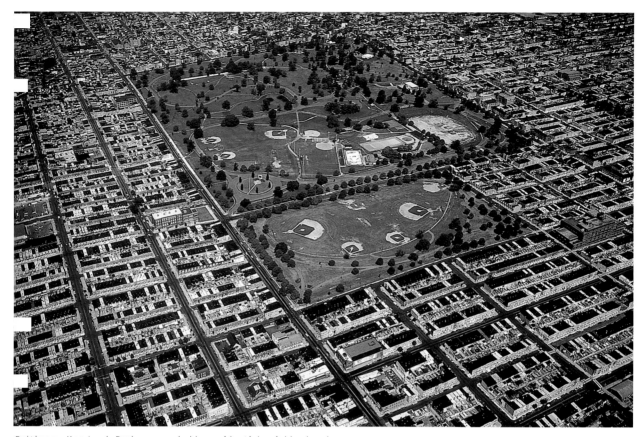

48 Baltimore, Maryland. Park surrounded by residential neighborhoods.

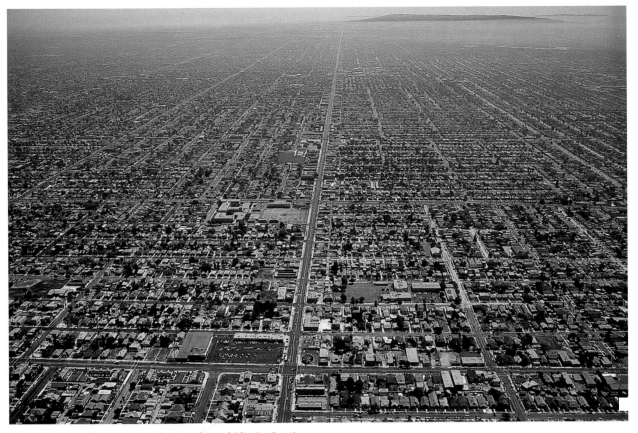

Los Angeles, California. Expansive housing grid in the Southgate area.

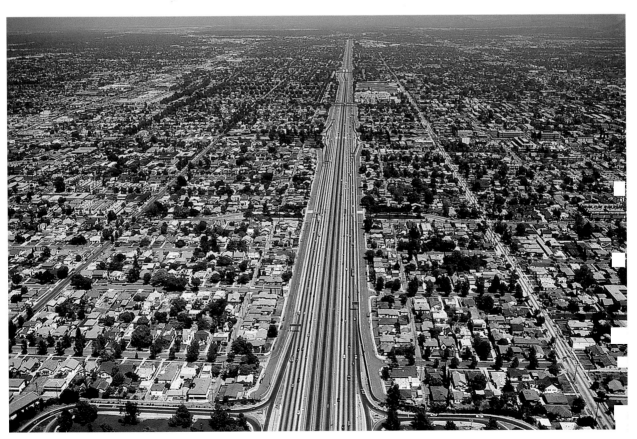

Los Angeles, California. The highway follows the grid.

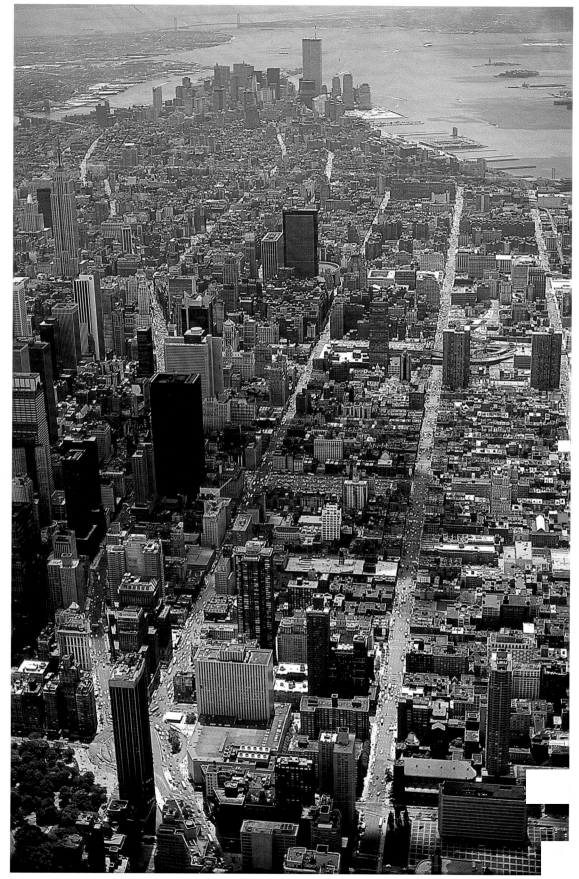

New York, New York. Colombus Circle to downtown Manhattan.

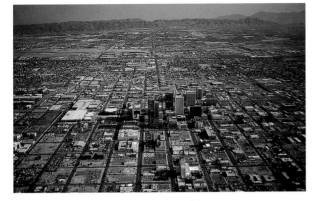

Phoenix, Arizona. Downtown street grid.

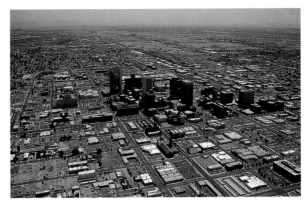

Phoenix, Arizona. Downtown.

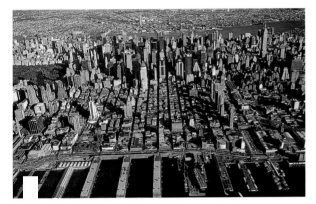

New York, New York. Midtown from the West Side piers.

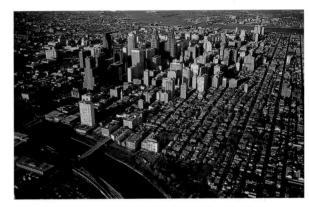

Philadelphia, Pennsylvania. View from Schuykill River.

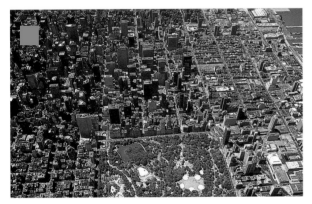

New York, New York. Central Park at Midtown.

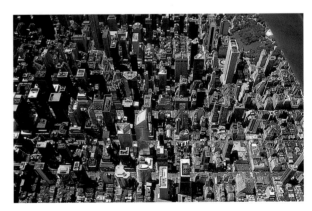

New York, New York. East Side of Midtown.

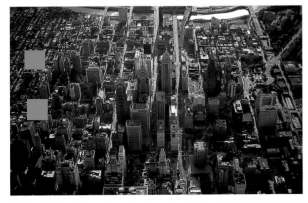

Philadelphia, Pennsylvania. Street grid from the Delaware River.

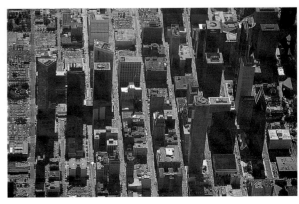

Houston, Texas. Tall buildings rise from the street grid.

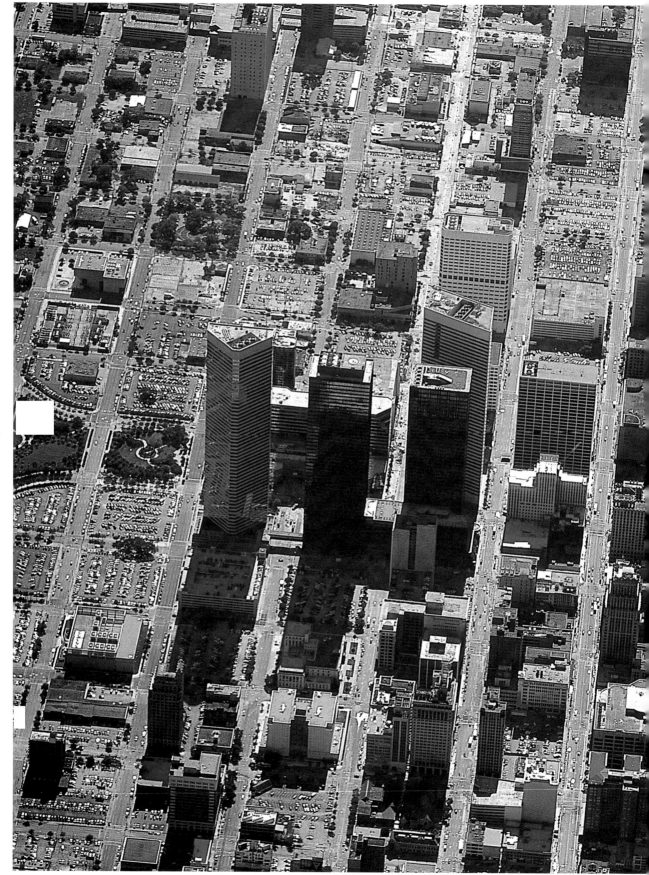

52

Houston, Texas. High-rises and streets.

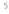

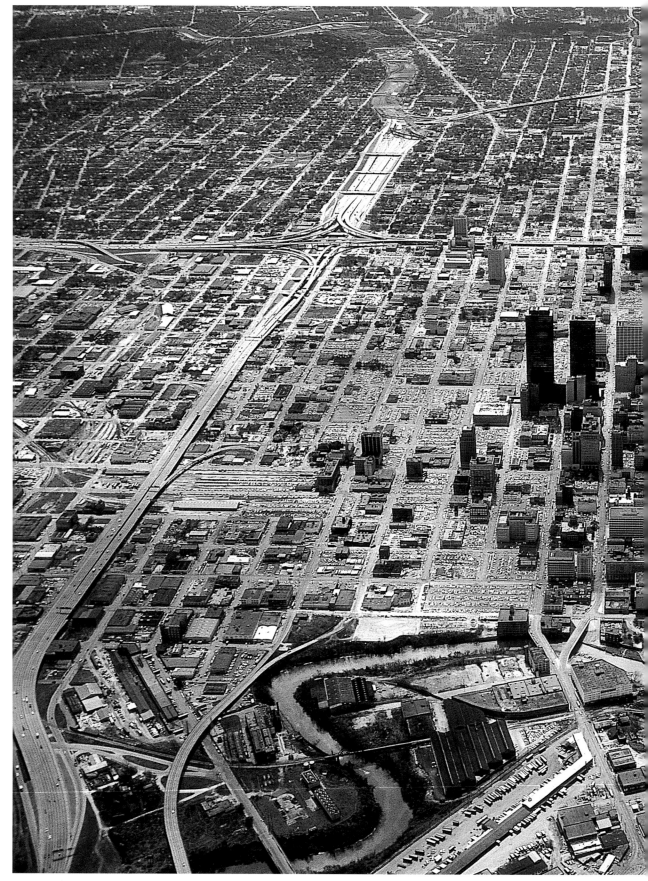

Houston, Texas. Street grid and Buffalo Bayou.

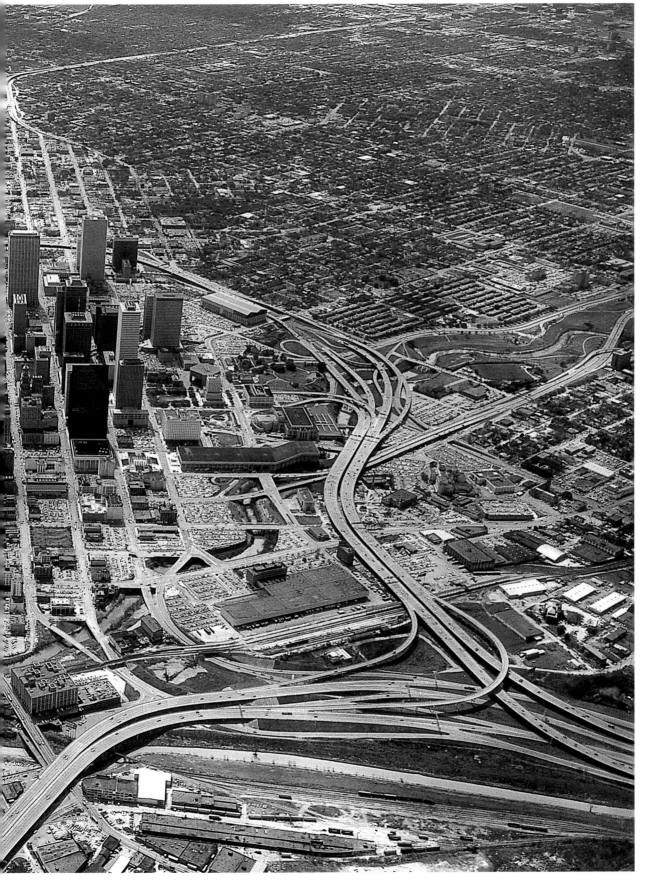

NATIVE AMERICANS

It is possible to fly over a hundred miles of designated Native American lands and not be aware of it. In the Southwest, most of the land is barren and undeveloped—as it should be. On occasion, one comes across garden agriculture on canyon bottoms and nomadic herds people living on arid land in the middle of nowhere. There are occasional strip mines and agricultural fields with pivot irrigation, which does not register as "Indian Land."

As for the ancient settlements and contemporary pueblos, they are naturally camouflaged through form and materials, and blend in with the landscape. In fact, prior to Global Positioning System (GPS) technology, it was quite difficult to fly off on a heading to ruins in such places as Mesa Verde and Canyon de Chelly and actually find them. When one arrived at the supposed destination, it was still next to impossible to locate these cliff dwellings in the massive open spaces of the Southwest. It was a relief, though perhaps it felt like cheating, to find the cliff dwellings by first spotting nearby tourist parking lots. The contemporary inhabited pueblos on prominent isolated mesas such as Acoma and Walpi are also difficult to detect. One could easily fly by without noticing them.

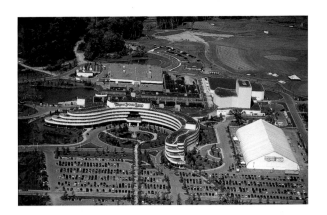

Verona, New York. Turning Stone Casino Resort.

By our Western way of thinking, it is curious that this culture still chooses to live in such dense multistory settlements sharing common walls in the midst of miles of open space in all directions.

Flying over these sites there one has a sense of sacredness, awe, and trepidation in taking unsanctioned pictures. A circling eagle, storm clouds, and the high altitude coupled with the clear visibility and striking light that make this space so large all add credence to these feelings. Visually, one senses a closeness and connection between these inhabitants and nature by the mere fact that they are able to survive in these barren lands.

One feels a different type of awe seeing huge gambling casinos on land controlled by Native Americans in other parts of the country. This is a complete disconnect with a heritage that is so closely connected to nature and the land. The culture has leapt into another world and economy. It is an interior, windowless world that is far removed from the spirit of the great outdoors. It is unfortunate that in gaining back the wealth of their land, the Native Americans have lost so much of their traditional culture.

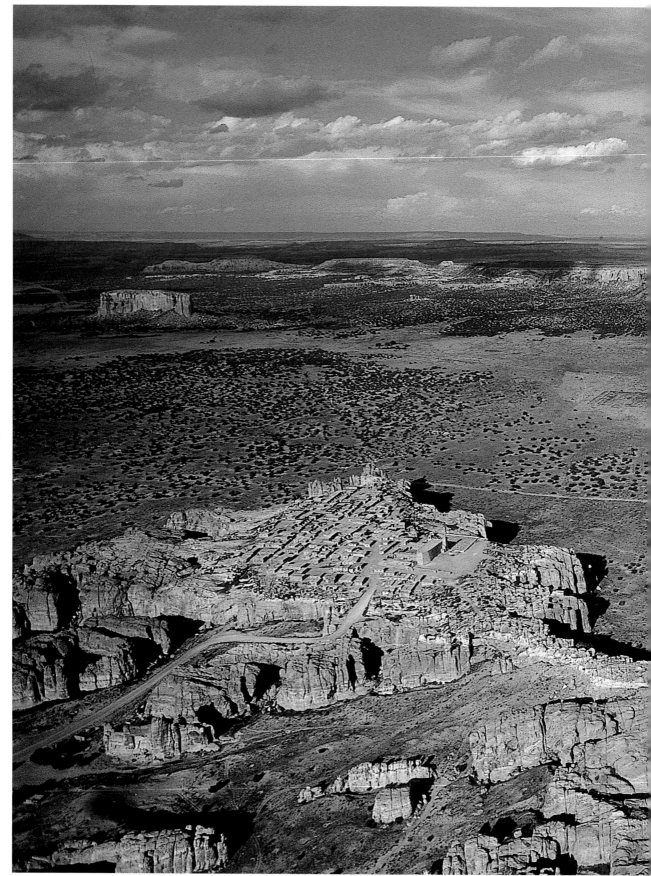

Acoma, New Mexico. Acoma Pueblo.

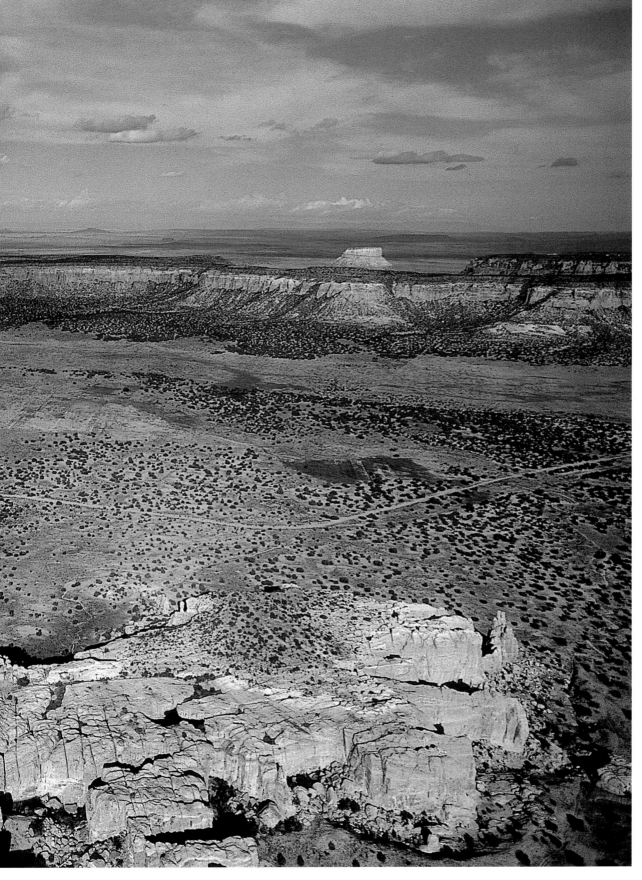

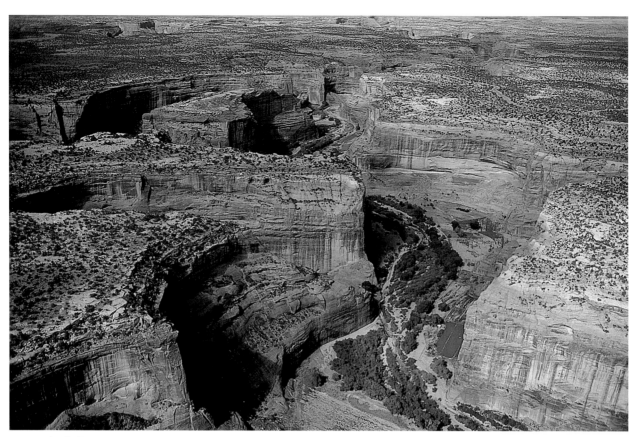

Canyon de Chelly, Arizona. Canyon floor with cliff dwellings.

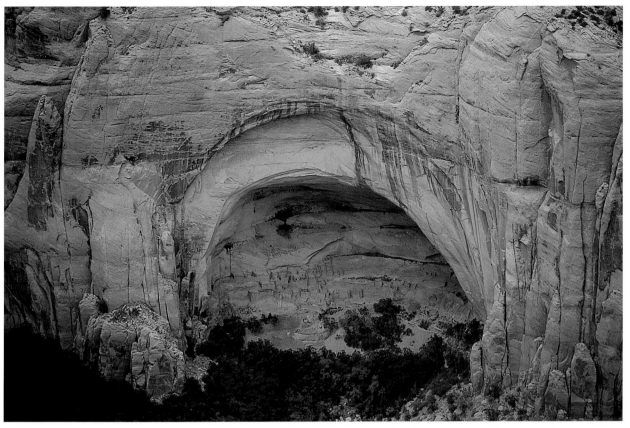

Navajo National Monument, Arizona. Cliff dwellings fill huge natural bowl in canyon wall.

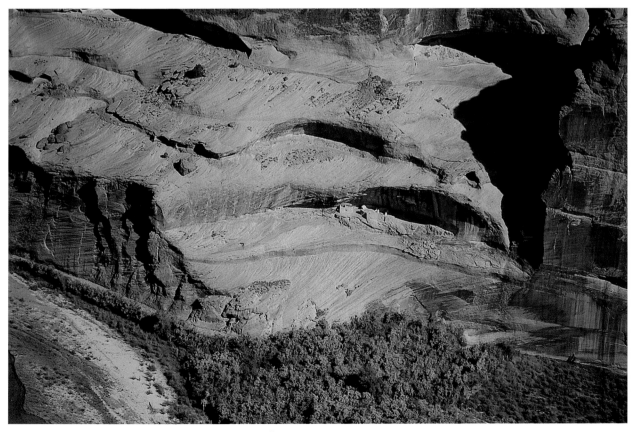

Canyon de Chelly, Arizona. Cliff dwellings in canyon walls.

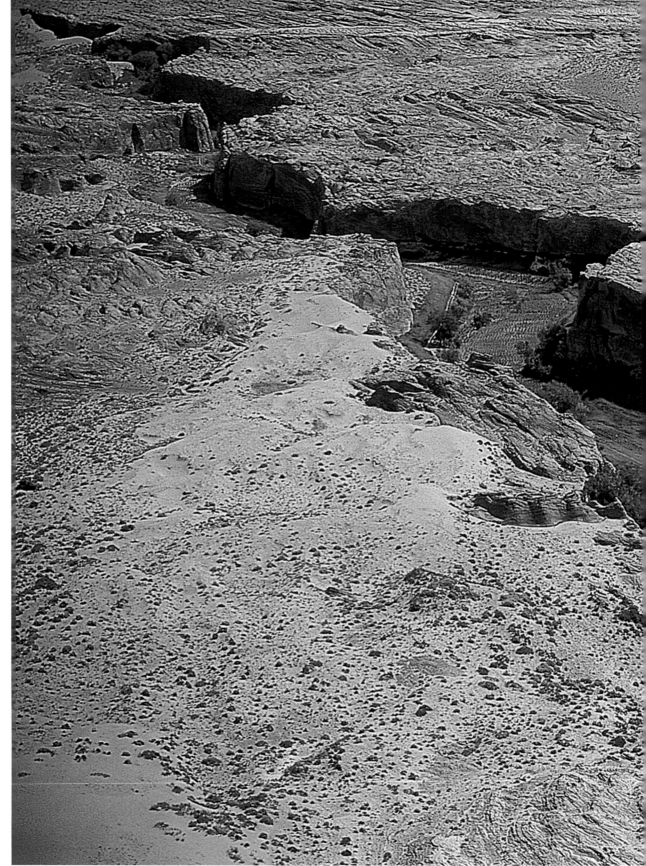

Tuba City area, Arizona. Native American farms along the canyon floor.

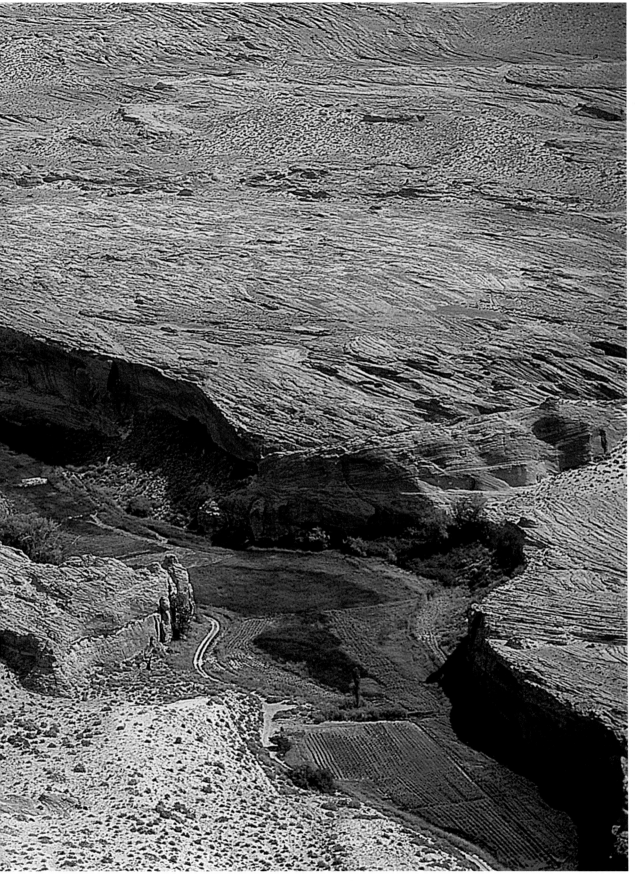

64 Blythe, California. Intaglio markings on the ground.

Chaco Canyon, New Mexico. Pueblo ruins.

Los Alamos, New Mexico. Bandelier National Monument.

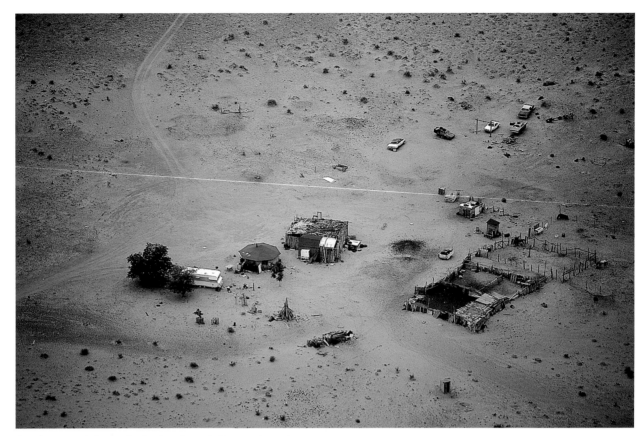

Tonalea area, Arizona. Native American shelters and corral.

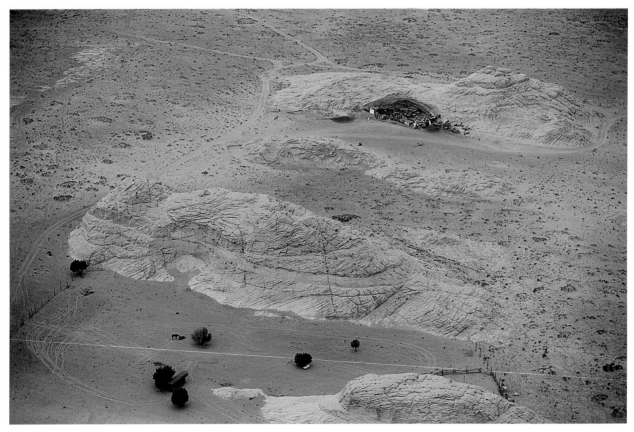

Tonalea area, Arizona. Sheep corral built into natural bowl.

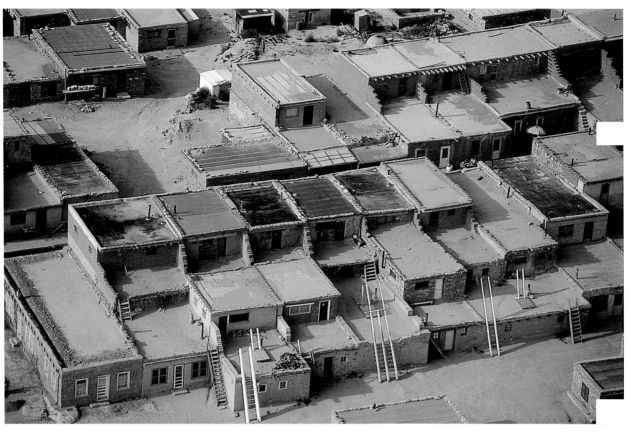

Acoma, New Mexico. Multilevel adobe housing.

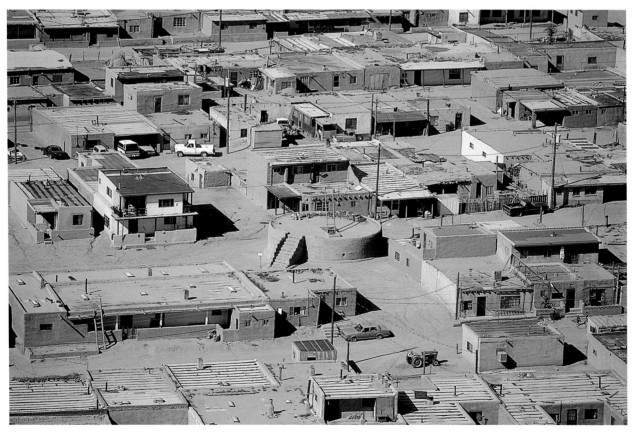

Navajo National Monument, Arizona. Adobe houses and kiva in Santo Domingo Pueblo.

Domingo, New Mexico. Detail of kiva in Santo Domingo Pueblo.

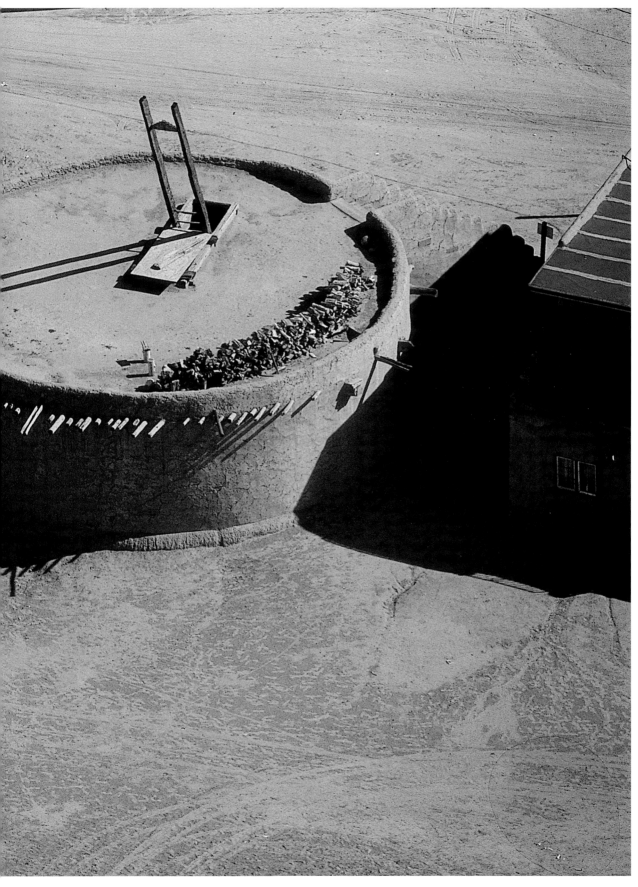

AGRICULTURE

By its very nature, agriculture is expressive of regional and local conditions. The types and patterns of agriculture are primarily shaped by topography, as well as by a combination of climate and soil conditions. Historically, these natural factors have been key determinants of land use. The immense area of the United States, combined with its wide range of temperature zones, results in countless distinct forms of agriculture. Farmers have had to align their agricultural practices with the prevailing local elements in order to ensure their own survival.

A prime example of regional identity and the responsiveness of agriculture to local conditions is "The Golden Wheat Triangle" in Montana. Its long, narrow strips of planted wheat alternated with fallow strips make it unique. The fallow and planted strips are rotated each year so that the soil can accumulate enough moisture to allow the growing of wheat in a sustainable way. The strips are kept narrow and are oriented perpendicularly to the prevailing winds so as to minimize wind erosion of the fallow strips. It is interesting how this pattern gradually changes as one travels east away from the Rocky Mountains. Because the winds diminish and the soils become heavier, and thus less susceptible to being carried away by the wind, the formerly narrow strips increase in width. The width of the strips corresponds to the width of the tractor till that plows the field.

It is exciting to fly into a new region and see how the landscape reveals itself. Regional expression through the built environment is most clearly visible in its agriculture. (It is certainly not revealed in the development pattern

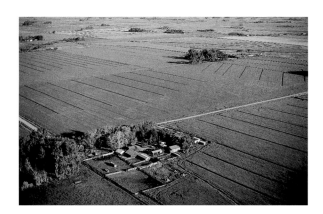

Fairfield Bench, Montana. Farmstead and fields.

formed around an interstate highway interchange.) In modern agriculture, there are specialized crops that require exacting conditions in order to thrive. Cranberries, for example, grow in extremely limited locations, and citrus trees must grow in frost-free zones.

Transitions between farm types depend on the direction in which one moves across the land. For instance, as one moves out of a river valley to a higher plain the transitions are abrupt. However, as one moves along a flood plain the agricultural landscape remains fairly constant. Since the soil and topography of the lower Mississippi Valley varies only slightly, the changes moving north/south are somewhat similar to the temperate zone transitions printed on the back of seed packets.

In conflict with modern agriculture is the romantic notion of living off the land. The small family farms that grow a variety of crops and keep livestock best exemplify this. It is these farms in particular that are characterized by a vernacular style that is typified by a farmhouse with its adjacent barnyard and outbuildings. Much of this landscape is in the process of being consolidated into larger corporate farms that rely heavily on technology and capital investment. The corporate farm points to global economic forces that are reconfiguring and changing the patterns of the land.

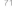

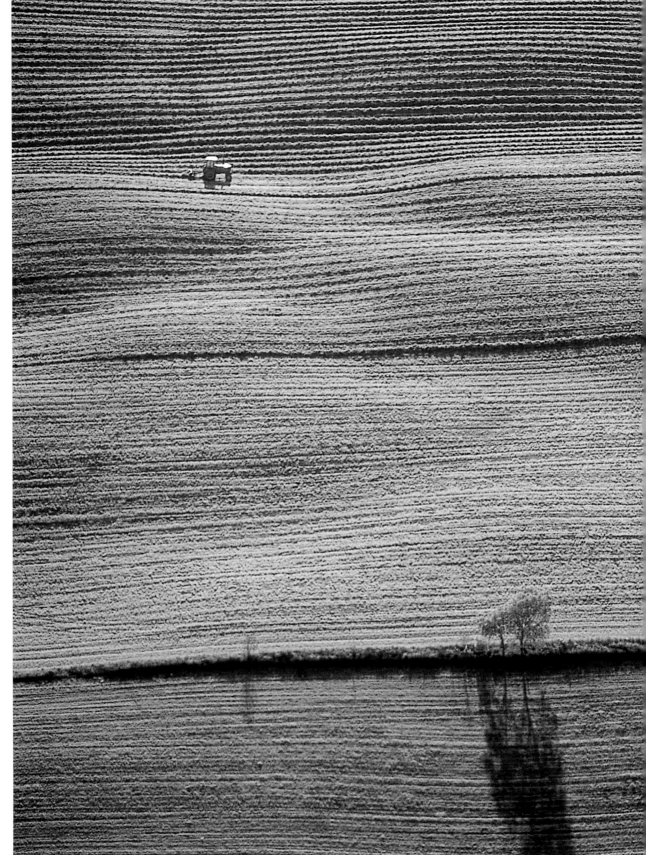

Browns Corners, Vermont. Winnowed hay fields.

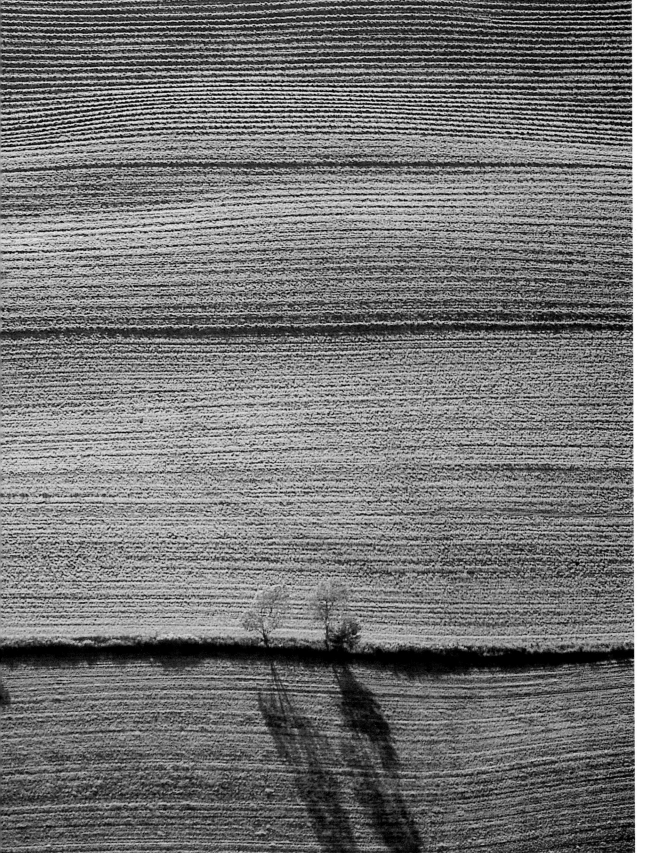

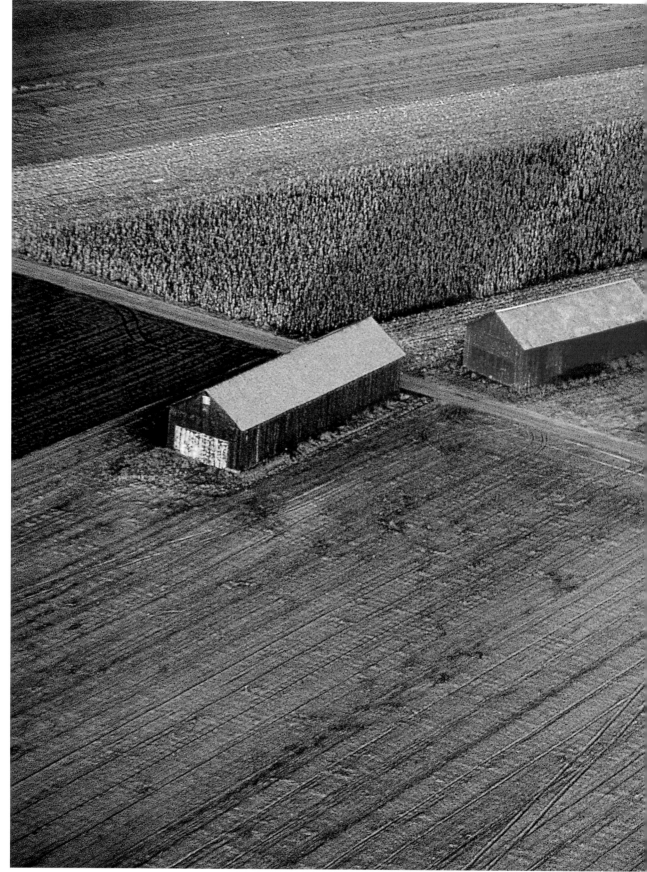

Hatfield, Massachusetts. Tobacco fields with barns.

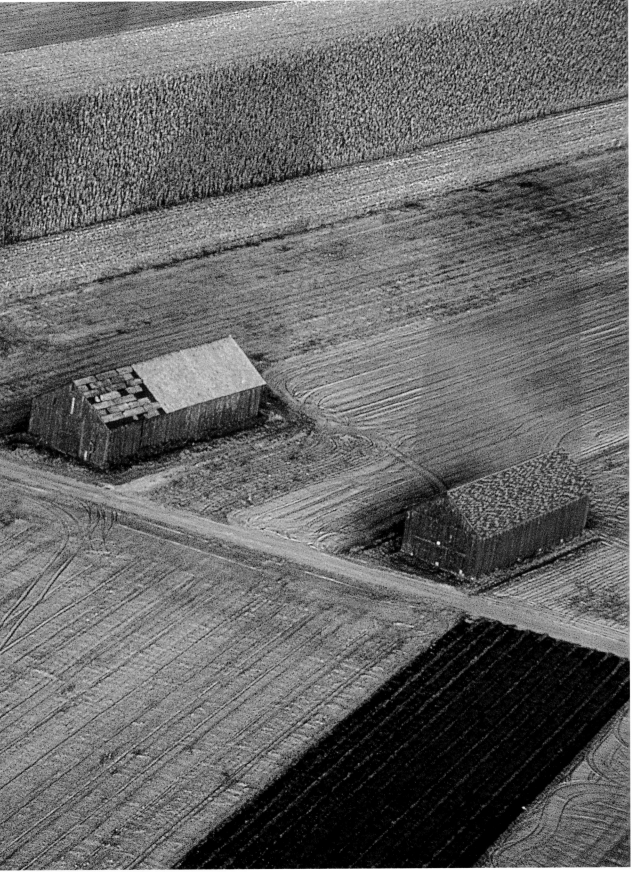

Napa, California. Farm buildings and vineyards.

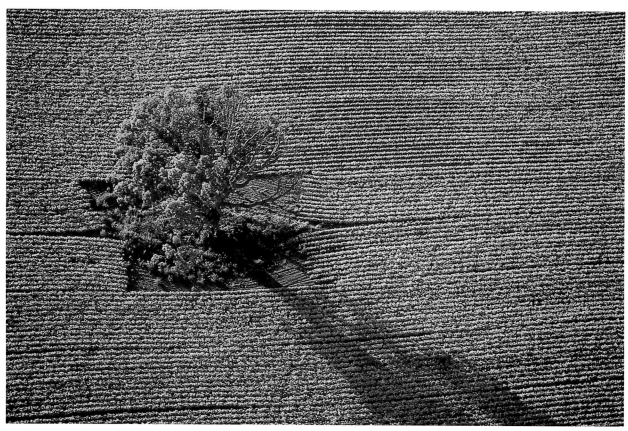

Central Indiana. Tree in corn field.

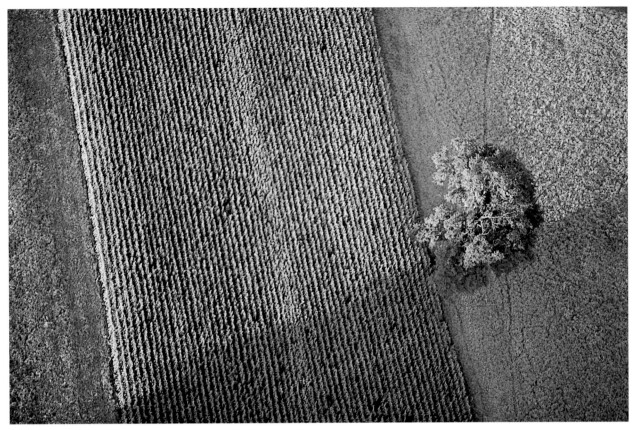

Berkshires area, Massachusetts. Tree alongside corn strip.

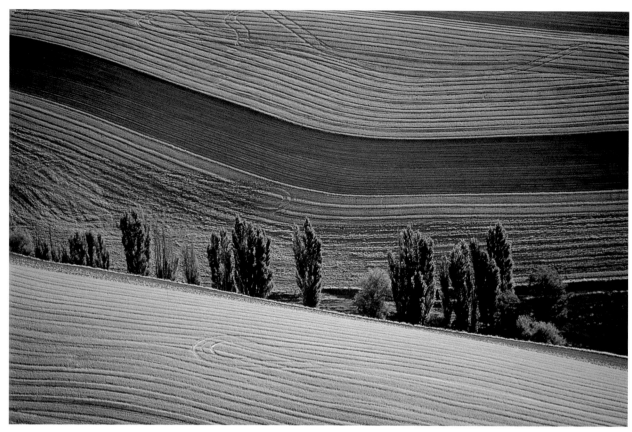

Pullman area, Washington. Plowed wheat fields on the Palouse.

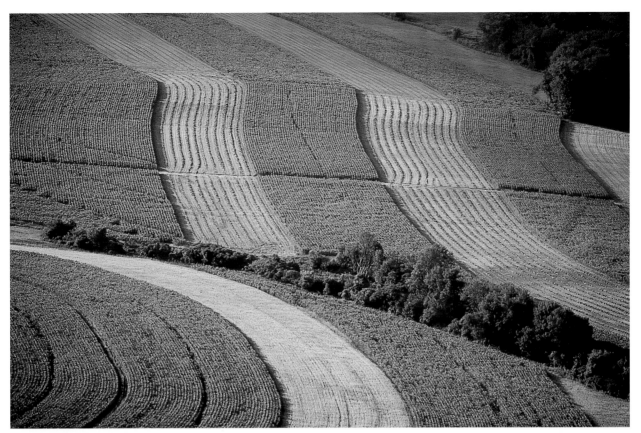

Central Ohio. Contoured fields with crop rotation.

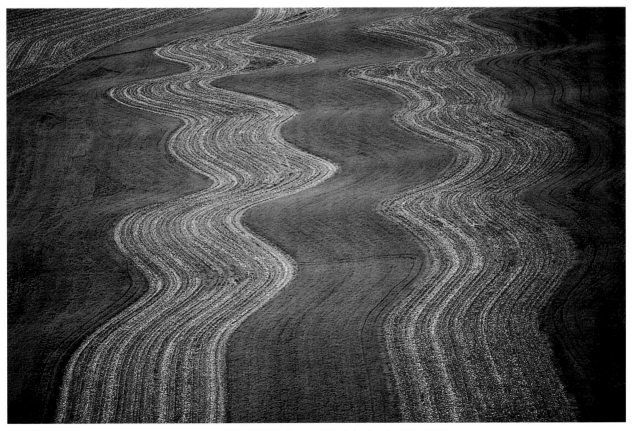

Western Illinois. Rotated use field strips follow the natural contours of the land.

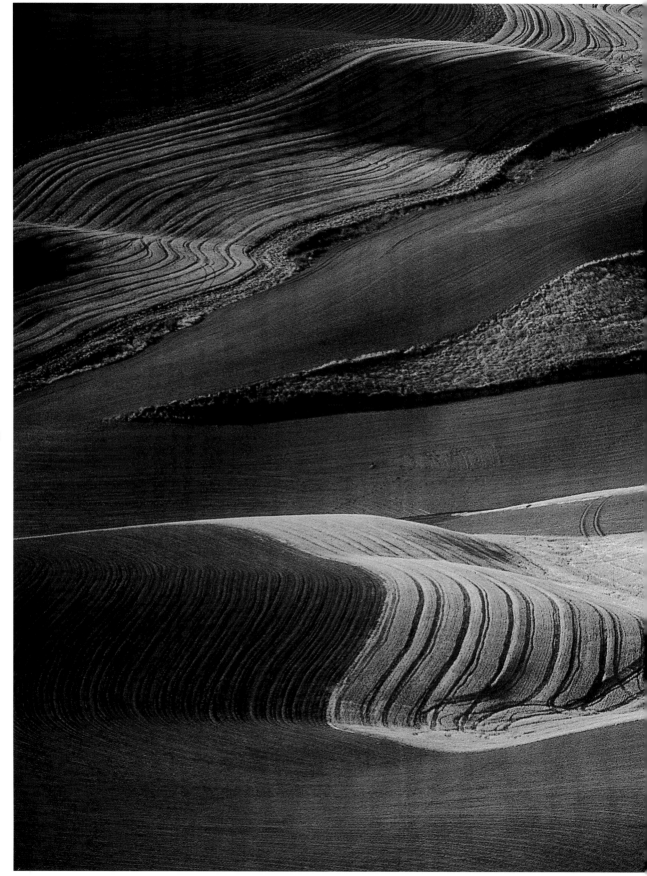

Pullman, Washington. Wheat stubble field on the Palouse.

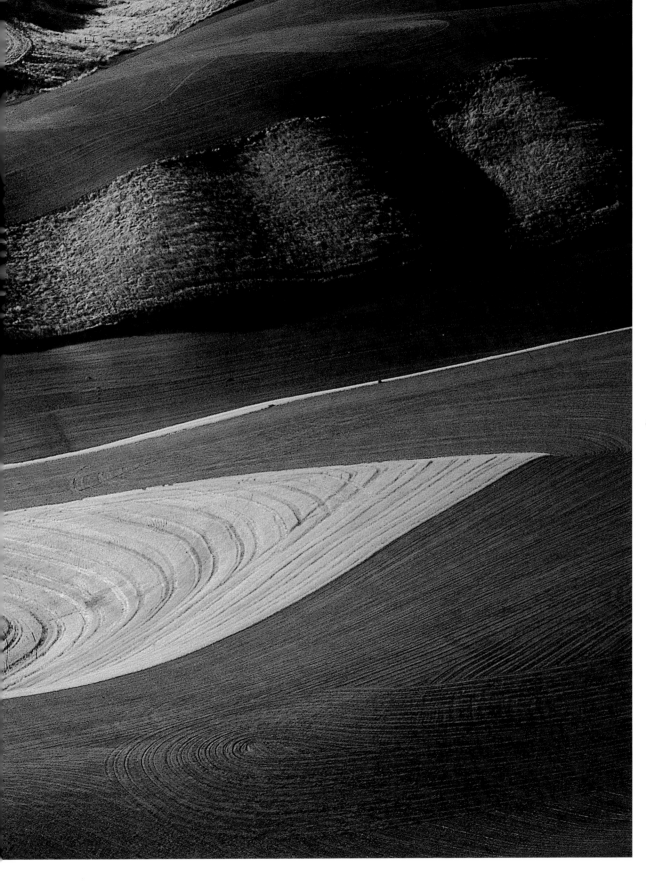

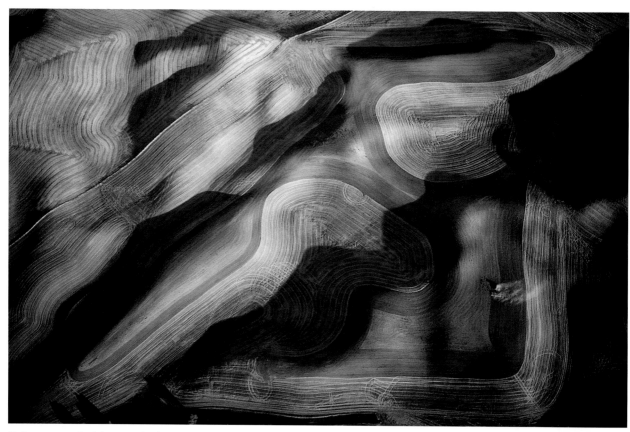

82 Pullman area, Washington. Plowing patterns conform to the rolling Palouse.

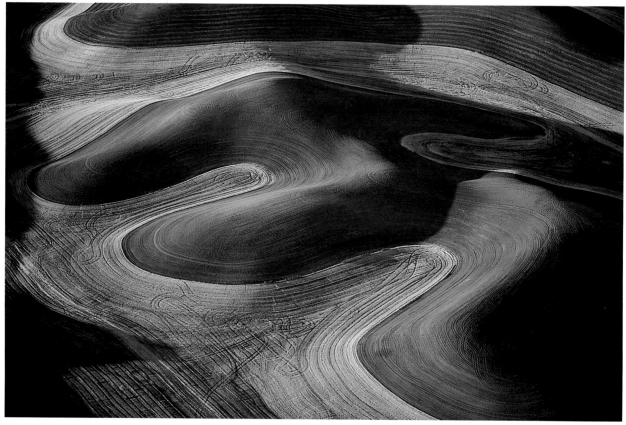

Pullman area, Washington. Wheat farming follows the contour of the Palouse.

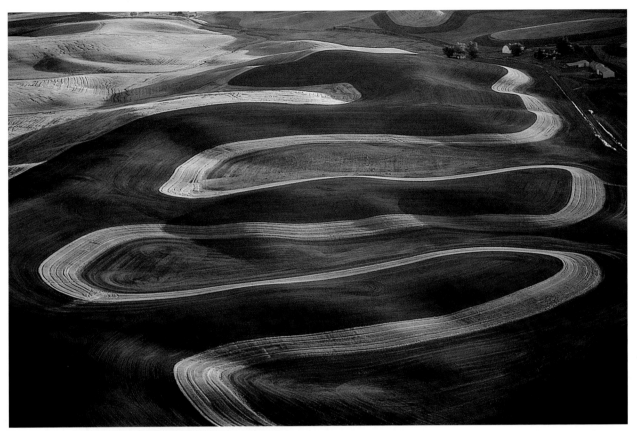

Pullman area, Washington. A ribbon of wheat field winds along the contour of the Palouse.

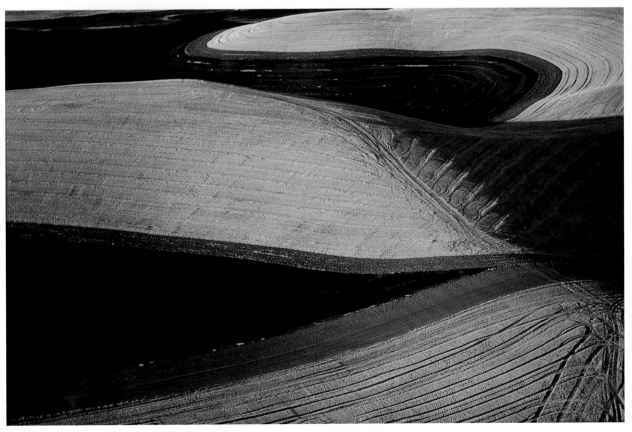

Pullman area, Washington. Plowing and harvesting patterns on the Palouse.

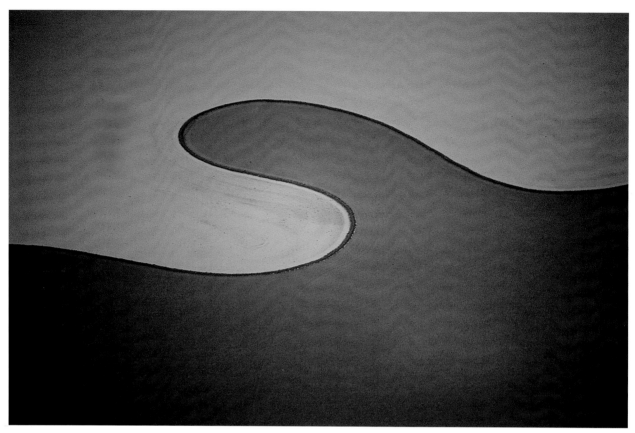

84 Southwestern Louisiana. A rice-farming berm forms a Yin-Yang symbol.

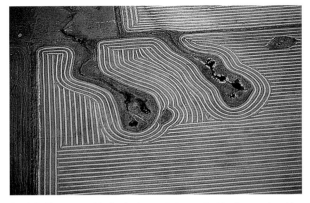

Cash Valley area, Utah. A stream interrupts the harvest pattern.

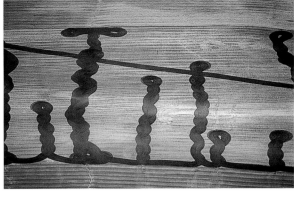

Cash Valley, Utah. Plowing pirouettes.

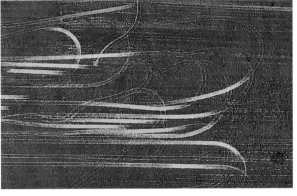

Munich area, North Dakota. Tracks from rock collecting among sloughs.

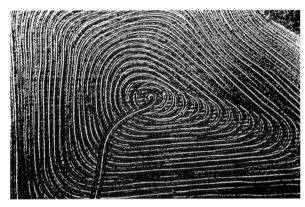

Boxborough, Massachusetts. Winter snowplow patterns.

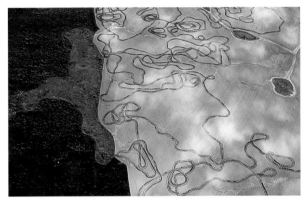

North central Ohio. Tractor tracks in a field of tomatoes.

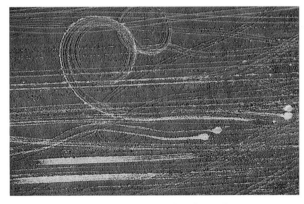

North central Ohio. Tractor tracks in a field of tomatoes.

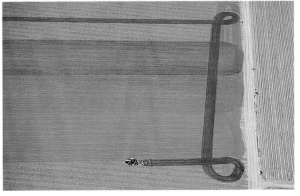

Santa Maria, California. Tilling loops.

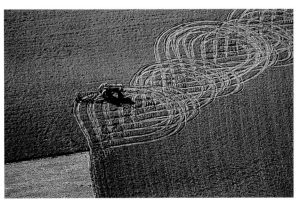

Windsor, Vermont. Tractor turning in a circle.

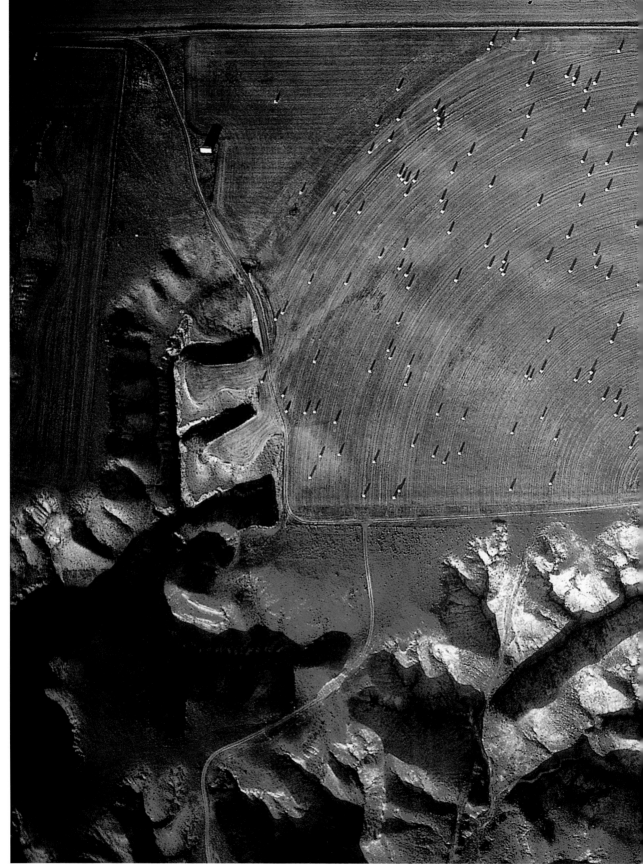

Loma area, Montana. Marias River drainage and pivot irrigator.

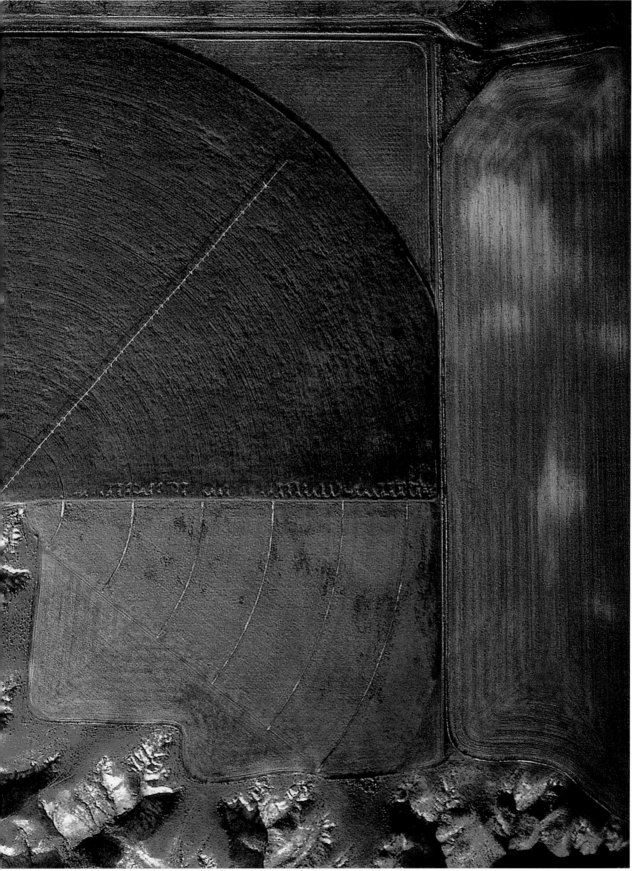

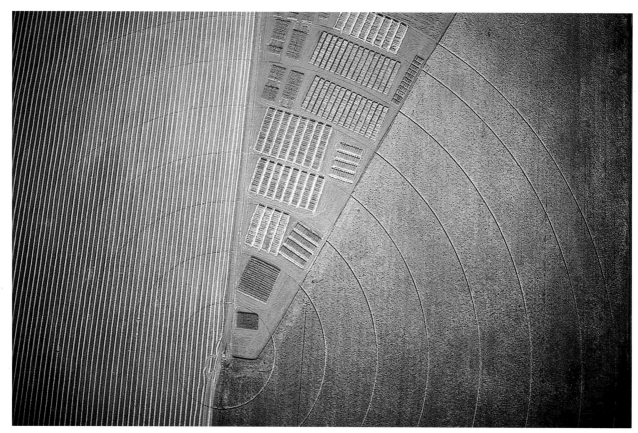

Barlow, North Dakota. Test beds on a pivot irrigator.

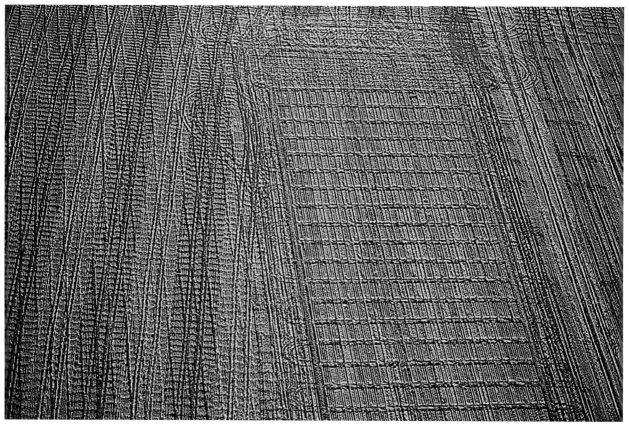

Eastern Illinois. Agricultural field pattern.

Eastern Indiana. Checkered mowing pattern in cultivated field.

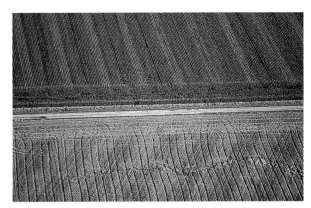

Eastern Illinois. Agricultural field patterns.

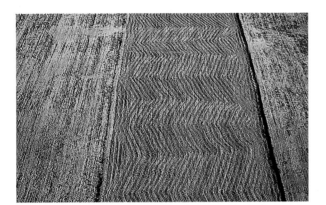

Lake Elwell area, Montana. Zigzagging cultivation.

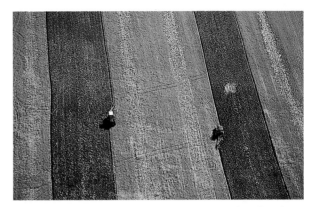

Western Ohio. Two tractors tilling a field in opposite directions.

Havre, Montana. Broad wheat fields.

Northern Vermont. Green field corner edged by tilled earth.

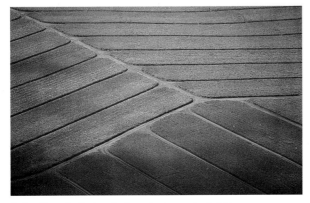

Oahu, Hawaii. Abstract view of pineapple fields.

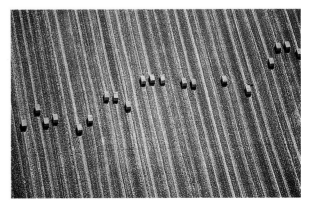

Logan, Utah. Hay bales in a Cash Valley field.

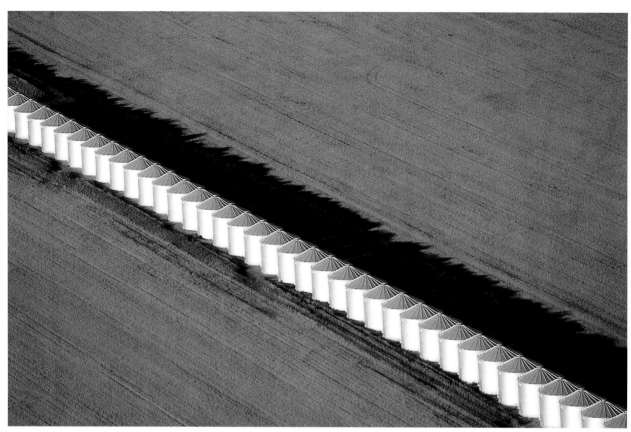

Gildford, Montana. Silo-shaped grain storage bins in a continuous line.

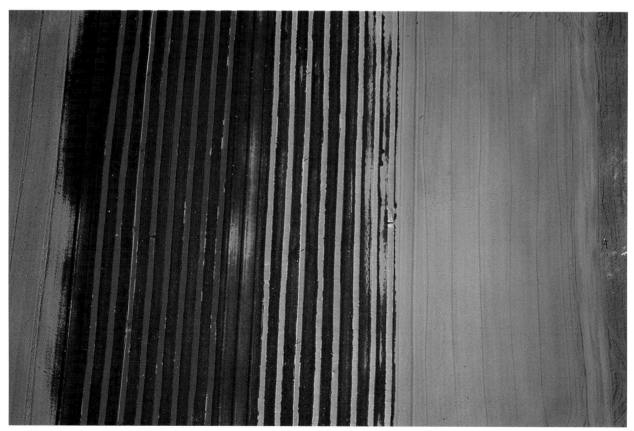

Lexington, Massachusetts. Wilson Farms mulching sheets.

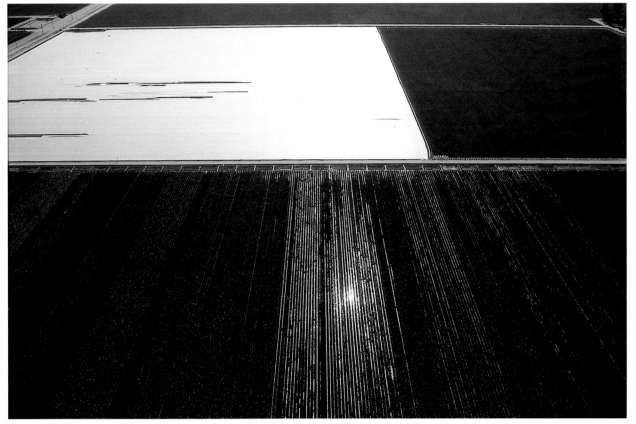

San Joaquin Valley, California. Flood irrigation of agricultural fields.

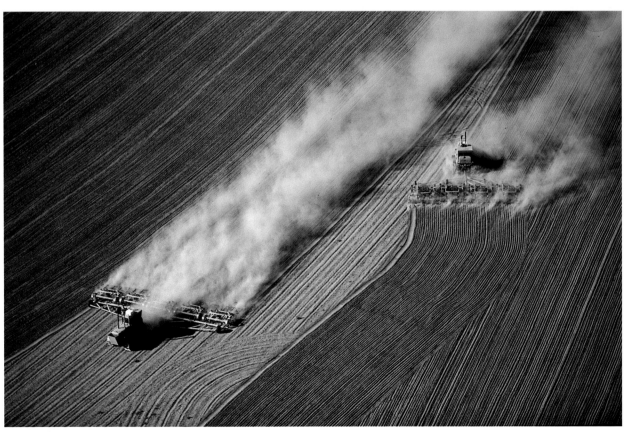

Eastern Washington. Tractors trailing dust while tilling fields.

FOREST

→ Forests and woods cover significant areas of the United States. Likewise, there are large sections of the country, mostly arid or on the plains, without any substantial forest growth. Forests around the country have basic distinguishing characteristics: natural forest versus planted forest; pine forest versus mixed deciduous forest; urban forest versus wilderness forest; and protected forest versus forest exploited by commercial interests. Mountainous forest is intrinsically inaccessible and unsuitable for agriculture or development, while agricultural areas may reveal the clearing of forest.

In New England, approximately eighty percent of the land was at one point cleared for agriculture and timber use. Slowly over time, this has reverted back and now the forest covers eighty percent of the land. The shift over time in the landscape is seen in tree-covered fields where taller trees mark old fence lines.

It is important to view forest over time; at least over the life span of a tree. Viewed in this longer time span, forests are in flux and constantly changing. The natural vegetative state of much of the land is forest. The great forests are associated with the named mountain areas, such as the Rockies, Cascades, White Mountains, Green Mountains, Smokey Mountains, and Black Hills. Appalachian ridgelines are covered with trees and look like long fuzzy woolly caterpillars with cleared agricultural fields lying in between.

The exploited forest is identified by vast tracts of trees cleared by the timber industry for paper, pulp, and wood products. In recent years, industry practices have become so mechanized and intense that these forests are now called industrial forests. Huge clear-cuts in pristine forests, as well as low-lying pine plantations in the south, are

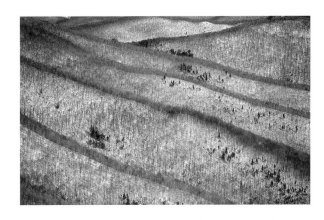

Berkshires, Massachusetts.
Mountains and snow with ridge lines.

the telltale signs of this practice. In flat lying areas, huge tractors in a single motion can fell, strip, and stack trees into piles. On the flat logging roads of Maine, logging trucks speed through the wilderness on dirt roads at ninety miles an hour. Trees on hillsides are quickly dropped in a radiating pattern and pulled by cable to landings below a central guy wire tower to be shipped out. After being cleared, planes often spray industrial forests with herbicides to ensure that only pine trees return.

These industrial practices have deleterious effects on wildlife, biodiversity, water quality, air quality, and scenic beauty. Coupled with the intense depletion of forest through clear-cutting are huge populations mindlessly consuming forest products without environmental awareness about the consequences of their consumption. Contrasting with the industrial forests are amazing tracts of protected forest such as the Adirondacks, which are so extensive that one flies around them for fear of a forced landing leaving one hopelessly lost in the wilderness.

Perhaps the most common forests are wooded areas that do not seem to belong to anyone. These areas appear to be leftover pieces of land, often bordering rivers and streams and running up nondescript hillsides, or just idle land lying between settlements. The importance of woods to earlier settlement is indicated by preserved wood lots still found today on farms in the Midwest that have been kept to provide wood for heating. The urban forest can unexpectedly be found intact in rapid growth cities such as Houston and Dallas in Texas. In fact, Houston's first-ring suburbs have a pseudo-forest—a lush canopy of trees covering what was once a prairie. The forest viewed in its present form and over time is a key component of our environment, economy, and cultural landscape.

Upstate New York. Mixed hardwood forest in autumn.

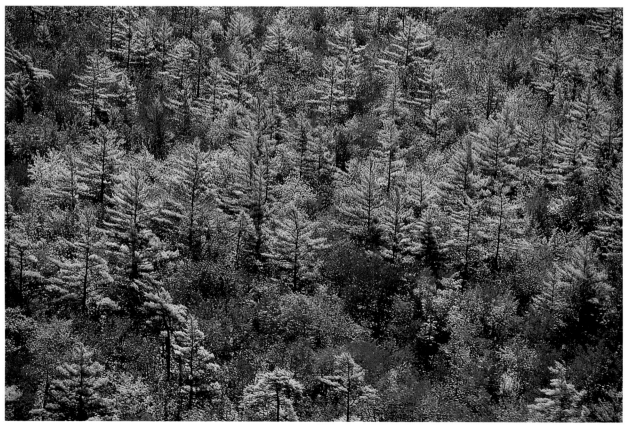

Taunton, Massachusetts. Evergreens among red Swamp Maples in autumn.

Upstate New York. Mixed hardwood forest in autumn.

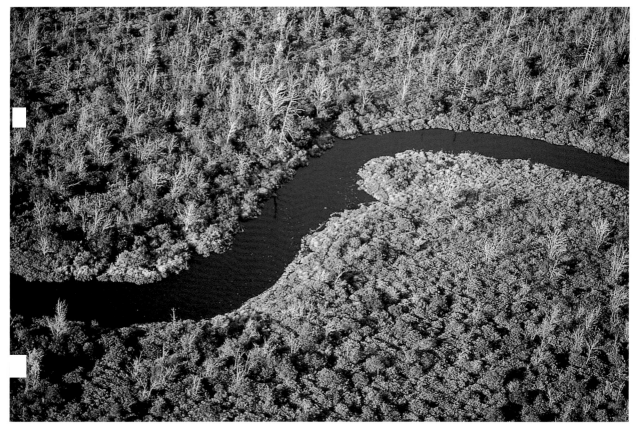

Sudbury, Massachusetts. Trees along the Sudbury River.

Taunton, Massachusetts. Trees in freshwater wetland.

Westborough, Massachusetts. Colorful autumn foliage in the Sudbury River area.

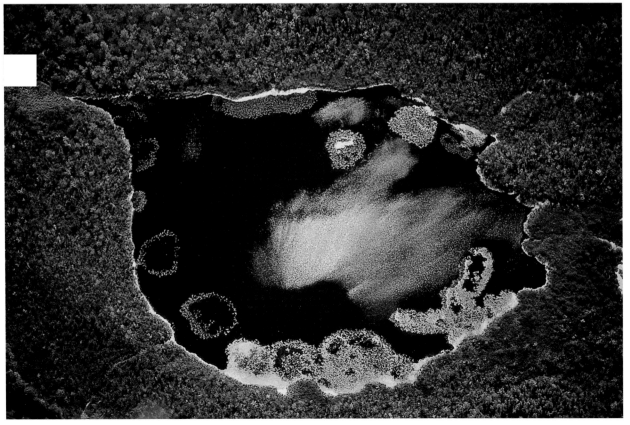

Westborough, Massachusetts. Cedar Pond swamp and surrounding trees.

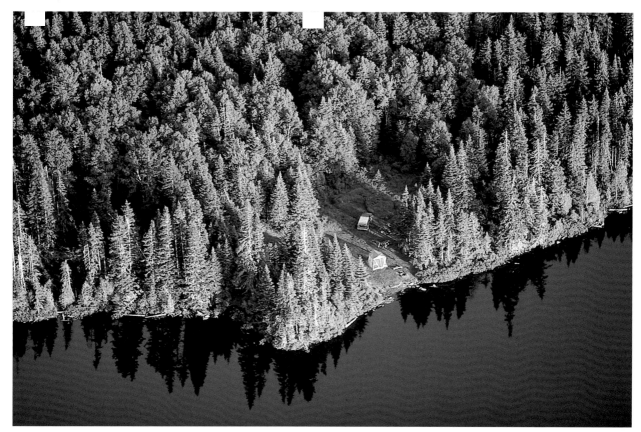

North of Moosehead Lake, Maine. Waterside campsite in forested area.

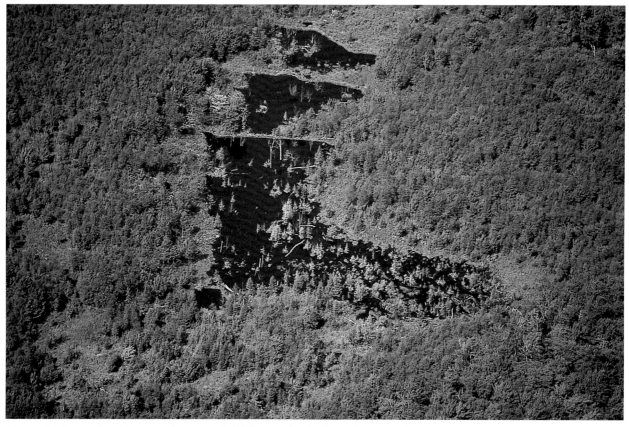

Chesterfield area, Massachusetts. Beaver pond with beaver dam in the Berkshires.

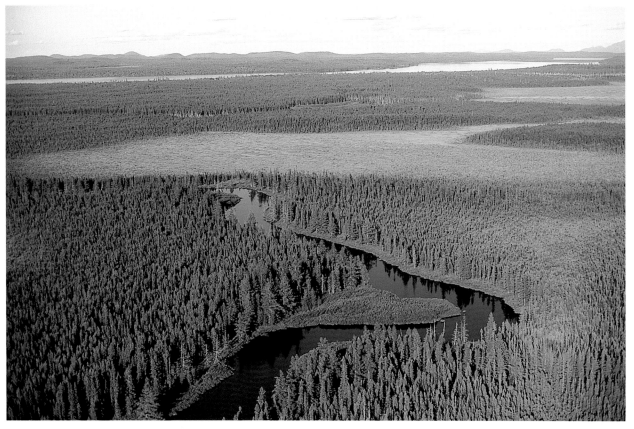

Chamberlain Lake area, Maine. Wilderness area along a stream.

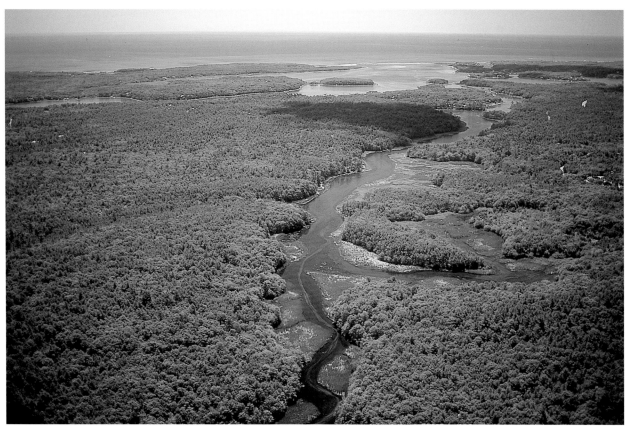

Mashpee, Massachusetts. Mashpee River estuary.

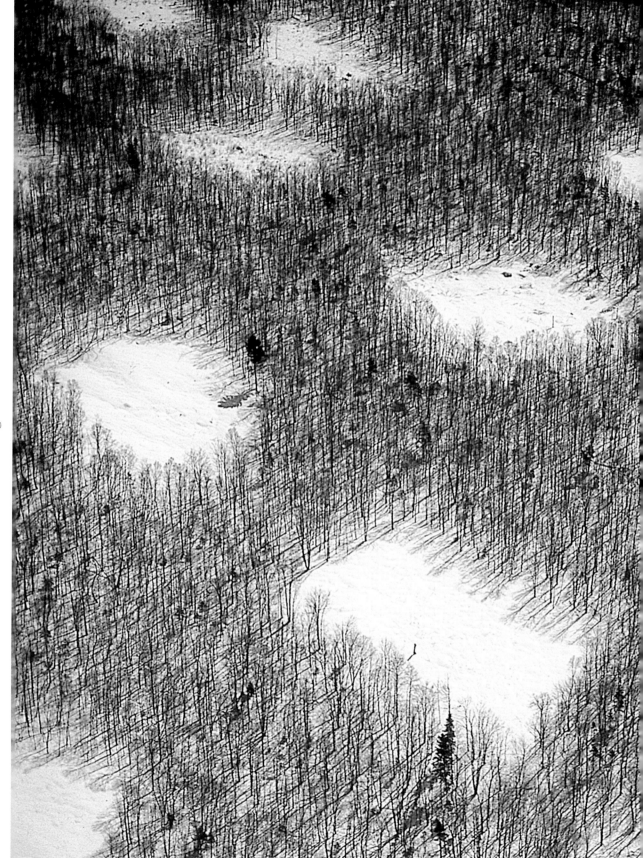

White Mountain National Forest, New Hampshire. Clear-cut patches of forest.

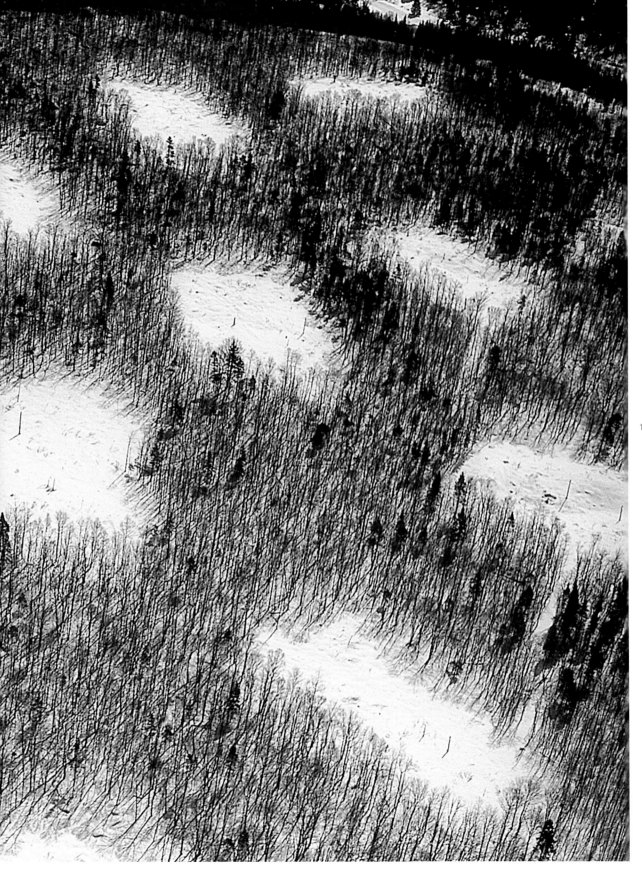

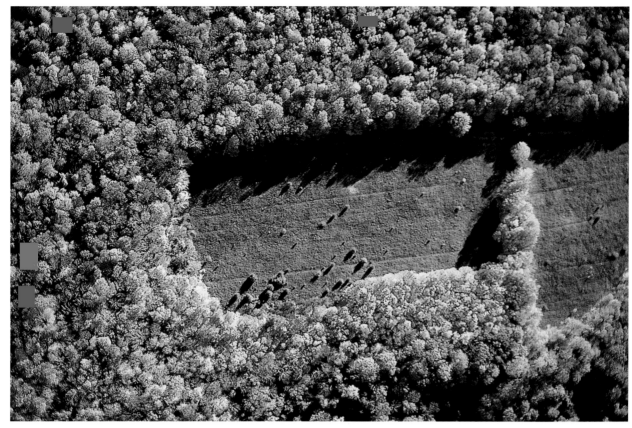

Great Barrington, Massachusetts. Field surrounded by trees.

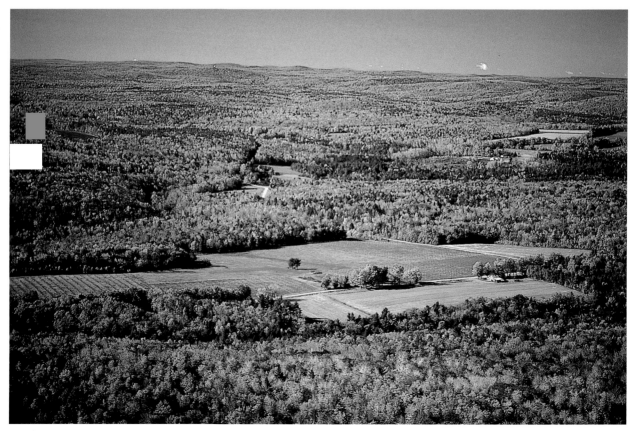

Western Massachusetts. Berkshire foothills valley farm.

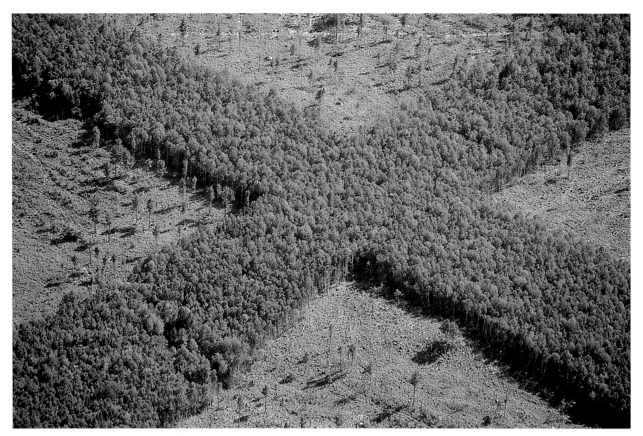

Sturtevant Pond, Maine. Clear-cut forest makes an X-pattern.

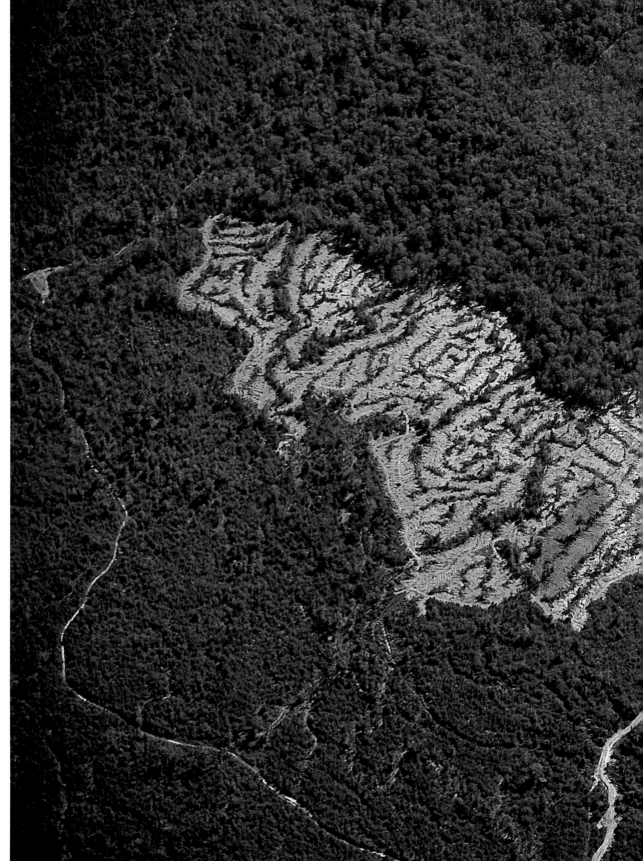

Southwestern Louisiana. Plantation forest clear-cut.

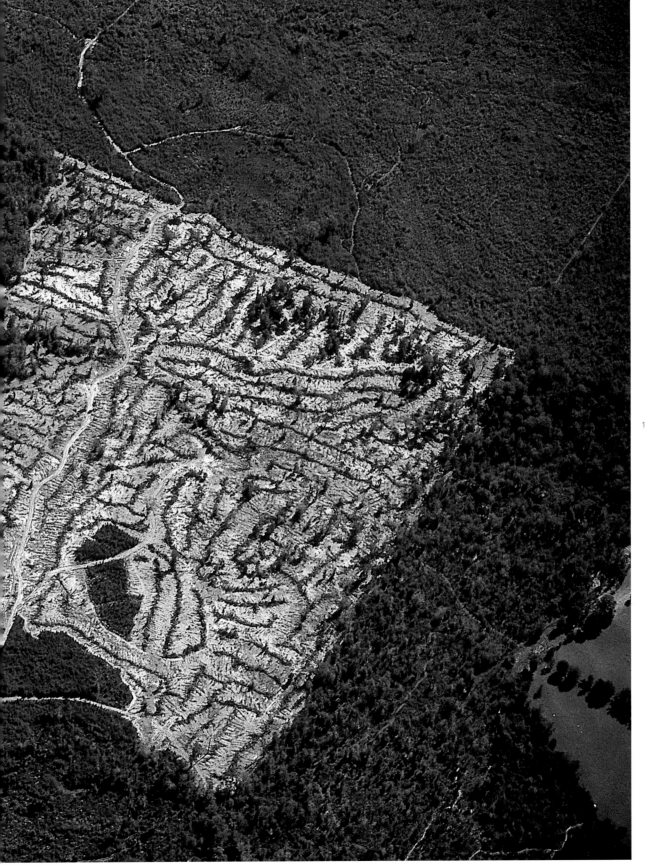

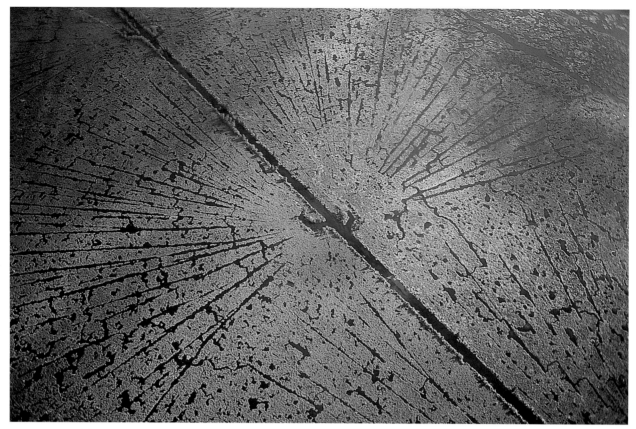

Maurepas, Louisiana. Channels dug in wetland for cypress logging.

Mount St. Helens area, Washington. Active clear-cut operation.

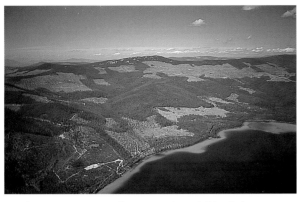

Northwestern Montana. Clear-cuts along Ashley Lake.

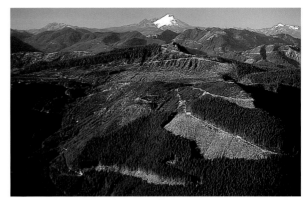

Western Washington. Clear-cuts.

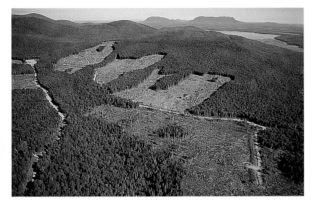

Moosehead Lake, Maine. Hillside clear-cut.

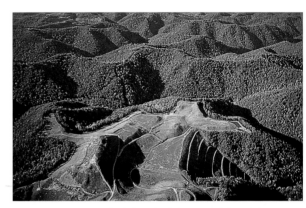

Beckley area, West Virginia. Hillside cut-and-fill mining.

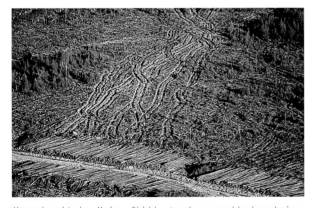

Moosehead Lake, Maine. Skidder tracks caused by logs being dragged from woods.

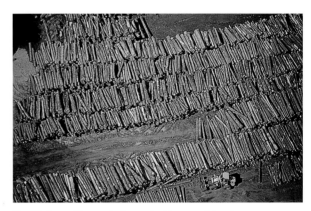

Brattleboro, Vermont. Harvested logs and tractor.

Bellingham, Washington. Log rafts.

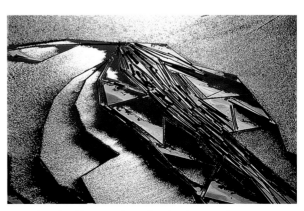

Longview, Washington. Algae floating between logs.

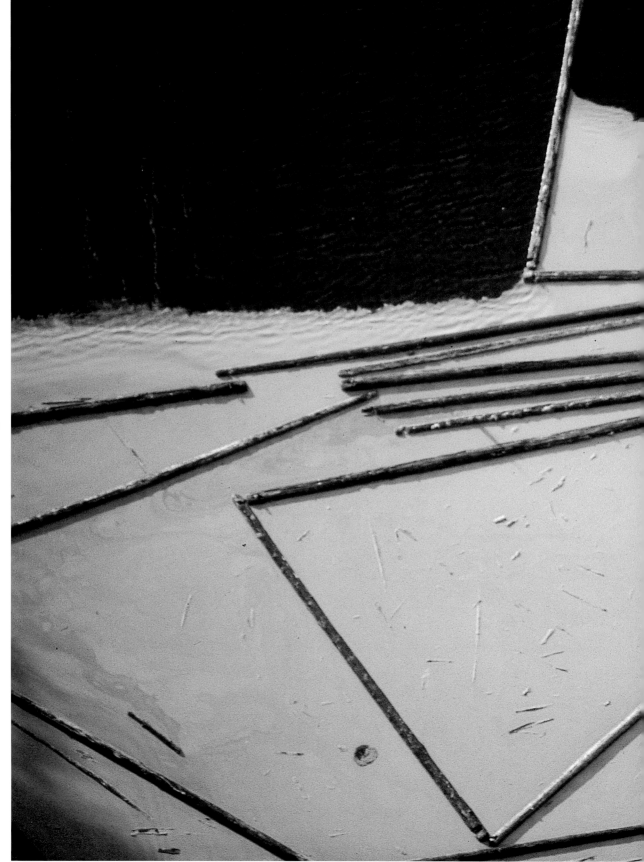

Longview, Washington. Algae between floating logs.

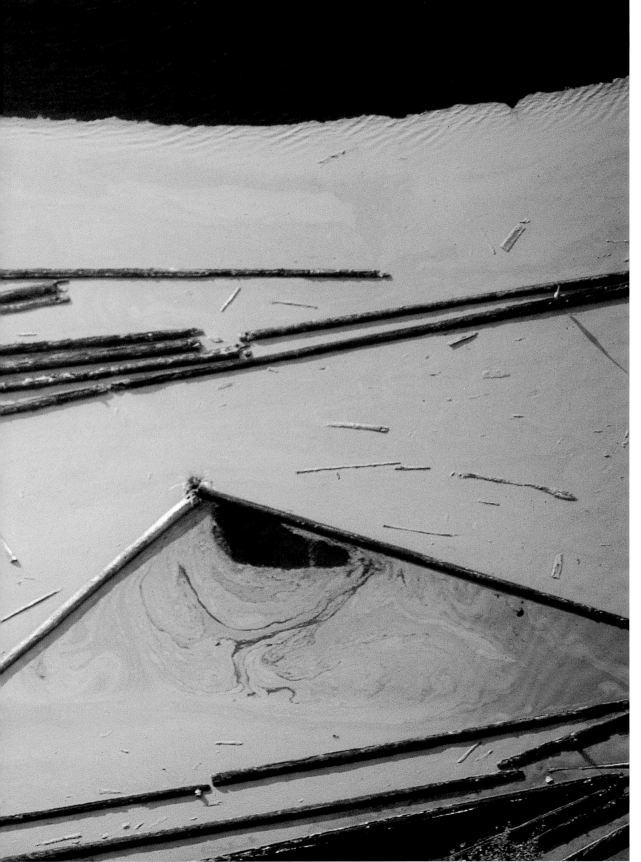

ABANDONMENT

Abandonment is part of the built environment and is seen in two distinct forms. One form results when waste becomes a land use in and of itself. Objects large and small are regularly abandoned and pushed into the waste stream to be either recycled or channeled to a permanent resting place. Auto junkyards, landfills, metal scrap yards, and other depositories represent this form of abandonment. A more interesting form occurs when land use such as housing becomes no longer habitable, manufacturing facilities are left permanently idle, or agricultural fields revert to forest or desert.

Land use abandonment is a big part of the evolution of landscapes and often is not predictable. Abandonment is a key marker of, and often an early indicator of, shifting cultural, technological, and economic forces. Classic examples of urban abandonment are vacant intercity housing and blighted neighborhoods that result from "white flight"—the migration of middle-class city dwellers to the suburbs. The Midwest's "Rust Belt" is another large-scale example. The term "Rust Belt" describes an area of the United States that was once heavily

Northeastern Oklahoma. Tree growing out of abandoned silo.

industrialized, but is now littered with a large number of permanently closed factories representing billions of dollars in capital investment.

The process of land use abandonment is more likely to be measured in decades than in days or months. Abandonment is interesting because it is usually unimaginable before its occurrence. It would have been hard to imagine the demise of canals before the invention of the steam locomotive and the construction of the railway network. Likewise, it would have been hard to foresee that trains and rail lines would largely be replaced by the automobile and interstate highway system. Today it is hard to imagine the possibility of highways being abandoned.

Abandoned spaces provide opportunities for rejuvenation through cleanup, recycling, and reuse. Empty warehouses and piers along urban waterfronts are being rehabilitated into housing, office and retail space, and recreational facilities. Abandoned rail lines are being converted into recreational trails. Landfills are covered over and landscaped to become parks or golf courses. In abandoned spaces lie opportunities.

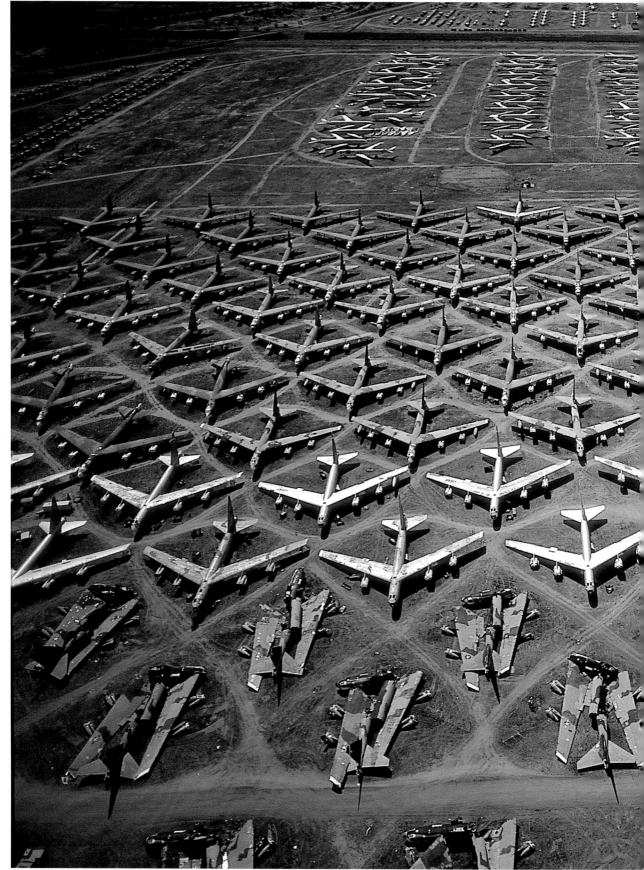

112

Tucson area, Arizona. Fleet of B-52 bombers at the "boneyard."

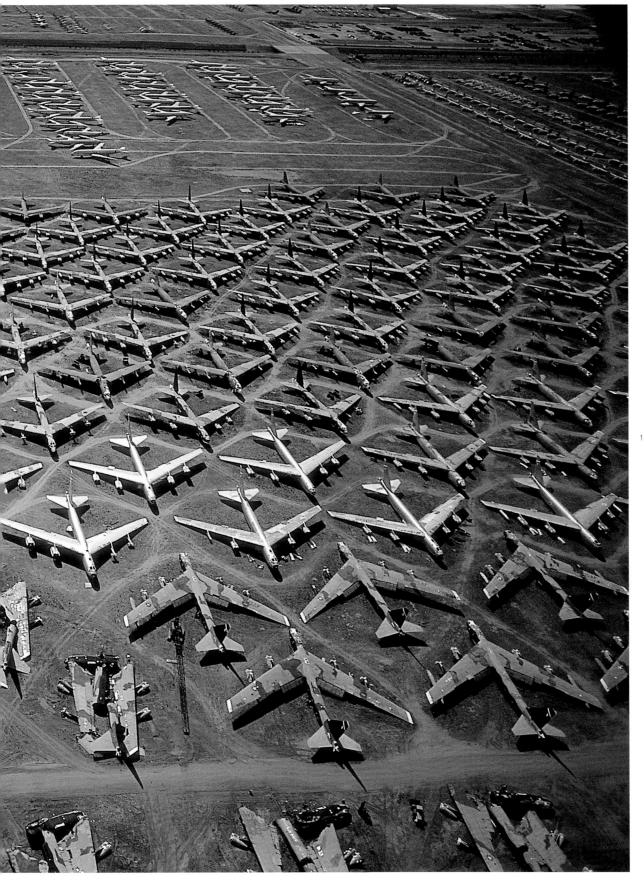

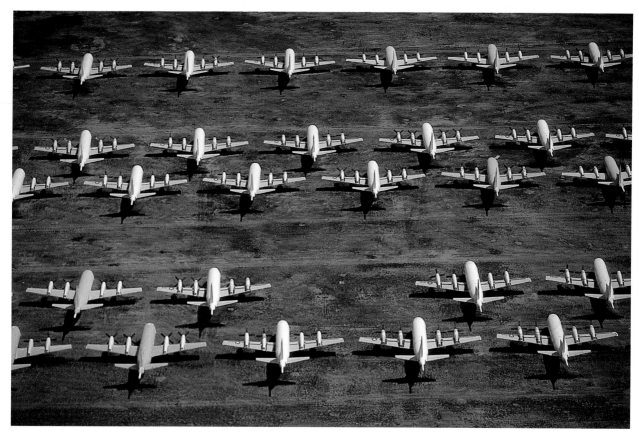

Tucson area, Arizona. Military cargo planes at the "boneyard."

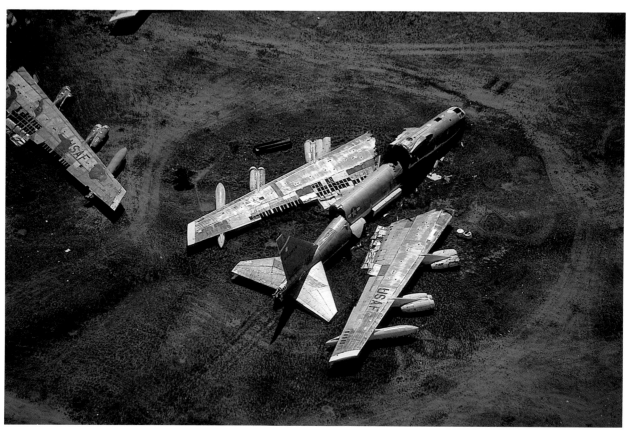

Tucson area, Arizona. B-52 bombers being systematically destroyed.

Tucson area, Arizona. Military jet fighters at the "boneyard."

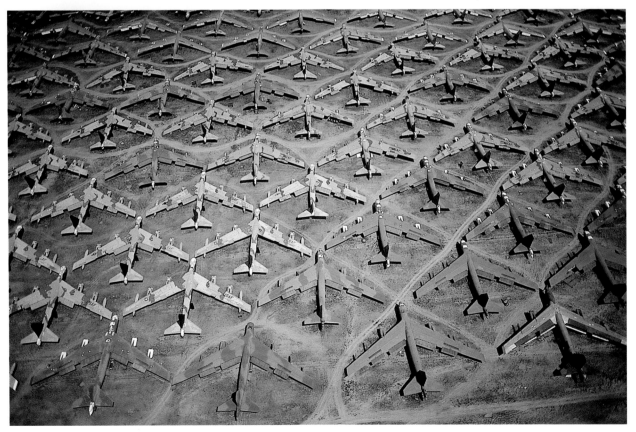

Tucson area, Arizona. B-52 bombers at the "boneyard."

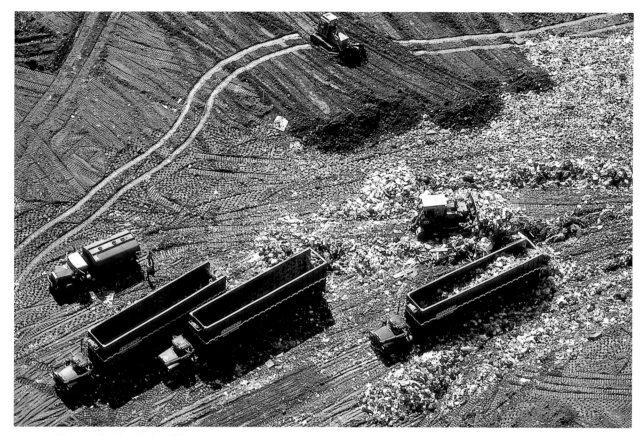

116 Laytonsville, Maryland. Oaks landfill.

Staten Island, New York. Beyond salvage.

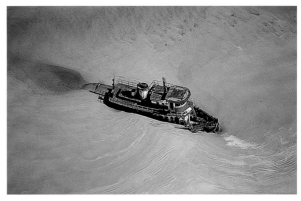

South of Savannah, Georgia. Abandoned tugboat in the sand near the coastline.

Wheeling, West Virginia. Trees growing up around railway cars.

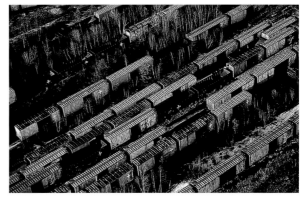

Billerica, Massachusetts. Abandoned trains.

Chicago, Illinois. School buses and waste pile.

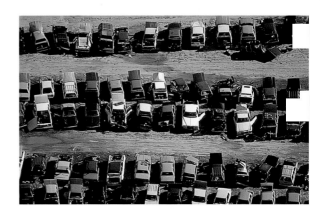

Plymouth, Massachusetts. Auto junkyard.

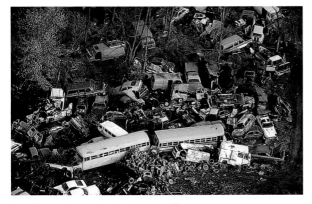

Pottstown, Pennsylvania. Junkyard.

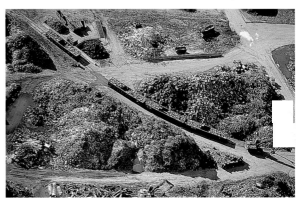

New Haven, Connecticut. Metal scrapyard.

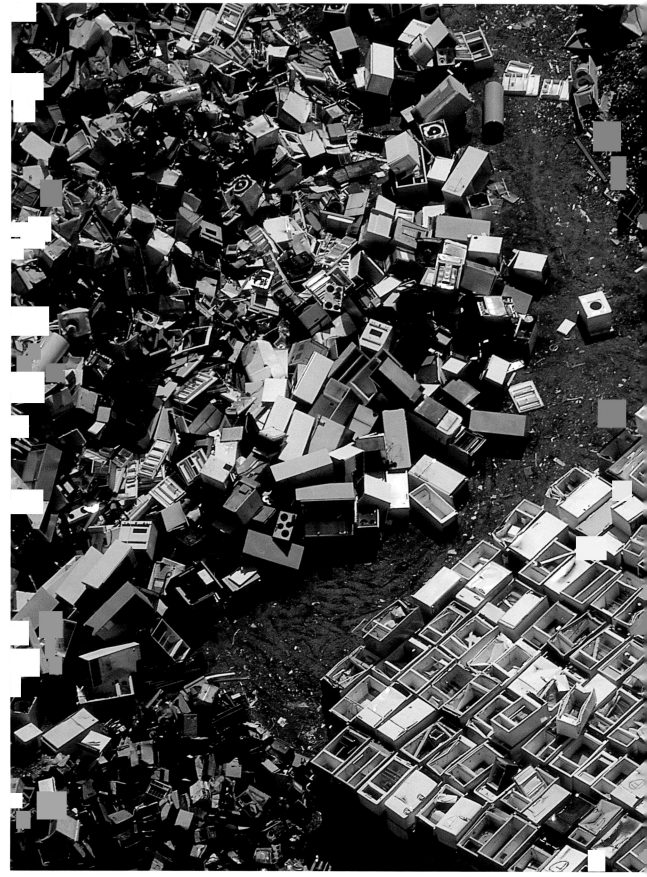

Walpole, Massachusetts. Waste pile.

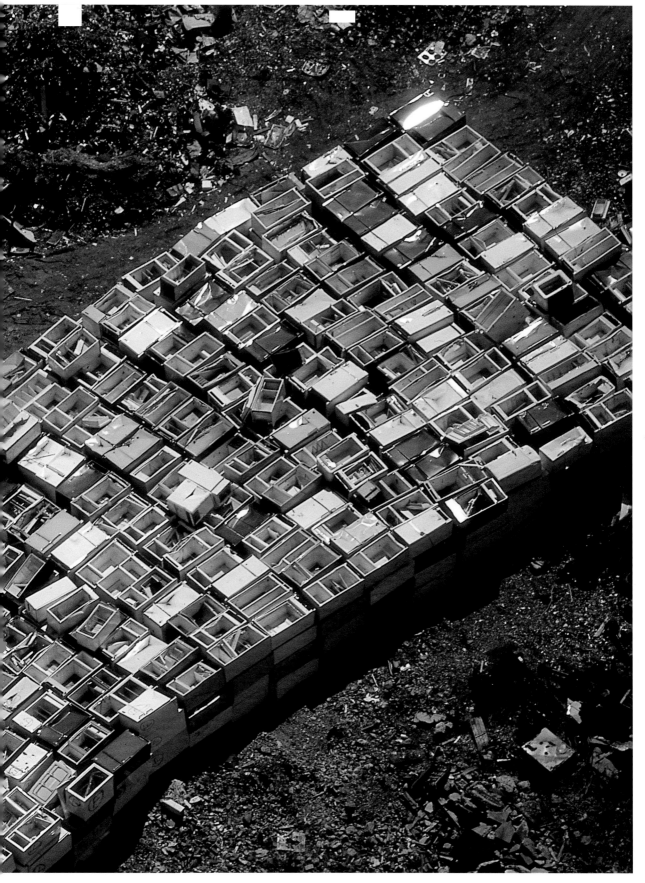

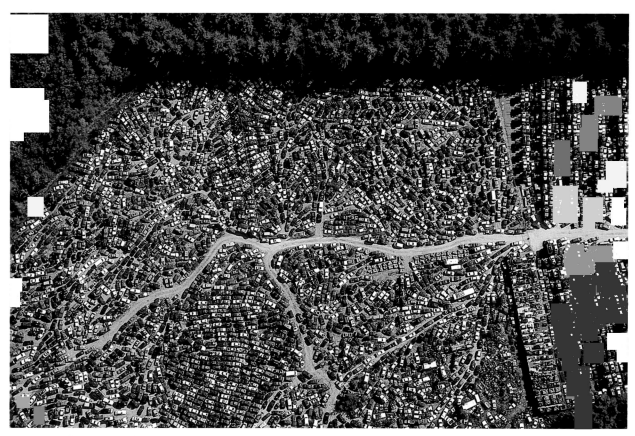

Ayer, Massachusetts. Auto junkyard with access road.

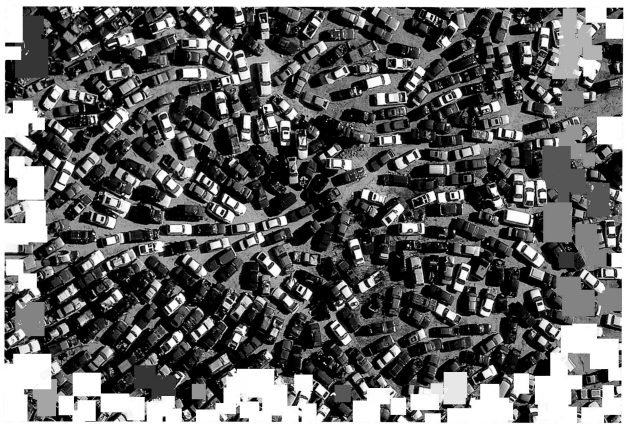

Ayer, Massachusetts. Auto junkyard.

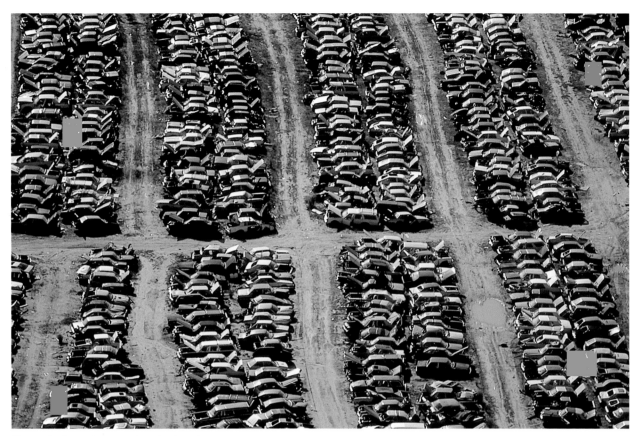

Plymouth, Massachusetts. Auto junkyard.

121

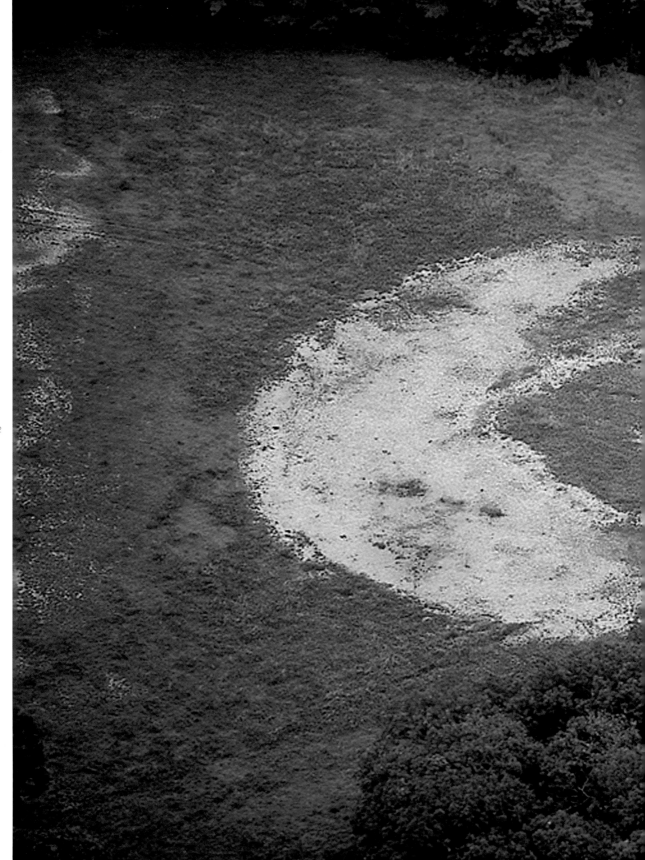

Newton, Massachusetts. Unused and neglected baseball diamond.

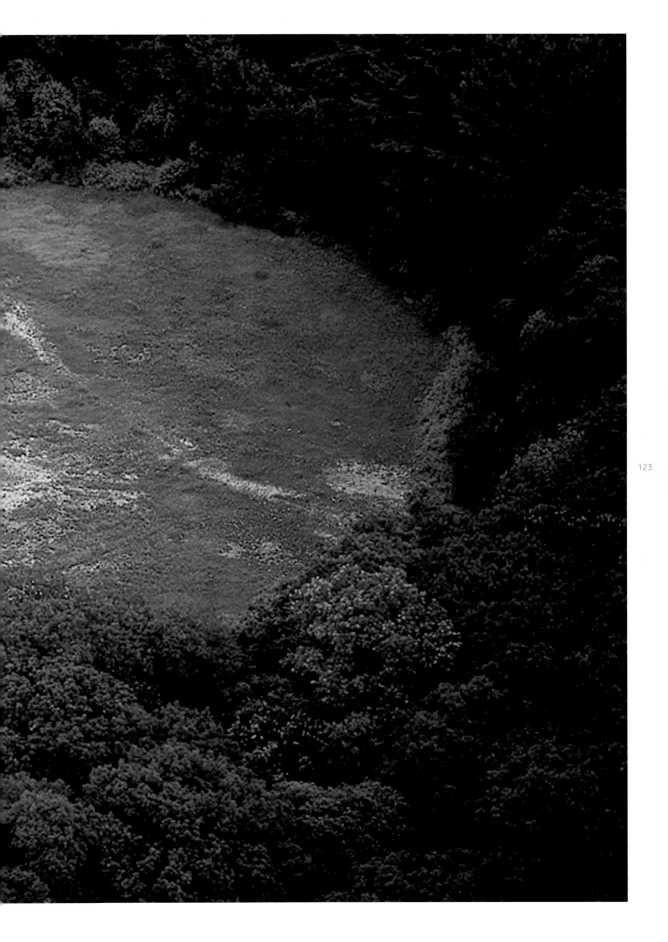

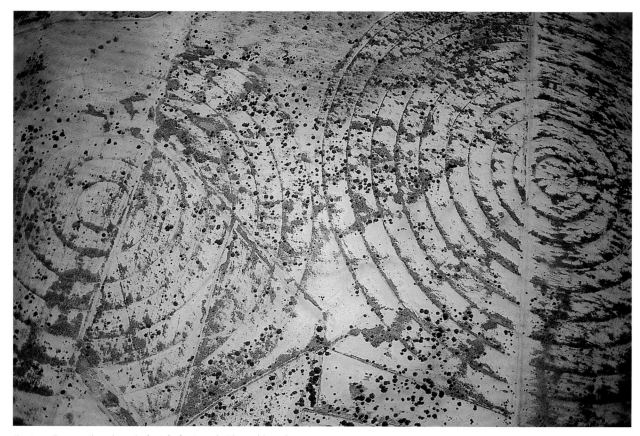

Western Texas. Abandoned pivot irrigators in the arid region.

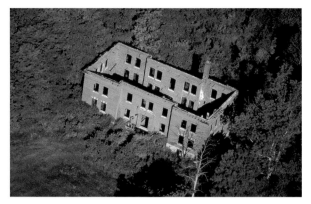

Boston, Massachusetts. Brick shell of abandoned building.

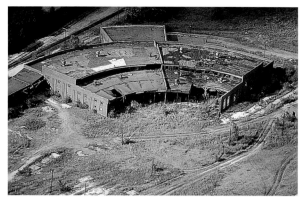

East Saint Louis, Illinois. Abandoned railroad train barn.

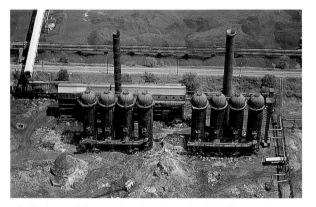

Lowell, Massachusetts. Lawrence Mills complex after a fire.

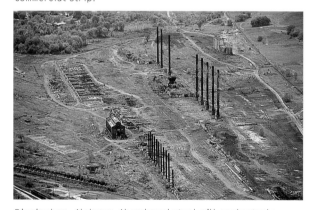

South Houston, Texas. Abandoned shopping mall on a commercial strip.

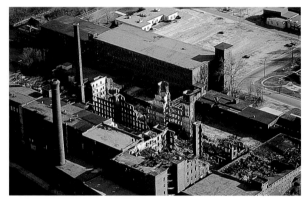

Birmingham, Alabama. Abandoned steel mill boilers and smokestacks.

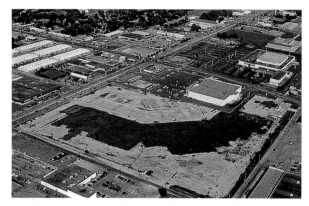

Birmingham, Alabama. Abandoned steel mill smokestacks.

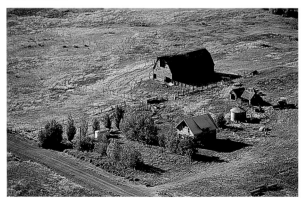

Eastern Washington. Farmstead with abandoned outbuildings.

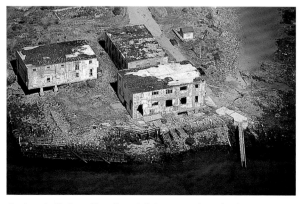

Eastport, Maine. Abandoned fish processing plant.

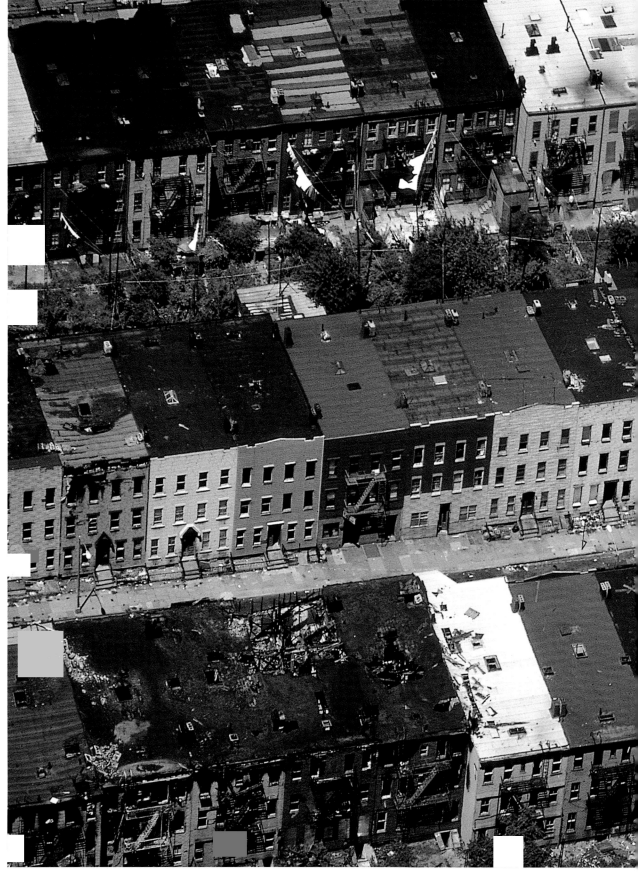

126

Queens, New York. Burned-out old townhouses in the Bushwick area.

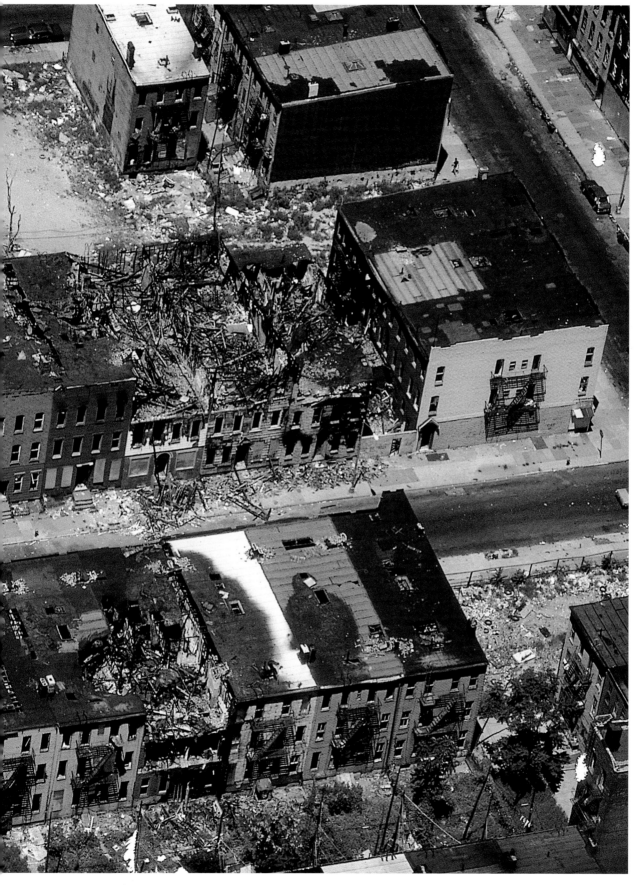

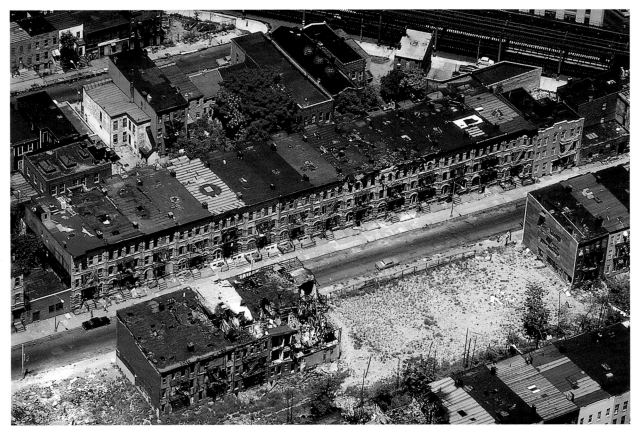

Queens, New York. Burned-out buildings alongside row houses.

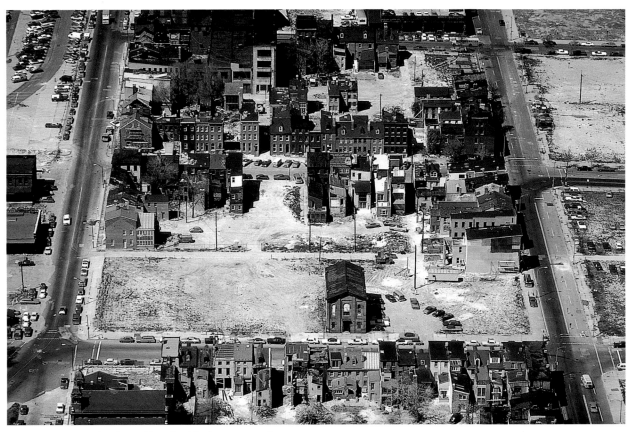

Baltimore, Maryland. Blighted housing block near waterfront.

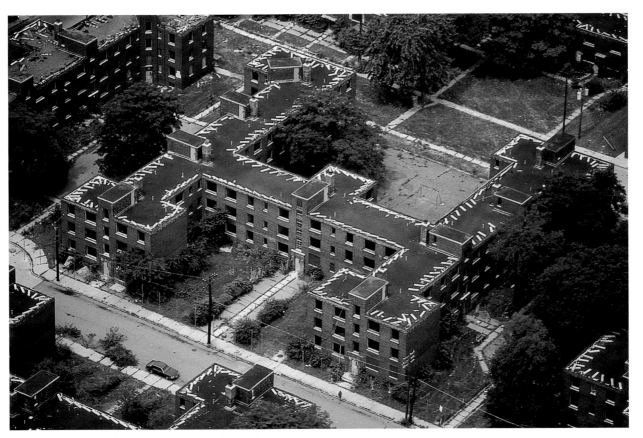

West Detroit, Michigan. Blighted public housing project.

BORDERS

→ Across the landscape the eye is drawn to patterns of transitional spaces, areas set off by differing and larger bodies of land. These transitional spaces are known as borders and are often distinguished by distinct boundaries and edges. They can be natural or man-made, or in some cases are both, as with the Rio Grande River dividing the United States and Mexico. The eye is drawn to borders not only for the patterns they create, but also as demarcations which help to define opposing spaces. For the photographer, borders, boundaries and edges are linear areas and lines that bring contrast to the landscape.

Natural land borders result from changes in soil, topography, and climate. These natural transitional spaces may be as abrupt as a shoreline or as gradual as a slope separating a valley from a plateau. They also occur on a continuum of scale seen in relation to one's distance above the earth's surface. The dendritic pattern of a watercourse shows this as small streams flow into larger ones to eventually become a river. Each little stream becomes larger as it merges with another stream and their borders along the edges become correspondingly larger. Flying above the earth one can more readily recognize borders of different scales at

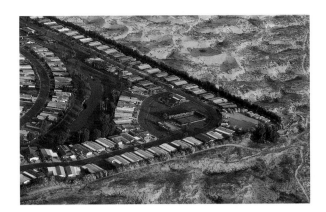

Palm Springs, California. Mobile home housing
community edged by desert.

different altitudes. Likewise, one sees borders highlighted differently depending on lighting, weather and
seasonal conditions.

Man-made borders are usually the result of boundary lines. Like most animals, man is territorial. We mark the
land with visible and invisible lines to define property ownership and federal and local jurisdictions, public and
private spaces, and areas of regulatory control determined by zoning and land use ordinances. While these
demarcation lines may not always be visible from the air, they can often be identified by the presence of
transitional zones or borders that run alongside them.

An interesting aspect of both natural boundaries and man-made borders is that they work in a similar
manner to filters or semi-permeable membranes, controlling and regulating flows and movements across the
earth's surface. Man constructs features such as dikes, berms, swales, and planted tree windbreaks in an effort to
exert such control. The resulting borders, boundaries and edges make patterns that draw the eye to an image and
help us to interpret and understand landscapes.

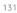

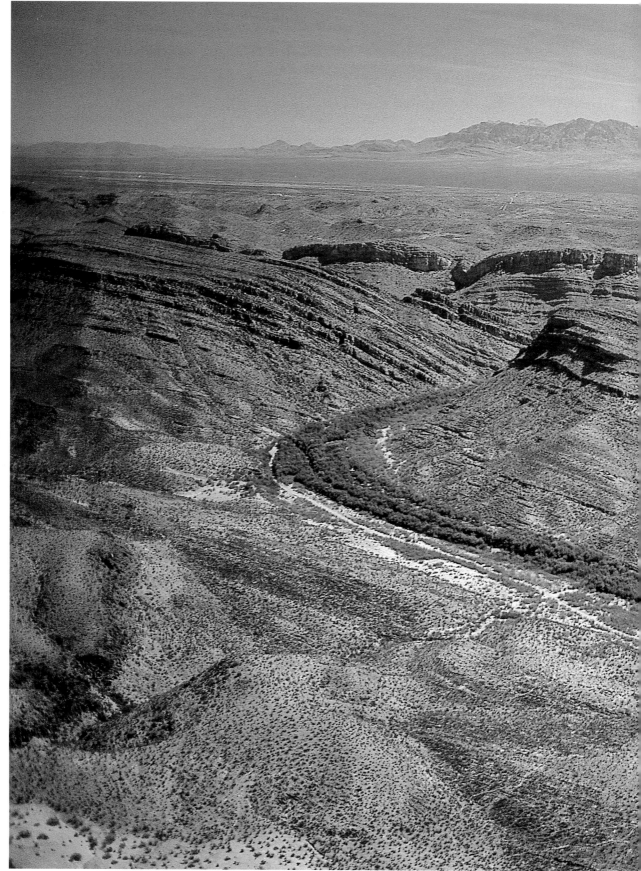

West Texas. The green strip of the Rio Grande River marks the border with Mexico.

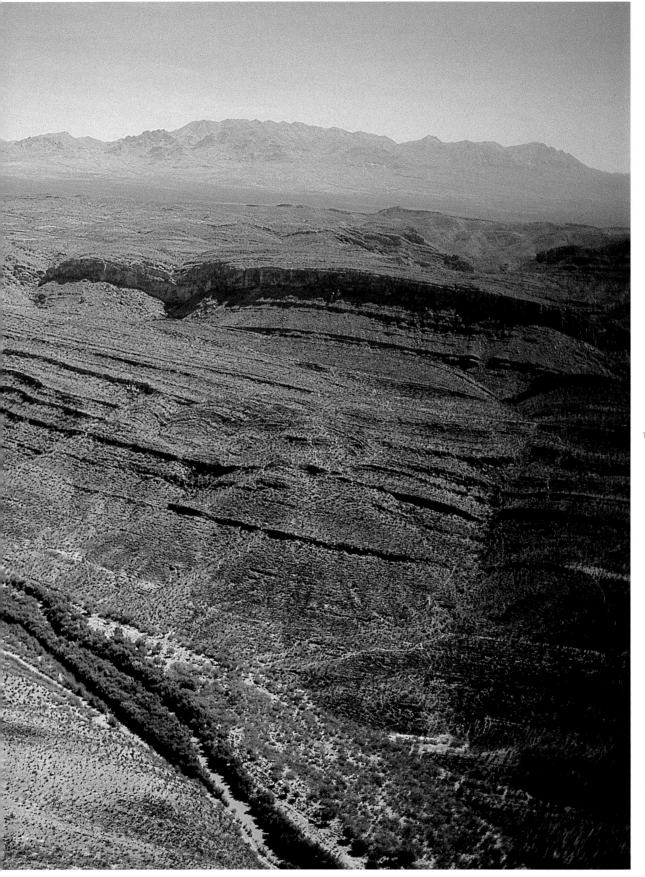

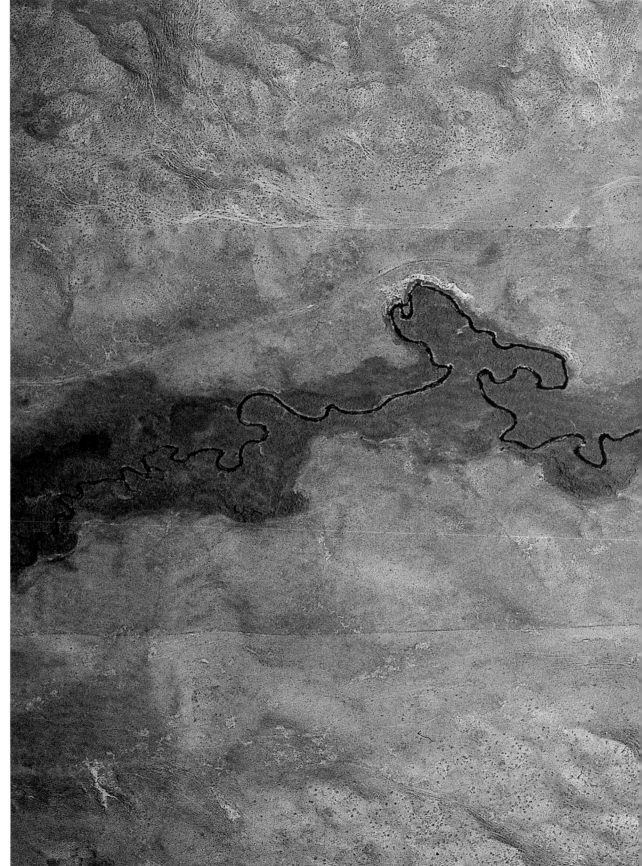

Western Nevada. A barbwire fence keeps livestock from grazing near a streambed.

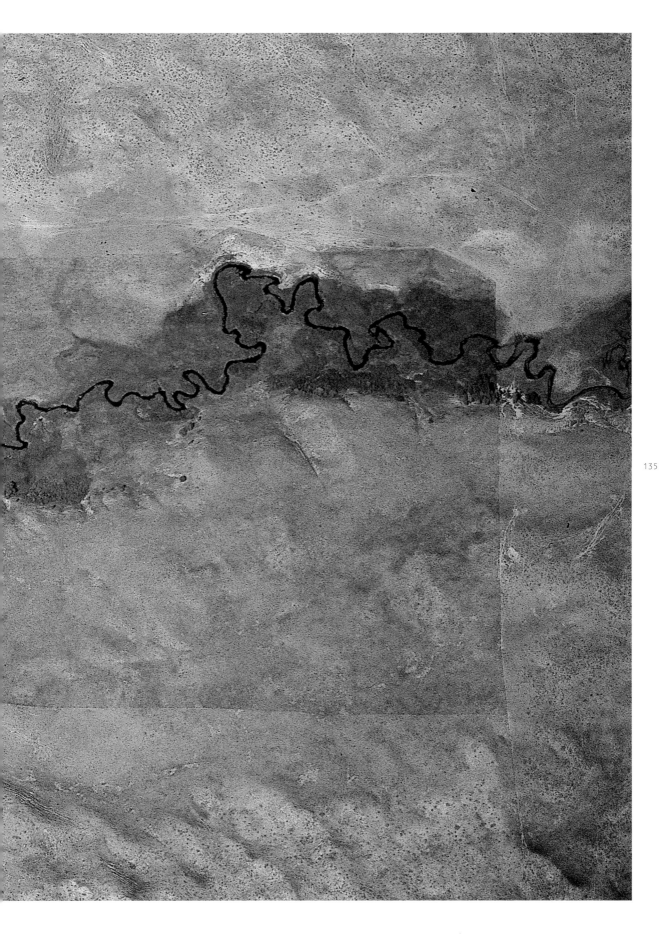

135

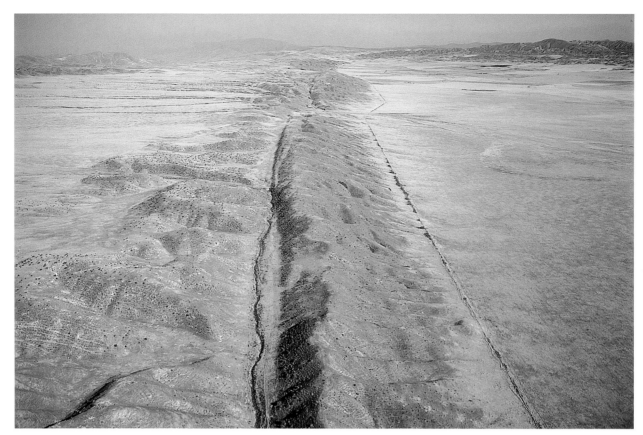

Taft area, California. San Andreas fault-line.

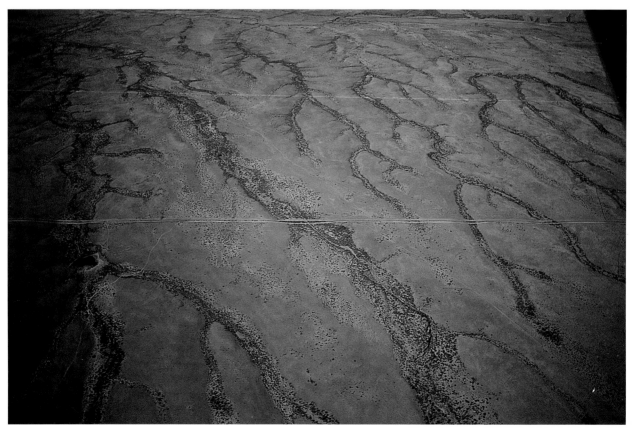

Naco area, Arizona. Barbwire fence cuts across arid land.

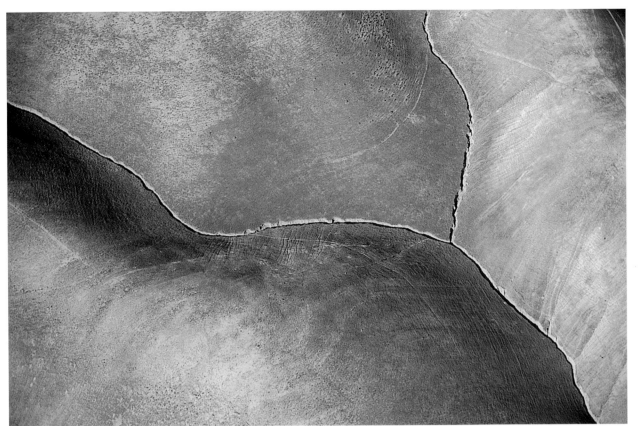

Taft, California. Hillside drainage pattern.

El Berrendo, New Mexico. Grazing patterns differentiate each side of the Mexico–New Mexico border.

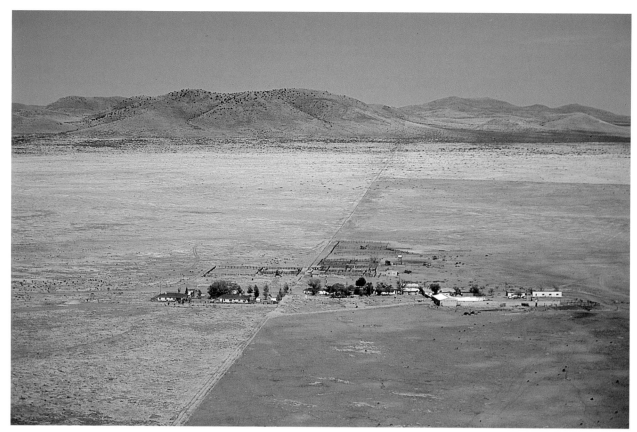

El Berrendo, New Mexico. The New Mexico border with Mexico.

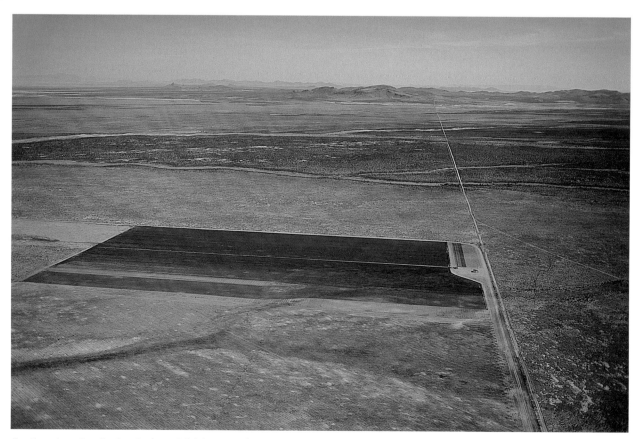

Southeastern New Mexico. Irrigated field surrounded by desert with a long boundary line.

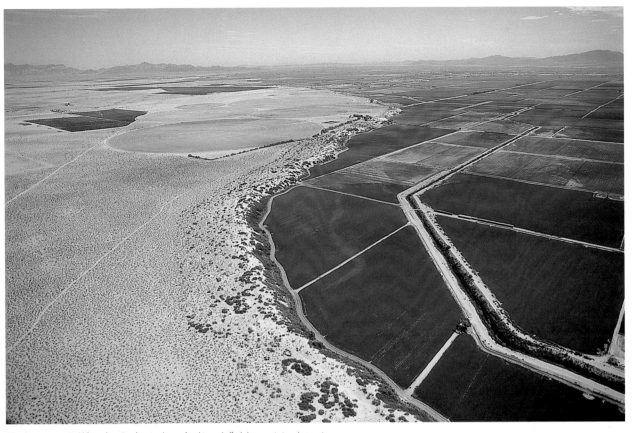

Blythe area, California. Irrigated agricultural fields next to desert.

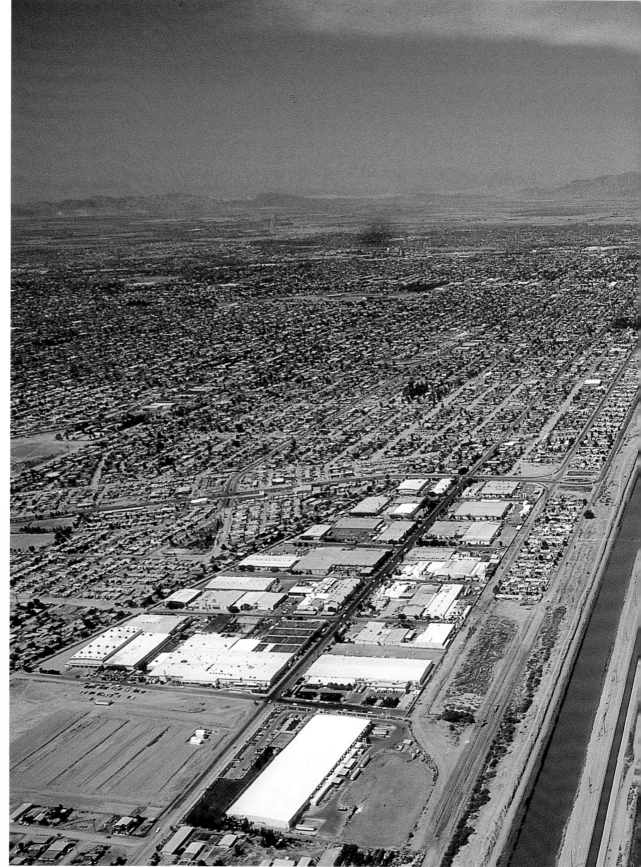

Calexico, California. Maquiladoras along the US border with Mexico.

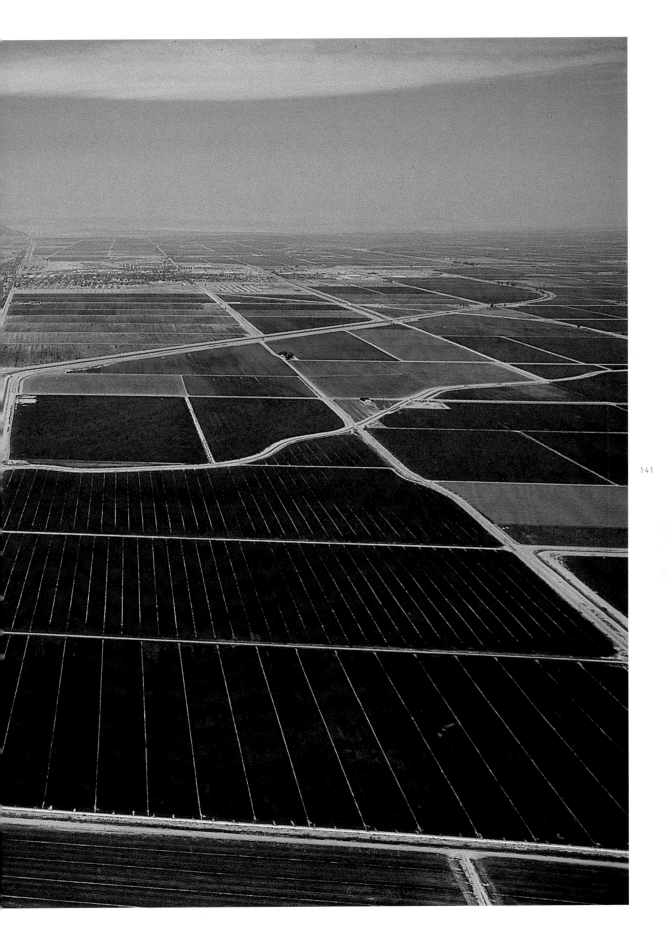

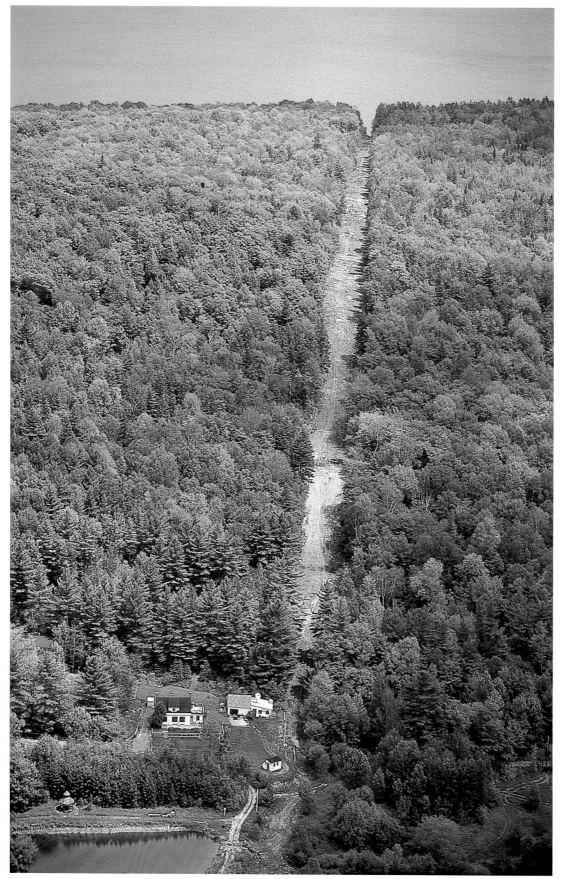

142

Newport area, Vermont. United States and Canada border.

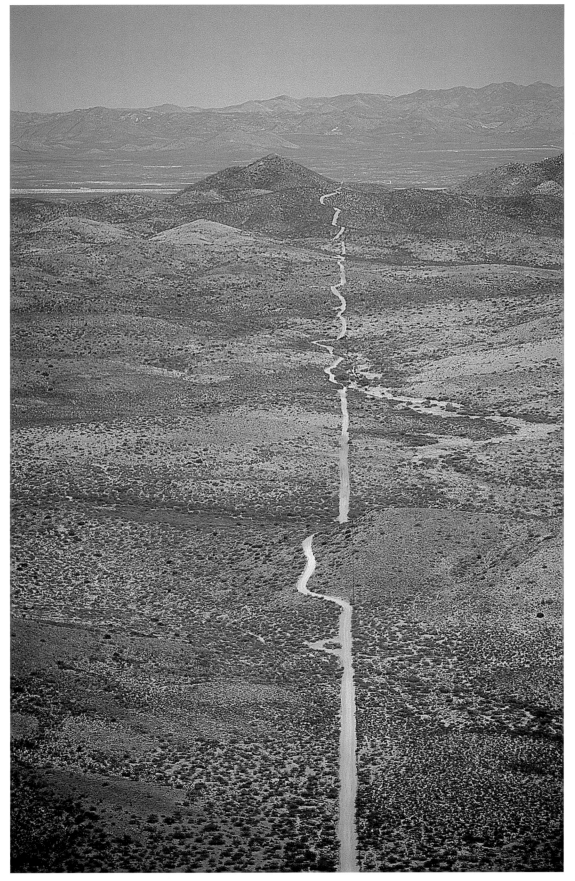

143

Southeastern New Mexico. United States and Mexico border.

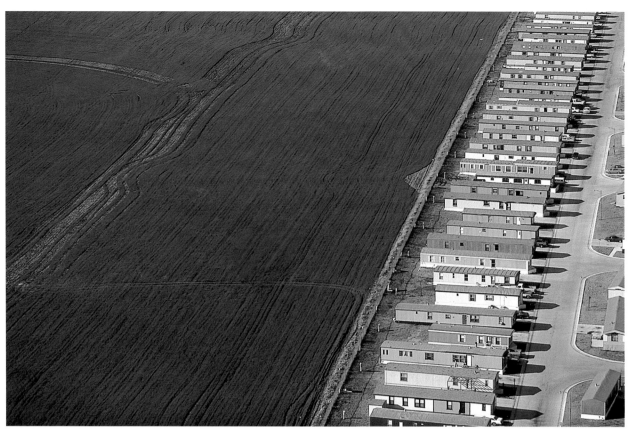

Central Texas. Trailer housing lines the edge of a field.

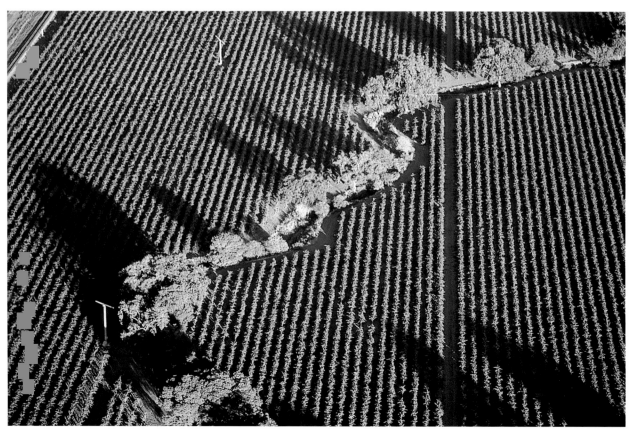

Napa, California. Vineyards planted up the edge of a stream.

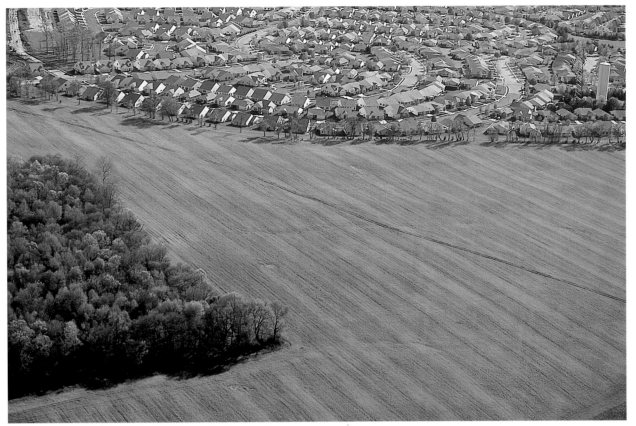

Princeton area, New Jersey. Housing and forest edge field.

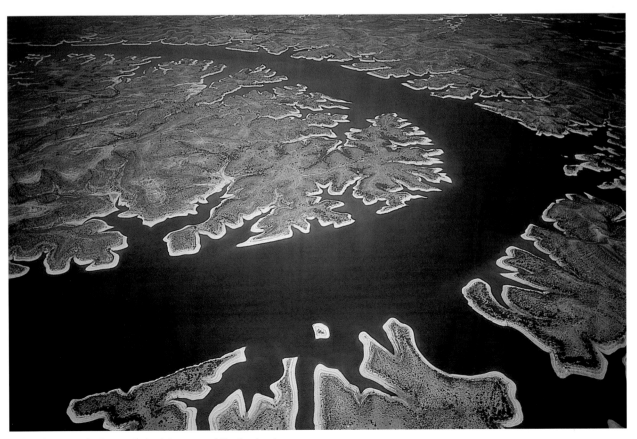

Amistad Reservoir, Texas. United States and Mexico border.

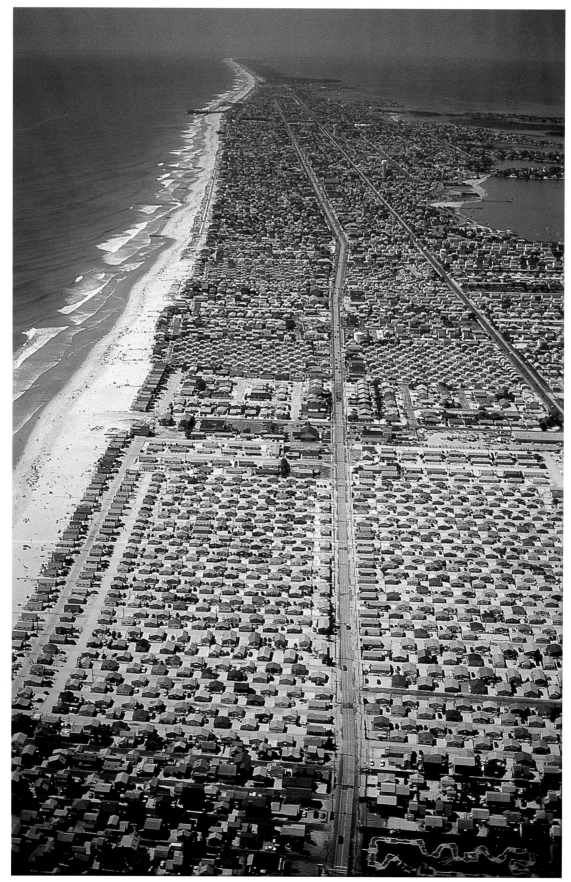

New Jersey coastline. Bungalow housing.

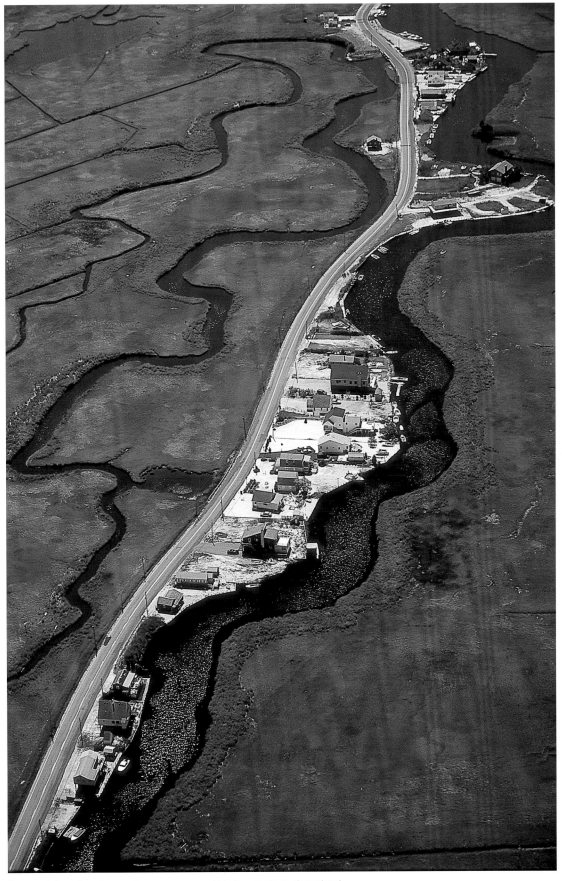

Barnegat Bay, New Jersey. Houses on a road that cuts through wetland.

LEARNING FROM MACLEAN

Gilles A. Tiberghien

→ Gilles A. Tiberghien is a lecturer in aesthetics at the
Université de Paris I Panthéon-Sorbonne, and also
teaches at the Ecole Nationale Supérieure du
Paysage in Versailles and the Architectural Institute
of the University of Geneva. His many books include
Land Art (Princeton, 1995).

→ Although it is not by any means a new phenomenon, aerial photography has seen a noticeable surge in interest in recent years. There are several possible explanations for this, of which the most obvious might be today's increasing awareness of the problems caused by the economic and demographic growth of human societies on a global scale. Conversely, it could also be said that it is to calm the uneasiness provoked by this awareness that we like to contemplate our world from on high. It may be true, as pioneering French photographer Nadar claimed when viewing Paris from a balloon in 1856, that there is nothing like distance to spare us from ugliness,[1] not to mention, we might nowadays add, the feelings of anxiety caused by our increasingly chaotic world. Alex MacLean's photographs could be seen in the same light, were we to consider them merely as works of art, but they take on an entirely different meaning once we become aware of the intentions which lie behind his work.

It was while studying for a degree in architecture that MacLean decided to learn to fly, and took an intensive course which allowed him to obtain his pilot's licence in a matter of weeks. At the time he was not interested simply in the aesthetic qualities of aerial views, but rather in using a plane to acquire a better understanding of what the land is, a more acute analysis of the complex relationships between cities and their surrounds, a fresh look at what we call landscape. In the originality and keenness of his way of seeing he is following in the remarkable footsteps of J. B. Jackson, whose lectures he had attended in the late 1960s as part of his architectural studies. The vision of the landscape that emerges from Jackson's writings is one of a "shared experience," which not only relates to geography and geomorphology, or to art and aesthetics, but also directly involves the ways and customs of those who have

lived in and shaped the land over hundreds of years. Jackson was second to none in his ability to transform the smallest facts into clues which others would have failed to notice and which he would make the focus of detailed research if they did not immediately make sense.[2] MacLean possesses the same gift for observation and the same passion for inquiry, so that any image, however striking or beautiful it may be, is always a question too. He sees the landscape as a constructed reality whose history can be deciphered by "rebuilding" the ground from the sky, almost as if, paradoxically, the latter held a reflection of the material and human values of the former.

Like Jackson, MacLean is not concerned with the traditional opposition of city and countryside, the latter supposedly the custodian of a form of natural reality that the former no longer possesses. As a cultural continuum, the landscape stretches from one to the other with little continuity. Fields and woods, villages and roads, suburbs and cities only have meaning as part of the landscape insofar as they reveal connections between people and the organization of space which either favors these connections, to however small a degree, or results in their break-up and loss.

For this reason, MacLean has sometimes chosen to work in collaboration with groups of architects and planners or with landscape architects such as James Corner,[3] in order to provide a kind of systematic basis for his own visual intuitions, the same intuitions that are pursued and given organized form in the courses and lectures he gives. His aim is to understand how our environment is threatened by industrial developments, how shopping malls and giant retail parks and supermarkets proliferate on the outskirts of cities, in strips which stretch along

the road for mile after mile. He also captures the way in which new housing developments are built; each has a garage out front and a yard out back, and lies isolated from any community life, twenty or thirty miles away from a huge shopping mall, and a similar distance from the nearest school, town hall and civic buildings, meaning that people and services are segregated according to their professions and their social class.

The contemporary reality visible in MacLean's images coexists with a much more traditional landscape, as many other photographs in this book show. Sprawl, the spread of housing regardless of the most basic community values and traditions, occurs side by side with traditional modes of settlement: small towns organized around identifiable centers, where local people can meet and where there is no need to use a car to go buy bread or cigarettes. Even aside from the huge diversity of its physical geography, America is a land of powerful contrasts, and the vision of the landscape apparent in these images lets us see and understand the entire history of the country, ranging from the resettlement of the Native Americans to the arid lands of the West, where the ruins of the ancient precolonial pueblos can still be seen, right up to the most striking forms of urban density, via the spectacle of the grid, stretching across the plains of the Midwest as far as the eye can see. This huge system, devised by Jefferson in 1785 and put into practice two years later, was imposed from East to West and now covers all but the first thirteen states. The historian André Corboz called the grid a "demiurgic act,"[4] and these images are a fascinating illustration of that fact, showing as they do the way that its geometry is often curiously superimposed on the landscape.

These aerial images are not merely maps, like those taken by photographers in the 1920s and 1930s, but geological documents. They follow the parallel drawn by the economist Paul S. Taylor while explaining to Dorothea Lange what he expected of a documentary photograph: in the face of raw reality that is meaningless to the layman, explained Taylor, a photographer, like a geologist, must extract the meaningful features and shed light on what has caused them, allowing history and meaning to be read where others see nothing but stones.[5]

This is exactly what Alex MacLean does. Because his primary concern is to inform, the scale and the angle of the shot—whether vertical, oblique, or almost horizontal—are always selected according to the subject and the best way to illustrate it. But more importantly, these photographs render visible the historical strata of the American landscape, and turn their author into a sort of radiographer of the landscape, through whose work the surface organization of the land takes on a deeper significance. Radiography is not only a technique that allows a new dimension of the landscape to be discovered or displayed, one which the human eye cannot perceive even from a tall building, a hill or a mountain top; it also implies a particular skill for interpreting images and reading reality through them. We cannot usually look at an X-ray and immediately know what it means: likewise, we do not always know how to "read" the views that MacLean shows us, nor do we know how to interpret them.

One of these meanings is the passage of time, which he shows through shadow play, color changes, and temperature variations which create fantastic forms on frozen water, seeming to belong to some microscopic world. Time is a dimension of the landscape, and its traces are visible on the slopes of ancient volcanic craters, in

the deltas of rivers where the tides ebb and flow, or, more subtly still, in the way that some farmers cultivate their land, creating irrigation channels and battling against erosion.[6] MacLean's images often seem enigmatic and, without an explanation from their creator, we would be content simply to admire their strange beauty. This beauty can sometimes be misleading or dangerous, like the shots of polluted water, whose blues or reds are as vivid as the shades of poisonous mushrooms. Here, beauty does not necessarily equate with goodness, and nothing may ever be taken for granted. The truth must be deciphered. MacLean is a master of decipherment, and uses this talent in the fight for greater ecological awareness and smarter urban growth. His images teach us lessons that extend far beyond the borders of the United States, and let us view the world we live in with a fresher and wiser eye.

1. Nadar (Gaspard Félix Tournachon), *Quand j'étais photographe*, Paris, 1900; repr. 1998

2. Jackson traveled the length and breadth of the United States on a motorcycle right up until his death at the age of 86. Melvin Charney also told me how Jackson arrived in Canada on his motorcycle and presented him with a list of some twenty questions about the geographical features he had observed along the way.

3. See Julie Campoli, Elizabeth Humstone, Alex MacLean, *Above and Beyond. Visualizing Change in Small Towns and Rural Areas*, Chicago, 2002; and James Corner and Alex S. MacLean, *Taking Measures Across the American Landscape*, New Haven and London, 1996.

4. André Corboz, "Les dimensions culturelles de la grille américaine," *Le territoire comme palimpseste et autres essais*, Besançon, 2001, p. 180.

5. Olivier Lugon, *Le style documentaire. D'August Sander à Walker Evans, 1920–1945*, Paris, 2001, p. 232.

6. *A Sense of Time, a Sense of Place* is a book by J. B. Jackson, which MacLean had with him the first time we met.

INTERVIEW WITH ALEX S. MACLEAN
Questions by Gilles A. Tiberghien

→ BEGINNINGS

Alex, can you tell me where you come from, what your background is?

Where do I come from? Actually, the first really big influence on how I see the landscape is the Thousand Islands in upstate New York, a place where I always return, where I spend my whole life in the summer. I have a very close relationship with that particular landscape, going back year after year, knowing the landforms there and the vegetation. I think a lot of people have a similar experience when they return to a landscape over the course of their whole lifetime; they imprint on the landscape and it's very familiar.

Another important experience in my life was when I was nine years old and my family went to Europe. Seeing a completely different landscape, both physically and culturally, than the American landscape, had a very large impact on how I read landscapes and different geological landforms and so on. So I think very early on, even at the age of nine, that had an impact on me.

Did you take landscape pictures at the time?

Oh yes, in Switzerland with my family I had a Kodak Brownie and I would take photos of landscapes more than portraits. It's interesting, when you look through a camera, you often remember those images in your mind. I can

remember in particular photographing an ox pulling a cart in a field in Italy, an ox-drawn cart. It's something you wouldn't see today, but I can see the image very clearly in my mind.

While I was in college I wanted to do something visually oriented, and to pursue a profession that was not close to what my family did—my father was a doctor. But I was always interested in creating things, and working with my hands. The last two years of college I began pursuing sculpture. I first did photography through the school newspaper, and learned the mechanics of it when I was probably about eighteen, nineteen. But I really didn't think of myself as a photographer at all at that time, though it was something that I enjoyed doing. Then I bought my first 35mm camera, a Nikon, from my own savings while I was a junior in college and started taking pictures again.

The best thing that I learned in architecture is not directly related to what I do, but I think it was learning how to learn. How to study a problem and, without any prior knowledge, pull resources together to solve a problem; that was one of the primary things I thought that I learned. But I also learned about space and how space is used.

Well, during the early years of architecture, I was really interested in a larger environment than just buildings— the way buildings fit into a bigger environment. While I was at school, I overheard one of my professors talking about flying and what a great experience it is, and I thought that I might be interested in it. And then, at the same time I had a very good friend who had a flight school, so I had the opportunity to learn. When I was with him in California, he rented a plane, and we flew from Los Angeles up to Santa Barbara and I thought it was just the neatest thing that he could go and rent a plane, and fly it and be so independent. I knew him well enough that I said to myself, "If he can do it, I can do it!" So all of a sudden, flying became a possibility.

Well, for the first year and a half of architecture school, there was what they call a core program of required courses and after completing that, I took a semester off, and during the summer, I learned how to fly. When I came back to graduate school, I was very interested in pursuing the landscape program, which had as a component a course on terrain analysis taught by Doug Way. It was a very integrated approach; you would use terrain analysis in your studio course and the studies were regionally oriented. It had a much broader scope: you would look at probably several hundred square miles of land south of Boston and analyze it.

Carl Steinitz, who was my teacher, was taking a similar approach to Ian McHarg in using overlays. McHarg was doing it with acetate, and Steinitz was starting to computerize this into grids. Basically, he would subdivide the land into very small grids and he would assign values, computer values for vegetation, soil type, topography, and things of this nature, settlement, land use, and we would put it on to these little grids. We'd actually do this with punch cards, the old computer cards that we'd type in, with holes in them; this was back in the seventies. And then, we'd have a big printer, and we'd print out these maps with Xs and Os to make dark areas, so they were very early, very crude computerized maps.

Where was McHarg teaching at that time?

McHarg was at Penn, the University of Pennsylvania. His course was pretty much coming from his book, *Design with Nature*. I was very enthusiastic about the idea of studying a larger landscape. I think my idea of landscape was originally more traditional, all about garden design, and small green spaces. But this was a very broad approach and I thought it was exciting. It was very new to me.

You had classes with John Brinckerhoff Jackson, didn't you?

Yes, that's right. At the time, I had heard of J. B. Jackson as a scholar of the landscape, but I had actually heard more

about him as a personality, someone who rode a motorcycle and wore a long leather jacket. I was looking for him on the campus, a sighting of J. B. Jackson! He gave a course on the European landscape that I took, which was very good.

How did he teach? Did he give a lot of details? I have been told he was very precise and detailed.

They were lecture courses, he would choose slides, both his own photos as well as maps and diagrams. He would tell a lot of personal stories, and he would use a lot of humor—understated humor—which was terrific. You would never fall asleep in one of his lectures! He was popular, and he would have teaching assistants that would work with smaller groups of students. I would talk to him about writing papers, he gave personal feedback, and he would hold office hours. The European course that I took was maybe thirty or forty people. The American landscape course was a very big course which I didn't formally take, but I would sit in on it, and then I did an independent study with him. I ended up giving a lecture to his American landscape course, on a flight I did from Kansas City to Miami. It was one of my first cross-country trips, and I photographed the whole way, and I gave a lecture about the trip and everything that I had seen along the way. I really prepared for the lecture, which took a lot of work. And it was very positively received, everyone liked it a lot. Jackson thought it was terrific, but it was similar to his style of traveling, taking pictures and making observations of the landscape.

159

So you finished your studies. Then what happened?

After graduating, I traveled for a year. I traveled three months in this country, photographing and visiting. In New Mexico, I stayed with a community that was working on energy efficiency—it was sort of a commune. They built solar- and wind-powered houses, it was very early for that kind of thinking. Then I traveled for six months through Central America and South America. I was actually planning to go around the world, but it took me a month to get through Guatemala and I was behind schedule!

How did you live at that time?

I had just a little pack, and I traveled by bus and I flew a little. I rented a plane. When I was in Mexico, I rented a plane and photographed Montalban and Oaxaca.

Did you fly?

Yes, I took a few little flights. I did one from Honduras down to Panama and did another one, an internal flight in Panama. What was interesting, as this trip progressed, is that I had a very hard time photographing. Over time, I became more and more at ease photographing and I knew what I wanted to photograph, I think, by the time I got to South America.

It was sort of a Grand Tour for you.

A Grand Tour, yes, that's right, I learned a lot of life lessons, I really did, it was almost like going to Switzerland when I was a kid. It was a whole new environment, seeing another slice of the world. It was the Third World, to which I hadn't been exposed. Typically I would travel by myself, and I would visit the big cities but when I couldn't stand the city anymore, I'd go way out into the small villages, Indian villages, and stay. Then when I couldn't take that anymore, I'd retreat to the big city and I'd go find the Sheraton and read *Time* magazine! I'd always stay at a very cheap hotel of course; I'd just go in the lobby and use a regular toilet and things like that, and then I'd stay in the city for three or four days and head out. Traveling was hard, though, because I didn't really have an itinerary. The most tiring thing was deciding whether to stay or whether I should keep going, but I found my way. I was alone the whole time.

Being a photographer in a plane is a lonely activity but you are used to working and traveling alone.

Yes. When I land on the ground, I usually make friends and visit people, and so the actual photography and the traveling in the air is usually by myself but I don't think of myself as a total loner; I like people. Being alone was actually one of the things that I learned after traveling in the Third World; that as well as the poverty. I was very influenced by the corruption, that it is almost impossible to do things when there is so much corruption, things just can't get done.

Then you came back, after a year.

I thought it was important that I come back and work as an architect and use my profession to try to improve things in some way. And I felt ready to go to work, you know, because after I got out of school, I wasn't really ready to go to an office and work! So I came back and there was a very poor economic time here and I couldn't get a job in Cambridge, so I went to Syracuse, New York. That was in part because it was near this place that I go to in the summer, it's about an hour away, so it was familiar, and I worked in a landscape architecture firm there.

Their office went from about thirty people to nine people and I got laid off because they finished their projects and didn't have any new projects. So I came back to Cambridge, and that's when I decided that I'd try to make a living doing aerial photography. I had done some aerial photography while I was at that architecture firm, for the projects that they were working on, so I was aware that there was a very valid application of aerial photography to planning and designing.

Did you decide to buy a plane then, or couldn't you afford one?

No, because when I came back here, I didn't know really how to do business, how to get work. I sold lots of my slides, copies of my slides to university collections, to Harvard, MIT, Berkeley, and other schools, and I made a catalogue of my work. At the same time, I was trying to get jobs with architects and planners to photograph, but

for the first three or four years, I was making money working as a waiter in a restaurant. I even drove a taxicab for a while, because it was expensive to fly, and at that time I was renting a plane. Eventually I had enough work that I started to have some photographic exhibits and I was still selling slides to university libraries and I was starting to think of making collections that libraries would like to buy. I also started to look for public assistance in the form of grants and so I filed for what is called an NEA grant—National Endowment for the Arts—and I won a Design Arts grant, which gave me enough money to purchase my first plane. That was 1979–1980, right in there. That was very important, because it meant that I could start flying on my own schedule, and I didn't have to rent a plane. I could take trips, and I didn't have to bring the plane back at the end of the day, so I could go away. I don't think they intended me to spend my money that way, but it really was pivotal.

What kind of plane was it?
It was a Cessna 172. I always flew a high-wing plane, where the wing is above the cockpit, so I could photograph.

If you had to describe yourself, would you say you are an artist, or a landscape-architect, a photographer, or what?
I think I could fall under a lot of different titles. My father, who did not get over the fact that I did not pursue architecture per se, calls me a sky-architect!

163

Were you interested in planes because you could see the landscape from the air, or just because you liked flying?

It's interesting, because on one hand I was very scared of flying. I never liked to fly commercially, for instance. On the other hand, I observe birds. When I was high school, I kept tumbling pigeons and would study them as to why they tumble. I studied their behavior for a science project I did in high school, and that was in part because my father was a behaviorist, a brain researcher. I worked with them for a long time. I would fly them in different numbers and different patterns, and I would dye their wings so that I could tell them apart. I would put patches over their eyes, I could fly them in different directions that way. But it was fun. So I was interested in flight and watching them from the ground, thinking about them as they would disappear out of sight; they go up so high, you couldn't see them any more. It was interesting,

When I started to learn how to fly, I was actually a very poor student because I was so scared! It took me ten or fifteen hours to get used to it. But I kind of liked the fear the first time I did some flying; I flew on a glider, without an engine, out in Colorado. Although I was very scared, I was totally exhilarated by it, and I took lot of pictures on that flight. I found it really comforting to put a camera between me and the experience because it would abstract it. And so I took a lot of pictures, and they were nice pictures, I really liked them.

So you were more attracted by the fact of flying than by the planes themselves.

No, it's funny, I really don't know airplanes at all, I don't know this type of airplane or that type. But aviation is fun, and I like fooling around with the plane, knowing how it works, fixing things that need to be fixed.

Do you think you have a special aptitude for flying?

It's interesting that I'm very dyslexic. I went to MIT last year and there was a person who studies dyslexics and he does a test where he projects on a screen letters that are far apart in a field, there'd be a letter here, a letter here, a letter here, and he shoots them at very high speed, like a tenth of a second, and he asks what letter is this, what letter is this, and I can process them all at once. Apparently, dyslexics are very good at seeing a broad field: as the letters move further apart, I can still see them. People who are dyslexic have this large view and can process things very quickly. It was interesting—previously I only knew bad things about being dyslexic. So I often feel that when I look at a landscape, I can process it, I see it very quickly.

Another thing that is very useful is that I feel sometimes like I'm physically built for doing this. I'm right-handed, but I'm left-eyed; I shoot with my left eye. So when I'm shooting in the plane from my seat, I can see the controls of the plane with my right eye while I'm looking out with the left. If I were right-eyed, I wouldn't be able to do that.

So you are perfectly shaped for your job.

I feel like I am. It works well. Another thing that's funny is in relation with the theory of ADD, attention deficit disorder. It's a learning disability and it's pretty common. It's called attention deficit disorder because people with ADD have trouble focusing and paying attention to one thing for very long, they are all over the place. I'm very ADD and in the plane, you have to be doing so many things at once that in my case, it might be helpful to be ADD!

When it came to choosing a type of camera, did you have an exact idea of what you wanted? Did you try to shoot with a particular camera from the start? Did you find the model you needed right away?

I had actually run through a lot of different cameras. At one point I had what was called a Pentax half frame, which was half a 35mm frame. It was a very small camera, but the significant thing that I really appreciated it for was its long rectangular format: it was easier to compose than in a more square format. But the negative was too small to enlarge, so I only worked with that for maybe a year. At the time a lot of my decisions were driven by money, like what type of film I bought, and with the half frame I could get twice as many pictures for one roll of film! It is silly, but when I was driving a taxicab, I was always very, very poor. When I drove my car, I was always afraid to run out of gas! When I started being more commercially successful, I started fooling with different equipment. I think it was a two-part thing: one was to get the results that I wanted, and also to try new things, try different films, try different lenses.

Do you use any filters?

For my commercial work I often do. The main filter I use, for at least the color, is a polarizing filter which is good for giving saturation and cutting through haze. I rarely use filters in my personal work. But for my commercial work, the client usually likes a dark blue sky and vibrant greens, so I polarize for that. It's a different look.

Sometimes you take pictures on a vertical, straight down. Sometimes the view is more oblique, and sometimes you show the depth and even the horizon. How do you choose which angle to shoot from?

I guess I can break my work down in three ways, into a matrix almost. There's vertical, looking straight down; there's oblique, looking at an angle, without the horizon showing; and then there's what I call horizontal, when you are looking out and you can see the horizon. So those are the three ways of distinguishing the angle. Then I look at scale. I distinguish that in terms of block, neighborhood, district and regional scale. Block scale is where you see an individual block with buildings, neighborhood scale is made up of several blocks, and the district scale is made up of several neighborhoods. Regional scale is where you see the whole region in one picture. Then you can take those different scales and apply them in a matrix against the view angle—vertical, oblique and horizontal. I can't really get high enough to take a vertical that will cover a whole region. I can get pretty high but not much above 14,000 feet—after that I need oxygen.

So how high can you take the vertical?

I can take the vertical at any altitude. What happens with the vertical is that the longer focal length you use, the flatter you can get the image, in the sense that you don't get distortion from one side to the other. If you use a wide-angle lens, and you tilt it just a little bit, one end is going to be more distorted, so I usually use a normal lens or a little longer for the vertical, which means that you have to be high enough to get everything you want in the picture. The only other thing to consider is the weather conditions. If it's hazy, sometimes I will choose to use a wider angle lens lower down, to eliminate the haze above me. When I'm closer, there is more saturation. So I make my decisions by what the light quality is like, and the air quality.

For your own projects, do you decide in advance to use one type of camera, or one type of view, or do you combine them? Or does it depend?

I mix things. There are a lot of natural forces that influence the way I see things. I pretty much work with anything from 24mm to 300mm, and I also have a gyro-stabilizer to reduce the vibration.

If you've taken a picture of something but you don't know what it is, do you land and ask people about it?

If I were in a different part of the country and I saw pumpkin fields and I didn't understand what they were, I

would land at an airfield and ask people there, "What are these fields with all these orange things in them?" When I was in Montana, I talked to the cropdusters, because they know the land very well; they know it better than you or I. Or if I'm in Maine and I'm doing stuff on forestry, I ask people up there that deal with the woods.

How do you ask them? With the picture, or without the picture?

Without the picture, I describe it. But maybe now with my digital camera I'll be able to show them, which would be nice! What is interesting is that a lot of my clients are specialists in a field, so if I'm working for a planner or a redevelopment project, they understand the theories, the economics, the zoning, the watersheds. For instance, if you're working with hydrologists, studying a river area, one of the issues is ground flow and the streams that come into the river. What happens is that sometimes the streams have too much water and sometimes they have too little water. In big parking lots, the water runs off so fast that the rivers flood, but when it's dry, because the water has gone off so fast, there's no water in the ground, and so the streams dry up in the summer. It's very uneven. So you learn a lot of little things like that through your clients that you wouldn't have necessarily known otherwise.

Your pictures seem very composed. Do you make references to paintings or photos?

I have to feel what I'm seeing. I'll think what I'm seeing is very surreal and I'll take it in that mode, or it's very

169

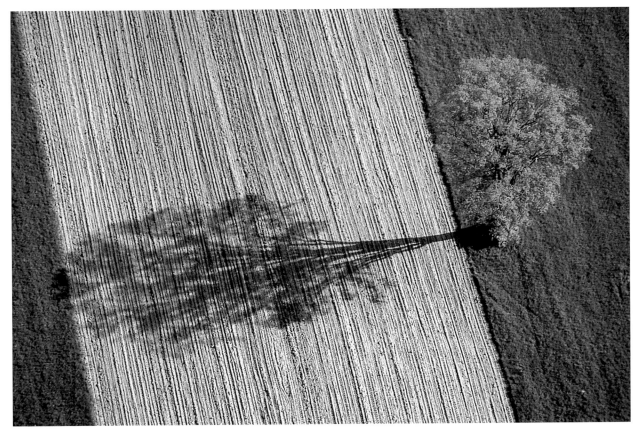

Williamstown, Massachusetts. Tree shadow.

painterly and I'll take it in that mode. I also can't think of taking a picture without having something to say; I always feel like I'm saying something in a picture; there's always something I want to say. I feel like I move into the picture when I frame an image, because I am hand-holding the camera. Some people think I attach the camera to the plane and shoot, but it's very far from that. I line up everything in the whole frame. It's not cropped, and after I take it I don't modify it; it goes right in, and I'm very proud of that. I never reframe. I find it's so satisfying to put what you see into the frame and it's usually that first moment you see it that it's there.

One picture that I really love that shows that (previous page). The tree, the shadows, the field, you know, it all works, it's just perfect. But if you shoot from any other angle, it doesn't work.

Could you be a painter or designer? Do you feel like an artist?

Well, I do because I know that it works when I do it. With photography, it's almost spontaneous, whereas a painting you build it, you shape it and think about it, you can change it. This is like putting a piece in a puzzle, it just fits when it's good.

Some of your images are very abstract. What are you trying to show? Is it the geometry that strikes you?

Every once in a while you see something you recognize as abstract and different and try to capture it that way. I did

one parking lot that's very good: there are the stripes and when you look at it, it doesn't look flat because of the perspective. It gives you something of the complexity of the vision, you want to capture it. I often smile as I am taking these things, because they are fun. It is a great pleasure. Then sometimes you shoot the picture to tell a story. One picture (pp. 134–35) is looking down on a streambed from way up high. A barbwire fence keeps the cattle out from the streambed, so you can see the difference where the cattle have grazed and where they haven't grazed. I put just a little strip here so you can see what's happened, where the cattle have grazed in the stream. So, it tells a story. It's just part of a composition; if I cut it like that, it just works a little better.

So it's the story that interests you?

Oh yes. I like shooting borders, when two different things come together, it's very fertile for making points about one versus the other. Pathways versus containments, too: pathways facilitate movement, and containments hold things in place, so they don't move, like a lake or a house. In all land uses, you see pathways and containments together and they are linked and form a network of sorts. Another thing that I really like is the idea of overlays, when things happen on top of one another, so you have depth that way. As I said, borders and boundaries are very interesting and very fertile and they often offer themselves for the final frame of the picture, so you know things that are happening in the picture.

171

It's the culture, the people that are settled on the land, the physical landforms, the grid. I'm jealous of the European landscape in its ideal form, where you have the concentration of people and the open areas. I think the way we settle is very environmentally unsound. We just move around, it's very inefficient, very isolating. We talk about how it's not good for other things too. It's very homogenous, everything looks the same, sites will look the same. When you land in Seattle or Miami, so much of the built environment is the same: the highway is the same, everything looks pretty much the same, and retail is all the same. Maybe that happens in Europe too. What happens now here is you don't use local materials. In the 1900s for example, you'd go to a New England village, and use the local materials to build, and you would go Santa Fe and use adobe. The subtlety and differences in materials as you go across the landscape, responding to the local context, that's gone.

When you see the huge landscapes of America, do you feel that it's the same country, in spite of the differences?

Oh no, I think that the landscapes are very different regionally. But we are losing our local accents, in both senses of the word. It's fun to go to little airports, because the accent is so much stronger than when you go to an urban area. In general, there is a trend towards the country becoming more and more homogenized, but when you get into the rural areas, you see a lot more distinctions than you do around the urban areas. The new growth areas

around the cities, that's where it's very homogenized. Look at a ring around downtown Atlanta, then look at a ring around Washington DC, or Denver, and it's all very similar. The development pattern and the materials, the settlement patterns are very similar. But if you go out to the smaller towns, you see the old greens, and there they have mixed use, apartments upstairs above the shops, and so on.

Do you think that your images help people to become more ecologically conscious, more aware of the country?
Oh yes, very much so. It's another part of my work, but it's important that people can visualize. I like sharing my perspective and trying to help people understand what's around them. I think like a photographer, and I like to collect themes and topics that interest me. When you get enough of them and compare them, it's interesting to be able to understand them, whether it's parks or prisons or whatever.

That's an interesting point, because from the air, the landscape you are used to seems very strange. In Malraux's novel *Man's Fate*, set during the Spanish Civil War, Republicans ask a peasant to come and show them where the Nationalists are hiding in his field. So they go up in the air, but he cannot see anything. He doesn't recognize his field. It's an unknown landscape for him, he's totally lost, despite the fact he has lived there for years and years. From the air things can be very abstract and hard to recognize.

I can understand that completely. The first time I flew over the Thousand Islands, this landscape where I used to go every year as a child, I was so confused, I did not recognize it at all. If you walk on the ground to get there, you'd have to go all the way around and so my conception of the landscape was totally different. In my mind, I saw it from a very linear, straight line perspective, and so the first time I flew over all these pathways that I was used to, it took me a while to sort it out. It was very confusing and this is a landscape I was very familiar with, but I had never put it into that perspective. Yet if I look at a landscape without that experience, I could tell you everything about it and how it fits together. I can understand why Malraux's peasant was confused even though he knew the land, but at the same time, that peasant could probably look at the field and tell you how it's mowed and why it's a certain way.

Do you think you can make people aware of what's happening with your pictures alone, or do you need words?
I think there are two levels. I think you have to draw people in. If you are going to explain something with a photograph, the photograph has to be of enough interest that people will look at it and read it, study it and admire it or whatever, so that they pay attention. Maybe sometimes, when it's an abstract image, people will study it longer because they have to figure it out, and in the process of figuring it out, they begin to understand what's going on. It has to be visually attractive to pull the person into it. But it may need captions too, like the ones I wrote for my first book *Look at the Land*.

Even with something as spectacular as the grid and its corrections?

Yes, and they are many grid corrections. I was talking to a crop duster, who flies a plane to spray crops, and I was telling him all the things that I was photographing out there, from kettle lakes to windbreaks, and I said I was also photographing some grid corrections. So I went out flying and came back and I saw him and he said, "Well did you get a good grid correction?" He made it sound like some are better than others, so I said "What do you mean?" and he said, "Oh, you know, like a big semi truck out in the middle of the field!" Apparently what happens is that trucks drive 80 miles an hour, the road turns at a sharp angle and it's very common for a truck to end up in the field, and so he thought that was a good grid correction! The crop dusters deal with it because when they spray, the field boundaries shift as well as the road.

Is that part of standard agricultural practice, to use planes as tools?

Very much so, in the West. Not so much in the East, but in the Mississippi flood plain, and all the way to the Rockies and California. It's a big business. They do three things with them, they fertilize, they use them for herbicide and pest control, and also to seed. Do you know Delta Airlines? The name doesn't come from the Greek letter. The company actually started out as an agricultural carrier, they did agricultural work, and it came from the Mississippi delta.

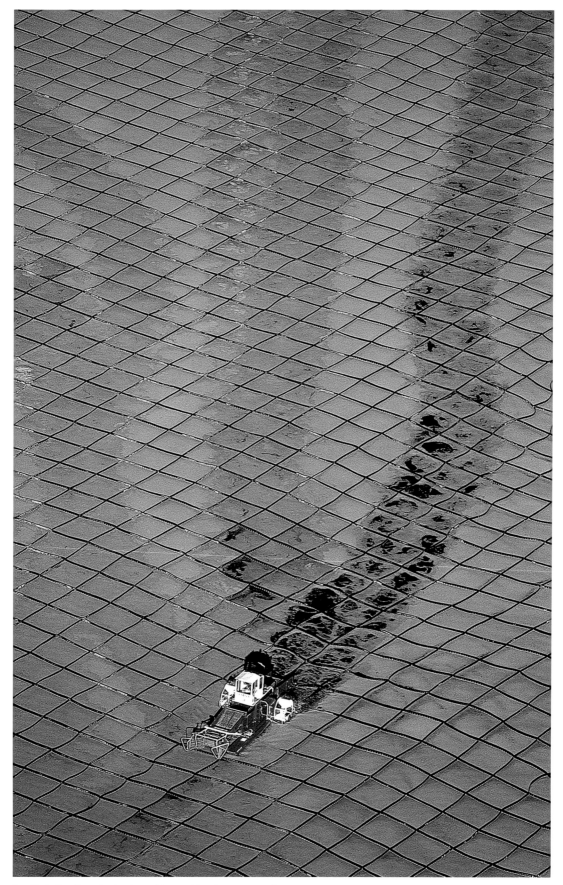

Devil's Lake, Nevada. Duckweed harvesting in a sewage lagoon.

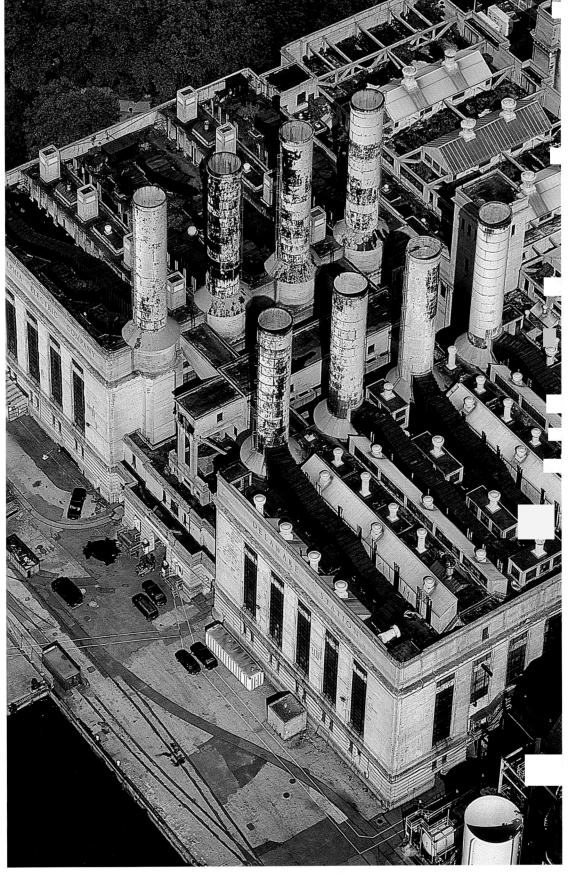

Philadelphia, Pennsylvania. Abandoned power plant on the Delaware River.

What do you feel is the difference between personal pictures and commissioned ones?

I think I shoot with different perspectives. It's partly because of the economics of flying. It's probably $150 an hour to pay for the plane, fuel, parking fees, maintenance, and insurance. When I go out and fly only one day I feel like I'm only paying for the gas, but when I figure out all the costs at the end of the year, it comes out to be expensive. I like to be productive, and unfortunately, beautiful abstract pictures only come once a day or less, so it's too expensive and too frustrating to go out and just try to shoot them. But while you're out there you see so many things on the landscape you want to capture: the environment, energy, pollution, sprawl, and so on. For example, because I think prisons in this country are just a crime, I photograph more prisons because I'm offended by them. I feel like I have a very large agenda of things that I want to capture, so I take a lot of different things. When I don't have a preconceived idea as to what I'm going to photograph, I just recognize what I see and it excites me, but I really have to connect with it. If I try to force it, it doesn't work. You can take yourself places where you want to photograph because you think there will be exciting pictures there and you can go out when the light is beautiful because that always helps. You can try to put yourself into a position where you can create, but I think you have to have a very open mind to be receptive to anything. If you just focus on doing one thing, it doesn't work. I enjoy the

commercial work because it is very focused. It disciplines me into flying the plane and doing things in a more procedural way so when I do find something I want to take, I can maneuver myself to be where I need to be. Flying the plane to me is not like riding a bike—if I don't fly regularly, it takes me a little while to get so I can bank and move the plane exactly. It's a bit of a skill that way. The commercial work also gets me out; I'll have to fly to New Haven to do a job and the whole trip there and back, I'm photographing for myself. Even when I'm shooting for a job, I'll see something else there that interests me so I'll just shoot it.

It seems that you put the same strength and the same insight into both your personal pictures and your commercial ones. Am I right?

Yes and no. First of all, I do some work where the client tells me exactly what they want, "You have got to do this and you have got to do that," and so I do that. But I usually do my best work when I understand what the client wants but he doesn't tell me how to take it; when I'm free to do as I please, but he explains the issues that are involved. When a real-estate client wants me to go shoot some buildings on the highway, that's really a very commercial job. But when I do my commissions, like the Houston project, I feel like I'm shooting for myself. I shoot for myself with a very large agenda, from environmental issues to planning issues to aesthetic issues. With a commission like that, I feel like someone is paying me to do what I want to do!

When people come to you with something like the Houston project, what are they looking for?

The Houston project[1] was quite different from other commissions. The idea was that they wanted me to photograph Houston at the end of the millennium, and they asked that I do it from my own perspective, how I saw Houston. It was a very open agenda, as far as what to shoot was concerned, and then they put people at my disposal to answer questions and offer their opinions, but it wasn't, "You must shoot this and you must shoot that." They just wanted me to be fairly free and photograph what I thought was interesting and unique to Houston and emblematic of the Houston environment.

So they wanted a vision?

My vision, yes, which was very nice. It was a wonderful assignment. What is always interesting when you start a project of that magnitude, is when you take the first picture, you know you have to start somewhere, and it's very exciting. When I arrived in Houston it was a beautiful day, the visibility was just perfect, so I flew around from a very high altitude to familiarize myself with the region and what it looked like. It is a big complex because there are two major airports there: Houston Hobby and Bush International Airport, so it was a new layout for me. So in the beginning there was a bit of getting familiar with the area.

1. In 1999, Alex MacLean was invited to take a series of aerial photographs of Houston by the Rice Design Alliance at Rice University, *Cite: The Architecture and Design* *Review of Houston* and the Menil Collection. These were exhibited at the Menil Collection in 2000. A selection of images was published in *Cite*, no. 48, Summer 2000.

How long did it take?

I shot probably 30 hours over three months. I stayed for a week and shot almost 8 hours the first day. I went back on two other occasions and shot probably close to 2,500 frames. Over the process of shooting, you begin to understand more and more about it. It's a very large area. I took a flight over to Austin, starting at the center of Houston and just going way out to where there's no settlement at all. It was quite interesting seeing that, how the landscape and the settlement pattern changed as I went out. One of the things that I found very interesting was that as you got to the edge, the expression on the landscape was much more about the individual than when you were in the center. You would find special communities, for instance the water-ski community, or a community that had its own runway. Then in the ranching country, the farmers are much more individualistic and not going through the same motions everyone else is going through. When you get way out you even see people doing illegal activities! There was one recycling center for oil tanks, where they just dug a big pit and threw all this waste in the ground out in the woods. They're like outlaws.

Can aerial photos also be a method of control?

A method of surveillance, sure.

So you are aware that your photos contain information that some people don't want to be known. Do people ask for very specific things—this, but not that?

I think that's very true, I think people have different points of view. If I photograph something for a developer who wants to market a property, if it's next to a garbage landfill, he doesn't want to see that in the picture. On the other hand, an environmentalist maybe wants to see landfill, and see the negative impacts, so everyone has his own point of view.

But what do you do when this happens? For example, if a planner doesn't want to see the landfill next to his project, but it's there in the image. Does he say, "Well can we get rid of it?" What do you do, if you never reframe your images?

Oh, I never crop my images. But in my commercial work, the user of the image will crop out things he doesn't want to see, and now of course with digital imaging, people start changing everything. They make the grass green and they take out the power lines and manipulate the image to make it what they want.

But is that part of the contract?

Not on my part, I don't do that. They have the image and they can sort of do what they want. It's something I

probably should think about as part of a contract, but usually most of my commercial work is on a handshake, on a verbal agreement as opposed to a written contract. Even the Houston commission, I don't think there was much in the letter of agreement. We just discussed what I was going to do and that was it.

Do you think that if your ecological involvement were better known, people would be suspicious about what you might show?

I think it depends who is presenting the information. Usually in a public process, there is a prosecutor and a defender. For the most part, my library is open to either party, even though one party has commissioned me to do it. For instance, there was one time when a developer was looking to put a building near Walden Pond, which I'm very much opposed to. But I did not feel bad about taking pictures for the developer because the same pictures were used for the people opposing it. It seemed to me that there was a self-evident truth in the pictures, that this was not a good idea, and so in that sense the developer paid for everyone to see what was happening. For the most part, because I control the images myself, I don't feel too bad about looking at problems.

Can you give some examples of commissions you've had?

Most of the commissions I get are to document new or proposed projects in urban areas, like new parks or

183

expanding parks or making links from one park to another, so they're pretty good projects. I like doing that work, but for the most part I work in the private sector. Public agencies, I rarely work for. It's amazing some of the different things that the people ask you to photograph. Construction projects for businesses and engineers; landscapes and topography for architects, pictures for insurance companies and realtors. There are many, many examples I could give: abandoned mills in Rhode Island for possible redevelopment, photos of the Big Dig in Boston that were used in a legal conflict with contractors, the islands being constructed in the Mississippi Delta for *Scientific American*, pictures of the Harbor Islands in Boston for the National Park Service, to create a new park. Some of the requests are strange. Once there was a woman that was murdered on a boat and they asked me if I had pictures of the harbor at that time in my files, so they could see whether the boat was there.

Did you have them?

I did. So there are all kinds of requests. I recently had a person call me because a boat had sunk on the Mississippi and I had the most recent photograph of the boat. I have had environmental groups that want to document timber companies that use herbicides to spray after they cut. They spray herbicides to kill the deciduous plants so the conifers grow, and in the process they spray over streams, getting the poisons into the streams. So I photograph where you can see the vegetation killed right up to the edge of the stream, just to create awareness

for the public in general as to what's happening. Most people don't know how much of the Maine woods has been harvested for timber.

When surveys are very extensive, photography must help to show the whole picture.

Exactly. I get asked for a lot of surveys of downtown areas, where they are going to redevelop the downtown, or where they are going to be doing new parkland along a waterfront. The planning process, in this country, is becoming more and more involved with the community. The architects and planners no longer say, "This is the way it's going to be." Now they really have to have a consensus from the community, they have to have approvals. So the surveys have to be presented to ordinary people in the neighborhood, and they have to be able to understand what the architects and planners are talking about. It becomes a very productive way of getting away from maps, which are very abstract. People have trouble understanding the issues just by looking at maps. But now the developer will often draw in pictures of what they're proposing to build right on to the photographs. It's also very cost-effective for the designer because they have a basis for their drawings and they don't have to put in the rest of the information, it's already there.

It becomes a very powerful tool in helping people visualize changes that are going to come. Often what happens in these hearings is that people will ask questions. When I was in Connecticut, they had a question about

how the river got under the railroad. They knew it went under somewhere, they didn't know where or how, whether there was a bridge or whatever, and the aerial photograph becomes a document that will show that. It works as a base line of information. If they want to know whether it's a brick building or a wood building, the photograph answers the question even though that wasn't its original intention. You wouldn't have that type of information on a map. When I describe my commercial work for planning, I really call it illustrative aerial photography as opposed to maps. When you start looking at things at an angle, you see the elevation, the vertical aspect and that's what really gives you a sense of place that you don't get with just looking straight down. You get a real feeling for what the place looks like, what the neighborhood is like and the texture and vegetation. The aerial photograph is as if you could make a perfect model of the site, and get far enough away to photograph it. You know it has all or most the answers there, because you can see them.

That must be a very useful tool for landscape architects. Do you get a lot of commissions from them?
Oh yes, all the time.

Is that to document the environment before or to document it after too?
Because of the way the economics work, I get a lot of requests when there are three or four teams that are looking

to get a project. Often they ask me to photograph the area first, so they can make their presentation. This serves two purposes. One is for themselves so they can better understand what they're looking at. The larger the project, the more effective it is because they can see the very large relationships, and see details within it. Then the second purpose is that it gives them a very effective tool to take to the client, and say "We've looked at this very carefully, here it is, and this is what we think," so they really look as if they have done their homework and have been giving this a lot of thought. It's a very effective way of making presentations. So I tend to get more work before they get the project. People also ask me to take pictures of the finished product because it's an advertisement for their work.

Do you ever come back at the same place years later and take another picture from the same point of view?
I haven't, you know. I have pictures that are close, but I haven't really done that yet. But I agree it would be very interesting, I should take some of my more interesting Boston pictures again. When I do presentations now, I show what it was like twenty-five years ago. The changes are unbelievable. Yesterday we flew over the Navy yard, remember near Charlestown? When you look at that now, it's hard to believe what it looked like twenty-five years ago. When I give a lecture, I often talk about planning because when you're younger—I know this was true of myself—you think things should happen really fast, within two or three years, but I think that with city planning you have to think on a very large timescale, twenty years or whatever is practical. It just doesn't happen overnight.

→ A SENSE OF TIME

Most of the time, when you are looking out the window of a plane, everything looks still and static, nothing is really happening. So if you look at a landscape within a larger time frame, you're incorporating the concept of time into it. These rocks (below right) out in Semi Valley, California, used to be flat lines, a sedimentary rock build-up, and then they got lifted and shifted up. Shiprock Peak in New Mexico (below left) used to be a volcano. At the core of the volcano is where all the earth eroded away, then the magma came up and solidified.

You see time in a lot of different ways. The salt marshes go from low tide to high tide and so there's a movement from the water and the marsh which captures time. Or, even something like the waves moving in on the coast; again it's motion that gives you a sense of time in the photograph. Likewise with the atmosphere, the clouds moving over the hills, they suggest a time and a place.

What I often like to incorporate into a photograph is an event, something that makes it truly a natural landscape. The fog, the moisture lifting up in the morning out in the Connecticut valley, that's part of an event. Then there's the motion of shadows that fall on the landscape during the course of the day— that suggests time. It's very subtle, almost subliminal. When you see the photograph, you don't really think about it, you just feel it. There are many to show time; one is the color shift during the course of the day. In the evening and the morning,

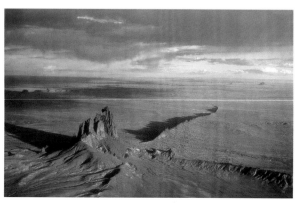

Shiprock, New Mexico. Shiprock Peak.

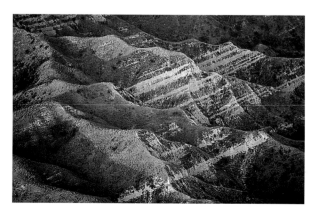

Santa Ynez area, California. Tilted innerbed rock formation.

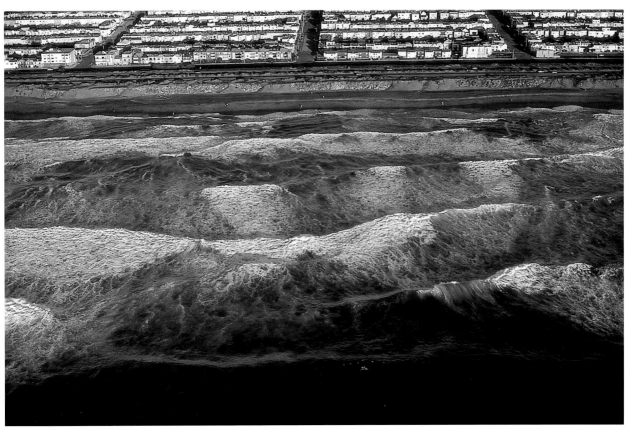

San Francisco, California. Waves on the Golden Gate coast.

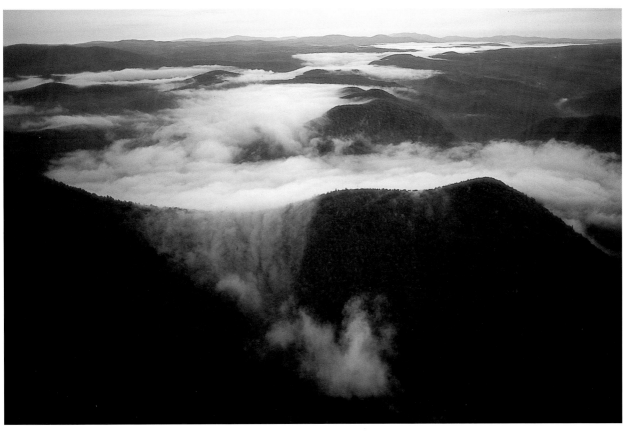

Berkshires, Massachusetts. Mountain fog.

the color's very warm and the temperature shifts during the day so even this shows time as an event. An ice pattern is another type of movement, just from temperature. The ice expands when it freezes, and if you look carefully you see the little cracks in the ice, from the expanding (opposite, above). Then the water comes up on to the ice and it moves across and melts the snow, creating a pattern. It's very subtle, very abstract. You do get a sense of scale, from the trees in the foreground, but it looks like it could be an image under a microscope. It is just the fluctuation in the temperature, it's a very subtle type of movement.

Another thing that happens on the surface is the change in vegetation, not only seasonal changes but progression. This is a pond that's putrefying (opposite, below): it's filling in with debris and dirt. The pond starts getting marsh around its edge and the marsh dies and eventually fills in. In secession belts, the pine trees come in first, they take hold first, and then they are followed by the hardwood deciduous trees. This happens over a hundred years, but in maybe two hundred years, the pine trees are gone and it's just deciduous trees. They come in and they shade the pine trees, the pine trees die, and that's called the secession belt. A secession belt is the progression of the forest. So again you have time and surface changes. And there's also seasonal change, just through the course of the year.

These photographs also say something about their own making. When you look at this landscape and it's so still, if you look in the landscape itself, if you look in that field right in the foreground there, you start to see

Brockton, Massachusetts. Pond ice.

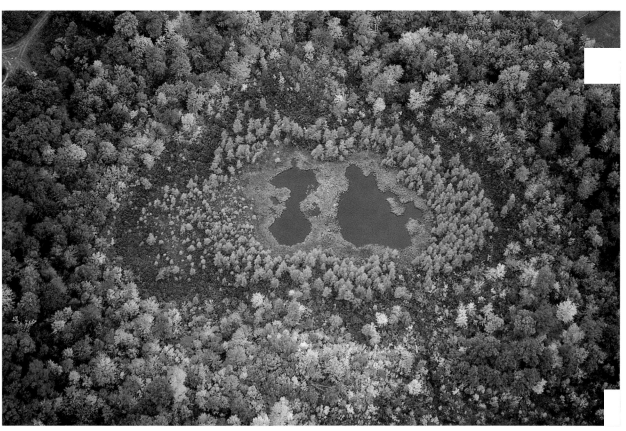

Albany, New York. Succession belt vegetation.

movement. It comes alive, becomes very active and this is what I would call a pathway. There are also containments which hold things in place, and are the opposite of a pathway. One way you can give a sense of time in the photograph is by showing pathways. The motorcycle racing on the ice (opposite, above) is an event but it shows time in a photograph. These rail cars (overleaf), coming together and going out in different directions, also give a sense of time.

The idea of pathways and containments is that you have the two together; you have the roadway and you have the areas to hold the cars in place. It's very important to have containments; you have to hold things in place so they don't leak out into the stream. Contour farming, where you have strips in the agriculture, that's about pathways and containments too. The strip is the pathway, but it's also a way of containing the run-off water and preventing erosion, which is very important. It also contains pests, so you don't get disease that spreads. Contour farming is a form of management.

Something else that shows time are overlays, things that happen in sequence. I'm interested in overlays because they show a sequence of events. In the image of German Valley, Illinois (p. 197), the farmer is plowing the field by the contour first. You see those light brown scallops? He's following the contour, and those lines going across horizontally show where there's a swale or a ditch; he doesn't plow there. Then he will come back later, plowing in a straight line, and the soil will be darker, there's more moisture in the soil where he has turned it over,

Detroit, Michigan. Pollution plume enters the Detroit River.

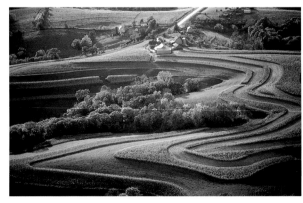

McGregor, Iowa. Contoured farm in autumn.

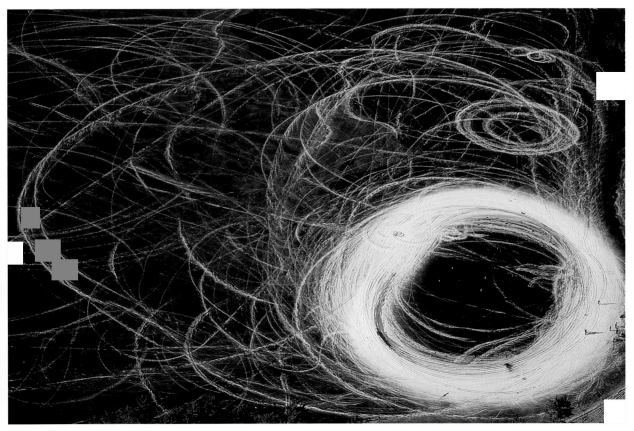

Southeastern Massachusetts. Motorcycle racing on ice.

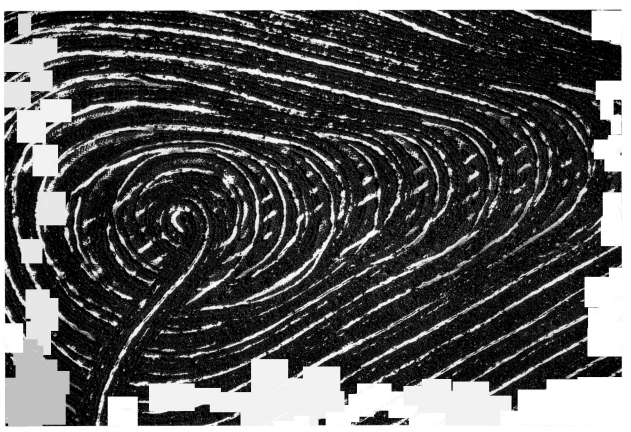

Boxborough, Massachusetts. Winter snowplow patterns.

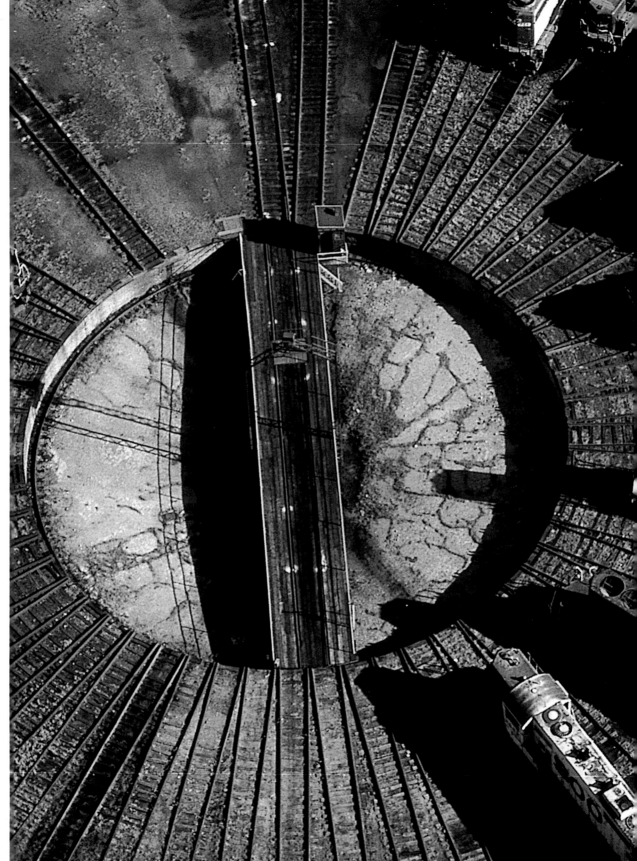

Minneapolis, Minnesota. Railroad turntable.

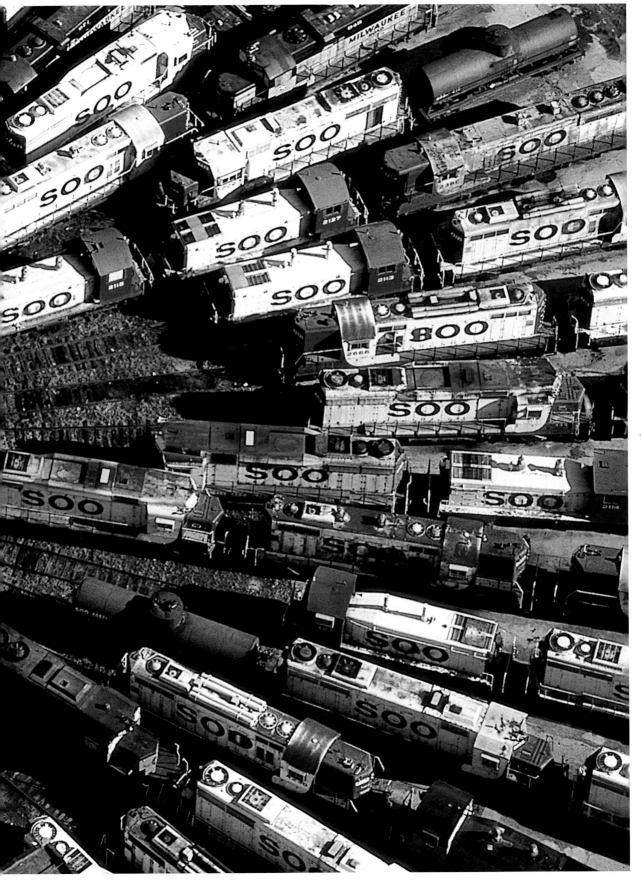

so you can see a time difference. Most likely he's also plowing perpendicular to the prevailing wind, so he doesn't get wind erosion. Those are both forms of containments, he's trying to contain the soil there, but it's also a pathway. What's also interesting is that if you look very carefully, you can see the old pattern under the new pattern. It's very subtle. If you don't take precautions and farm carefully, you get erosion, this is down in Texas (opposite, above).

Overlays are another theme that interests me. You get seasonal changes laid on top of one another. For instance, you play baseball in the summer and you play football in the fall and winter, and so there is a changeover in late August. This is a baseball park (below left) where they play baseball in the summer. Then in the fall they start to play football, and they put down the chalk lines to mark the football field. So that's about that idea of overlay and change.

This is a baseball field that no one plays on anymore: it's been abandoned (below right). Abandonment is another theme that I see and talk about a lot, leaving things. Abandonment also has a sense of time to it, it's a transition. When you look at landscapes, abandonment is very important, because although it seems very static, you can see that something is going to happen over the next twenty or thirty years. You know there is going to be a change there, and this is part of that change. Abandonment also includes the waste of resources, and the idea of walking away from capital investment.

Minneapolis, Minnesota. Baseball diamond overlaid on football grid.

Newton, Massachusetts. Unused baseball diamond.

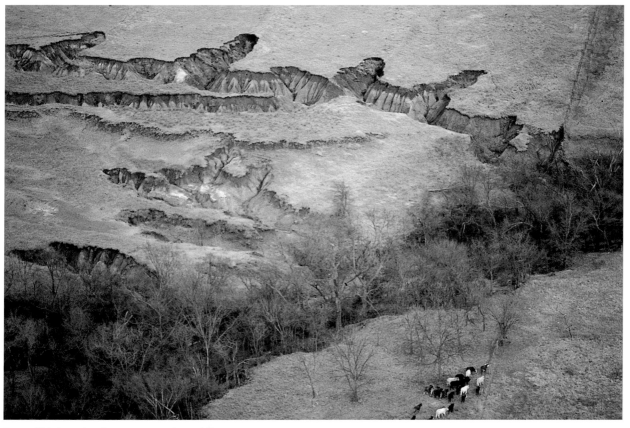

Texas/Oklahoma border. Large erosion gullies.

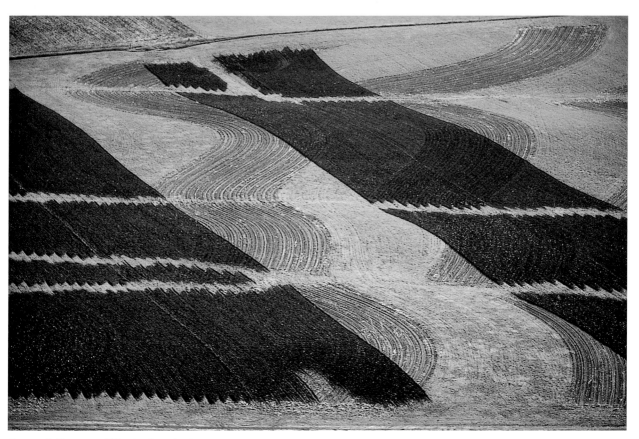

German Valley area, Illinois. Overplowing.

These B-52 planes are out in Tucson, Arizona (opposite, below right). You know each plane is worth millions of dollars and you just walk away from it and you cut it up.

This is the US/Mexican border (opposite, top right), with Mexicali and the US side on the right, the Mexican side on the left, and you can see the American factories just over the border. They produce goods there and just ship them right back into the United States. Edges are very important; with an edge, you can create access. Here they have these daisy docks so everyone can have a place to dock their boat, because everyone is sharing a very small edge and there's not a lot of access to the dock so you have to climb over everyone. You see it all the time in nature: the more edge you have, the more access you have. It's like your lungs and your chest: they have all these little cavities and you can get the air. This is sort of the same thing but in a two dimensional plane. So you see these themes over and over again in the landscape.

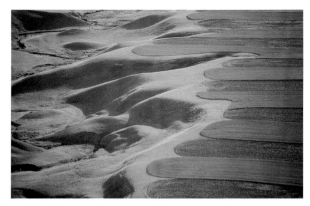

Cut Bank area, Montana. Field edge.

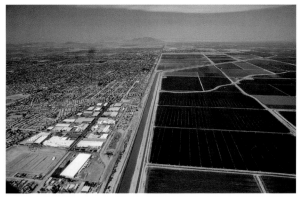

Calexico, California. Maquiladoras on the US/Mexico border.

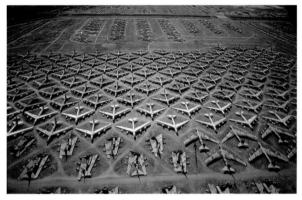

Tucson area, Arizona. "Boneyard" of B-52 bombers.

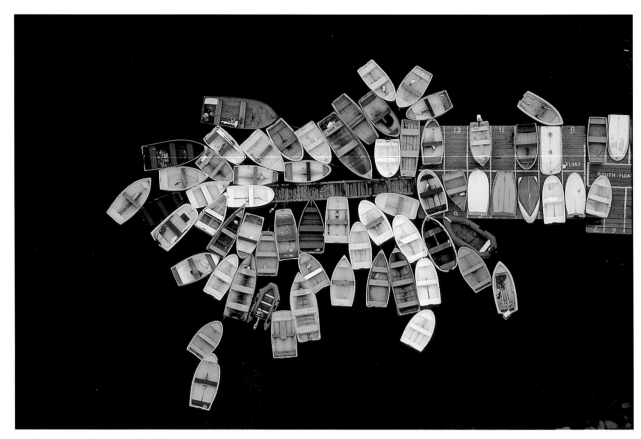

Duxbury, Massachusetts. Dinghies clustered around a dock.

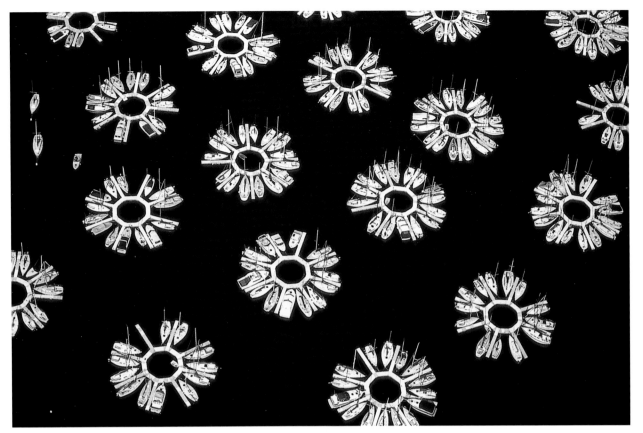

Chicago, Illinois. Floating daisy docks.

DESERT AGRICULTURE

→ There are moments when flying over irrigated arid areas that one forgets that the lush, green land below was once desert. But one is reminded upon reaching the edge of these irrigated areas and suddenly seeing the harshness of the barren, natural landscape. Agriculture in the desert and in arid areas is made possible in two ways—by flood irrigation and by pivot irrigators.

Water used for flood irrigation usually arrives by canal and is literally poured out onto fields and into parallel furrows. Therefore, it makes sense that the unit of measurement is an acre-foot (one acre-foot is the amount of water needed to cover an acre of land to a depth of one foot, or 325,851 gallons of water). Fields fed by flood irrigation and linear pipe sprinklers are rectangular in shape and create seamless areas that stretch on for miles since there are no farmhouses or barnyards. The absence of inhabitants is a unique feature of this type of agricultural production.

With pivot irrigators, water is usually pumped out of the ground from aquifers below. A large elevated pipe on wheels, with a radius arm commonly a half-mile in length, pivots around a central pump to make a circular field.

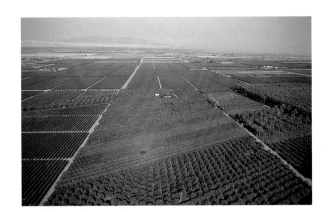

Palm Desert, California. Irrigated orchards in the desert.

The pivot irrigator is a relatively new technological instrument and its use has expanded from the southwest to northern parts of the country. Pivot irrigators are drastically changing the appearance of the landscape by replacing rectangular fields with circular ones that have odd unproductive spaces in between each other. This type of irrigation uses large amounts of energy to pump and distribute water at up to 1,900 gallons a minute. The driving force behind this technology is a desire to increase efficiency in order to save both ground water and energy costs.

Farming in arid areas is blessed by consistent sunny weather that has a certain predictability. Water supply is less predictable as it is susceptible to changes in climate and precipitation. The competing water demands of nearby growing metropolitan areas may also affect the supply. It is commonly believed that cities in the desert will not run out of water, regardless of how much is squandered on green lawns, because they will always be able to tap into the water supply of farmers.

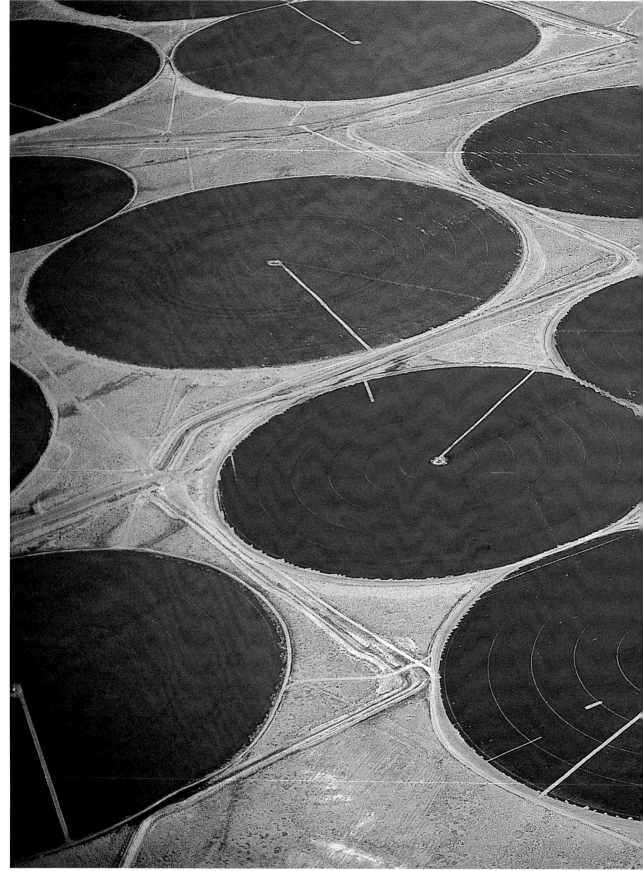

Farmington, New Mexico. Field with pivot irrigator.

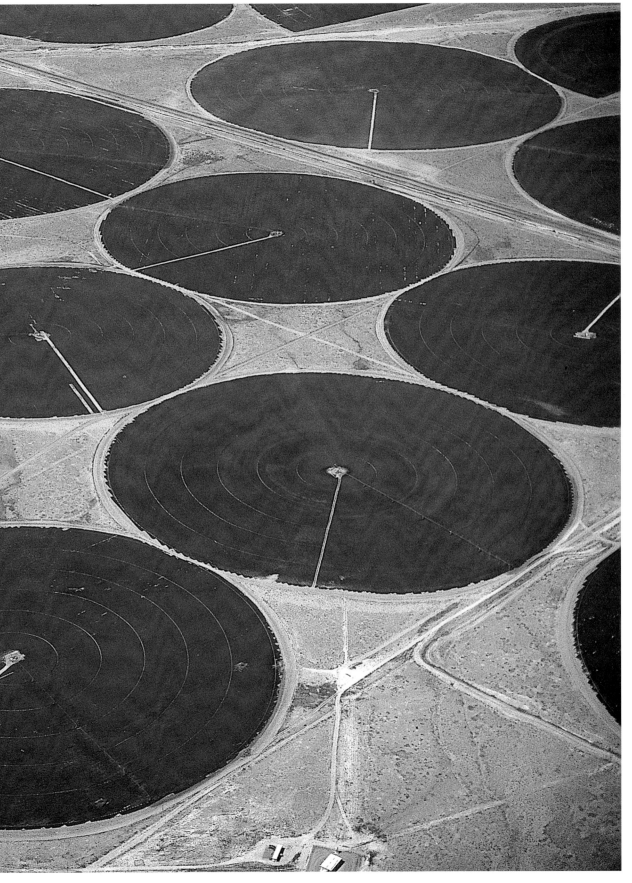

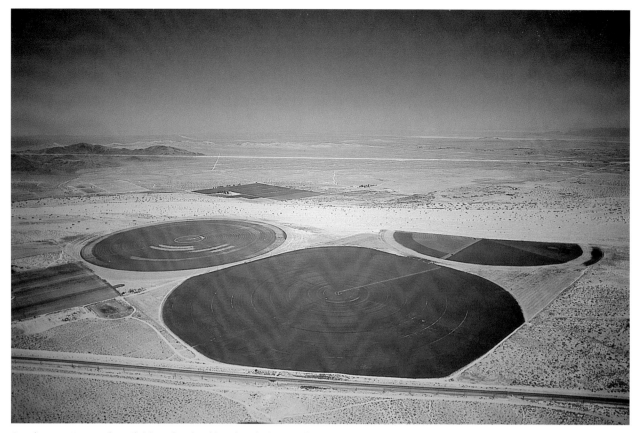

Farmington, New Mexico. Fields maintained by pivot irrigators form odd shapes.

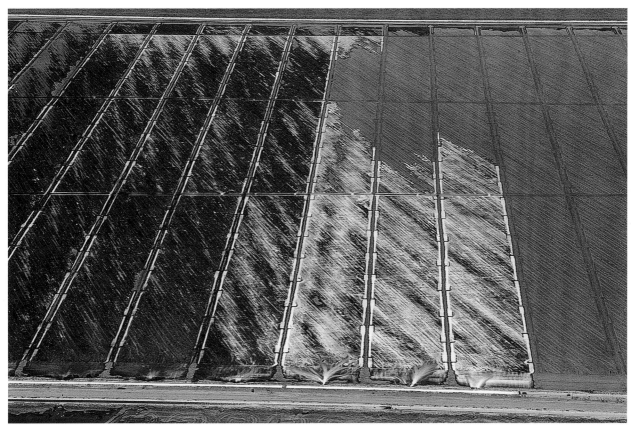

Imperial Valley, California. Irrigation.

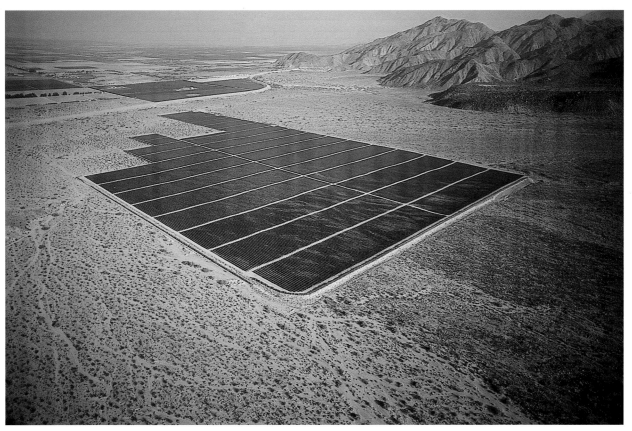

Palm Desert, California. Floating irrigated field in desert.

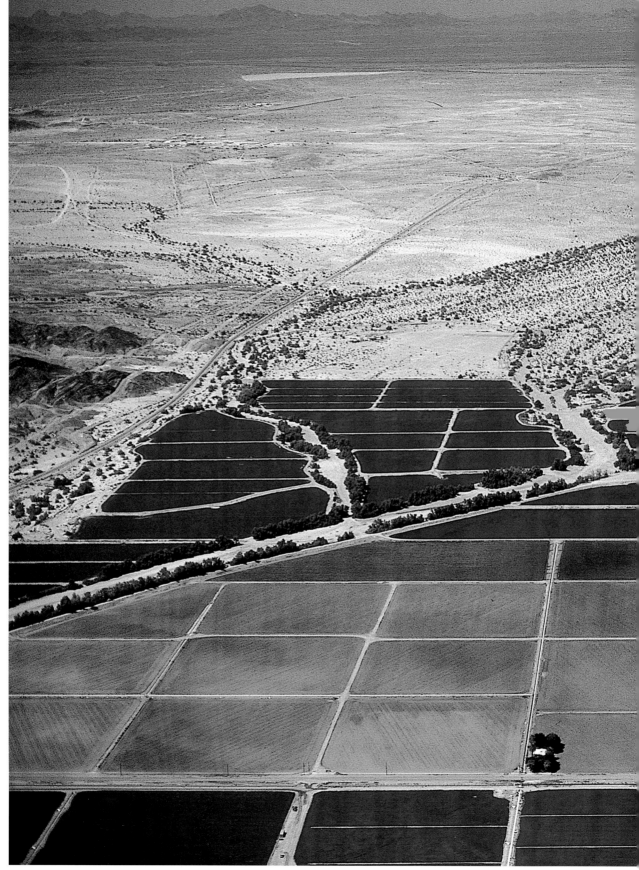

Holtville, California. Irrigated fields in the desert.

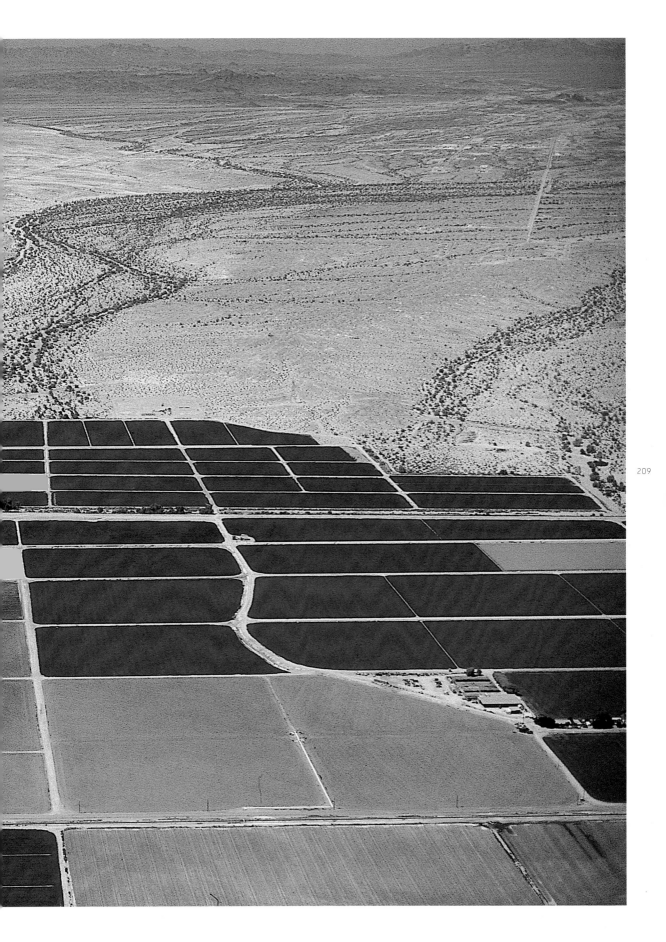

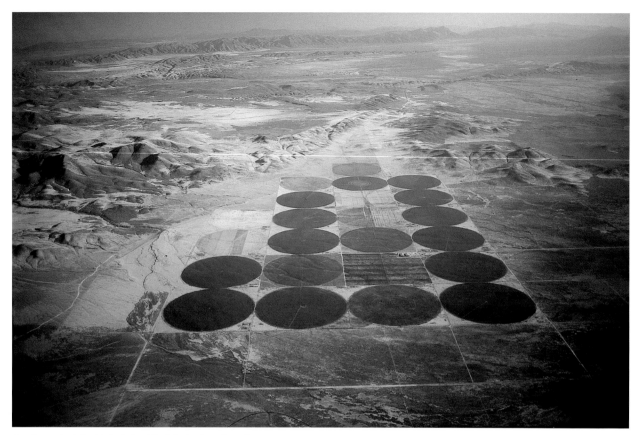

South central North Dakota. Pivot irrigators in a desert area.

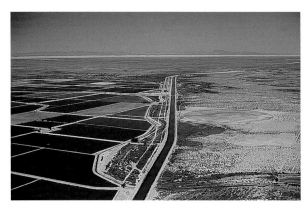

Blythe area, California. An irrigated agricultural valley
meets the edge of the desert.

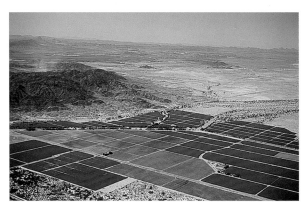

Holtville, California. Irrigated fields in the desert.

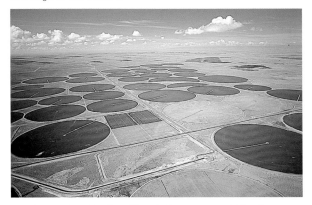

Bakersfield area, California. Agricultural fields planted to
the edge of the desert.

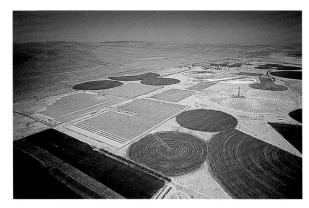

Holtville, California. Desert and irrigated agricultural fields.

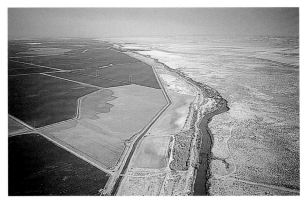

Farmington, New Mexico. Pivot irrigators on arid land.

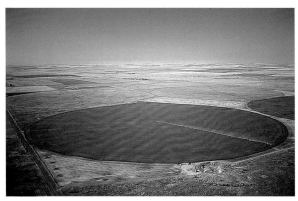

Barstow, California. Pivot irrigators with solar furnace and
collectors.

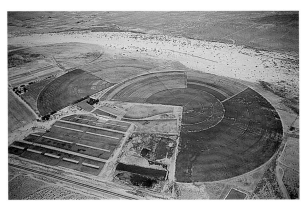

Barstow area, California. A pivot irrigator swings around a
livestock feed lot.

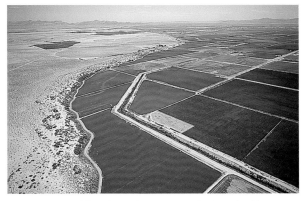

Ritzville, Washington. Circular pivot irrigator.

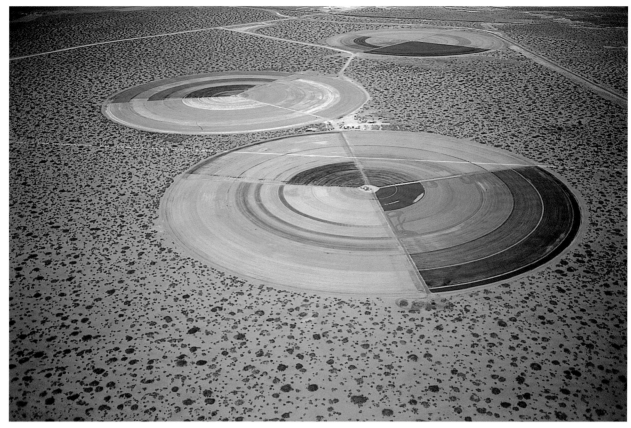

Strauss area, New Mexico. Pivot irrigators and quarter arcs.

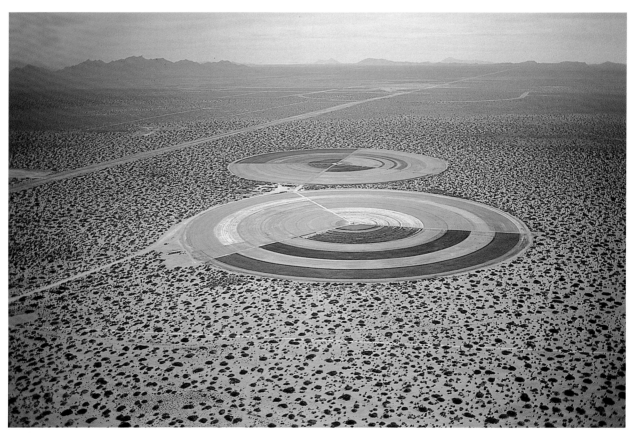

Strauss area, New Mexico. Pivot irrigators in the desert.

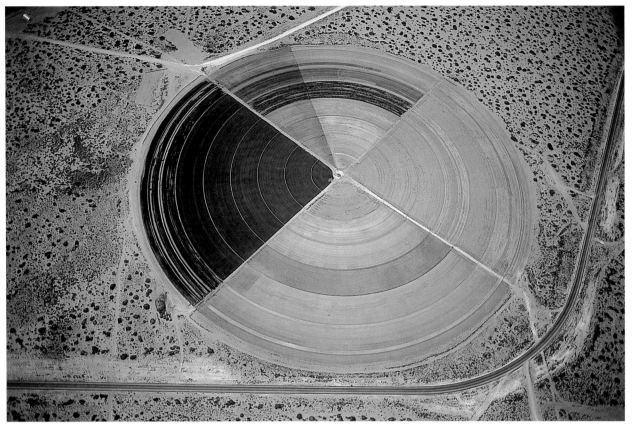

Strauss area, New Mexico. Pivot irrigator field.

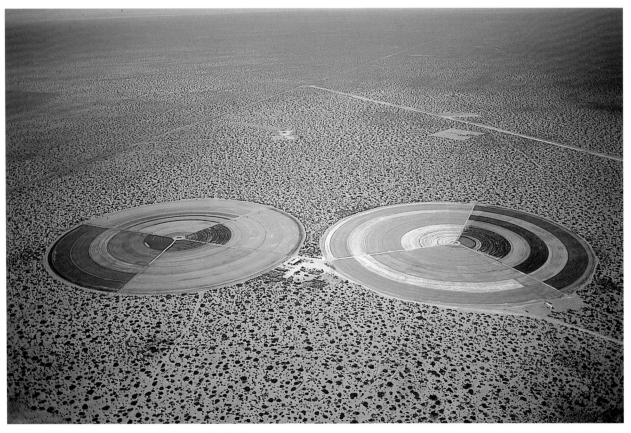

Strauss area, New Mexico. Pivot irrigators in the desert.

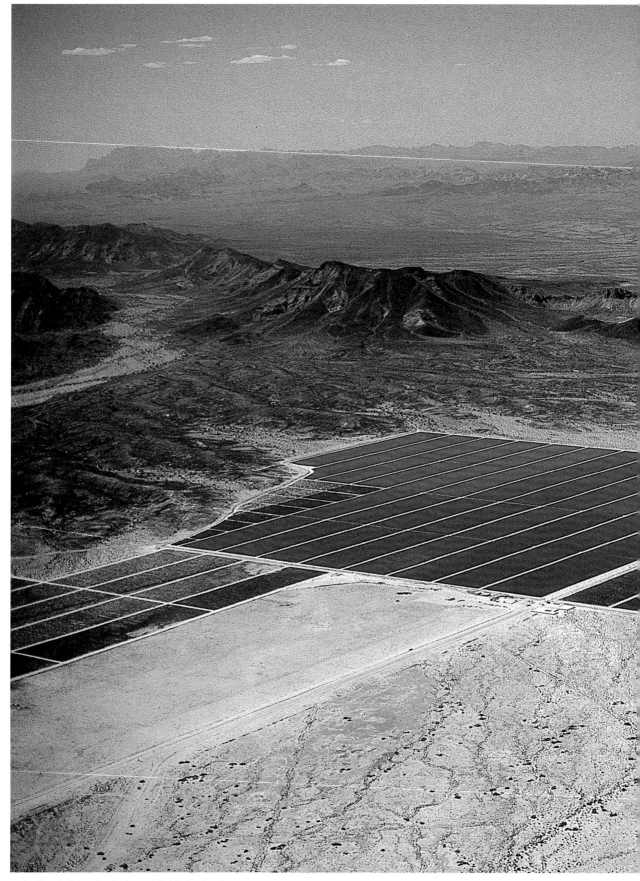

Holtville, California. Irrigated fields in the desert.

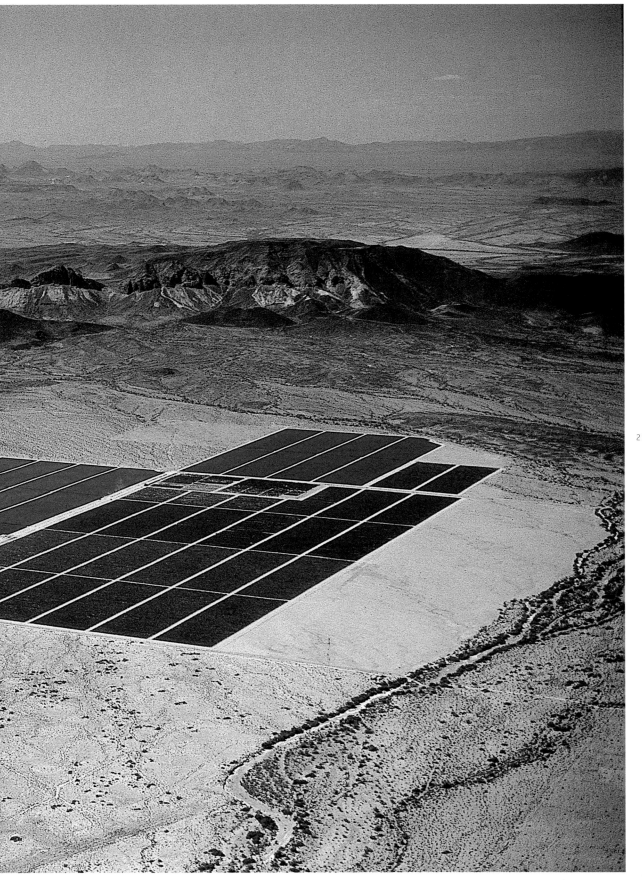

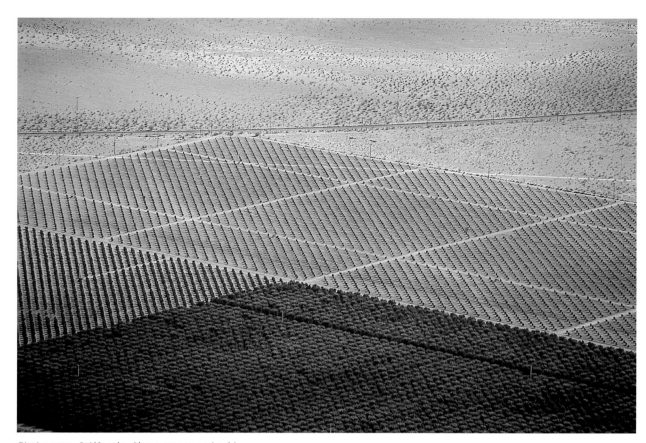

216 Blythe area, California. Citrus groves and grid.

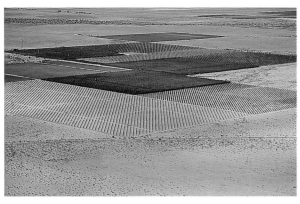

Blythe area, California. Irrigated citrus groves.

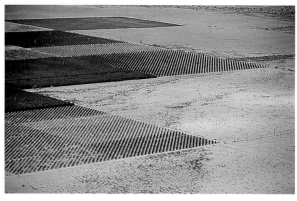

Blythe area, California. Citrus groves point into the desert.

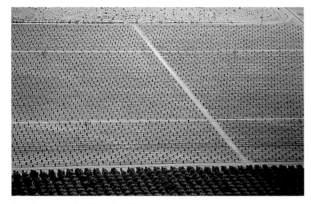

Blythe area, California. Citrus groves planted on the grid.

Blythe area, California. Citrus groves planted on the grid.

Blythe area, California. Desert orchard.

Blythe area, California. Citrus groves planted on the grid.

Kalispell, Montana. Tree farm.

Blythe area, California. Crowns of citrus grove.

ENERGY

→ When we look at the earth's surface, we conceptualize it in terms of objects fixed to the land. However, energy can be seen as a dynamic resource that flows across the earth's surface. In its natural state it is most evident in the movements of water and wind that are driven by solar radiation. Plainly visible from the air are key collection points where raw energy is concentrated and converted to a lesser amount of energy for transportation, distribution and consumption at various destinations. Energy is stored in many visible forms such as reservoirs, coal piles, oil storage tanks, and even trash piles that are destined to be incinerated.

Energy can be transported by a variety of conveyances such as electric transmission lines, pipeline rights-of-ways, water sluices, ships, barges, rail cars, and trucks, as well as the significant amount of fuel sloshing around in hundreds of millions of cars. It is not without consequence that it takes energy to transport energy. As a result, energy sources are often magnets for human settlement and development. An example of this is seen in the case of older mill towns that were originally situated along rivers in order to harness the weight of falling water. "Mine mouth" power plants are so named because of their close proximity to the mouths of mines in order to minimize

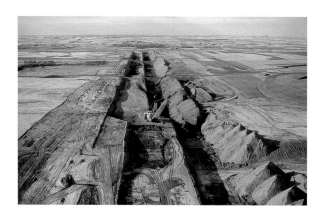

Beulah area, North Dakota.
Stripmining for coal on the Great Plains.

infrastructure costs and energy lost in transporting coal to distant power plants. Energy can also be seen in the destination points where it is being consumed, such as in housing, transportation, and commercial spaces. Over the years, these consumption points have increased in size and complexity and have moved farther apart from one another.

By looking over enough of our land, we can get a rough sense of the proportions as to where the energy is coming from and where it is being used. For instance, vast staging areas have been built along the Gulf of Mexico to channel imported oil to cars that are stalled in rush-hour traffic in metropolitan areas. It isn't hard to believe that there are more than 230 million cars and light trucks in use today. Transportation accounts for two thirds of our petroleum use.

We can readily see energy sources and the way energy is transferred over the land to where it is consumed. These are the undeniable visual links that identify the inefficiencies inherent in the transfer and consumption of energy and make a statement about our misguided priorities when it comes to energy use.

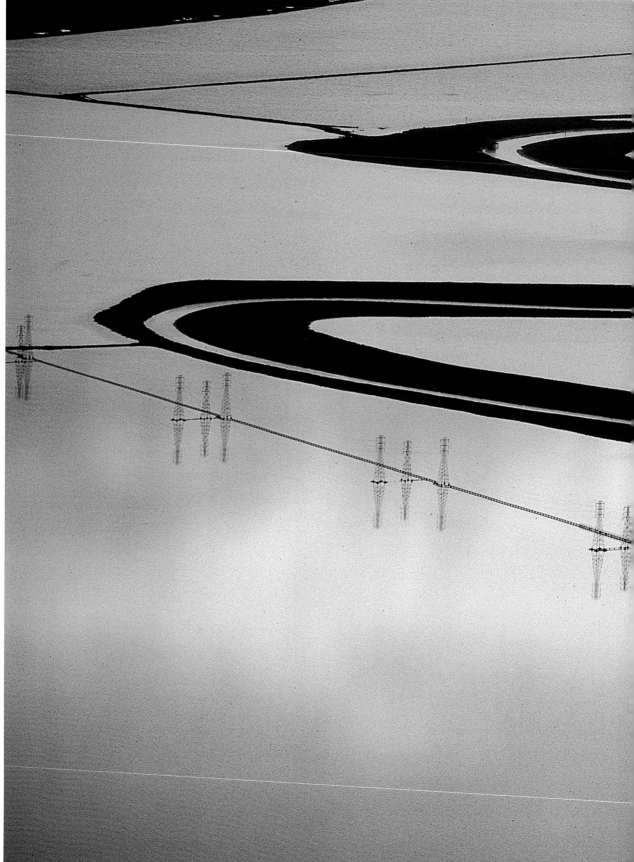

Fremont, California. Bay channel.

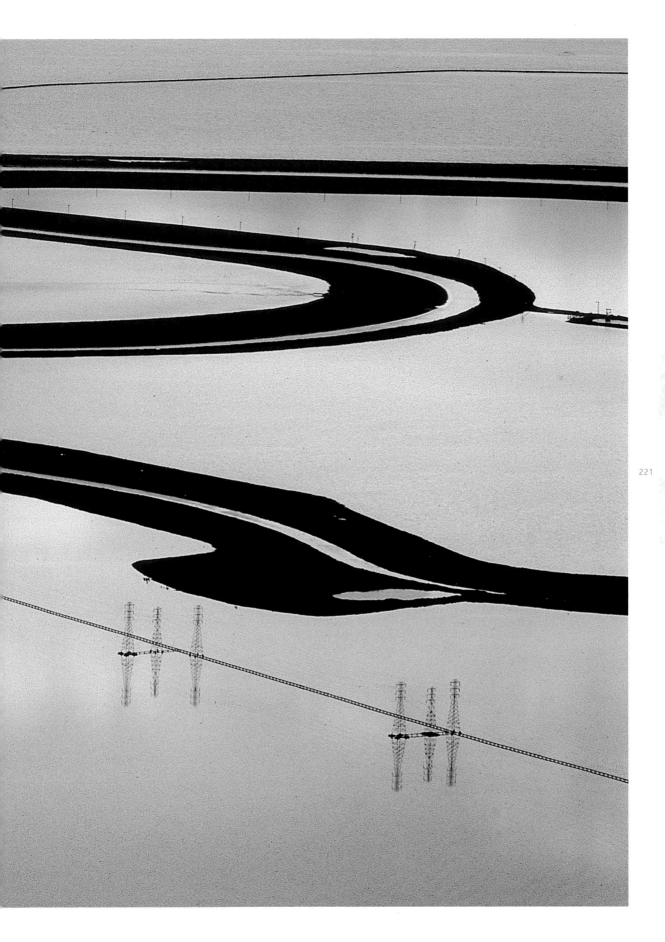

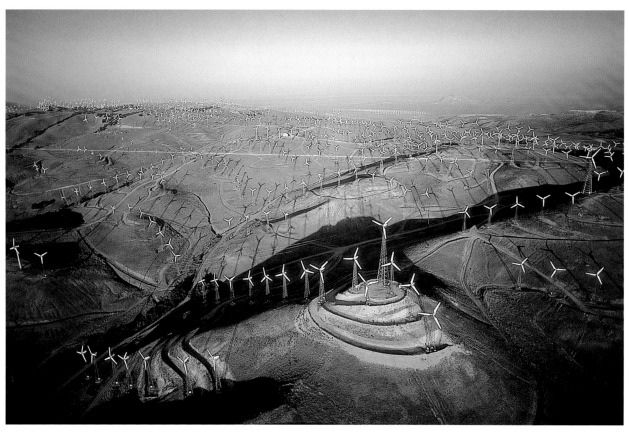

Tehachapi, California. Tehachapi Pass.

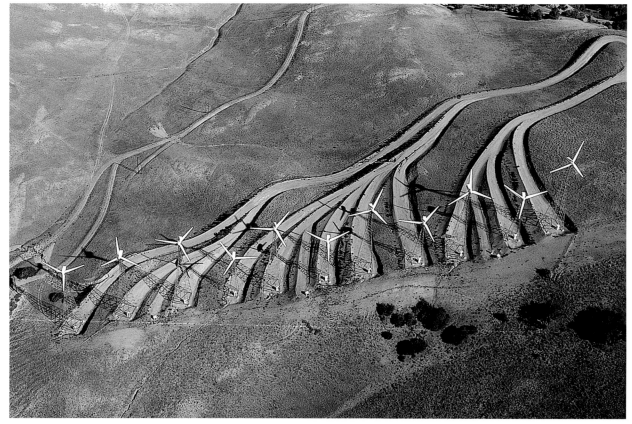

Tehachapi, California. Wind turbines.

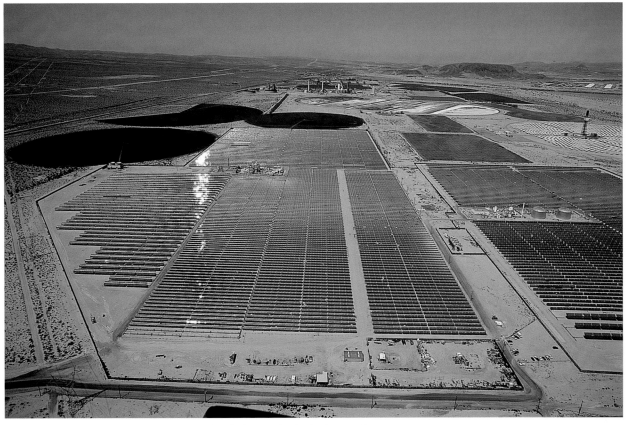

Barstow, California. Solar collectors with pivot irrigators in the background.

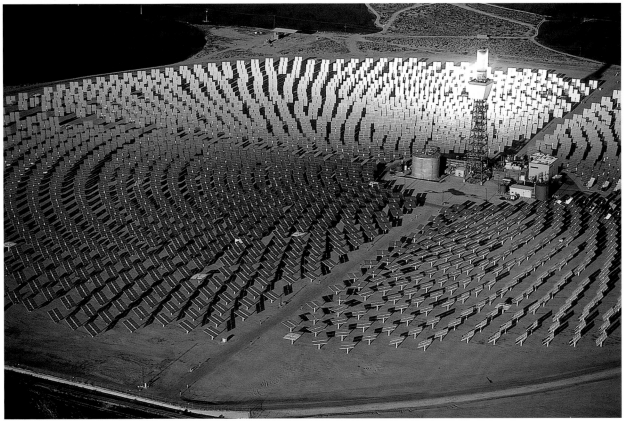

Barstow, California. Solar furnace.

Palm Springs, California. Power-generating wind turbines lined up in the desert.

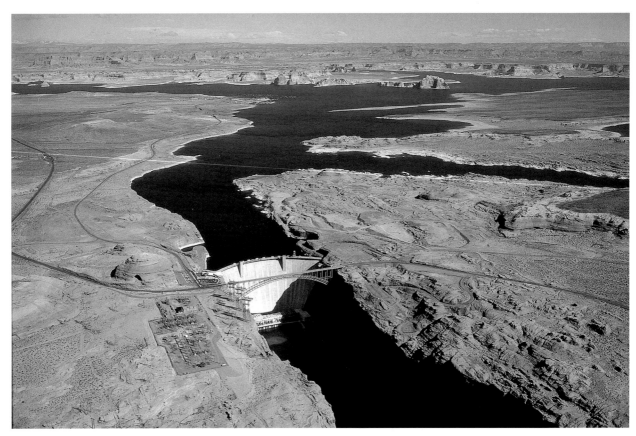

Page, Arizona. Glen Canyon Dam forms Lake Powell on the Colorado River.

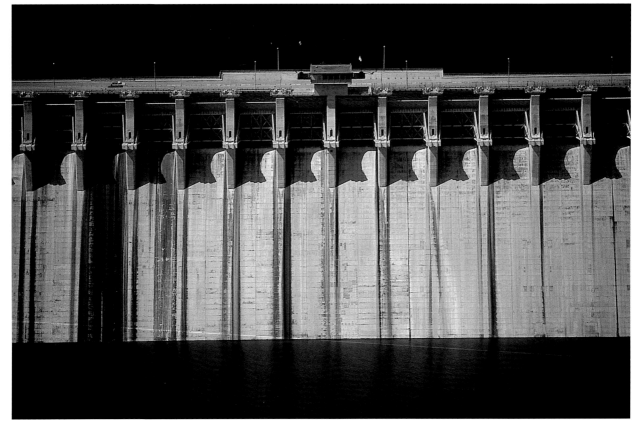

Amistad Reservoir, Texas. A dam marks the border between the United States and Mexico.

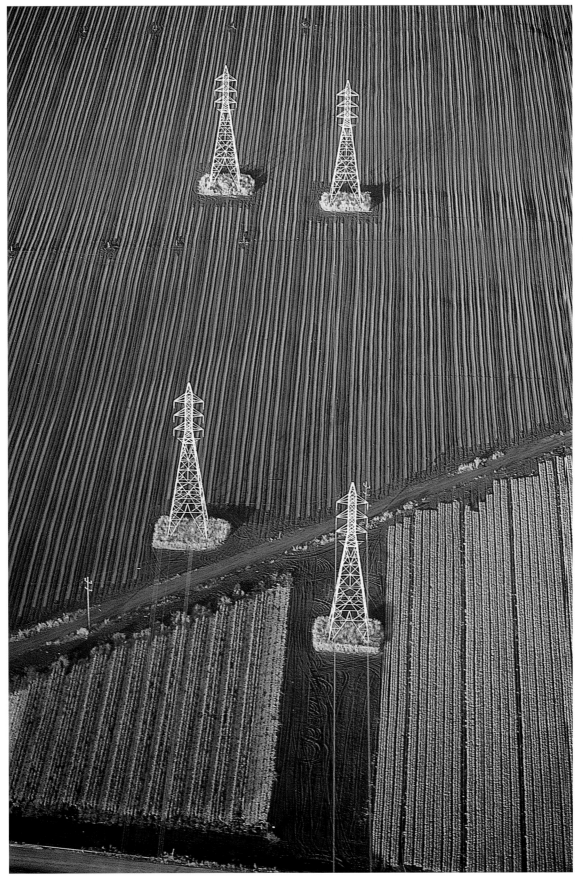

Oahu, Hawaii. Four white transformer towers in a field.

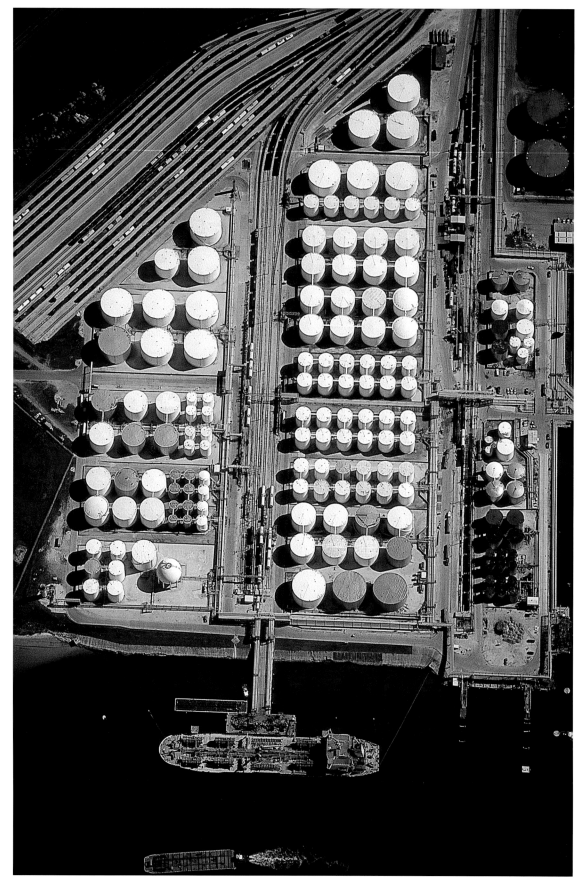

Houston, Texas. Oil refinery offloading facility on Ship Channel.

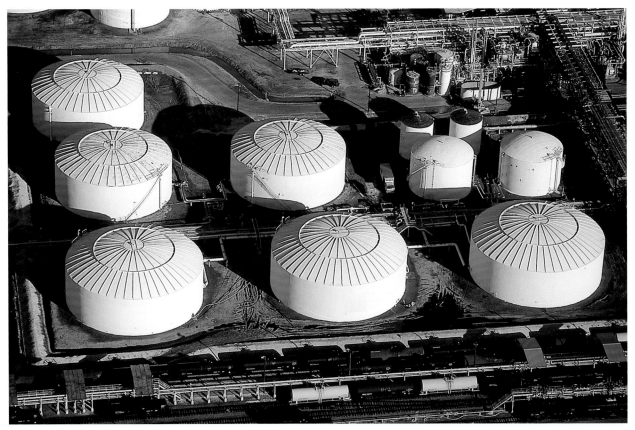

Baton Rouge, Louisiana. Oil storage tanks.

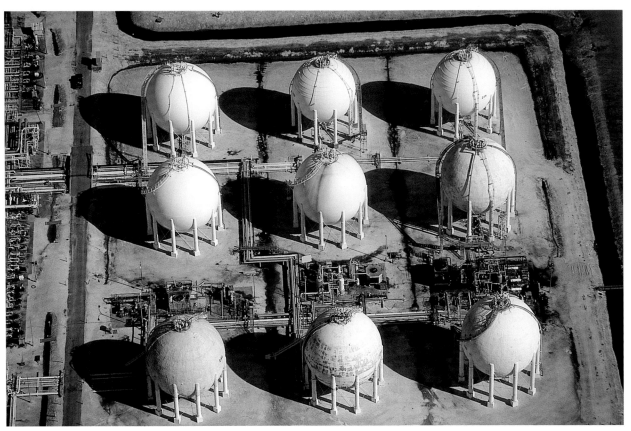

Baton Rouge, Louisiana. Spherical oil storage tanks.

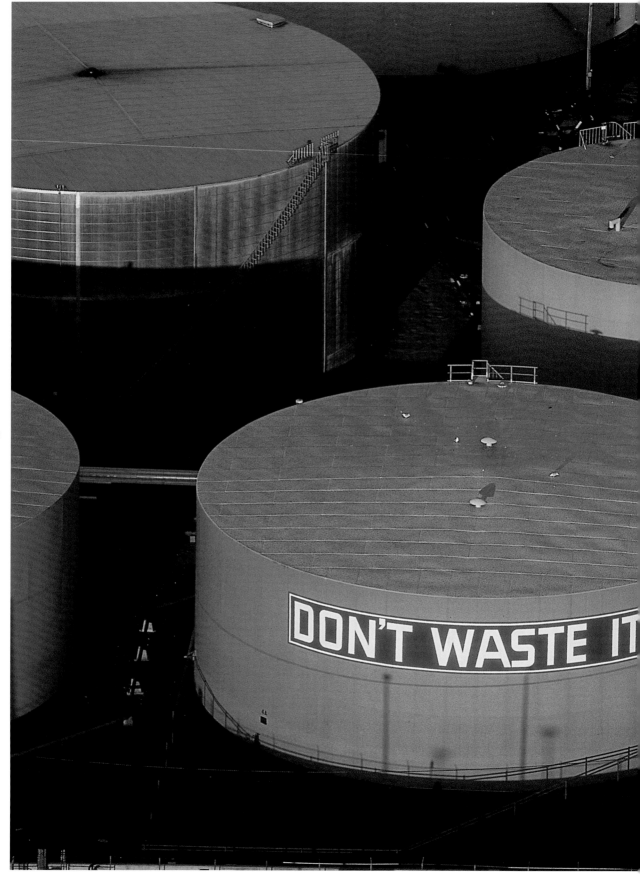

New Haven, Connecticut. "Don't Waste It" painted on the side of a petroleum storage tank.

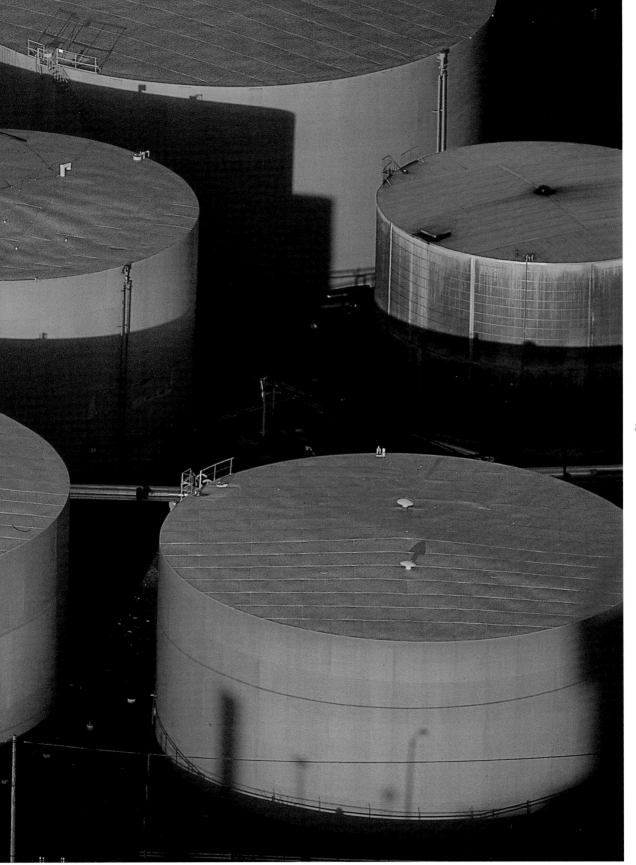

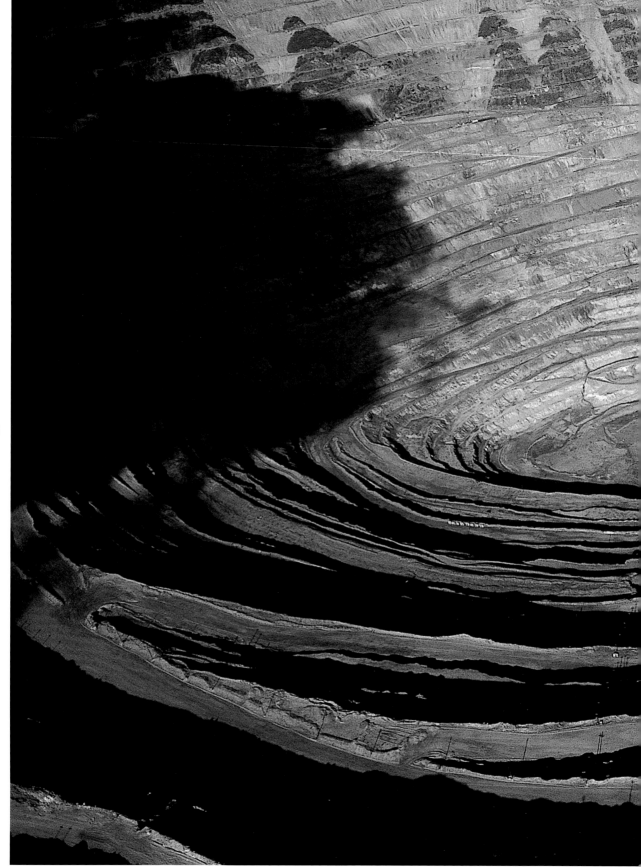

232

Bingham Canyon, Utah. Kennecott copper pit.

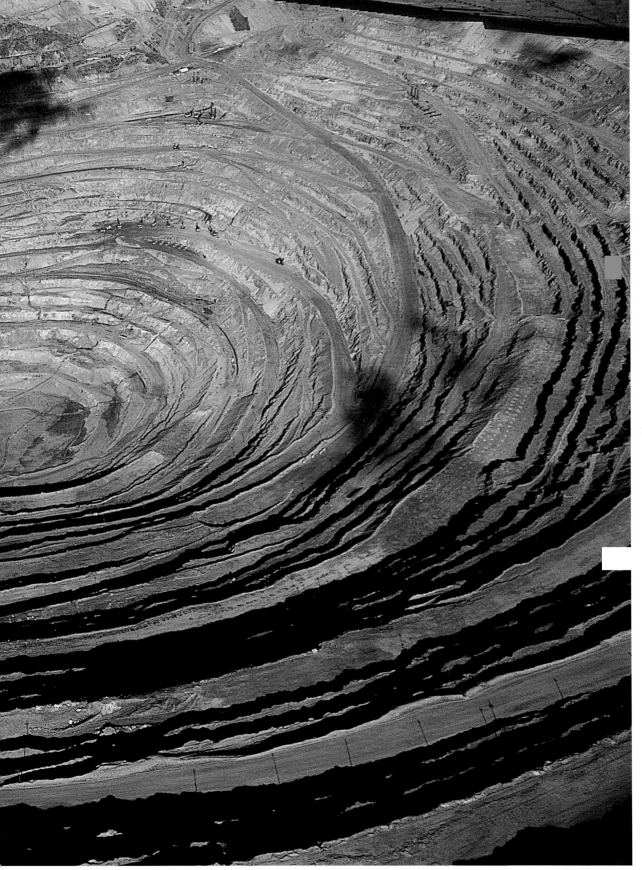

234

Ashtabula, Ohio. Truck driving between oil piles.

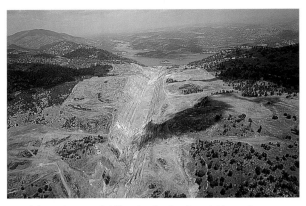

Stanislaus County, California. Coal vein cut through mountain.

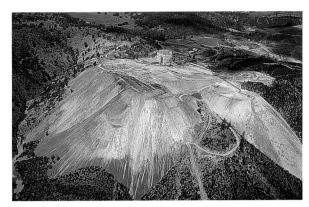

Calaveras County, California. Mine tailings spill over mountain top.

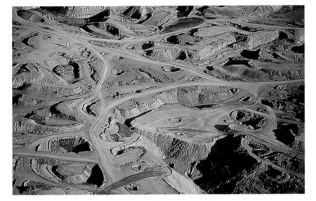

Beckley, West Virginia. Strip-mine waste piles.

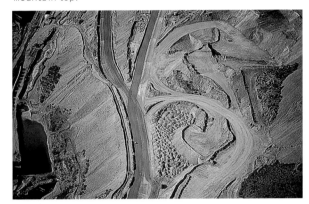

Northeastern Arizona. Open pit mine.

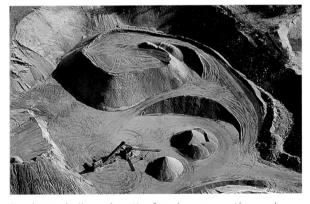

Westborough, Massachusetts. Gravel quarry sorting yard.

Saint James Parish, Louisiana. Industrial waste pit.

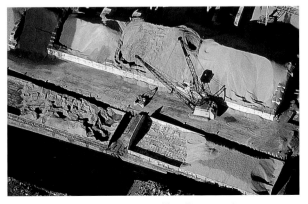

Stamford, Connecticut. Barges offloading gravel.

Chicago, Illinois. Barge at loading dock.

HOUSING

→ American housing takes countless forms and configurations in different locations with varying dimensions, densities, building types, and materials. Housing says a lot about individual and cultural values. There are trends in housing that are transnational, making new housing more homogeneous and undifferentiated from one part of the country to the next. This has as much to do with similar regulations such as zoning, building codes, financing, and marketing as it does with building techniques and materials. Other trends in housing are unit sizes that are steadily increasing at the same rate that garages, driveways and property lots have been changing to accommodate families with two or three cars.

The aerial perspective is an effective way to survey where and how Americans choose to live. A good representation of American housing can be seen when flying across a metropolitan area starting from the urban core. At the center of the metropolitan area we see row housing and walk-up apartments interspersed with high-rise residential towers. Going out from the center we come across a "gray area"—land that is depopulated and blighted as a result of outward migration of middle-class residents to the suburbs. This area is made up of deteriorating housing and public housing projects for the poor.

Continuing out we move across older streetcar neighborhoods and first-ring suburbs. Streetcar neighborhoods are dense with multifamily houses that follow old streetcar lines. In the first-ring suburbs, unit and lot sizes are small by today's standards. From here continuing outward we will cross a major highway ring road and other highways and arterial roads that spoke out from the city center. Beyond the ring road, we move to new suburban neighborhoods that bring us to the present-day housing developments under construction. In areas served by sewer and water lines we find the housing to be denser and sitting on smaller lots.

As we move out to the edge of the metropolitan area, lot sizes increase with each house taking up two to ten acres of land. These houses have their own septic systems and wells. This type of housing is land-consumptive. It is

Canton, Massachusetts. House with concrete
driveway off of cul-de-sac.

laid out and configured at such low densities that it precludes the viability of public transportation. Each home is auto-dependent—more often than not dependent on two or three cars.

At the edge we will also find a scattering of estate homes with three- to five-car garages, outbuildings, pools, tennis courts, and perhaps a putting green, all conspicuously fenced in.

We will see older estate homes throughout the metropolitan area where they were built at the old edge. Within the metropolitan area there are small town and village centers that have their own radiating pattern of housing corresponding to their own time period. Beyond the metropolitan area we find smaller villages and towns that have their own contemporary suburbs that look very much like suburbs around the bigger cities, just smaller in scale. We will also see second homes and farmland housing.

The dilemma for Americans is how to reconcile the need for denser housing with the competing space demands for larger unit sizes, extra cars, and the desire for a decorative front lawn and private back yard. By looking at current building trends it appears that the side yard is the first to go, followed by the front lawn. The back yard is then reduced to patio size and at some point the garage and on-lot parking get displaced to common areas. A grid street pattern proves to be more efficient in accommodating density than curvilinear streets. As density increases the individual housing lot gives way to units with common walls, and then gives way to units stacked on top of one another.

Regardless of its density, new suburban housing is poorly configured in that it lacks diversity. There is neither diversity of uses nor diversity of its inhabitants. There is also no diversity in its design and architecture nor is it rich in details. As a result, suburban housing is monotonous, sterile, inefficient and pedestrian-unfriendly. It is missing a larger plan that goes beyond the responses to market forces, finances and restrictive regulations. This monotony and lack of a larger plan is plainly visible from the air.

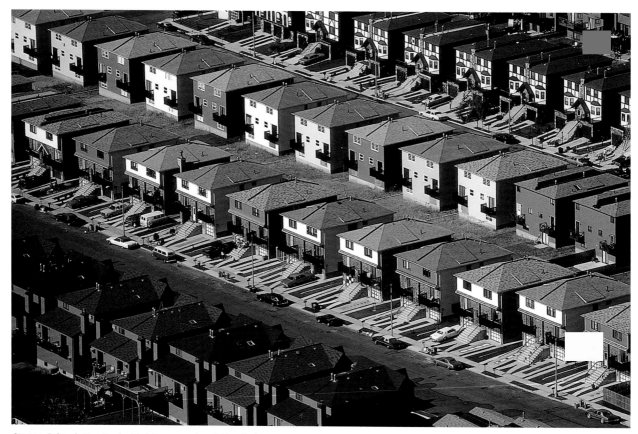

Staten Island, New York. Tightly spaced multifamily houses.

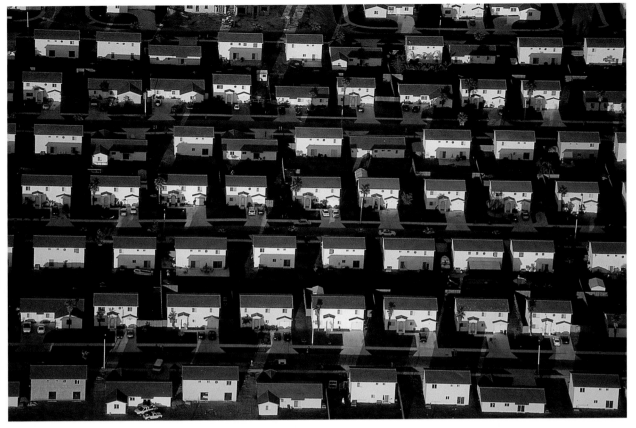

Miami, Florida. Repetitive dense housing.

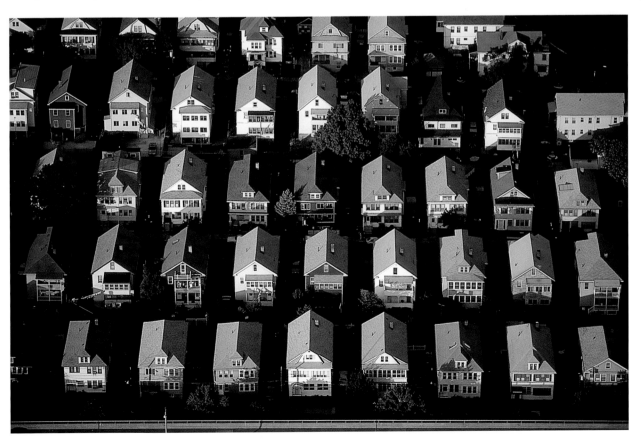

Somerville, Massachusetts. Multifamily housing.

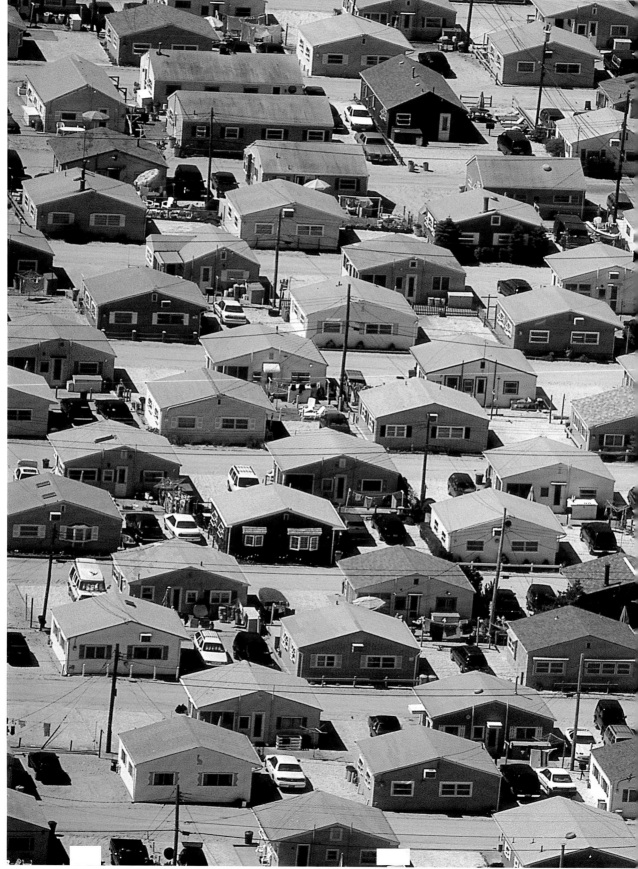

New Jersey coastline. High-density seasonal beach housing.

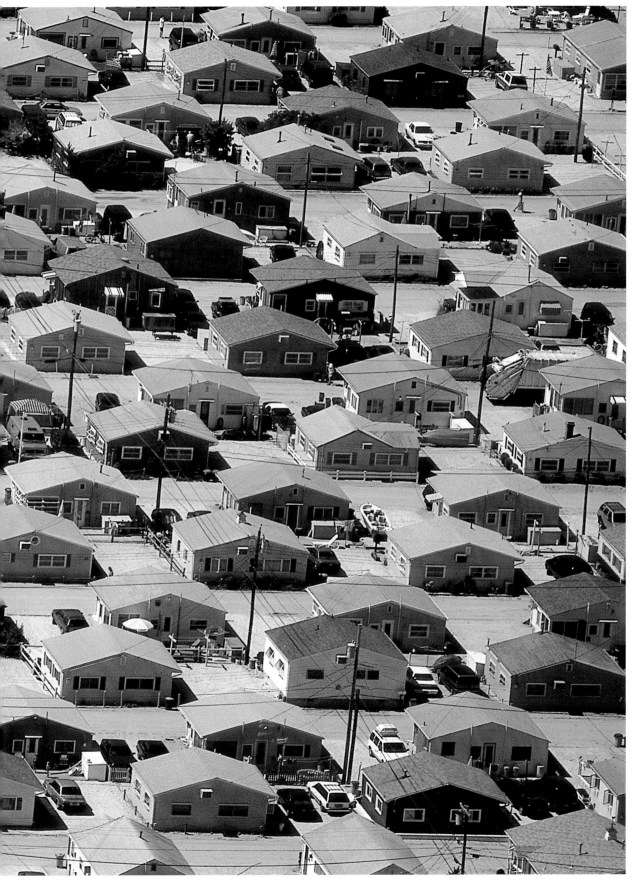

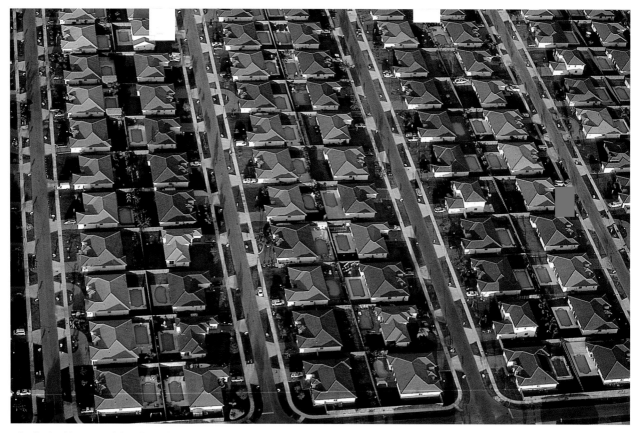

Miami, Florida. Repetitive dense housing with pools.

Palm Beach, Florida. Retreat.

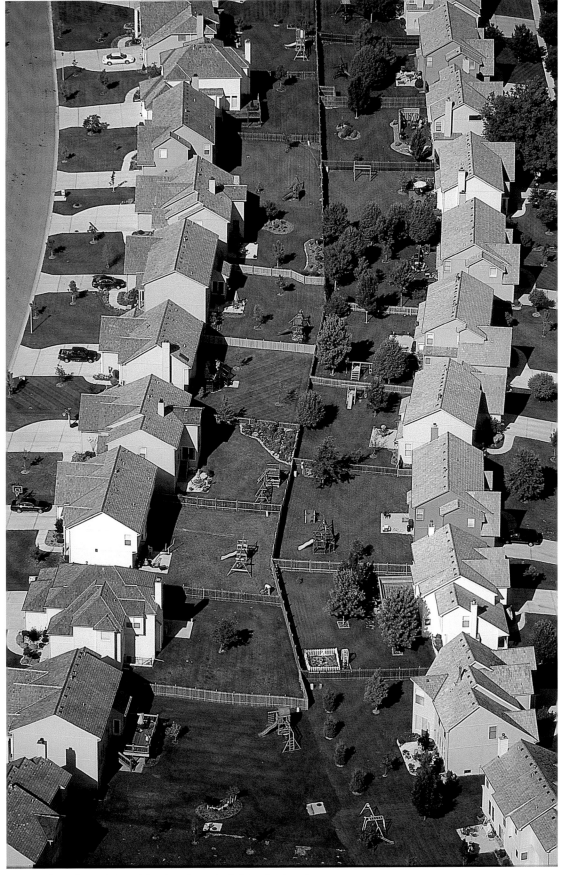

Kansas City, Missouri. Grandview housing sub-division backyards.

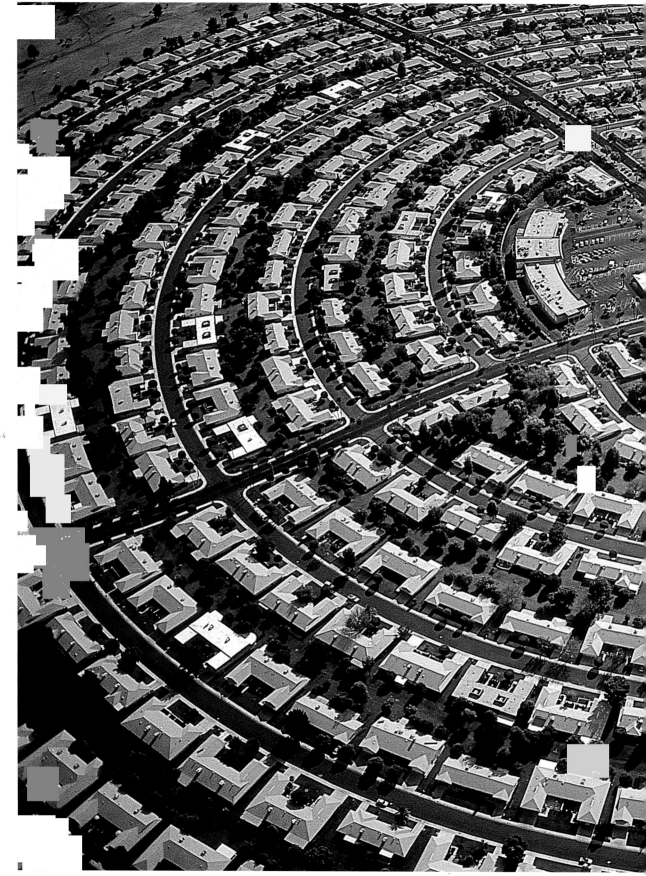

244

Sun City, Arizona. Circular housing development.

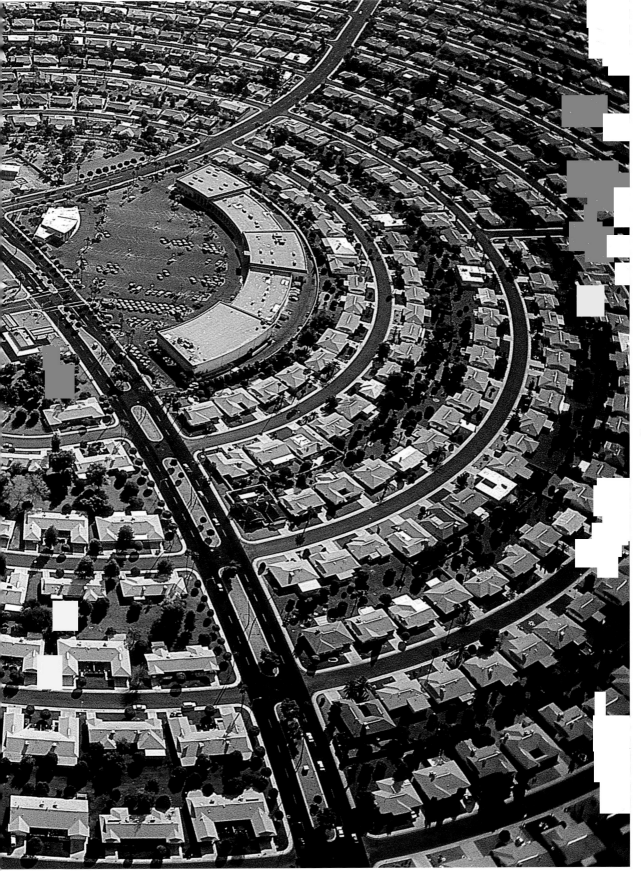

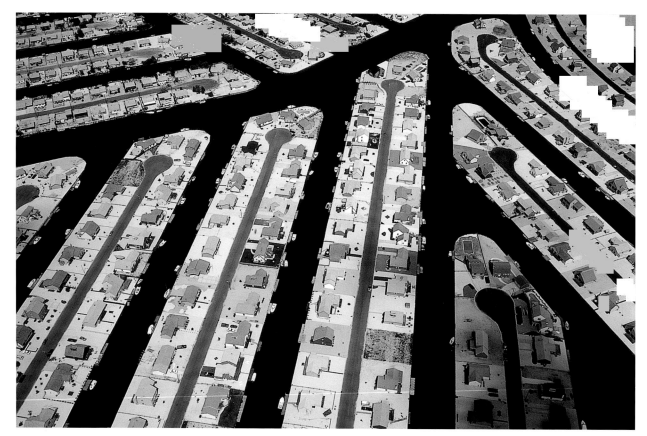

Barnegat Bay area, New Jersey. Housing quays.

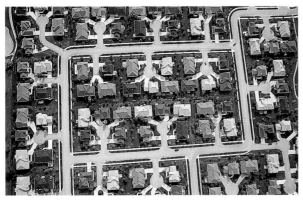

Bloomingdale, Illinois. View north over Wickham, Torrington and Parkway Avenue.

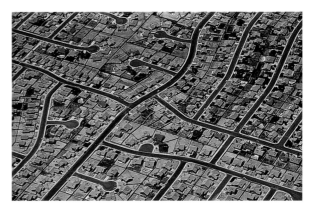

Pleasant Valley, Arizona. Suburban tract housing layout.

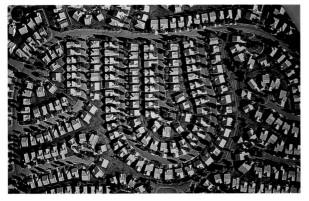

Columbus, New Jersey. Housing cul-de-sacs form a horseshoe shape.

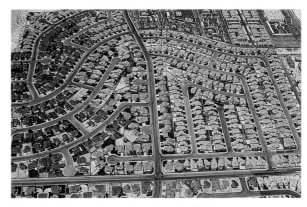

Phoenix, Arizona. Dense housing sub-division.

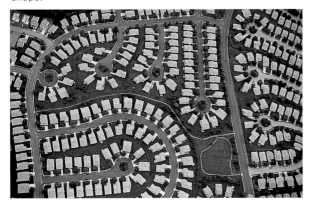

Columbus, New Jersey. High-density suburban cul-de-sac housing development.

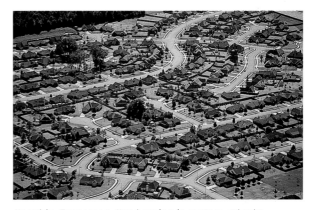

Memphis, Tennessee. New housing in western suburbs.

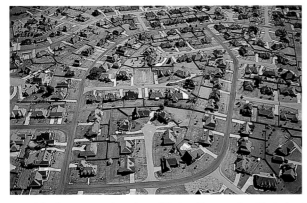

Memphis, Tennessee. Overview of Harbor Town on the Mississippi.

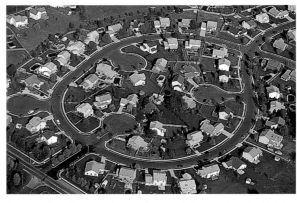

Camden, New Jersey. Ring road and cul-de-sacs in sub-division.

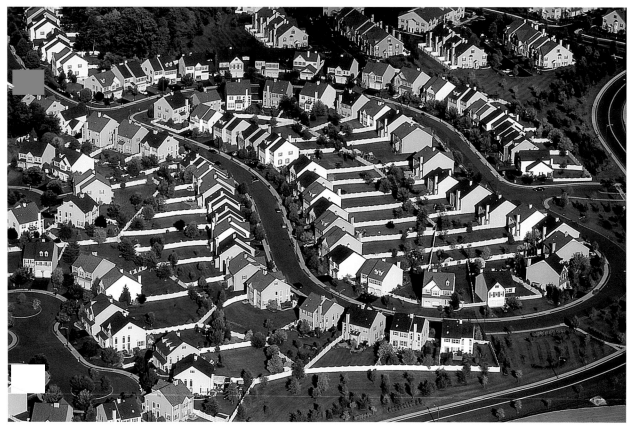

Northern Virginia. Housing sub-division with fenced yards.

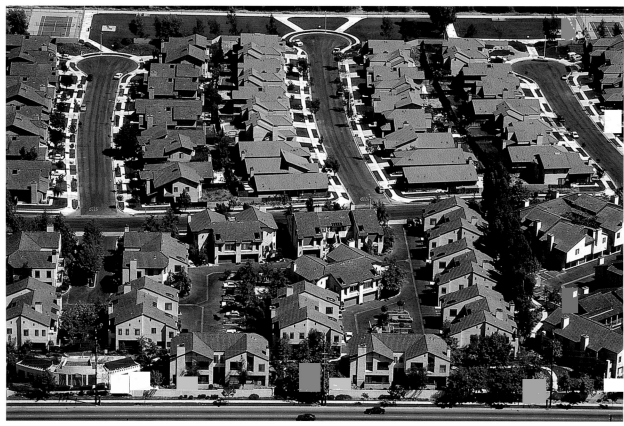

Thousand Oaks area, California. Apartment housing.

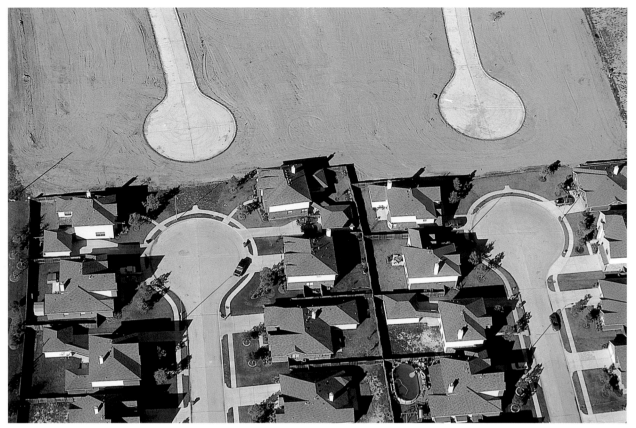

Houston, Texas. Opposing culs-de-sac, built and not built.

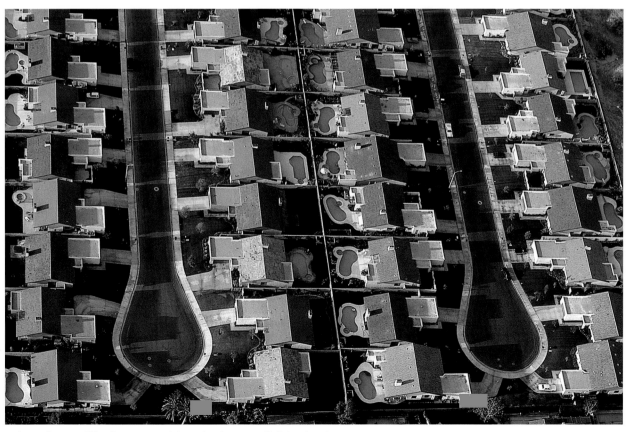

Palm Springs, California. Houses with pools along parallel dead ends.

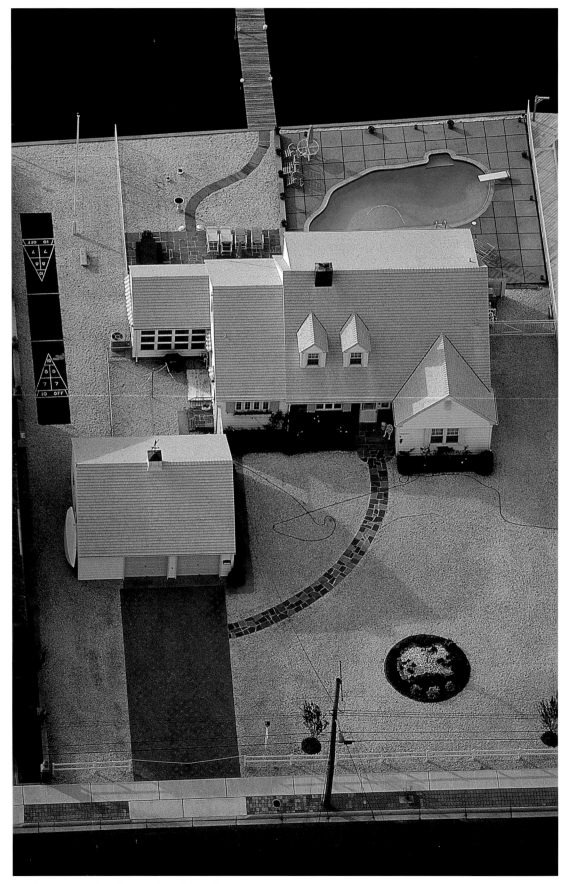

New Jersey coastline. Houses with pink roofs.

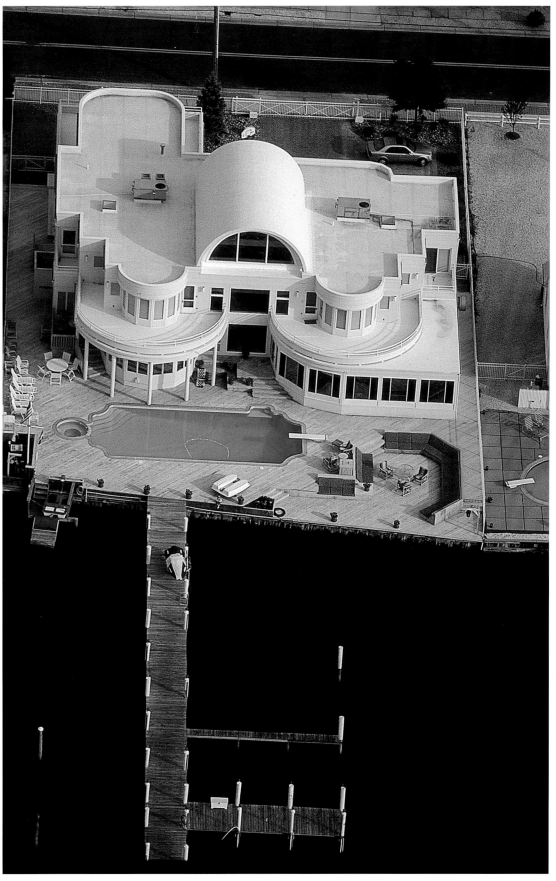

New Jersey coastline. Large bay-front home.

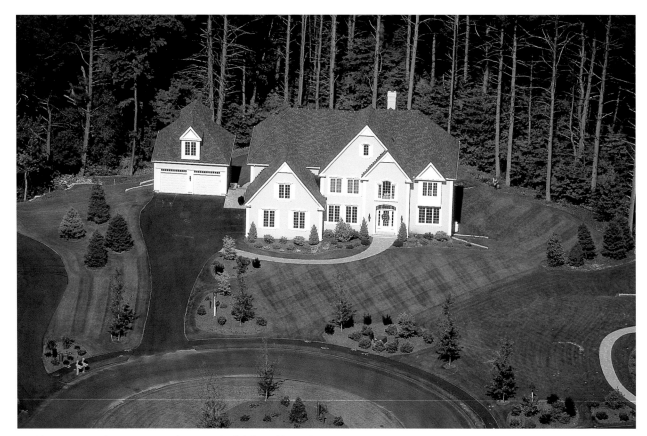

Hopkinton, Massachusetts. House in new sub-division of large houses.

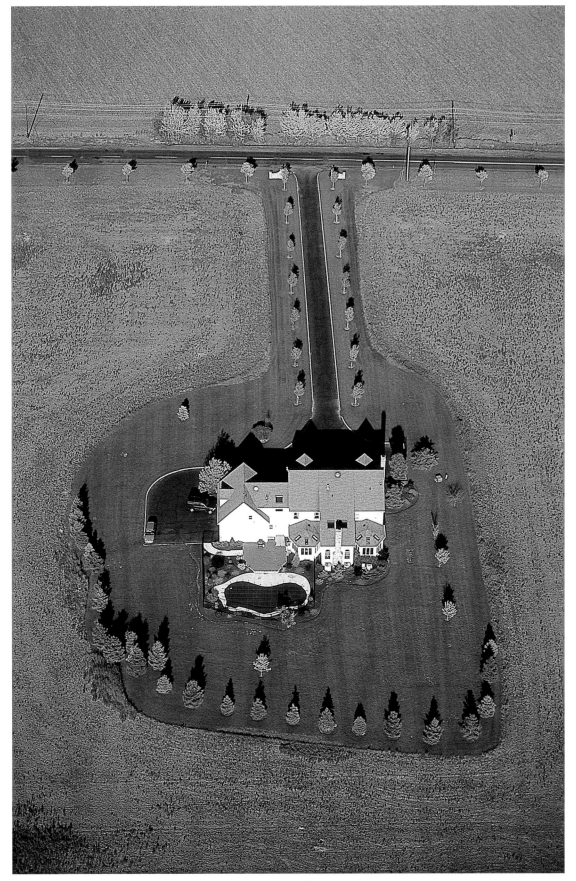

Princeton, New Jersey. Estate house with large green lawn in field.

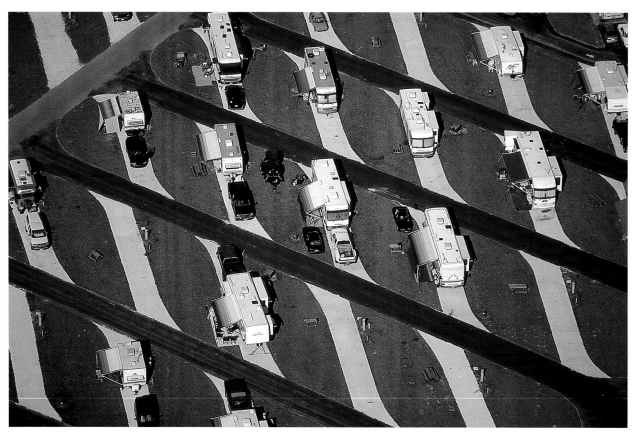

Orlando, Florida. Trailer home convention.

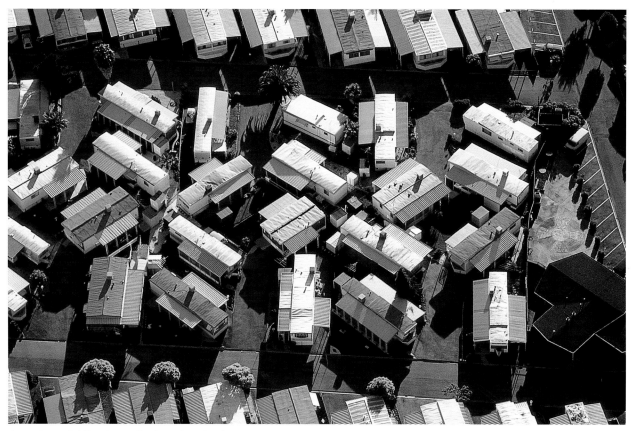

Santa Rosa, California. Trailer home housing lots.

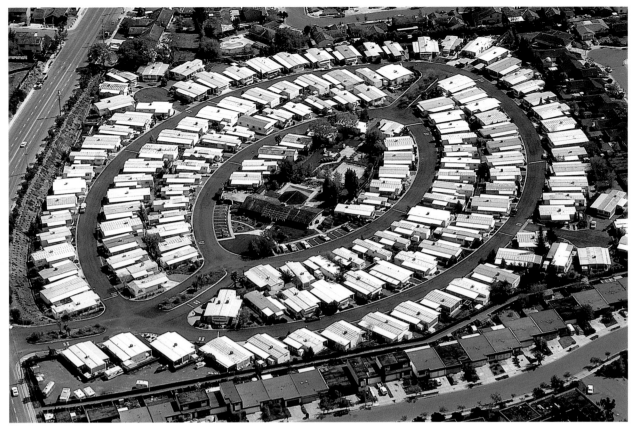

Santa Rosa, California. Residential trailers form an eye-shaped trailer park.

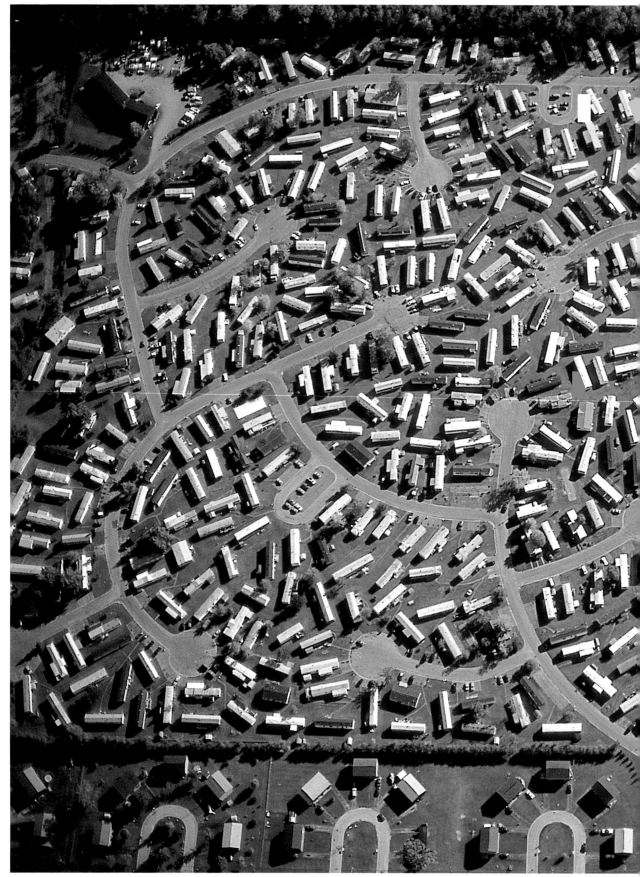

Syracuse area, New York. Dense residential trailer park with cul-de-sacs.

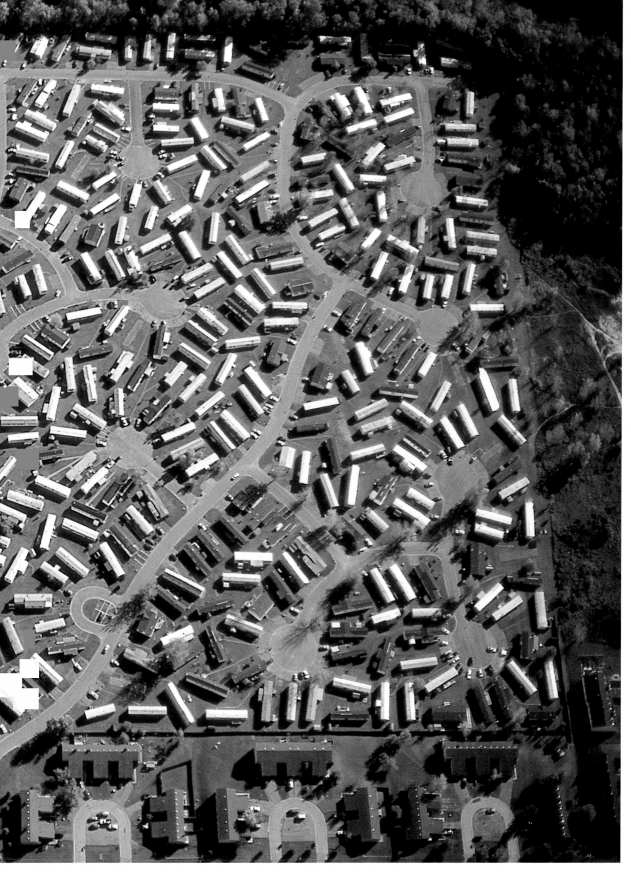
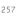

POLLUTION

→ Like energy, waste is dynamic in that it is not fixed to the land. It is a byproduct of converting natural resources into products and useable energy. These polluting byproducts are seen in the form of gases, fluids, and solid waste. Waste is problematic because it is difficult to contain and tends to move, leaking into and polluting larger environments.

Gas byproducts are not always visible. However, we can see and smell the cumulative output of gas from invisible sources such as car and factory exhausts in the form of haze that can blanket a region. Air pollution may also be seen at its source. For example, coal-burning plants along the Ohio River send smoke billowing from incredibly tall stacks. They are tall in order to minimize local impact, but they bring haze and decreased visibility to the sky hundreds of miles downwind.

Water pollution is visible as partially treated fluids that flow from wastewater treatment plants and from factories such as paper mills which use water in the fabrication process. Wastewater is treated in an array of clarifying tanks, aeration basins, and settlement ponds. The liquids in these ponds often have dazzling colors and form patterns with white foam coming from agitators and aerators. These fluid byproducts are disposed of in

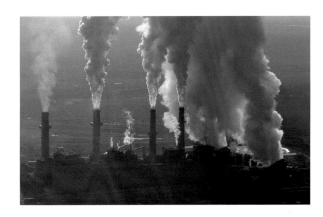

Four Corners area, New Mexico. Smoke plumes rising from a
generator at the mouth of a mine.

larger bodies of water such as streams, rivers, lakes, and the seemingly infinite repository of the ocean. Historically, industries have located next to rivers for reasons of transportation and energy, but factories also have been built by rivers because water is usually a major part of the production process and because rivers have been convenient for waste disposal. Water pollution also comes from non-point sources in the form of run-off from agricultural fields that are laced with fertilizers and pesticides, and parking lots contaminated with fluids leaking from cars.

Solid waste pollution is seen at auto junkyards and landfills. Piles of strip mine tailings are another example. Solid waste is not as "solid" as its name implies. These depositories seem fixed and stable, but in fact are constantly decaying and emitting contaminated fluids and gases. Run-off from solid waste sources contaminates ground and surface water. Lacking is an industrial ecology in which waste is circulated back into the production cycle. We see the forest where trees are cut for paper production and we see the paper mills where it is produced. We see the places paper is used and the landfills where it is disposed of. The process is linear as opposed to circular. Pollution in all of its forms points to the need to convert byproducts back into the production cycle.

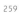

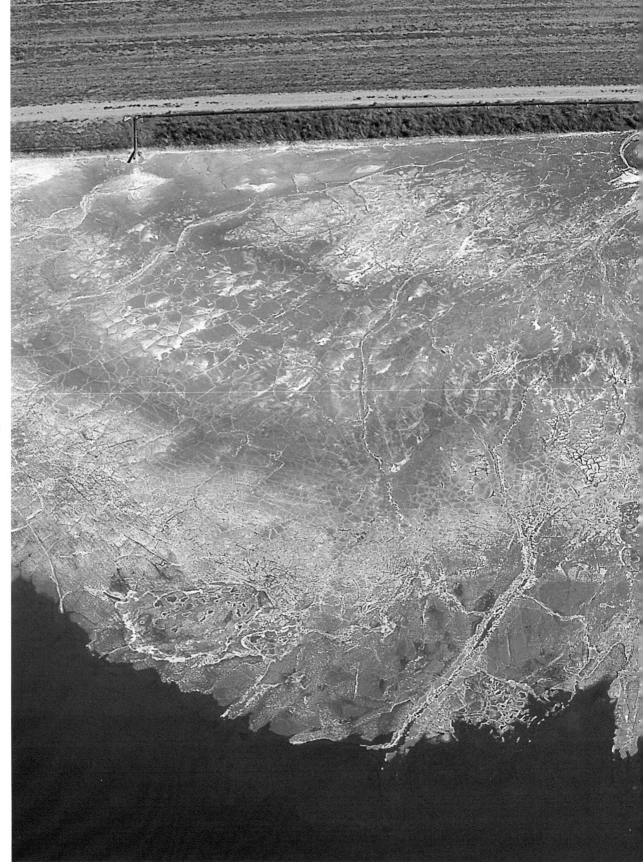

Burnside area, Louisiana. Rivulets of red industrial waste.

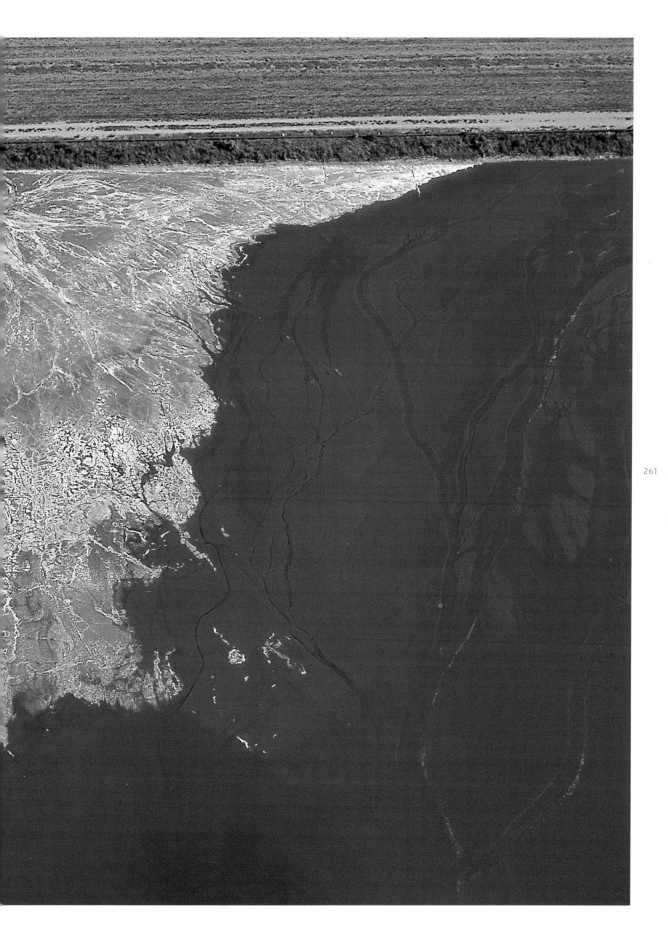

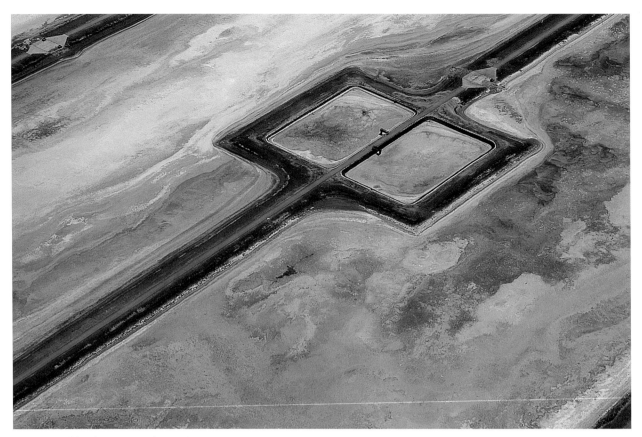

Barstow, California. Evaporating pools.

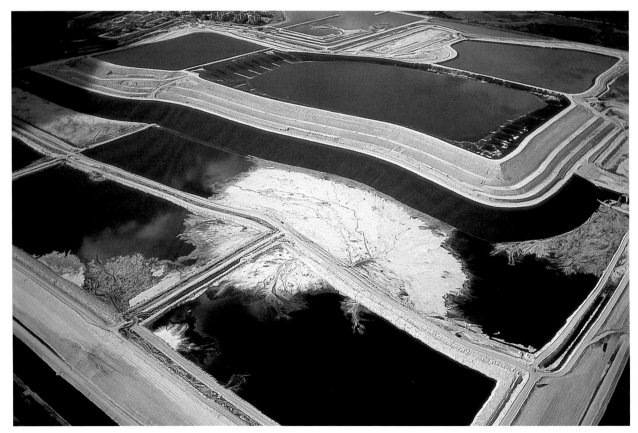

Crystal Springs, Florida. Large industrial settlement ponds.

Hayward, California. Salt flats.

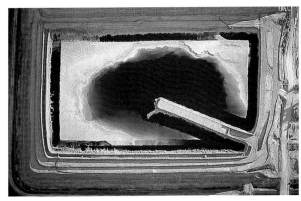

Convent, Louisiana. Cane fields next to industrial waste pond.

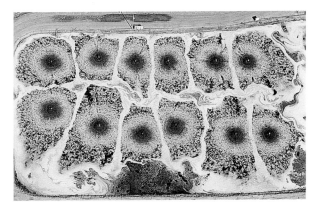

Richmond, California. Sprinkler blooms from a waste treatment plant.

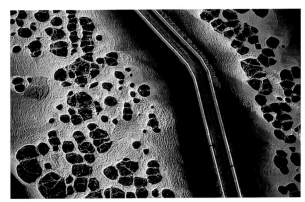

Natchez, Mississippi. Aeration bubblers at a paper mill water treatment plant.

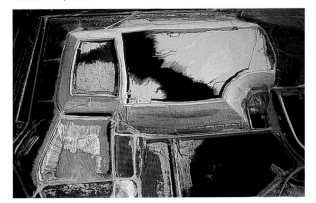

Convent area, Louisiana. Industrial waste pits.

Gary, Indiana. Barrier wall and run-off in Lake Michigan.

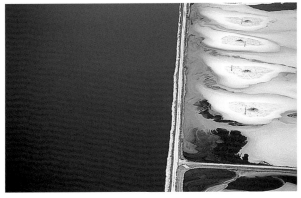

Western Tennessee. Paper mill water treatment plant on the Mississippi River.

Erie, Pennsylvania. Water treatment ponds.

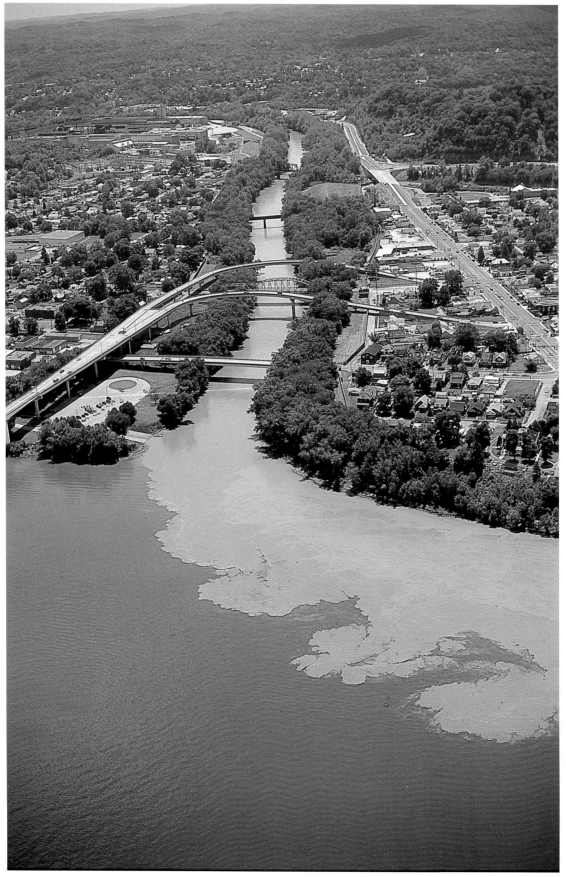

Huntington, West Virginia. The muddy Guyandone River empties into the Ohio River.

Ashtabula, Ohio. Ore piles and loading docks.

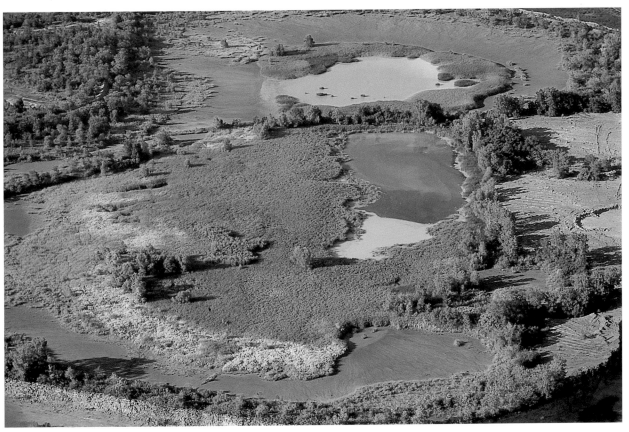

East Saint Louis, Illinois. Inactive industrial waste settlement ponds.

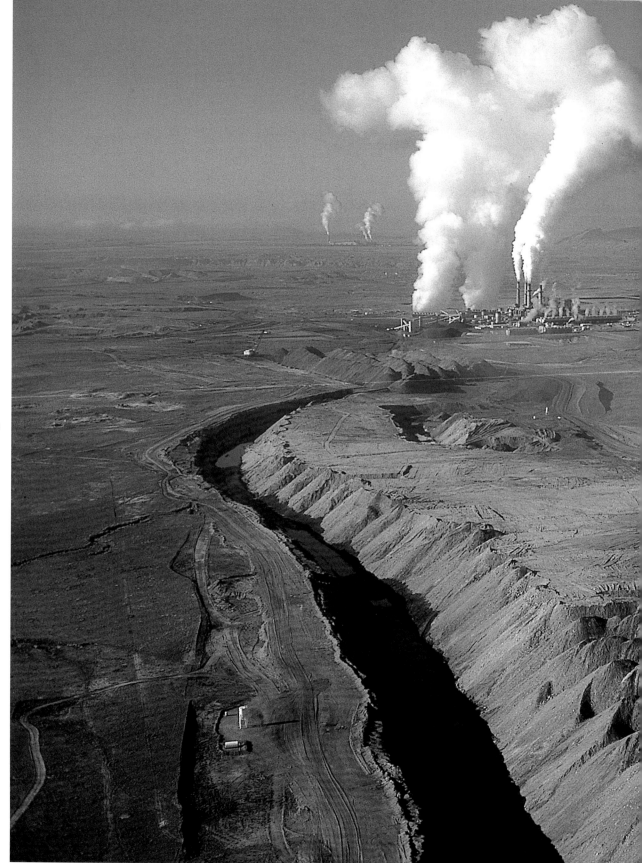

Four Corners, New Mexico. Strip mine for coal-burning utility.

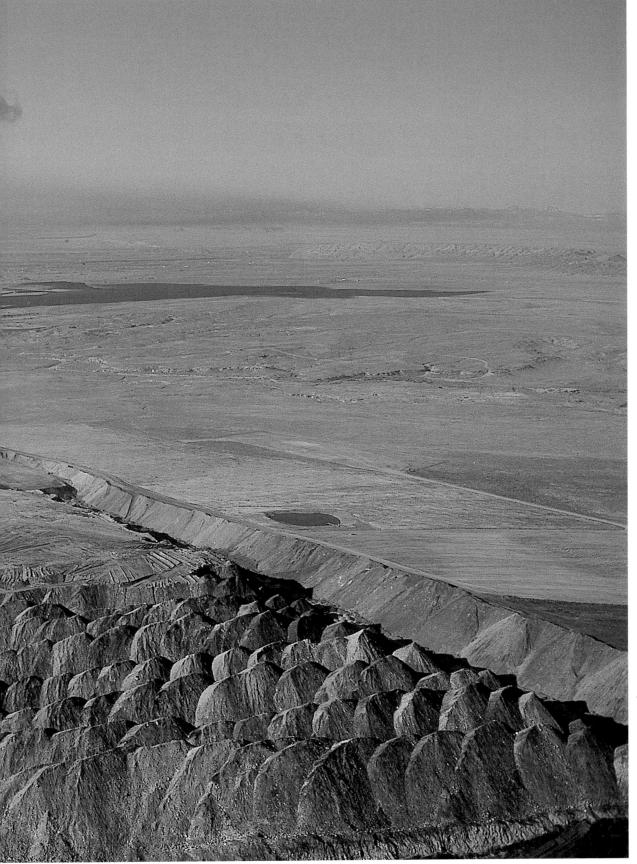

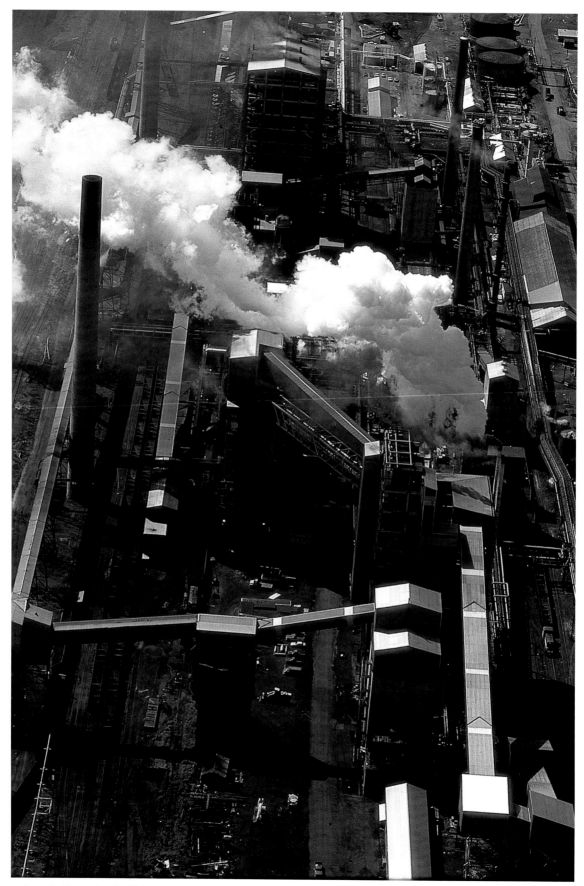

Gary, Indiana. Steel mill by Lake Michigan.

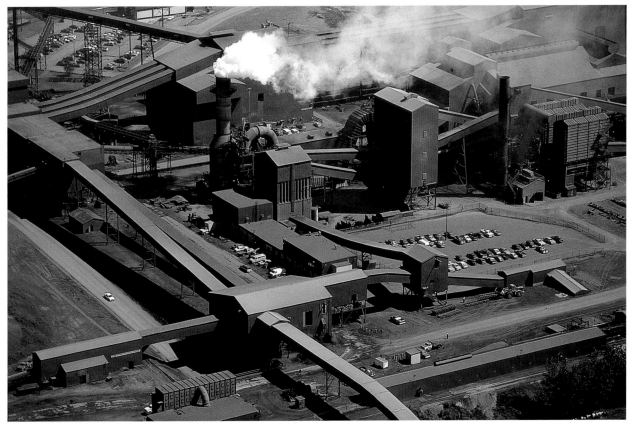

Gary, Indiana. Smoke plume from steel mill.

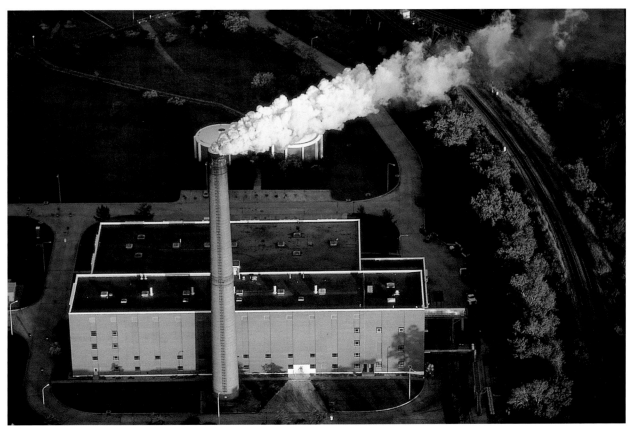

Saint Louis, Missouri. Industrial smoke plume.

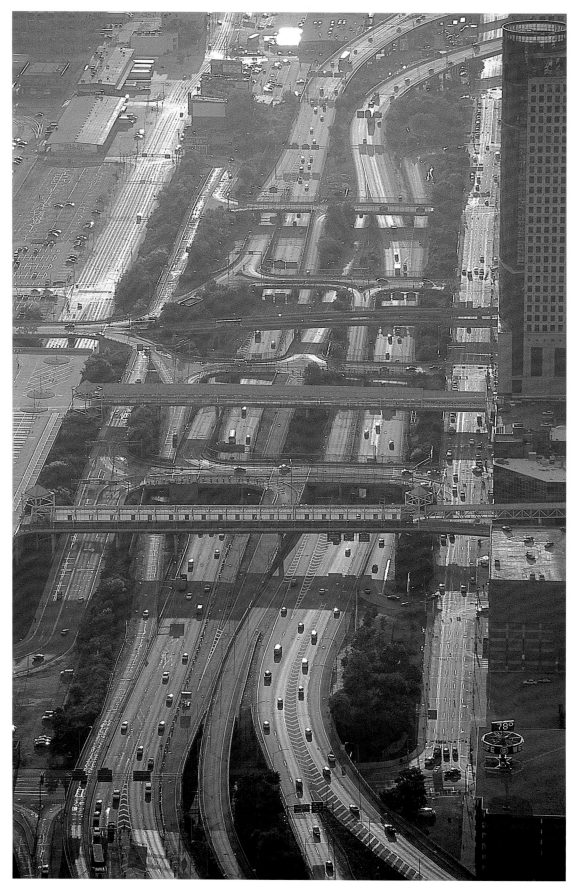

Cincinnati, Ohio. Inner-city highway barrier in the downtown area.

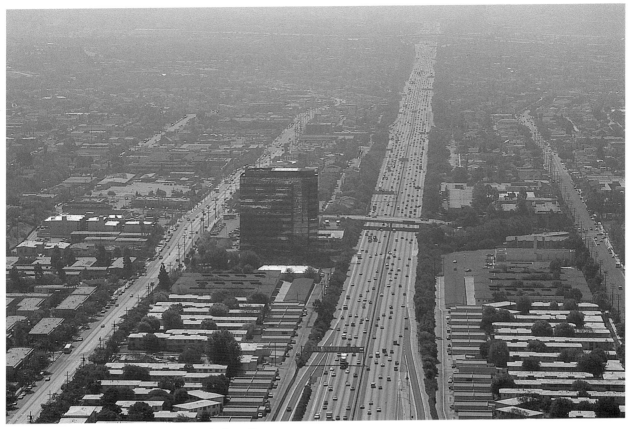

Burbank, California. Route 101 cuts through the valley.

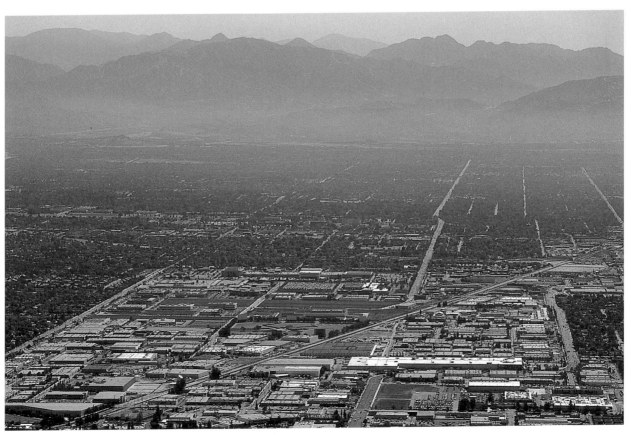

Van Nuys, California. Industrial building in the San Fernando Valley.

PARKING

→ Parking and parking lots identify destinations. They are pods on the road network showing activity points at which drivers and passengers must leave their cars. Huge areas of asphalt are devoted to this transitional use of space. Parking lots are carefully planned to accommodate the needs of commercial and retail districts, office buildings, campuses, stadiums, rapid transit stops, airports, and even wilderness entry points. A goal of both the driver and traffic engineer is to get the car as close as possible to its destination.

A curious aspect of parking lots is that they are empty most of the time. This is especially true in the nighttime since most cars, like most people, go home at night. It is said jokingly, but somewhat accurately, that shopping mall parking lots are designed to meet the capacity needed for the last Saturday before Christmas. In this case a lot reaches its designed capacity for just twelve hours a year. This absence of regular use is best illustrated by the huge lots at places where events occur infrequently, such as at sports stadiums and motor speedways. The opportunity to take pictures of empty parking lots is not rare; in fact the reverse is true.

In downtown areas parking usually comes at a premium. Lack of parking, rather than the lack of public transportation and pedestrian amenities, is often thought to be the problem with failing city centers. The lack of parking has been wrongly "corrected" by clearing of buildings for construction of more surface lots and garage structures. In most cases this solution has simply exacerbated the bleakness of these failing centers. As it is now,

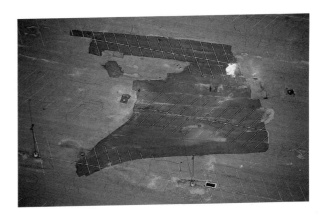

Albany, Georgia. A previously marked surface shows
through current eroded parking

downtown city high-rises are usually surrounded by blocks of surface parking that make for difficult pedestrian access to areas beyond the downtown.

Parking is mandatory in suburbia. The standard assumption is that it must be free and readily available. For retailers, it is important that there be a "sea of parking" out front to attract drive-by shoppers. Parking and pedestrians do not mix well. Parking lots are not ordinarily places where people linger, but they occasionally give way to other uses such as street hockey, weekend flea markets, carnivals or fairs, and tailgating parties at sporting events.

The vast areas devoted to impervious parking surfaces cause pollution and other environmental problems. Traffic engineers often measure parking lot use by the pattern of oil stains left by leaking crankcases and cooling systems. Watersheds in suburbia are polluted by contaminants and debris contained in water run-off from these impervious surfaces. Streambeds also suffer. Streams located near parking lots tend to flood from sheet water run-off and then dry out in the summer since this rapid run-off severely depletes the surrounding groundwater. Such extreme fluctuation in water flow also causes the loss of plant and wildlife habitats. The increasing size of the average American car to sport utility vehicles and light trucks exacerbates the problems associated with parking.

Parking is very much a part of our culture. It highlights our willing enslavement to the automobile and demonstrates our lack of public transportation and pedestrian mobility.

273

274

Taunton, Massachusetts. Parking lot.

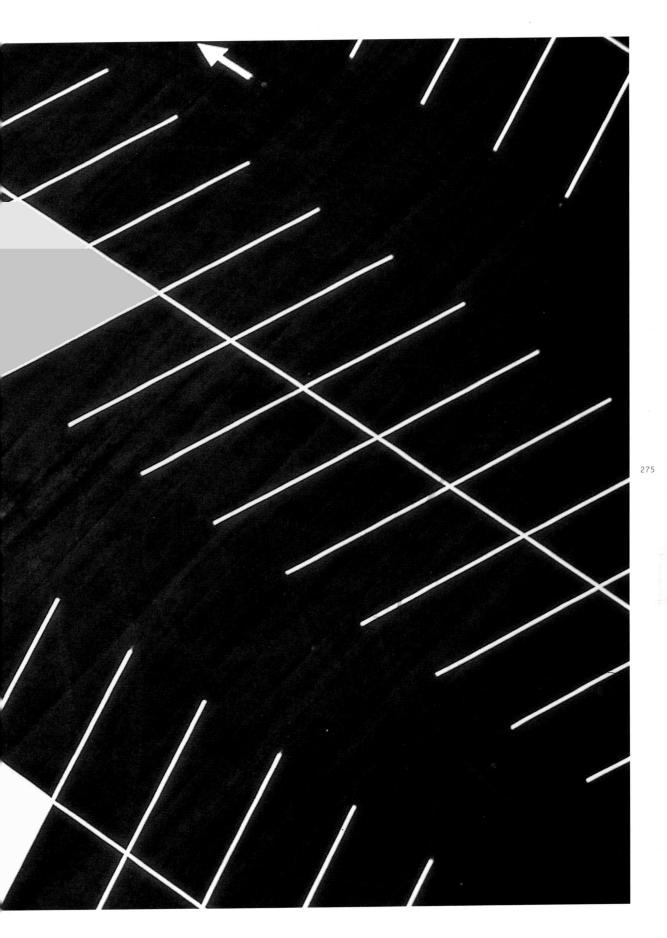

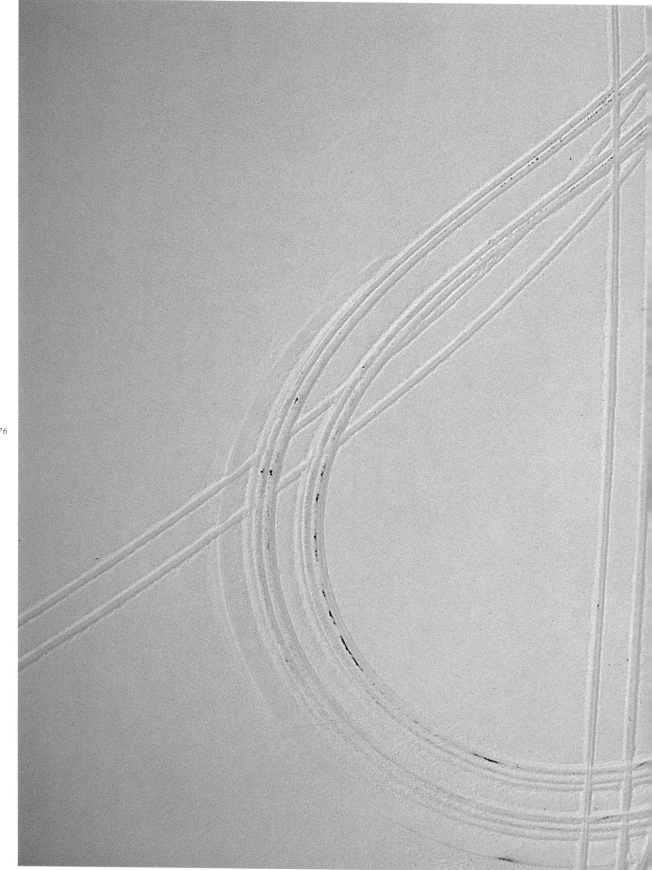

Taunton, Massachusetts. Snowplow stripe in snow-covered parking lot.

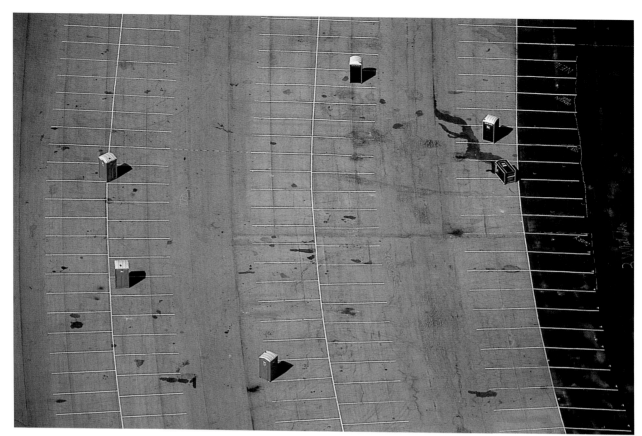

Fort Worth, Texas. Fort Worth–Denton Speedway parking area.

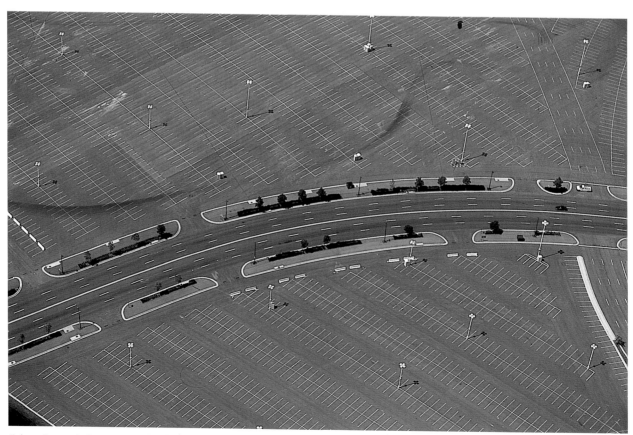

Prince George's County, Maryland. Stadium parking lot.

Nashua, New Hampshire. Detail of mall parking lot.

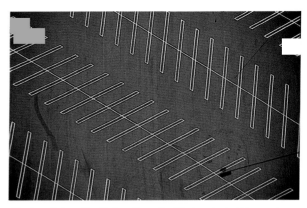

Winston-Salem, North Carolina. Double band of yellow and white parking space stripes.

Cincinnati, Ohio. Parking lot stripes.

Baltimore, Maryland. Designated handicapped parking spaces at PSINet/Ravens stadium.

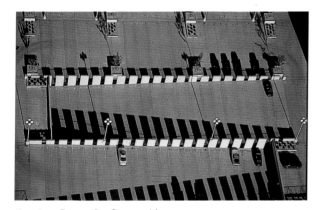

Houston, Texas. Rooftop parking.

Houston, Texas. Galleria parking garage rooftop striping.

Houston, Texas. Handicapped parking spaces.

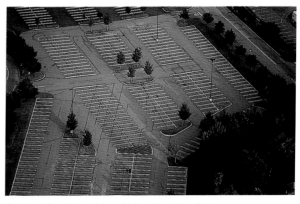

Nashua, New Hampshire. Striped parking lot.

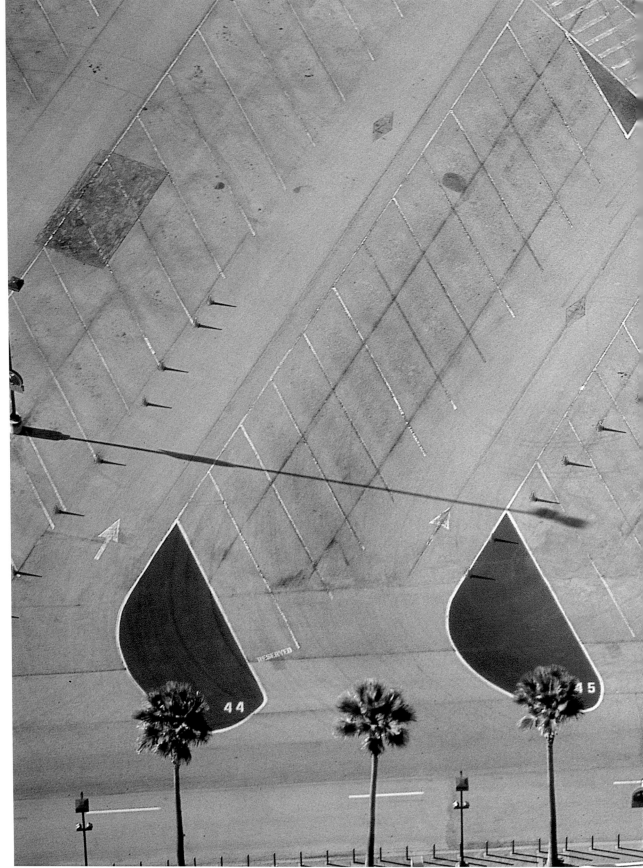

Orlando, Florida. Disney World parking lot with red areas and striped walkway.

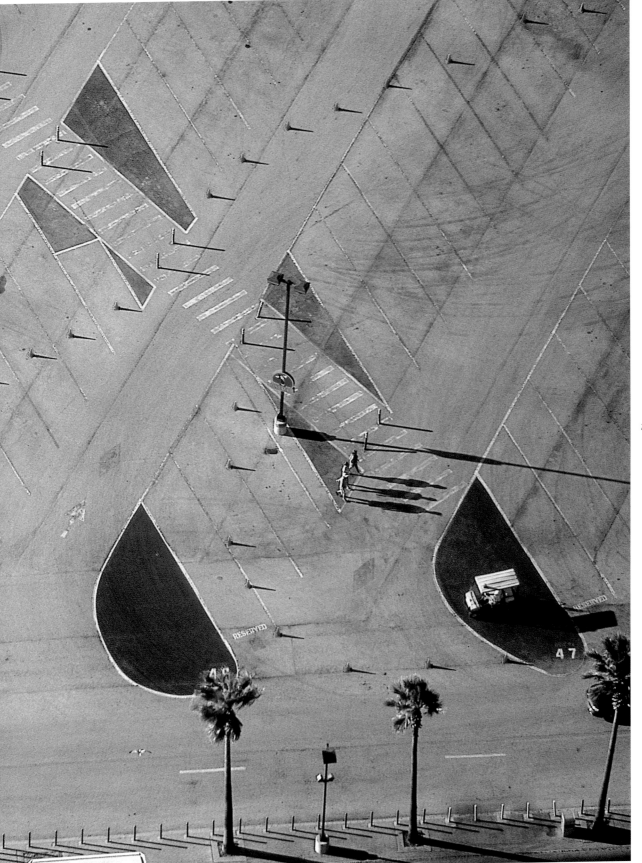

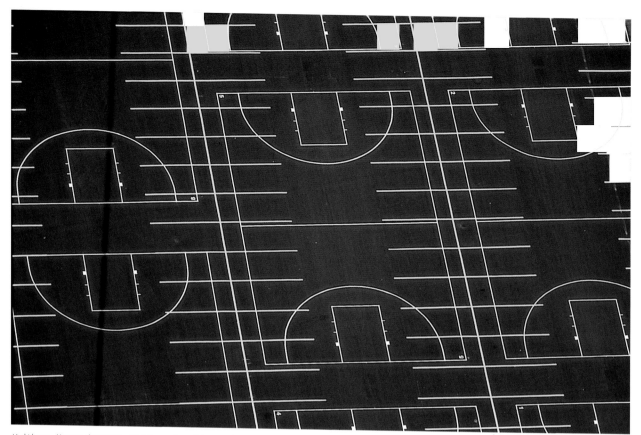

282　Waltham, Massachusetts. Overlay of parking and sports grids.

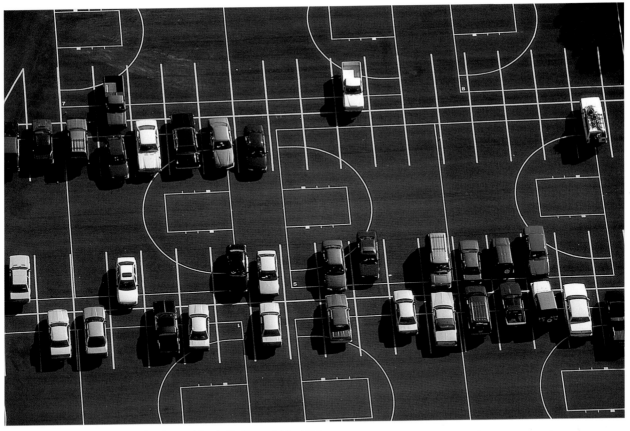

Waltham, Massachusetts. Parking lot and basketball court blacktop.

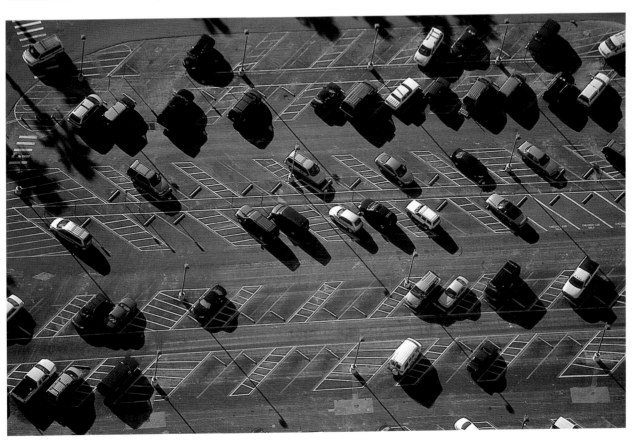

Orlando, Florida. Designated handicapped parking spaces.

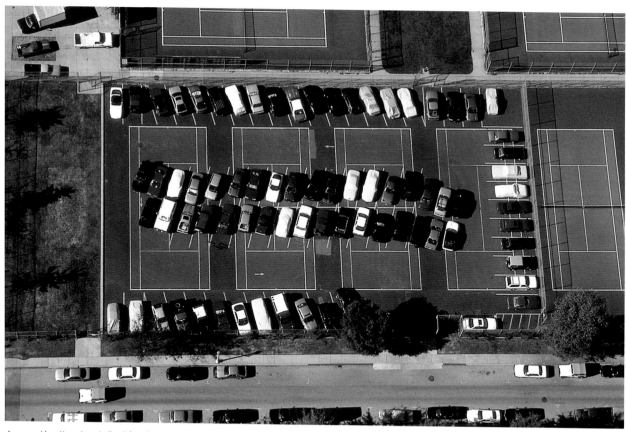

Annapolis, Maryland. Parking lot and tennis court overlay.

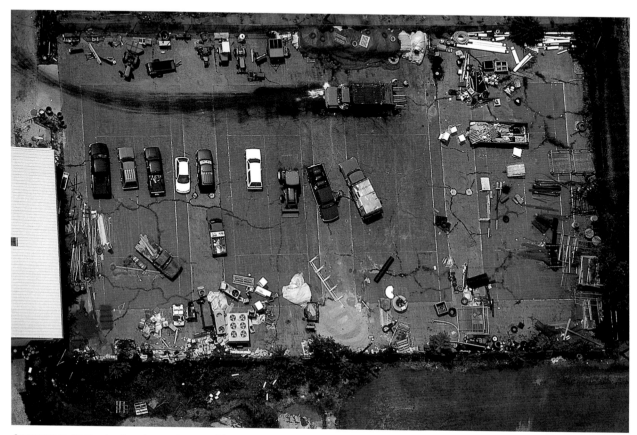

Georgetown, Kentucky. Tennis courts turned into a construction yard and temporary parking lot.

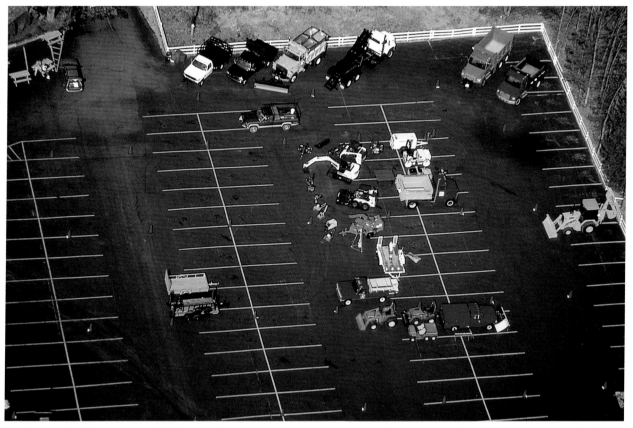

Eastern Massachusetts. New construction equipment on display.

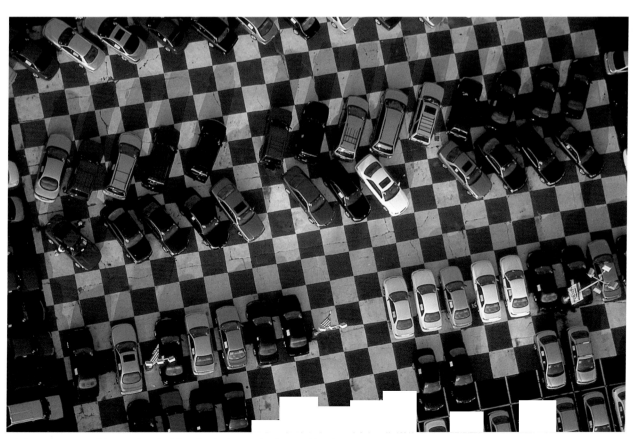

Nashua, New Hampshire. Red-and-white checked auto dealer parking lot.

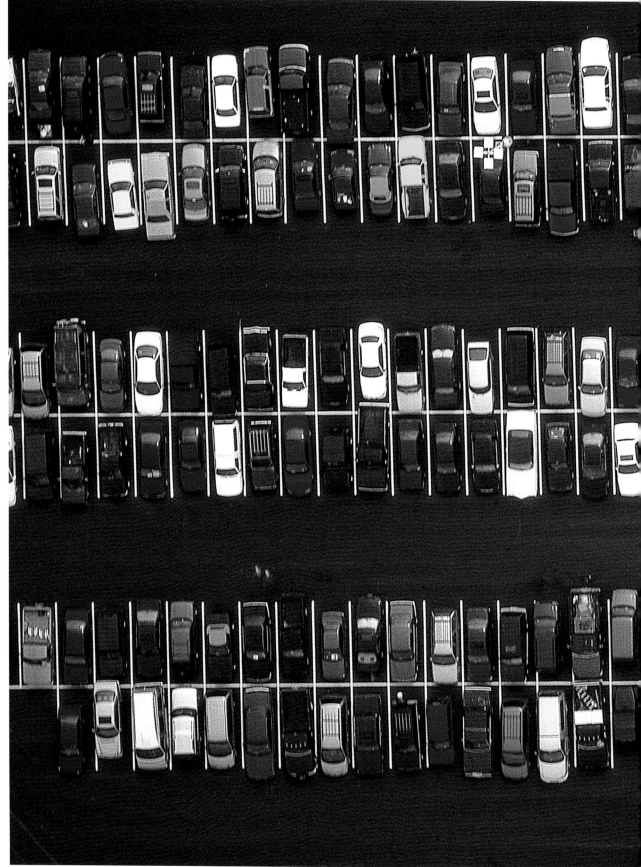

Mitchellville, Maryland. Jack Kent Cooke/Redskins football team stadium parking lot.

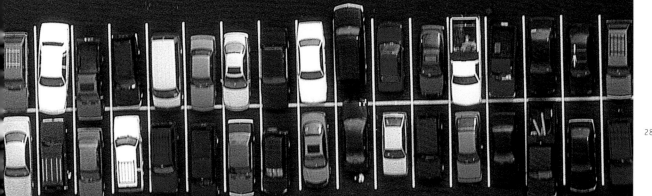

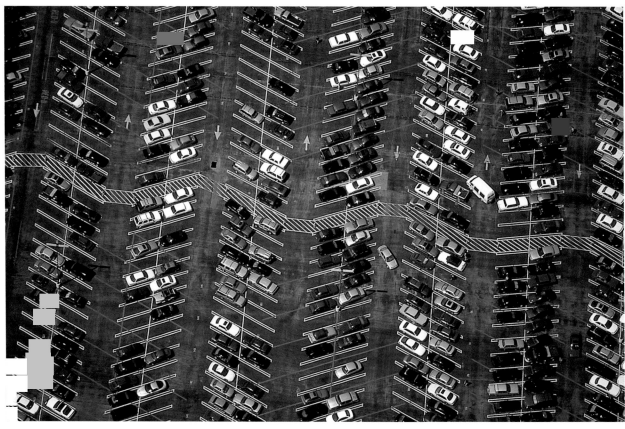

Gainesville, Florida. University of Florida parking lot with marked pedestrian area.

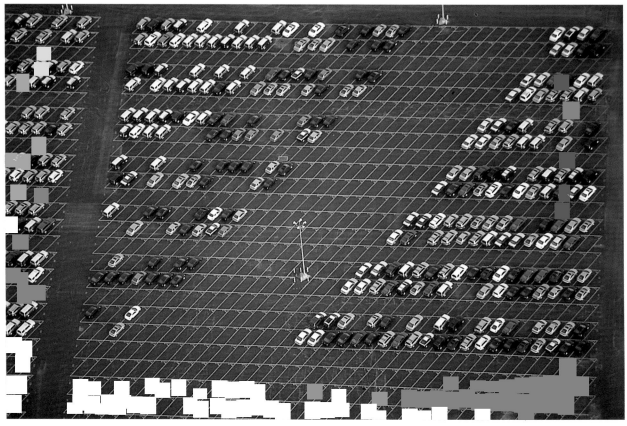

Jacksonville, Florida. Offloading facilities parking lot for newly imported cars.

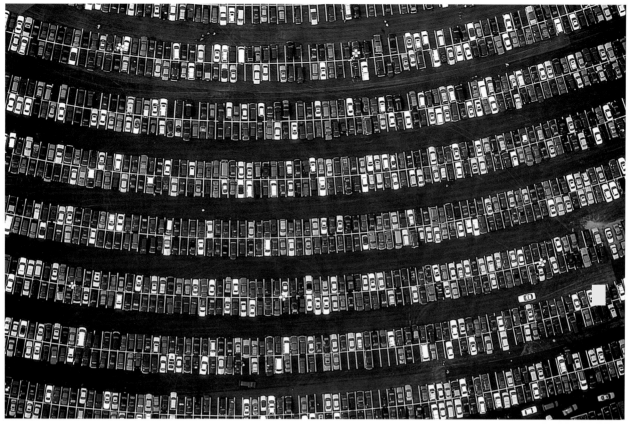

Mitchellville, Maryland. Jack Kent Cooke/Redskins football team stadium parking lot.

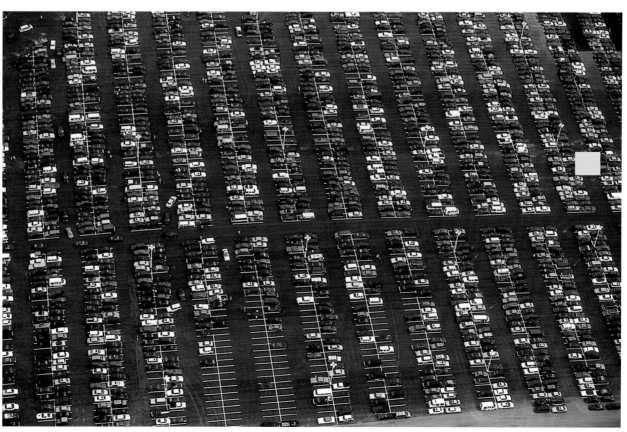

Mitchellville, Maryland. Jack Kent Cooke/Redskins football team stadium parking lot.

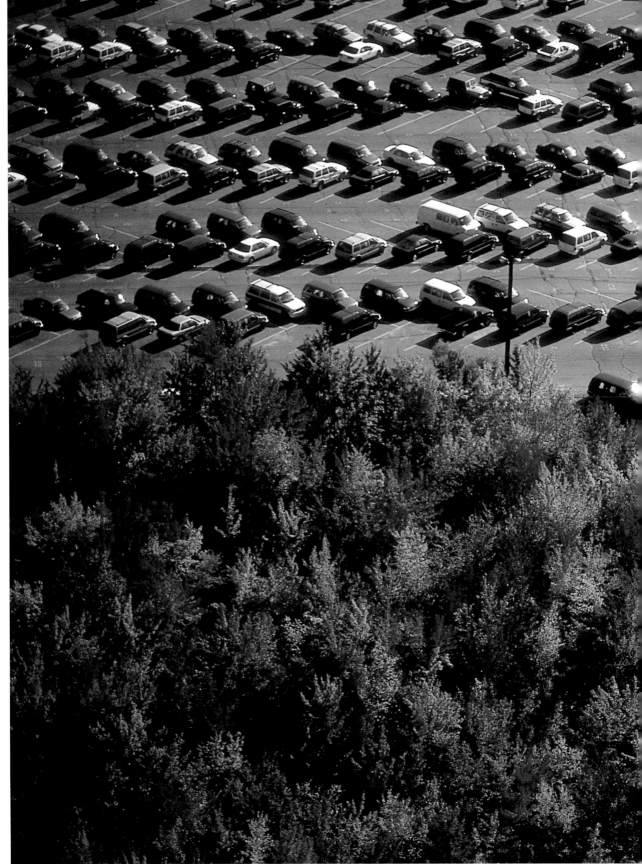

Westborough, Massachusetts. Offload parking facility against autumn foliage.

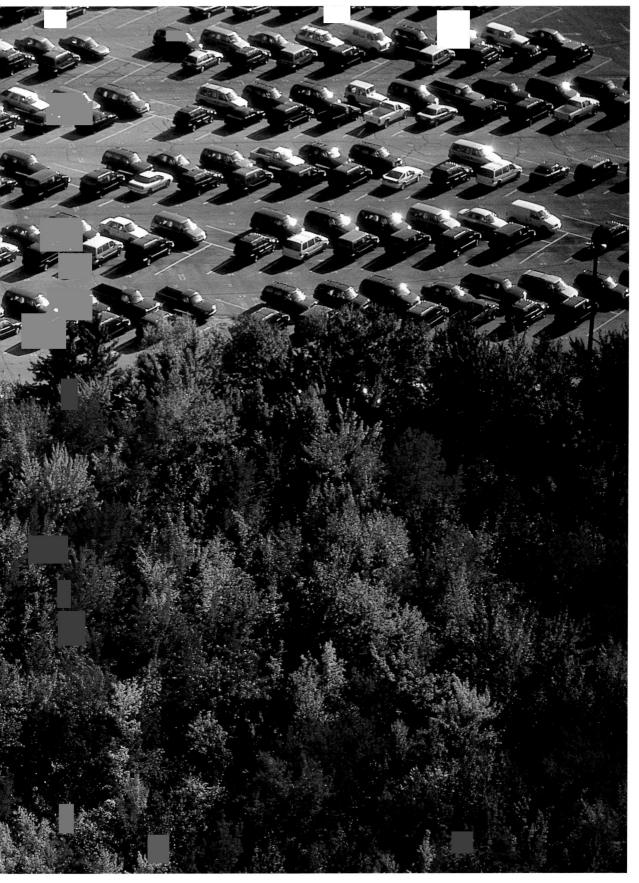

SPRAWL

→ Most of the new development across the country since the interstate highways were built can be characterized as a pattern now recognized as sprawl. As the name implies, it is spread out. It is a land-consumptive phenomenon, consuming outlying farmland and countryside around cities, towns, and villages. Sprawl is market-driven, feeding on cheap land made accessible by the roadway. It has been further fueled by government policies that provide seemingly free infrastructure and tax incentives. It is so ubiquitous and repetitive across the American landscape that there must be a formula of policies and regulations and/or a conspiracy of greed that have brought this unfortunate and ugly pattern to the surface. Unfortunately, it has homogenized the look and feel of much of the country by diminishing regional and local character. It is ugly more for what it represents than the look of its paved "hardscape."

The pattern of sprawl encompasses day-to-day land uses such as housing, retail shops, work and production spaces, schools and recreation areas. These land uses are segregated into their own spaces that are all within driving distance of one another. The inhabitants of sprawl must be able to drive to commute through this space. It is not suited for public transportation or for pedestrians. For this reason it discriminates against children and the elderly who cannot drive. The public domain is difficult to find in the pattern of sprawl. Ironically, it has been usurped by privatized spaces such as shopping malls and food courts. It still seems unfamiliar to see churches, civic buildings or parks lined or surrounded by parking lots.

Sprawl is a creation of space generated by private developers who often build "spec" (speculative) housing, offices, and malls without the guidance of a larger plan. They are creating space that is simple to produce and a

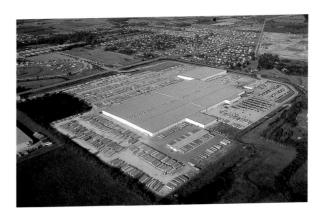

Colombus, Ohio. Large container truck warehouse facility.

safe bet, with the blessings of existing regulations and lenders. For residential space we see a tract housing development of twenty, fifty, or more houses all of the same type. This results in neighborhoods where not only the houses look the same but also the inhabitants are similar to one another. This pattern holds true for apartment complexes as well. This residential development pattern results in the segregation and clustering of people of the same socioeconomic backgrounds into enclaves within our communities. Such income sorting is a common characteristic within sprawl patterns across the country.

As for retail development, much of it is produced for franchised stores. Their formula for success is in marketing predictability. This predictably is advertised through repetitive and identical logo buildings. Some retail has moved to the marketing formula of big box stores that stand alone or in clusters. These big box stores are supported by even larger distribution centers lined with hundreds of tractor-trailers. This is all part of the landscape of sprawl—to date the trend is still growing and the elements that comprise it are also getting bigger.

The negative social, economic and environmental impacts of sprawl are at last being recognized on a national level for what they are. Sprawl as a development pattern is being successfully challenged by environmentalists, preservationists, New Urbanists, and smart growth advocates. Their stated goal is to encourage development in a more compact fashion in growth centers, with mixed income communities offering affordable housing and mixed uses that are pedestrian friendly. Sprawl will not survive because the inefficiencies of its form and its adverse environmental impacts make it unsustainable. Unfortunately, as with most shifting patterns on the land, this shift away from sprawl will take time measured in generations rather than years.

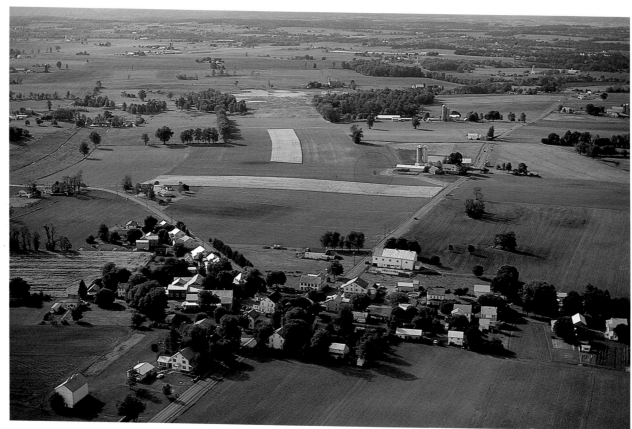

Reading area, Pennsylvania. Small hamlet amid farm fields.

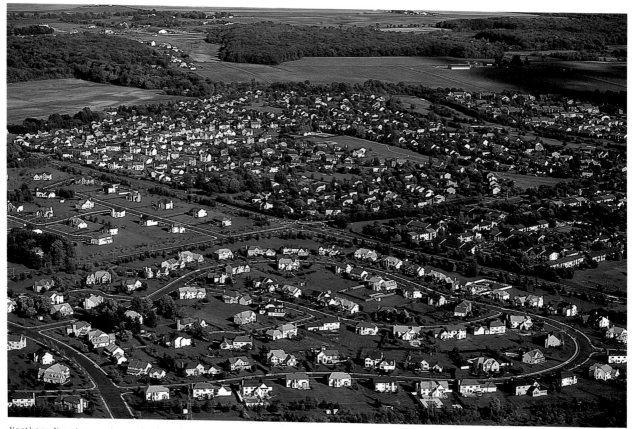

Northern New Jersey. Large-lot housing sub-divisions blanket the countryside.

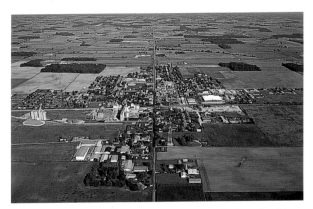

Central Ohio. Small town situated on the agricultural grid.

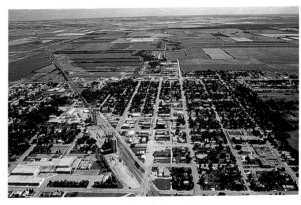

Rolla, North Dakota. Small agricultural town.

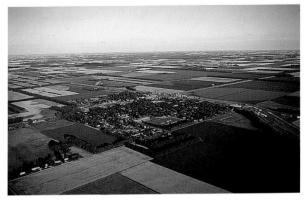

Fargo area, North Dakota. Small town in Red River Valley.

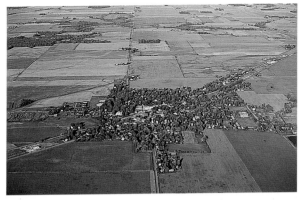

College Station, Indiana. Small farm town in agricultural area.

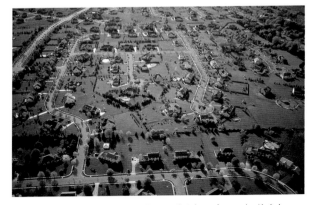

Princeton area, New Jersey. Large-lot housing sub-division.

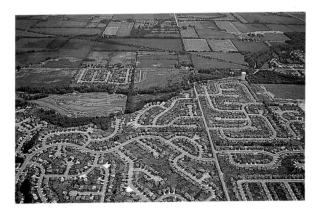

Columbus area, Ohio. Housing sub-division encroaching on agricultural land.

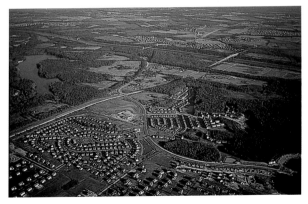

Bear, Delaware. New housing development.

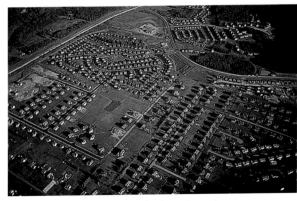

Bear, Delaware. New housing development.

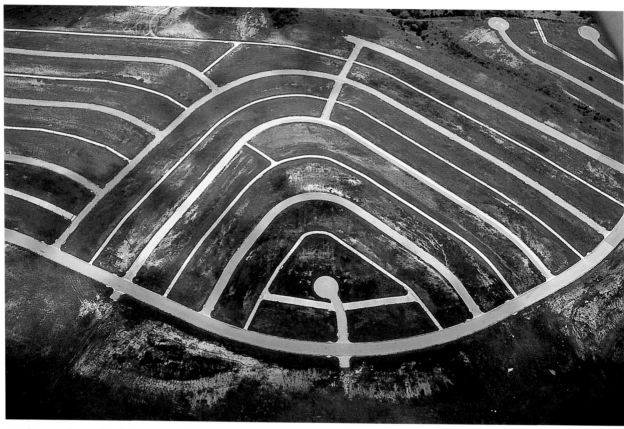

296 Austin area, Texas. Roads for new housing development.

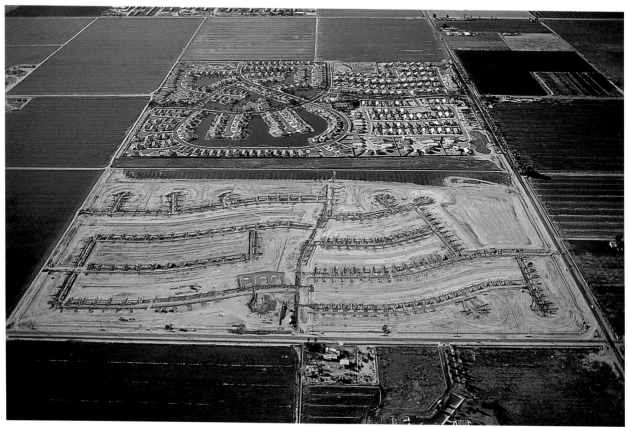

Chandler, Arizona. New sub-division layout east of Phoenix.

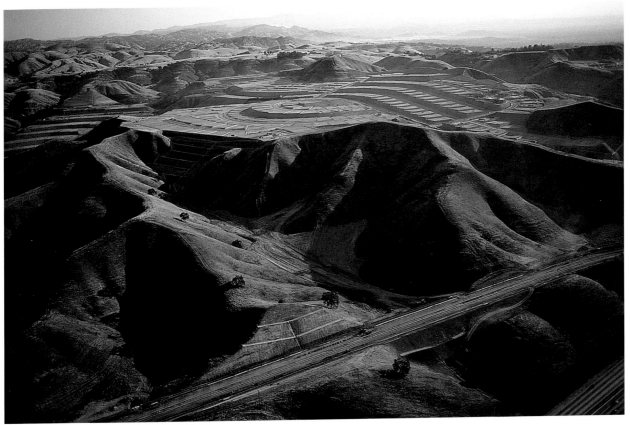

Los Angeles, California. Earthworks for hillside housing.

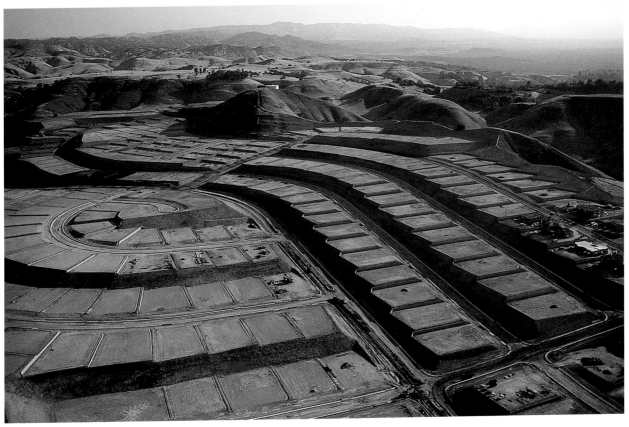

Los Angeles, California. Plots for hillside housing.

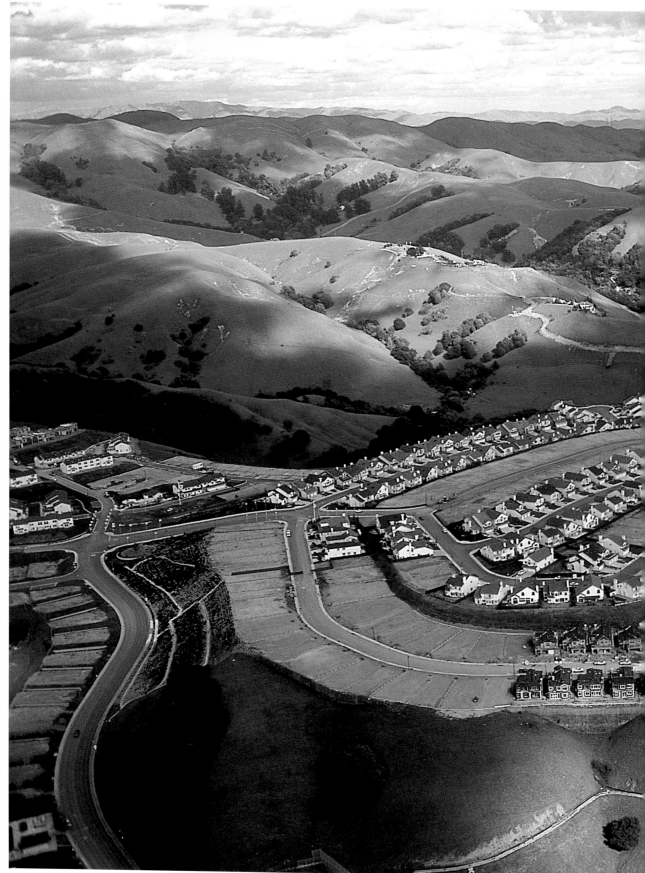

Dublin Canyon area, California. Leveling hills for a new housing development.

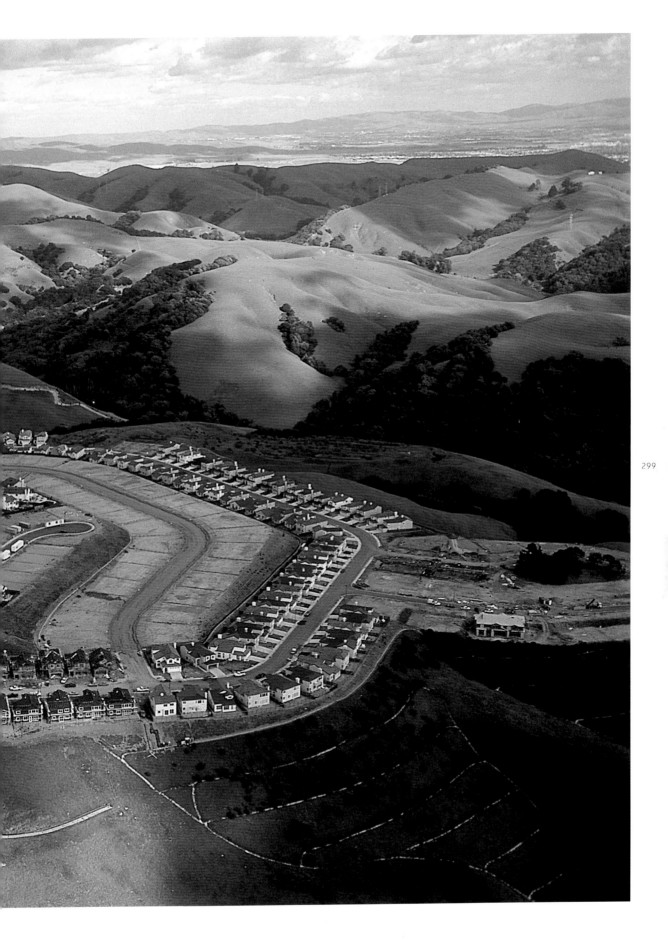

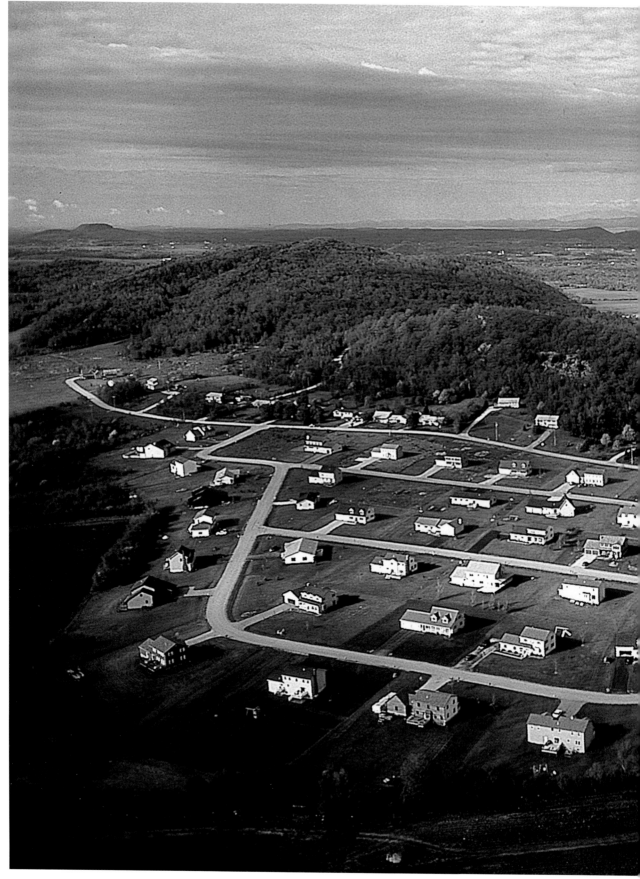

Saint Albans, Vermont. New housing development in a rural area.

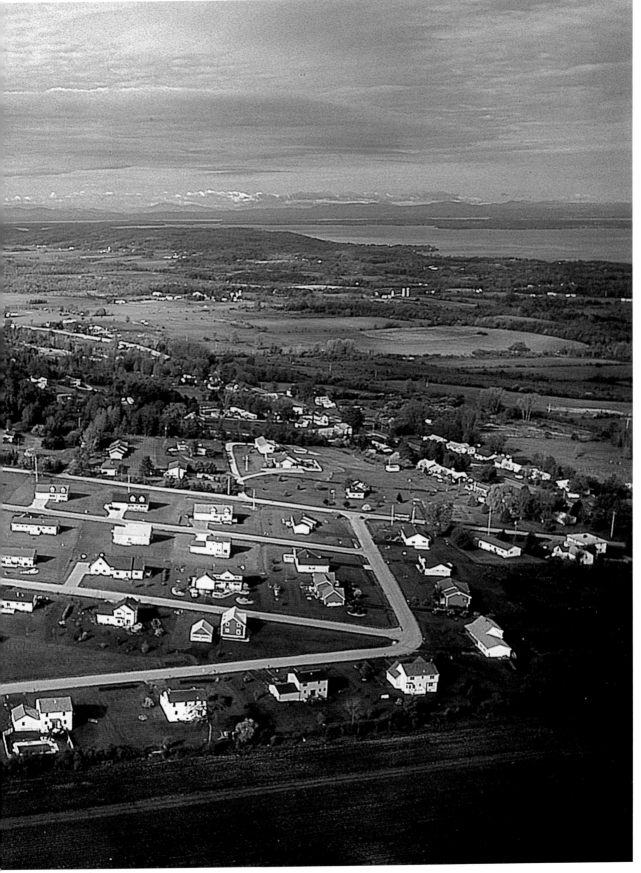

Houston, Texas. New cul-de-sac with wood-framed house structure.

Houston, Texas. Cleared land and cul-de-sacs with tire tracks.

Bowling Green, Kentucky. New black-topped cul-de-sac loop.

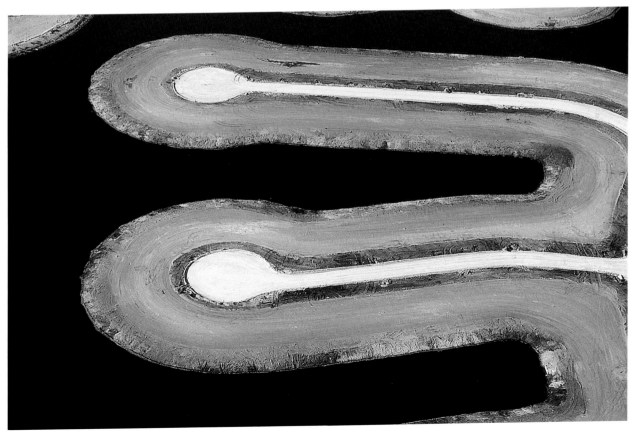

Miami area, Florida. Cleared housing lots and paved cul-de-sac.

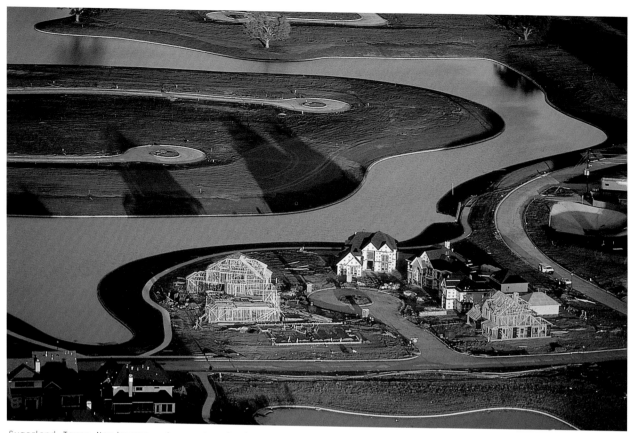

Sugarland, Texas. New houses under construction in cul-de-sac community.

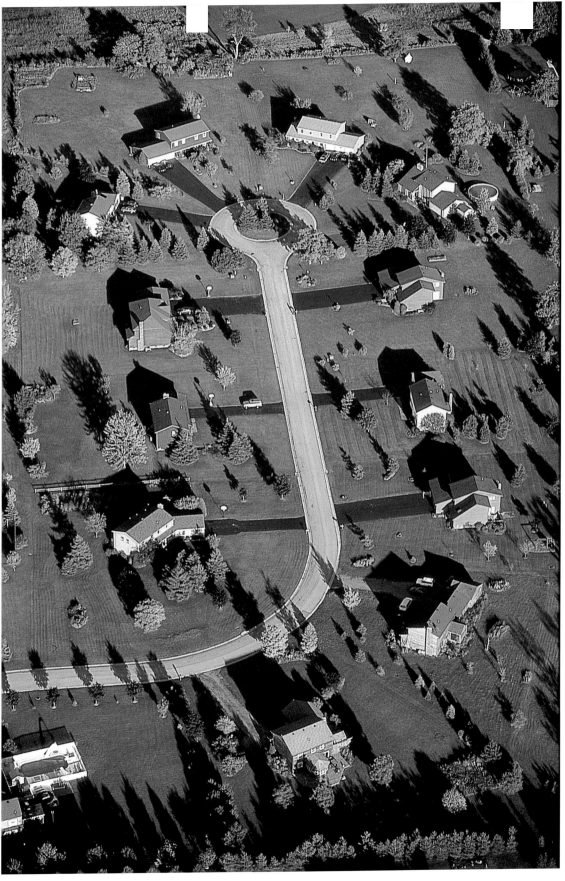

Rochester, New York. Houses on a cul-de-sac.

306　Carver, Massachusetts. New house foundations around paved cul-de-sac.

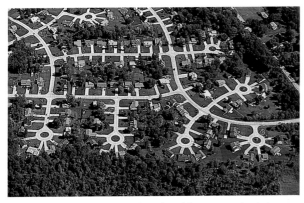

Cleveland area, Ohio. Tract housing driveways and cul-de-sacs.

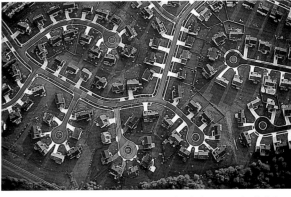

Gaithersburg, Maryland. Plan view of cul-de-sac sub-division.

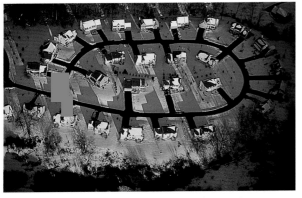

Southern Pennsylvania. Housing sub-division in winter.

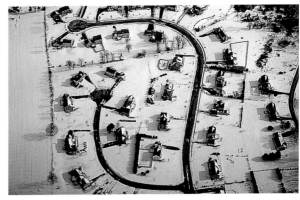

Southern Pennsylvania. Housing sub-division in winter.

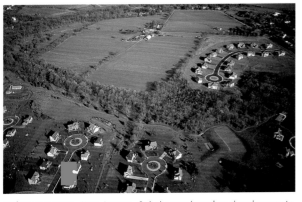

Princeton area, New Jersey. Cul-de-sac housing developments surround a farm.

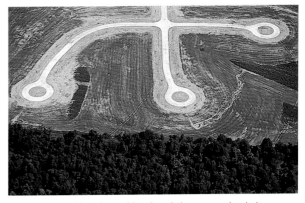

Akron area, Ohio. Cleared land and three paved cul-de-sacs.

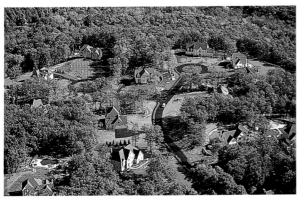

Hopkinton, Massachusetts. Large-lot single-family houses on cul-de-sac.

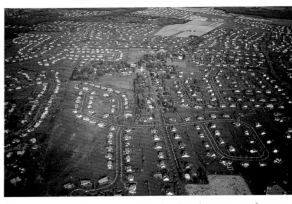

Princeton area, New Jersey. Housing development on former agricultural land.

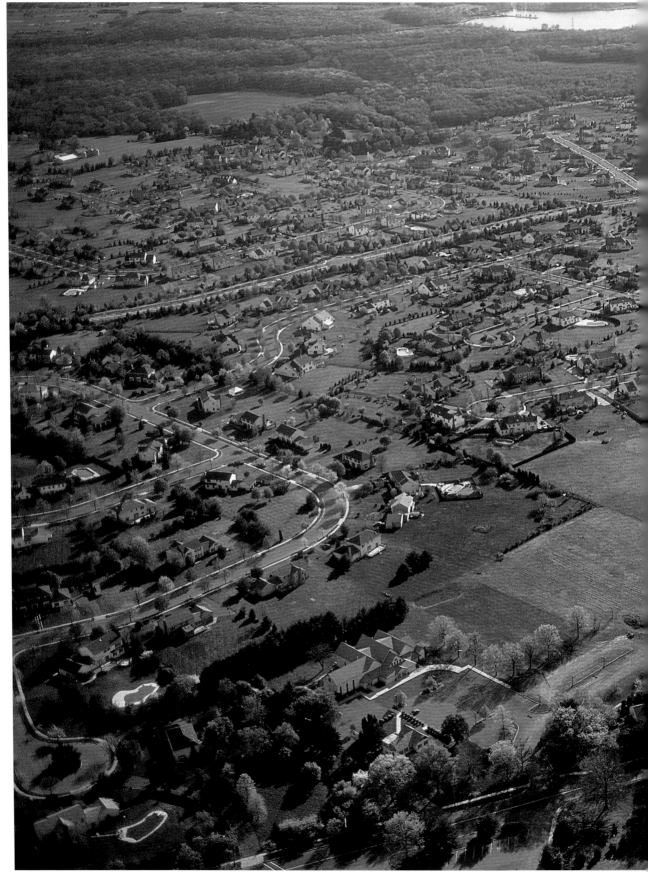

Northern New Jersey. Large-lot housing sub-divisions blanket the countryside.

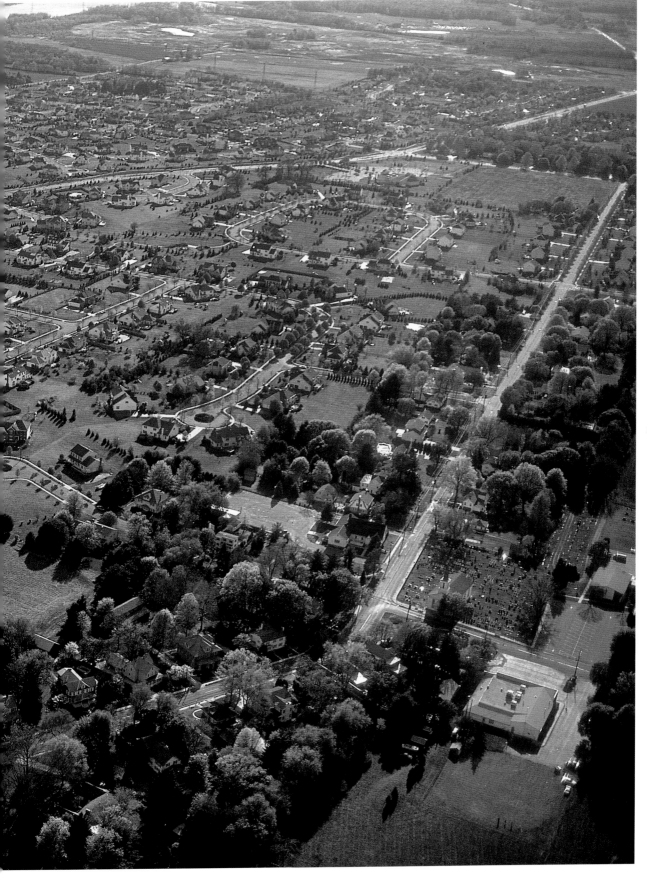

310 Kansas City, Missouri. Modern church with large parking lot.

Orange, Connecticut. Home Depot big box store.

Nashua, New Hampshire. Staples Office Supplies big box store.

Houston, Texas. Katy Mills mall entrance.

Nashua, New Hampshire. Big box logo stores.

Bowie, Maryland. Street front shops face a shopping mall.

Houston, Texas. Shopping mall.

Palm Desert, California. Shopping mall and parking lot.

Bennington, Vermont. McDonald's Restaurant drive-through.

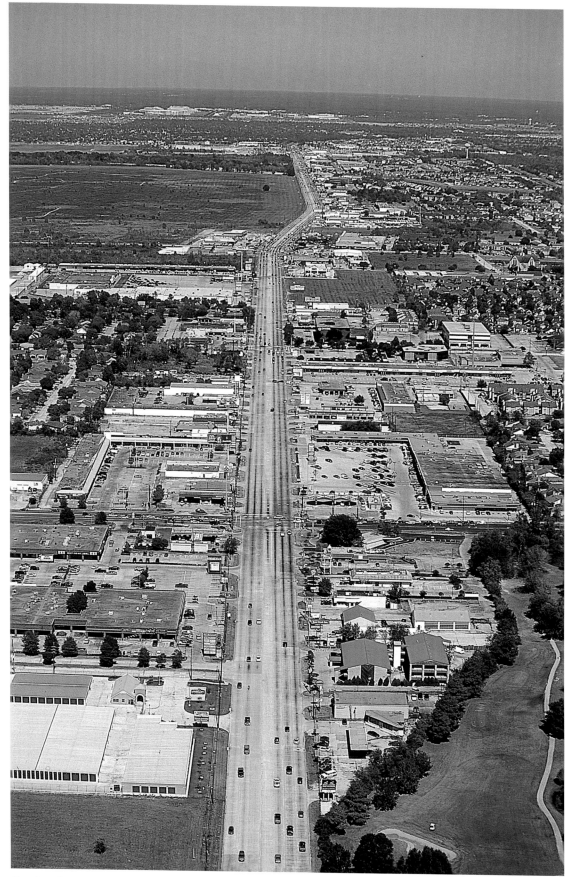

312

Houston, Texas. West Houston retail strip.

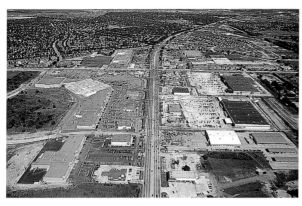

Houston, Texas. Copperfield Crossing shopping area.

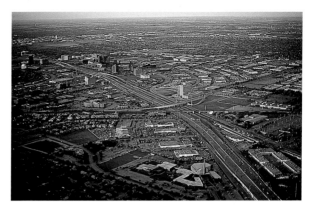

Dallas, Texas. Major highway interchange and associated development.

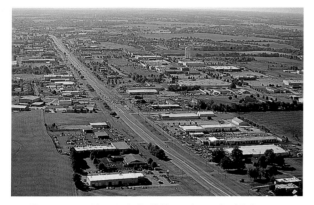

Bowling Green, Ohio. Strip buildings along the highway.

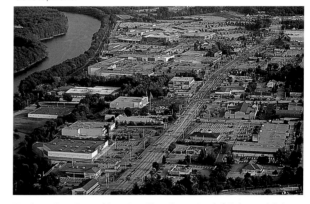

Nashua, New Hampshire. Retail strip on Daniel Webster highway.

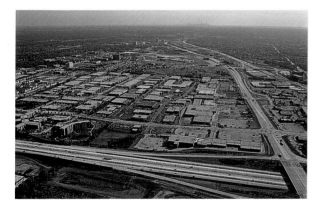

Lombard, Illinois. Finley Rd and 22nd toward Butterfield.

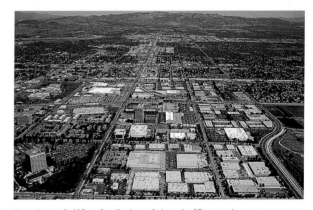

Van Nuys, California. Industrial and office park area.

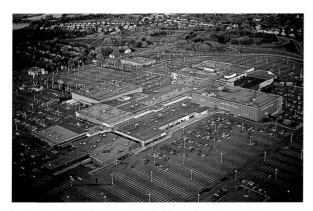

Peabody, Massachusetts. North Shore shopping mall.

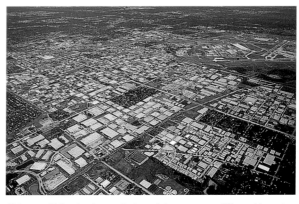

Chicago, Illinois. Large industrial area near O'Hare Airport.

314

Orange, Connecticut. Connecticut Post Mall on I-95.

SCALE

→ With the aerial perspective we gain an immediate scale shift from what we are used to seeing from the ground. In fact, aerial photography makes it possible to reduce objects and large planning areas to perfect models. The model is realized with distance and is documented and shared with others by recording it on film. We can fly around this perfectly reduced model and record it from different perspectives and elevations. We can photograph straight down for a map-like view or from the side, with or without the horizon showing. From side-looking views we gain vertical information such as tree heights and the facades of buildings, thereby providing a look and feel, or sense of place, that we do not get from the surface view. With the horizon showing we can gain a better sense of context. We can fly high and see out across an entire watershed or metropolitan region. Unlike the model in the studio, the dimensions of the real-life model come without an end. From a child-like perspective it is the perfect railroad model in every detail. With running trains, a railroad station, switching yard, grain elevator, trucks, and tractors, it is complete even with city and countryside. The details keep appearing as we move closer in by altitude or by using longer lenses.

In theory we control our vantage point at will by moving in three-dimensional space over this model. The dimension we cannot control is time. It remains a real-time model as witnessed by how it is lit. The lighting for

this model is by sunlight slicing through the atmosphere. The light is naturally filtered during the course of the day and seasons. We have to wait for the afternoon to illuminate a west-facing facade. We have to wait days for the overcast thin high clouds to cut down the black shadows that obscure downtown streetscapes. We have to wait months for the leaves to come down in order to see through the trees. Fortunately, there is plenty to see while we wait for these changes.

Scale shifts, as in modeling, are powerful in conceptualizing objects and special relationships. Our eyes are drawn to the unfamiliar, wanting to place it back in order and make it familiar. In flying we have made scale shifts by reducing the size of the familiar. It is startling to see scale shift in reverse, when the familiar is enlarged and out of scale. We see this in a building that looks like a picnic basket or a swimming pool shaped as a guitar. There is an element of playfulness in scale shifts that is entertaining. Our eyes play—dancing over models for information and new understanding. We are able to conceive of relationships and recognize patterns that we never would imagine. We are filled with wonder and inevitably engaged in learning.

317

318 Newport area, Rhode Island. Playground with large colored USA map.

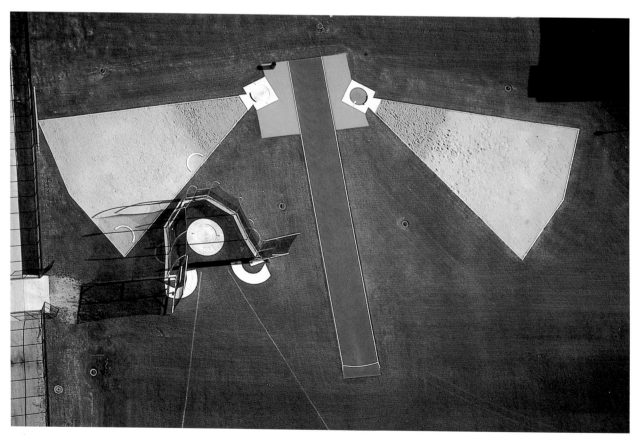

Urbana, Illinois. Field event markings at the University of Illinois.

Litchfield, New Hampshire. Playground with USA map.

Washington DC. City playground with USA map.

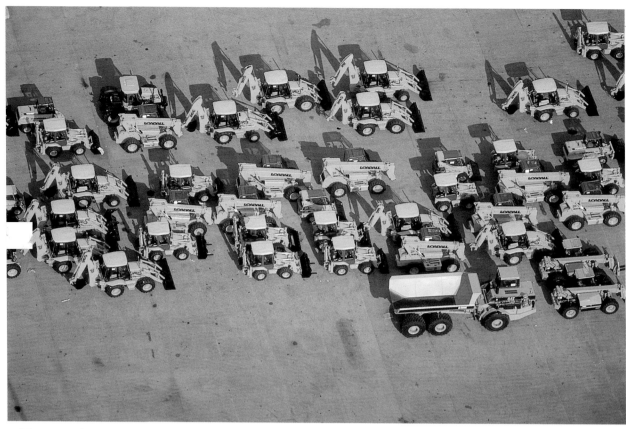

Baltimore, Maryland. Tractors on a loading dock.

Baltimore, Maryland. Tractors and agricultural equipment on a loading dock.

Baltimore, Maryland. Tractors and school buses on a loading dock. 321

Lake Charles, Louisiana. Twin tugboats.

Middletown, Rhode Island. Twin aircraft carriers at dock.

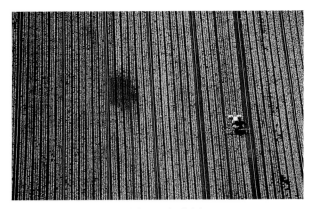

Oahu, Hawaii. Lettuce cultivator in field.

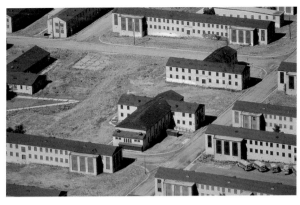

Brigham City, Utah. Barracks housing.

Kalispell, Montana. Harvester and trucks in formation line.

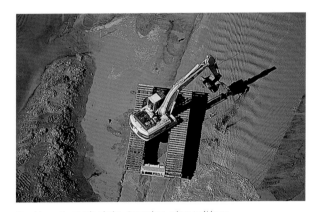

Beckley, West Virginia. Dump truck spilling mine tailings.

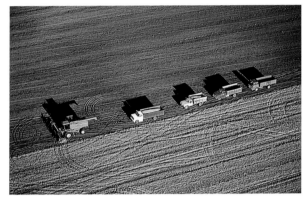

New Jersey coastline. Rollercoaster on beach.

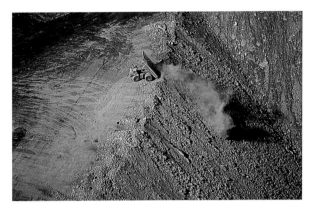

Beckley, West Virginia. Dumping mine tailings.

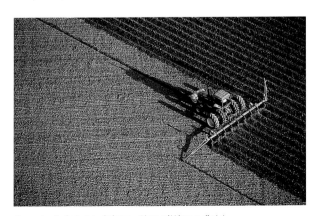

Poverty Point, Louisiana. Plow tilling a field.

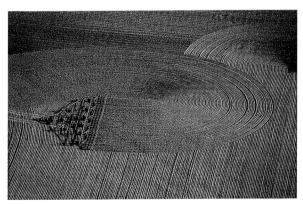

Gildford area, Montana. Caterpillar back hoe.

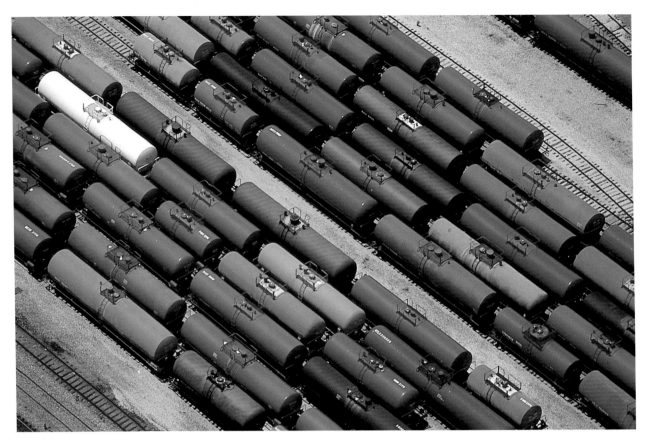

Wheeling, West Virginia. Blue tankers in train yard.

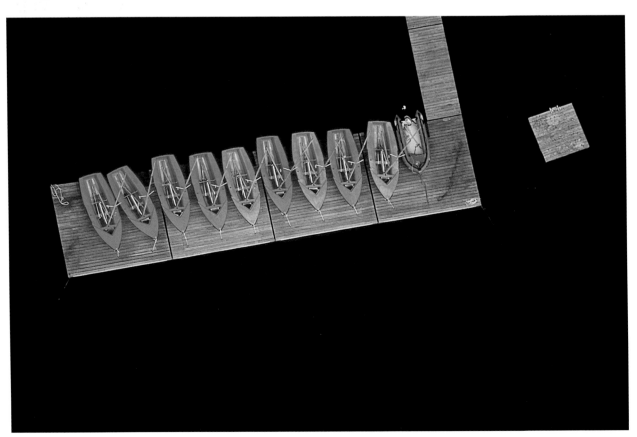

Eastern Massachusetts. Blue sailing dinghies lined up on dock.

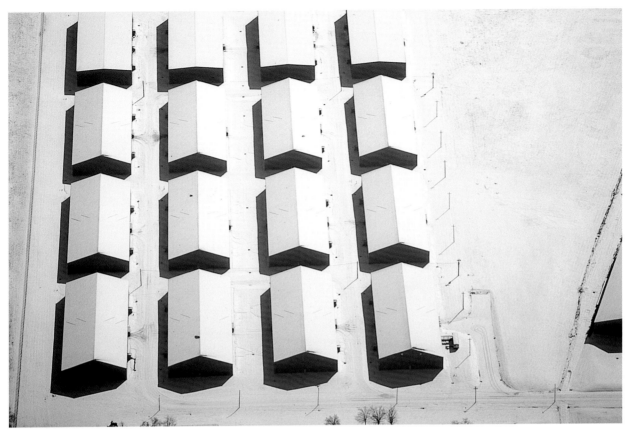

Northern Virginia. Warehouse buildings in winter.

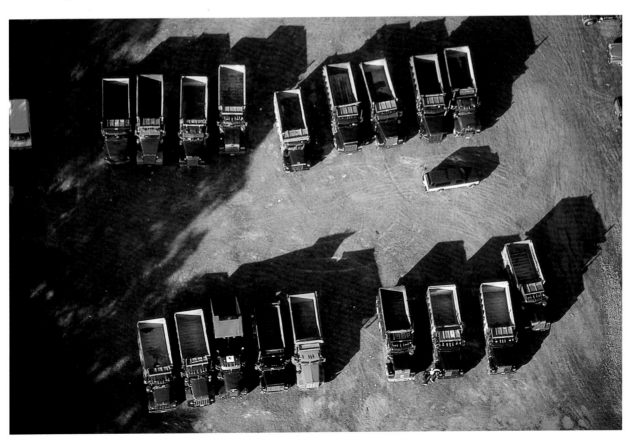

Rockville, Maryland. Truck yard at gravel pit operation.

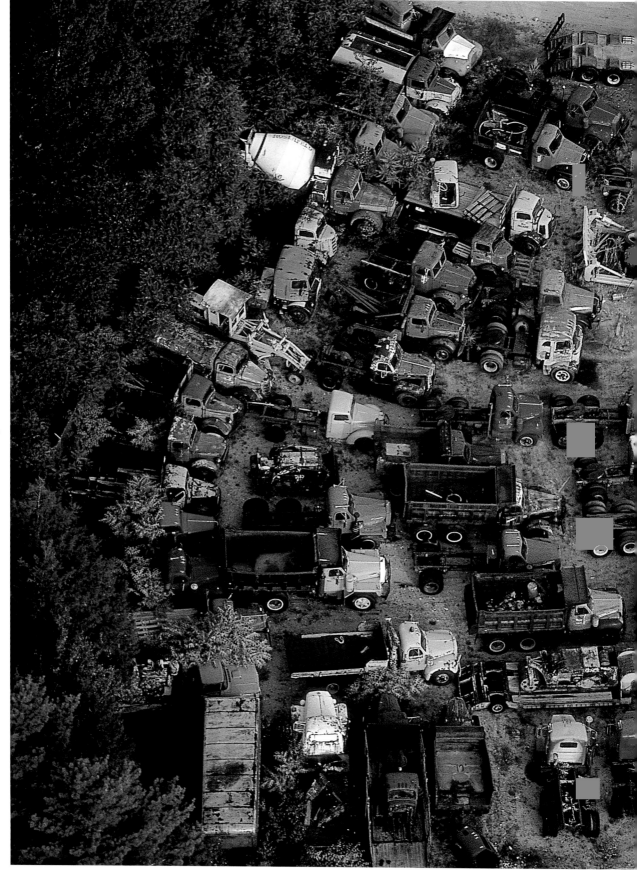

Nashua, New Hampshire. Truck yard.

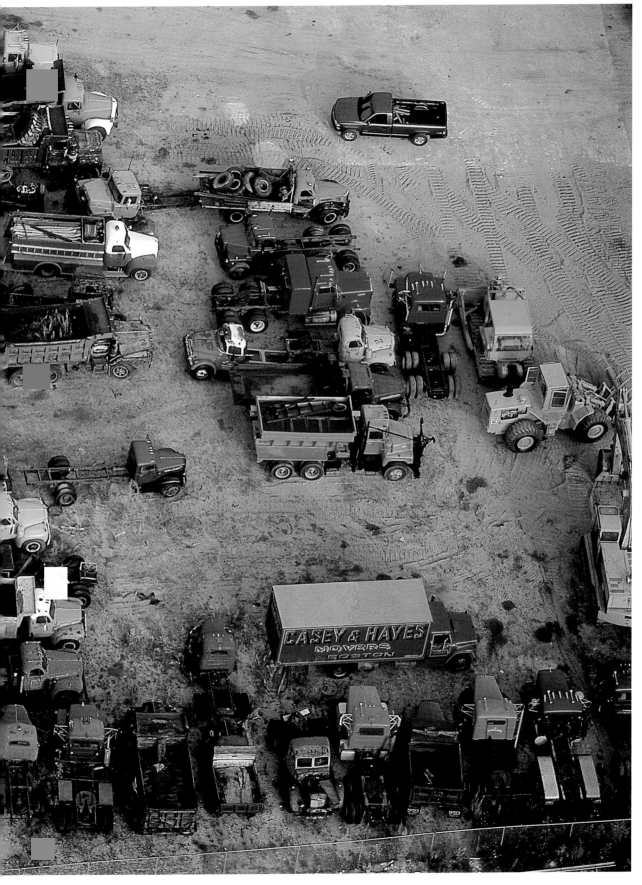

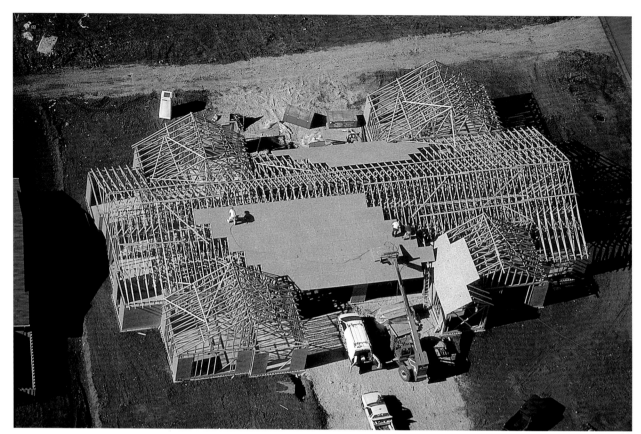

Bowling Green, Kentucky. Wood and plywood framing of an apartment structure.

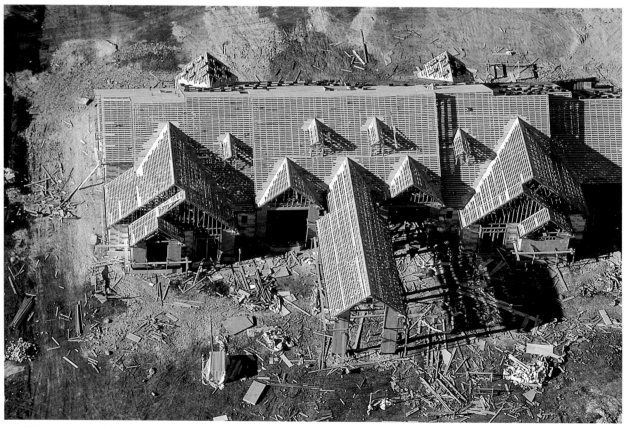

North Andover, Massachusetts. Large single-family house under construction.

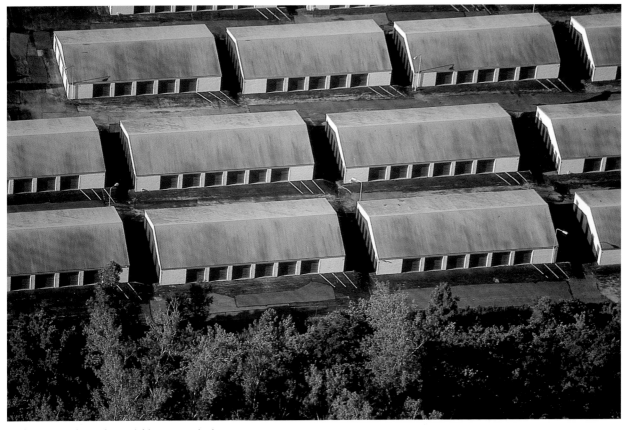

Kansas City, Missouri. Roadside storage lockers.

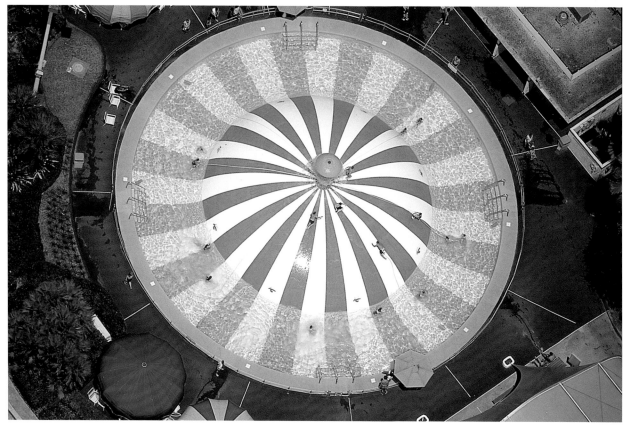

Orlando, Florida. Blue-and-white striped recreational pool with central mound.

Hampton Beach, New Hampshire. Waterslide and catch pool.

Orlando, Florida. Theme motel guitar-shaped swimming pool.

Orlando, Florida. Theme motel piano-shaped swimming pool.

New Jersey coastline. Water park.

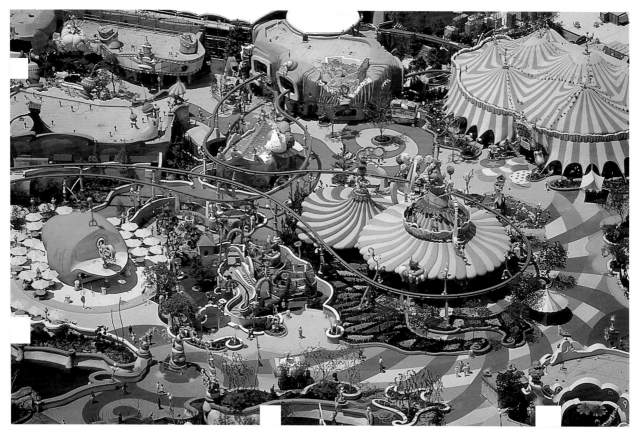

Orlando, Florida. MGM Studios theme park amusement rides.

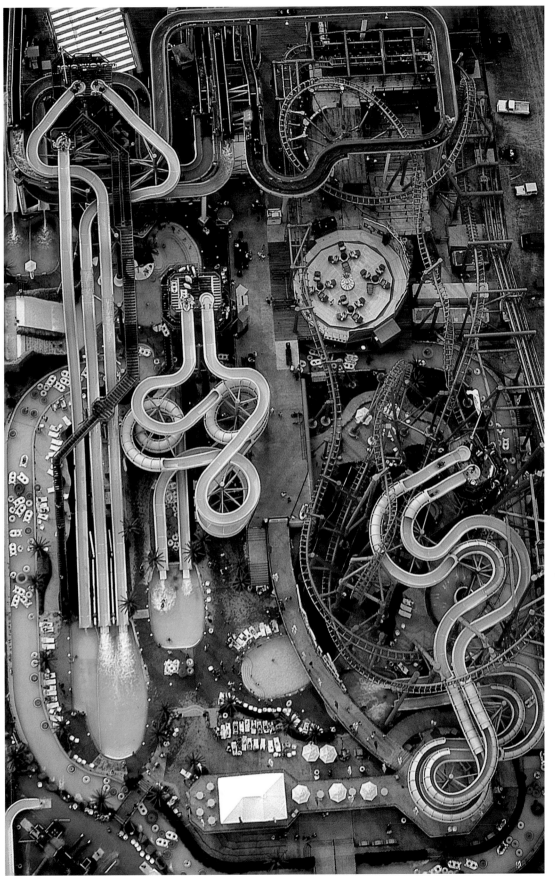

New Jersey coastline. Water park.

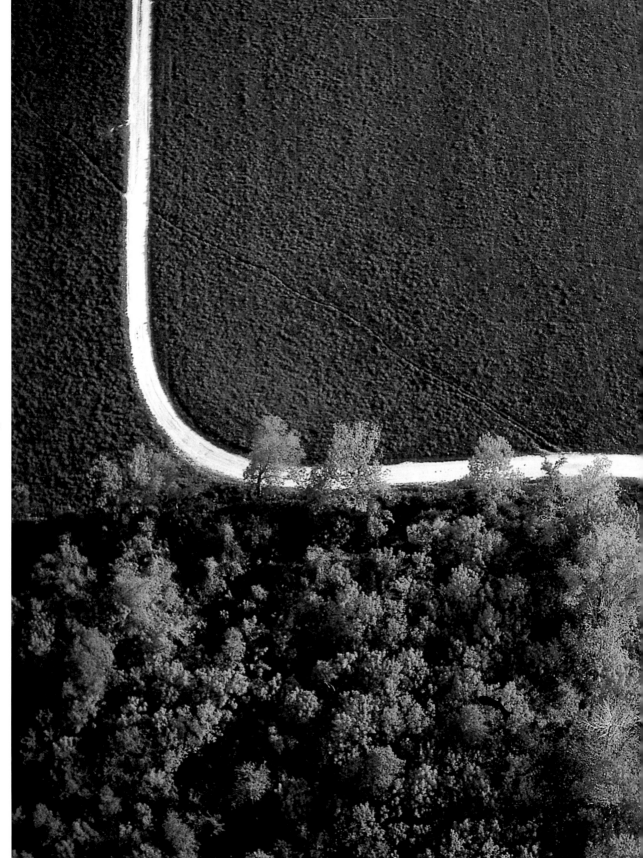

334

Red River Valley area, Massachusetts. White road and trees.

AERIAL GEOGRAPHY
Jean-Marc Besse

→ Jean-Marc Besse is a researcher at CNRS in Paris, specializing in the history of geography. He teaches landscape history and culture at the Ecole Nationale Supérieure du Paysage in Versailles and the Architectural Institute of the University of Geneva, and has published many books and articles.

To learn, we must walk and to understand, we must glide.

The point of the pyramid is also its base.

Things must be separated in order to come together.

Paul Claudel, *Conversations dans le Loir-et-Cher*

Aerial photography and views from the air are not merely a technically new way of seeing: they show an unexpected dimension of the earth's reality in all its power and grandeur. This new dimension, this new entity that aerial photography reveals the existence and perhaps even the very nature of, is the landscape. Views from a plane, and the photographs which record these views, show the landscape—as the expression and evidence of the way in which human beings collectively populate the earth's surface—as a unique store of information worthy of study in its own right. It should be stressed that the view from the sky demonstrates not only the existence of the elements that make up the world's landscapes, but also shows that they have substance and even *substantiality*. Aviation and aerial photography are the potential technical means to create a new way of thinking, what could be called an ontology of surfaces.

When the historian and "critic" of the American landscape John Brinckerhoff Jackson founded the journal *Landscape* in the spring of 1951, he was already well aware of the many new opportunities that aviation had to offer. In an essay, he wrote:

It is from the air that the true relationship between the natural and the human landscape is first clearly revealed. The peaks and canyons lose much of their impressiveness when seen from above.... What catches our eye and arouses our interest is not the sandy washes and the naked rocks, but the evidences of man.[1]

This approach to landscape, later inherited by Alex MacLean, who studied under Jackson at Harvard, is not easy to sustain, or to define. It is in constant tension between two opposing poles, each tending to cancel it out or, at least, prevent it from being grasped in all its originality. The first pole could be defined as hyperobjective: the appearance of the landscape is simply a veil, sometime transparent, sometimes opaque, which can both reveal and mask spatial, natural and social realities which are more fundamental, and can, at any rate, provide true explanations. The other pole is hypersubjective, and is based on the axiom that landscape only truly exists in the representations which culturally codify the perceptual and intellectual relationship which human societies maintain with their environment. In either case, whether viewed as a mask of reality or as a projection onto reality, landscape is neither designated nor understood as a separate entity; it is merely an illusion of reality, which must be escaped if the true causes are to be found, whether on the earth or in the mind. However, in both of these cases, the missing element is the landscape itself, the basic reality of what can be seen or, more widely, perceived, the recognition of the specific and irreducible nature of visuality as a way of being, as a dimension of the earth's existence. French philosopher François Dagognet commented:

It is on film, even in seemingly trivial details, that the truth shines out and can be "fixed." Nowhere else....
Let us be wary of this abyss, that drags us down into its depths. Let us not abandon the ground, which is the
environment, the habitat, the landscape, where living creatures, raw materials, facts and societies themselves
have become established.[2]

The plane is a rehabilitation of the great book of the world, and its writing: the earth as it is written, geo-graphy.

The history of geography and the bird's eye view

The role that J. B. Jackson attributed to aerial photography places him within the wider framework of the geographical
thinking of his time, to which he also made more explicit reference. The article quoted above, on the landscapes of
the southwestern United States, was clearly inspired, both in form and intent, by the analytical methods of the French
geographer Pierre Deffontaines, who was at that time involved in the production of an aerial atlas of France. As well
as this specific reference, which will be discussed in detail later, the visual perspective adopted by Jackson was a
continuation of a much older geographical trend, which had begun to recognize the analytical and synthetic
advantages of aviation from the beginning of the twentieth century on.

The view from the air, however, is in itself nothing new in geographical terms, and could even be considered one
of its oldest imaginative resources. From the earliest days of the discipline, there have been many theoretical texts

and stories that defined the intellectual position of the geographer on the basis of his aerial view of the earth.[3] Traditionally, the geographer, like the mythical Atlas chosen as a symbol by the Flemish cartographer Gérard Mercator, looks down on the earth from the top of a watchtower. The distance his gaze must cross to reach the ground, and his "detachment" from any concrete involvement in the material substance of things, lead the geographer's eye toward a sort of abstraction, and grant him a powerful understanding of reality which would not have been possible had he remained focused on the details of the world. From such a great height, what the eye sees is the world in miniature, already laid out like a map or diagram. This means, in turn, that any cartographical understanding of the earth presupposes the capacity to raise oneself above the ground. This kind of panoptic vision is implied in the very definition of geography, and from Pseudo-Dionysius the Areopagite in the 2nd century AD to Onésime Reclus, author of *A Bird's-Eye View of the World*, in the nineteenth century and beyond, the geographer has been characterized by his voyage through the air.

This myth makes geography a continuation of a longstanding literary and philosophical tradition, which first appeared in ancient Greece within the context of Stoic and gnostic philosophies. This tradition sees an aerial view of the world as the central element of a particular mental state, whose nature had long been defined within the context of the discussion of philosophical activity. This state was that of *theoria tou kosmou*, contemplation of the world. From Plato and Aristotle[5] onward, contemplation was seen as the philosopher's fundamental task. As a necessarily intellectual and sensory experience, its true object is Everything—in other words, the world, the totality

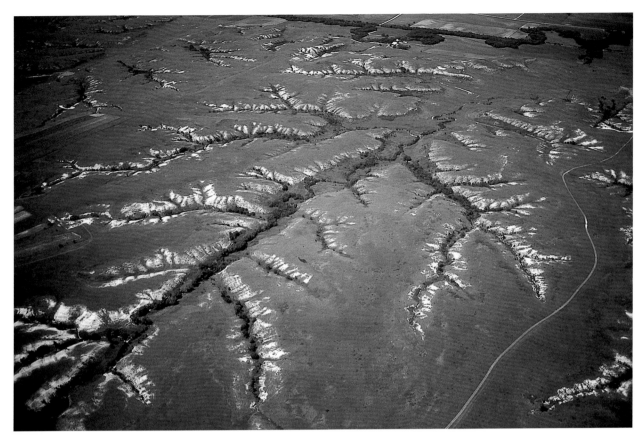

Central Missouri. Erosion gullies in agricultural land.

of what is, as a spectacle, a state of order and a truth. The tradition of the bird's eye view falls within this philosophical and literary tradition; it can be seen in several works by Lucian (particularly *Icaromenippus*), in the letter of 1336 in which the poet Petrarch describes his ascent of Mount Ventoux, and here, in a quotation from the *Meditations* of Marcus Aurelius:

> ...if thou shouldst suddenly be raised up above the earth, and shouldst look down on human things, and observe the variety of them how great it is, and at the same time also shouldst see at a glance how great is the number of beings who dwell around in the air and the ether, consider that as often as thou shouldst be raised up, thou wouldst see the same things, sameness of form and shortness of duration. Are these things to be proud of? (*Meditations*, XII, 24, 3)

The bird's eye view was therefore primarily a "theoretical," contemplative way of seeing, and it embraced the specifically philosophical issues raised by contemplation of the terrestrial world, and in particular the alternating currents of aesthetic and religious admiration and moral contempt for the world which run throughout the entire history of Western thought. The view from the air both glorifies and condemns the state of the world. In this respect, it cannot be discounted that the public success of panoramas in the nineteenth century, and, more recently, of photography exhibitions showing "a bird's eye view of the earth," is at least partly due to the sort of moral and

aesthetic philosophical shock that is created by a world suddenly turned into a spectacle.[6] Since the Renaissance, however, the bird's eye view has become more than merely a myth. Within the iconography of cities and landscapes, the form of the perspective view has become one of geographers' favorite methods of representation. In this respect, it has taken on a functional role, and has been used both for analysis and for planning.[7]

The many "views" and "portraits" of cities produced in Europe from the end of the sixteenth century onward have two striking features. On one hand, they create an "impression of reality," or, more accurately, a completely convincing impression of *evidence*. The efficient mimicry of these images lays out the pictured locations before the viewer's very eyes, as is wonderfully demonstrated by the collections created by Georg Braun and Franz Hogenberg in Germany (*Civitates orbis terrarum*), or by the French engraver Matthieu Merian. On the other hand, because of the lack of technology that existed before the end of the eighteenth century, a truly "lifelike" view was in fact impossible to execute. These views show us cities in a way that no human being could ever really have seen them.

The writer Louis Marin describes these perspective views as "the utopic figure of the city." He draws a distinction between the utopic figure and two other types of image: the *panorama* and the *map*. The panorama is an elevation, a frontal view: the viewer is fixed to one spot on the ground, the city is seen as a horizon in the distance, but only the buildings in the foreground can be seen, the others remain hidden. In the flat plan, the whole city is "given as a whole, simultaneously," but purely as a surface structure, a geometric diagram. The map's flat image shows a vertical view of the city, but there is no living eye that could see this "view." Strictly speaking, there is no "view," and there

is no "city." The fact that everything is visible gives away the truth that the so-called "city" is purely a drawn space. You cannot live in this city and you cannot truly see it; you can only see a map.

The utopic figure lies between the map and the panorama. Between a map and an elevation, it shows a "staged" version of the town, "a view from above, following the rules of linear perspective." The bird's eye view shows a complete image of the city, but from a single viewpoint. It is a positioned view, from which point the city seems completely displayed, hiding nothing. A possible view in one sense, and yet also an impossible one, for no one would be able to occupy this total viewpoint for a long time to come: "One can see all. But the eye placed at this point occupies a place that is an 'other' point of view: it is in fact impossible to occupy this space. It is a point of space where no man can see: a no-place not outside space but nowhere, utopic."[8]

But while this "utopic" place opens onto an impossible view, it must be conceded that it may have been impossible at one time, but was not impossible for all time, as the aviators of the future went on to prove. It must also be said that however "impossible" this view may be, it exists nonetheless, because it appears in a picture. Of course we do not really see Amsterdam, Frankfurt or Venice as these images show them to us, but the images do show them to us, and therefore turn these cities into possible visual experiences, which are disseminated in geography books and postcard collections. To be exact, the images are the locations in which *virtual* experiences are illustrated and portrayed. Bird's eye views, like utopic views, are therefore virtual views. And it is the relationship between utopia and virtuality which therefore needs to be clarified. A perspective image of a city is an illustration

of the utopia—the no-place—within a real space, the space of maps engraved by and shared among people, but this illustration takes a *virtual* form, or, rather, the form of a virtual *place*, which people would in future be able to occupy.

From the Renaissance onward, different types of images and views of the world have been categorized according to their potential uses and cognitive effects. Views of the landscape can be divided into frontal views, vertical views, and oblique views, and it was verticality and perspective that were to alter most radically our understanding of the world from the air.

Two key factors in the development of "bird's eye" views of cities during the nineteenth century were the first hot-air balloon flight by the Montgolfier brothers in 1783, and the first panoramic paintings by Robert Barker in 1787. Panoramas grew more and more popular throughout the Western world, and they were shown in specially constructed buildings, at universal exhibitions, and even on the pages of the most widely read newspapers. These views usually showed cities and the surrounding landscape as they would have appeared from the basket of a balloon; indeed, at the 1855 Universal Exhibition in Paris, one of the most visited attractions was an "Overall View of Paris from a Balloon," exhibited by Victor Navlet. Balloon journeys became a popular literary subject, and also provided the theme for several popular series of lithographs; for instance, a collection by the draftsman Alfred Guesdon showing the cities of Europe.

However, it was some time before bird's eye views became anything other than geometric or pictorial constructions, which is all the more surprising during the very period in which technological advances in the fields of air travel

and photography had made "real-life" views of towns possible for the first time. Guesdon's obituary, published in June 1876 in the *Revue de Bretagne et de Vendée*, describes the drawing techniques he used to produce his aerial views, techniques almost identical to those used two or three centuries earlier by the pioneers of the genre. Like the artists of the sixteenth century, Guesdon based his work on a flat plan, which he turned into a perspective view by placing the line of the horizon very high. After researching his location and making many preliminary sketches, he then traced the elevations of rows of houses, gardens, squares, and important buildings onto this grid, giving the impression that he was up in a balloon or in another elevated position. But the hyperrealism of his pictures cannot mask the fact that they remain drawn constructions.

However, aerial photography had already been invented, and soon made an impact on the imagery of the cityscape. In October 1858, Gaspard Félix Tournachon, known as "Nadar," patented a new method of aerostatic photography, which could be used to survey land for topographic, hydrographic or taxation purposes. The basket of the balloon was covered with a tent, which served as a darkroom, and the camera was suspended from a gimbal so that it remained vertical. Nadar used this method to photograph the Bièvre valley in the winter of 1858, although the picture does not survive; this was soon followed by a view of Boston taken by James Wallace Black in 1860. In June 1868, Nadar went to Paris and took pictures of the Arc de Triomphe and the neighboring streets from Henri Giffard's tethered balloon, and these became the first views of a city to be actually obtained from the air. In June 1879, Triboulet took the first aerial photos of Paris from a moving balloon. Picturemaking experiments were also done

using methods other than balloons, both freefloating and static, including airships, pigeons, and even kites, using

a mechanism invented by Arthur Batut in 1888. But it was not until the age of the airplane that aerial photography

became part of the general public's visual vocabulary. The first aerial photograph from a plane was taken by

L. P. Bonvillain in 1908, from a craft flown by Wilbur Wright over Le Mans, France. The military use of photography

and aircraft, both before and especially during the First World War, later led to significant improvements in image

quality. Since a plane could be maneuvered, the photographer could reach the required height and also achieve a

level of stability that was impossible with a balloon or kite. Improvements in photographic techniques, including

first stereoscopic photographs taken from the air, soon established its supremacy over any other type of aerial image.

Geographers were very quick to realize the potential of photography as a tool for exploration, interpretation and

communication, even before the advent of the airplane; photographic collections had been used alongside maps

and other geographical resources since the early twentieth century.[9] On the initiative of the German geographer

Albrecht Penck, the International Geography Congress, held in Washington DC in 1904, planned to create a

Photographic Atlas of the Forms of the Earth's Surface; a specimen copy was circulated in 1911. The project was never

completed due to the outbreak of war in 1914, but some twenty contributions were amassed by the project's

directors, Emmanuel de Martonne and Jean Brunhes. Brunhes, convinced of what he called the "demonstrative power

of the photograph," can be considered a true champion of aerial photography as a geographical tool, both for research

and teaching purposes.[10] From 1912, Brunhes was the director of *Archives de la Planète*, founded by Albert Kahn, a

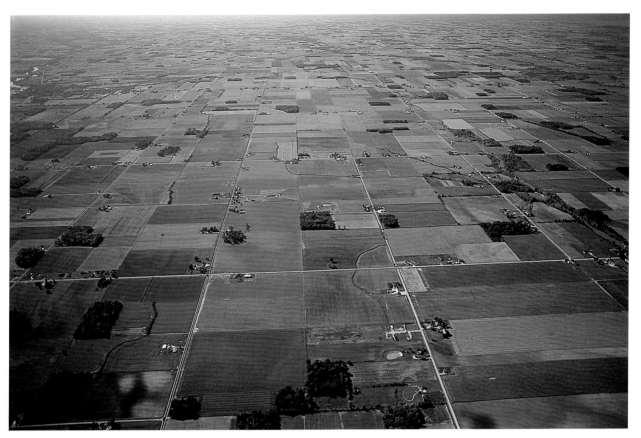

Haskin area, Ohio. Gridded agricultural land.

project whose aim was to create a store of photographs and films, "to capture for all time aspects, practices and customs of humanity, whose permanent disappearance is simply a matter of time."[11] By the time that Brunhes included oblique aerial views and even vertical views in the third edition of his book *Human Geography* in 1925, aerial photography had become a standard tool for geographical research.

Geographers, however, were not the only ones to take to the skies in order to look at the landscape. From the mid-1920s, archaeologists also began to recognize the importance of aerial photography in their own discipline. Pioneers in this field included Antoine Poidebard, a French Jesuit priest who is notable both for the results of his many research flights (a survey carried out between 1925 and 1932 enabled him to discover a network of Roman roads in Syria, from Bosra to Palmyra and the River Tigris), and for the technical and mechanical innovations he introduced.[12]

Throughout Europe and America at this time, geography and archaeology were looking toward aviation as a new resource. In a book on the "documentary style" in German and American photography in the period between the two wars, Olivier Lugon discusses the relationship of mutual influences which characterized photography and geography in Germany in the late 1920s. He recalls the widespread popularity of photographic atlases, "scholarly works of geography, published by specialists, but in which maps and diagrams are replaced by photographs."[13] The large and attractive images were sorted into detailed categories, allowing readers to "learn by studying the shapes of rivers, the layout of roads, the division of fields and the spread of towns."[14] Aerial photography became the keystone of such publications, and thus constituted "the true link between new geography and documentary

photography." It even came to be considered a potential foundation for a "new geography," a true science of landscapes. Marvin Mikesell writes:

> The landscape of the geographer is thus very different from that of the painter, the poet, or novelist. By means of survey, sampling, or detailed inventory, he achieves the comprehensive but synthetic perspective of a helicopter pilot or balloonist armed with maps, photographs, and a pair of binoculars. Indeed, it has been suggested that the geographic definition of landscape might be framed with reference to air photographs, both vertical and oblique....[15]

The united interests of aviators, geographers and photographers led to the organization of the First Congress on Aerial Geography in Paris in 1938, although its findings were not published until after the Second World War. It was there that the vital role of aerial photography in the study of the landscape was finally recognized. Leading contemporary geographers viewed the plane as an "elevated observatory" which a geographer "may move as he pleases, altering the height and the shot."[16] The Congress commissioned Emmanuel de Martonne to produce a "Handbook of Aerial Photography," which was published in 1948.[17] The same year saw the publication of a work entitled *Découverte aérienne du monde* (The Aerial Discovery of the Earth), edited by Paul Chombert de Lauwe,[18] an ethnologist and wartime fighter pilot, as well as the earliest photographic reports in the French journal *Revue de géographie*

humaine et d'ethnologie (Review of Human Geography and Ethnology), which provided great inspiration to J. B. Jackson when he founded *Landscape*.

The objectives of the aerial view

Historical perspectives may of course be misleading. While it is true that aerial photography can be seen as the continuation of one of geography's most longstanding preoccupations, the fact remains that, as far as the consciousness of the 1950s and 1960s was concerned, the plane brought about major changes in the relationship between geographers and the earth's surface. The most varied of sources all concur on this point: the plane caused a shock, a revolution in spatial awareness and in geographical objectives. It profoundly altered the nature of our experience of the world. Even before the Second World War, Antoine de Saint-Exupéry had written:

> The airplane has unveiled for us the true face of the earth. For centuries, highways had been deceiving us. We were like that queen who determined to move among her subjects so that she might learn for herself whether or not they rejoiced in her reign. Her courtiers took advantage of her innocence to garland the road she traveled and set dancers in her path. Led forward on their halter, she saw nothing of her kingdom and could not know that over the countryside the famished were cursing her. Even so have we been making our way along the winding roads.[19]

It was with both these words and Chombart de Lauwe's work in mind that Eric Dardel, attempting to compose a philosophy of geography, wrote: "It is...our entire image of the earth that is thrown into question, our repertoire of forms and appearances, our sense of human boundaries.[20]" The awareness of this novelty, in objective as well as in vision, is expressed even more vividly by Pierre Deffontaines:

> The most astonishing change produced by air travel is not simply a revolution in speed, but also a revolution in vision. The airplane has brought about a complete change in our way of seeing the earth, a greater change than the one experienced by the earliest navigators when they saw the land from the sea for the first time. The airplane has replaced linear, ground-level vision with a vision of surface or even of volume; it has given us a fresh viewpoint on the earth and it represents, in actual fact, the most wonderful source of knowledge, to the extent that, seen from an airplane, the earth looks like a completely different planet. For all those who are haunted by "the earth alone" and who are already disillusioned by *déjà vu*, here lies a totally new area of nature to revive our waning curiosity, to reawaken our inquisitiveness.[21]

There is a powerful magic in the view from a plane, a rapture of the senses, a magic which aerial photographs crystallize and reflect. Flying slowly above the ground at an average altitude ranging between 1,000 and 2,500 meters, an aviator, photographer, or geographer (sometimes one and the same person) discovers a world that is truly new.

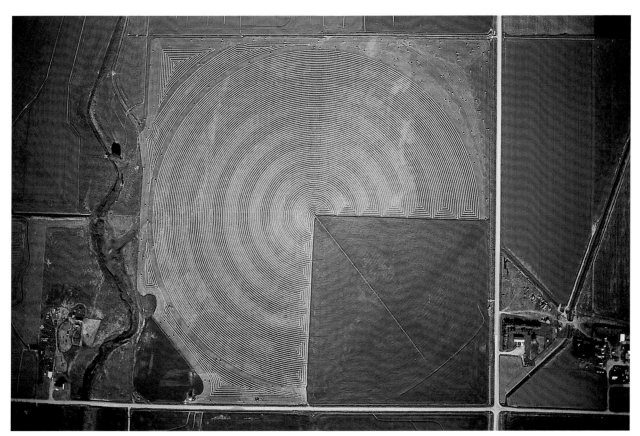

Fairfield Bench area, Montana. Pivot irrigator with square field.

It is not just the same world seen differently; it is another world. The plane reveals the existence of something totally new, something that it alone permits us to see:

> Altitude reduces forms that are indiscernible or mediocre when lifesize and renders them intelligible and beautiful.... Only the vertical aerial view allows us to see things "face on," and hence in their true form, since we are then completely detached from their surface. This is why we have the impression of a picture that gradually takes shape the higher we climb. The harmony that we perceive on earth only in reliefs, in three-dimensional sculpted forms, now emanates even from lines and surfaces, their flat patterns completely escaping our earthbound shortsightedness.[22]

As Pierre Deffontaines stated, the aviator/photographer/geographer travels to a "different planet." Outdoing even the navigators of ancient times, he sees the earth for the first time. It is the dawning of a new era. A new evaluation of the world, both in time and in space. But while planes and aerial photographs have brought the world alive for us again, for geographers they have contributed to a better understanding of the landscape, and its meaning. Aviation was quickly adopted as a means of describing and interpreting the contours of the landscape, and it has formed the basis of a complete reappraisal of geomorphology and hydrography. Aerial surveys have also enabled the mapping of living things, particularly vegetation. Human geography too has found this way of observing and

understanding the landscape to be an indispensable tool, both for understanding of the basic structures of space, and also for seeing through time, with a depth that is almost archaeological.

The advantage of aerial photography is its cartographic quality. It allows our gaze to escape the linearity of observations on the ground, and elevates it, letting us grasp an entire region at once. Aerial photography records rural land divisions, road networks, the geometry of towns and the patterns of land use. In this sense, photography is a more efficient tool for learning about the land than any ground-level survey, however thorough. Pierre Deffontaines underlined this point when describing the river Rhône in France:

Linear vision at ground level is a cause of constant distortions in observation and frequently even a cause of misinterpretation. The true image of the "region" is too often obliterated by the compartmentalization of the route. From Lyons to Marseilles, neither the railway nor the road give any idea of what the Rhône corridor is really like. An overland journey envelops the traveler in the elements of the landscape: valleys, forests and passes; compartmentalization is particularly serious in mountainous regions. Planes, on the other hand, provide an overall view. They let us understand the composition of a land, a whole landscape, by showing all the elements of which it is formed, and the way those elements are laid out and ordered. The Rhône corridor unfolds in a series of widenings and narrowings. The synthesis that the plane provides lets us see the causal factors and make out the dominant note of the landscape: perhaps the wind or the river, perhaps forest, irrigation, or dams.[23]

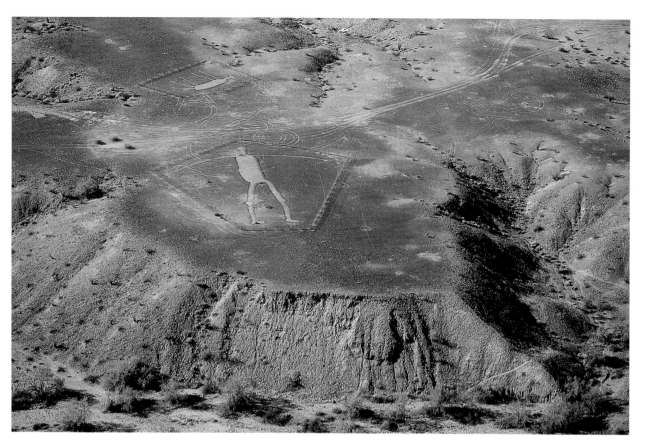

Blythe, California. Intaglio markings on the ground.

A plane is a sort of real-life atlas. As it moves over the landscape, it lets us measure landforms and their contours, breaks in continuity, different land uses which exist side by side. Airplanes and aerial photography are the motors of a comparative intelligence, which collects and contrasts. This strictly spatial form of intelligence permits a truly "complete geography," which "resolves the issue of large causal chains, by showing, simultaneously, all the aspects of varied regions that need to be understood."[24]

The advantages of aviation also relate to our concept of time and the landscape. The view from the air gives renewed credibility to the hackneyed metaphor of the palimpsest, giving it a role that fundamentally alters the way we think about images. As discussed earlier, aerial photography became one of the tools of historical geography and archaeology in the 1920s, making it possible to unearth the invisible traces of long-vanished civilizations which were characterized by "their methods of settlement, the groupings of their homes, even the position of their places of worship."[25] There is an entire science, a whole geography of ruins, which is primarily a way of viewing the landscape as a "monumental piece of writing" on which the history of the human populations that have inhabited may be permanently inscribed.

The earth's surface is not only the foundation for the constructions of modern humanity. If we examine it closely, we can see the traces of people from other periods of history showing through, as though covered by a transparent veil. As we examine aerial images, we become more aware of the successive layers of civilization that have followed each other, each one leading to the next. Beneath the structures of modern-day agriculture we can

make out the boundaries of earlier land divisions belonging to older societies. Beneath the holy sites of living religions, we can recognize the traces of the ancient civilizations that have gone before. Aerial photography is a tool which restores the *transparency* to the overlapping layers of human history which have marked the land, and thus it allows geographers, archaeologists, and historians to rediscover the true *temporal depth* of the landscape, and to comprehend it in the same glance and in the same thought.

Aerial archaeology also teaches us something else about the history of mankind's relationship with the land, as it is expressed in the landscape: that history is also a kind of geology.[26] The landscape is like a series of layers of human activity, stacked up on top of one another in differing patterns and directions. Aerial photography, as we have said, allows us to see through the strata of human history superimposed on the landscape. It is as though the layers of history were unfolded and laid out next to one another in a shared present, not outside history but with their own historicity preserved and intact. All of those earlier eras seem to coexist in the present, because a photograph can capture them together in the same moment in time, in a single image. We now realize that the land is not a *tabula rasa*. On the contrary, the land lets us see the whole history of our species, at the same time and within our own time, because it still bears the marks of it all; periods of history and ways of life that vary so widely in impact and meaning.

This new human geography, however, is more than just a mere concern for knowledge, and raises another issue whose power must be evaluated. To view the world from the "winding roads" Saint-Exupéry wrote of is to perceive

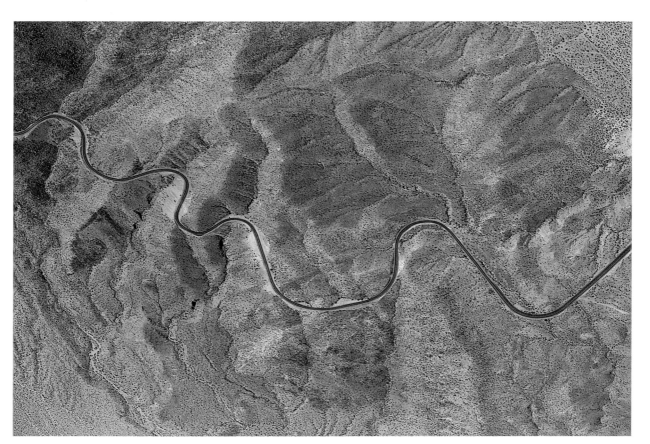

Borrego Springs, California. Road snake.

a humanized world, a welcoming, verdant land. But the familiarity of this view is misleading; its perspective is totally wrong. We need the plane's power to "derealize," the "brutality" of the aerial view, to perceive the abnormality, or, more precisely, the *contingency* of landscapes that is revealed by the plane. In reality, the earth is not welcoming by nature or by some sort of divine gift; the earth is not human, and the human landscape is merely laid on top of this indifference. The landscape seen from a plane is a layer of humanity placed, for better or for worse, on a completely impersonal base:

Roads avoid the barren lands, the rocks, the sands. They shape themselves to man's needs and run from stream to stream.... Thus, led astray by the divagations of roads, as by other indulgent fictions, having in the course of our travels skirted so many well-watered lands, so many orchards, so many meadows, we have from the beginning of time embellished the picture of our prison. We have elected to believe that our planet was merciful, and fruitful.

But a cruel light has blazed, and our sight has been sharpened. The plane has taught us to travel as the crow flies. Scarcely have we taken off when we abandon these winding highways that slope down to watering troughs and stables or run away to towns dreaming in the shade of their trees. Freed henceforth from this happy servitude, delivered from the need of fountains, we set our course for distant destinations. And then, only, from the height of our rectilinear trajectories, do we discover the essential foundation, the

fundament of rock and sand and salt in which here and there and from time to time life like a little moss in the crevices of ruins has risked its precarious existence.[27]

The straightness of air routes caused a philosophical change in our way of seeing. Here is another way to measure the world: the plane takes short cuts and diagonal routes, it cuts across and through our usual way of seeing. It shows the other side of the landscape, revealing its contingency and chance, its historicity, perhaps even the undeniable fragility of human existence. On a flight to Tokyo in 1955, Le Corbusier observed: "A plane journey could inspire a whole new study of the human condition."[28]

Indeed in the postwar period, geographers used the view from a plane to come to exactly the same conclusion about the landscape. It is a human condition—that is to say, both a position of potential and the expression of humanity on a non-human platform. Aerial photography exposes the scattered tracks and traces of humanity on the planet's surface, their extent, their shapes, and their layers—in a sense, everything that defines human settlement as an aspect of the earth's surface. It also demonstrates that the landscape is always both the incidental product and the physical expression of the meeting between mankind and nature. The plane justifies the "physiognomic" definitions of the landscape—as a system of imprints and marks made by humanity on resistant ground—that geographers of the 1950s and 1960s used to support their interest in photography. In other words, it could be said that aerial photography provided demonstrative proof, visual evidence, of their affirmation that

landscape is essentially "cultural" in nature. These remarks by Pierre Deffontaines could almost have been written by J. B. Jackson:

> The discovery of the whole physical framework of nature is astonishing by plane; however, what an aerial view makes particularly easy to comprehend is the role of man. A landscape seen from a plane is essentially a picture of man's labors, of man's struggle with the land. A region resembles a picture of human effort, testimony of a true human epic, in which we can measure the progress man has made in his battle against nature. A landscape is essentially man-made and we can understand why someone can call himself by the name of a land.... Country by country, we discover an astonishing variety in the strategies of humanity. Each land is dressed in its own human costume, and is inhabited and worked by men of the land, who can rightly be called countrymen.[29]

Of course, contemporary landscape theory and Jackson himself would probably no longer be content to view the landscape solely as the relationship between man and nature, and particularly not as a "battle" between them. Both Jackson and many of the most important of current landscape theorists have added a sociopolitical element to this "fabricated" and "culturalist" conception of landscape. A landscape, they conclude, does not merely recount the story of the relationship between man and nature, but also that of the relationships between men themselves. Plainly

put, while there is a general consensus today that the state of a landscape tells us a great deal about the state of
the society that helped to create it, that "state" also includes social and political factors as well as technical and cultural
ones.[30] Alex MacLean's work could be seen as an illustration of this profound theoretical change in the way that
landscape is viewed.

Nevertheless, the new complexity that the landscape has acquired does not undermine our original affirmation,
which remains unaltered in principle. The landscape is an archive, a great human document, and we must learn how
to read it. Aerial photography must therefore be considered within the more general framework of geographical
theories on the nature, shapes, and dynamics of the land, as well as on the way in which aerial views and images
permit us to see and understand them.

The difficulty of educating the photographic eye to see geography was encountered by geographers at an early
stage. The pioneering Jean Brunhes had to force the photographers who traveled with him to turn their eyes and
their lenses away from the striking and picturesque scenes that they were used to shooting, and to focus instead
on elements which may have been less spectacular to photograph but were more significant from a geographical
point of view, such as "the daily life of the people, what they do, where they live, which animals they raise at home
or in the fields, which tasks are carried out in different seasons...."[31] When deliberately used to gather geographical
data, the aerial view allows for what could be called a classification or codification of surface elements. Brunhes
outlined the major points in *Human Geography* in 1906:

Suppose we rise in a balloon or an aëroplane some hundreds of yards above the ground...and with our minds

freed of all that we know of men, let us try to see and note the essential facts of human geography with the

same eyes and vision which would discover to us and distinguish the morphological, topographical, and

hydrographical features of the earth's surface. From such a supposed observatory, what is it we see? Or better

still, what are the human facts that a photographic plate would register just as well as the retina of the eye?[32]

There are six elements on the surface which Brunhes identifies as elements of human geography: houses, roads, cultivated fields, domestic animals, exploitation of minerals, and devastation in plant and animal life.[33] These are "fundamental facts," on the basis of which, he believed, a study and, eventually, an understanding of the landscape could be established. As mentioned above, the role of these elements is to provide an epistemological coding of geographical data, including aerial views. Within the specific (yet representative) context of the contemporary American landscape, and of course taking into account modern technology and modern subjects, Alex MacLean's commitment to exploration can easily be viewed as part of this longstanding intellectual heritage. This eulogy to the plains from Pierre Deffontaines's *Atlas aérien* could be written in the margin next to some of MacLean's photos:

The most sensational discovery of the new aerial view, the most unexpected, is the revelation of the plains.

In the mountains...a plane merely reinforces what can already be seen from any number of earthbound

viewpoints...it is simply a better viewpoint. But on the plains, the plane revolutionizes our vision. In these areas, the landscape is made up predominantly of land and fields; at ground level, all we can see is the horizon as it merges into the vast and omnipotent sky. But from a plane, it could be said that the earth is restored to us. The plains takes the place of the sky, and we see the carpet of fields and all its shapes, its geometries, its borders in an extraordinary kind of natural cubism. The fields assume the leading role and somehow seem to replace the relief: the different colors of the soils, from black and white, to red and yellow, passing through the entire range of satins and moirés; the even larger range of colors in the vegetation, with the yellow of the ripe wheat, the green of the beets, the red of the clover, and the bluish-purple of the cabbages. The plane seems to bring the plains to life again before our eyes....[34]

If it is true, as Italian architect Vittorio Gregotti said, that all landscape is an encounter between geography and geometry—if in other words, the landscape is both an illustration of the morphologies and dynamics of culture within the primordial morphologies and dynamics of the earth's surface, and, at the same time, the presence of this space-time of the earth within the space-time of man—then an evidently huge intellectual and even practical importance should be attached to the ability to decipher these "written" signs that can be read on the surface of the earth, in the country and in the city, from a plane. Whatever our beliefs, these great patterns stretching across the ground, when captured in a photograph, clearly betray the state of the world and its possible future. We remain aware, of course, that a landscape can lie and conceal, but planes possess the power to reveal even the most closely guarded of secrets.[35] Planes explore the world and show it to us, but they also censure it.

1. John Brinckerhoff Jackson, "The Need of Being Versed in Country Things," *Landscape*, Spring 1951, pp. 4–5. Jackson discussed Erwin A. Gutkind's book *Our World from the Air* (London, 1952) in *Landscape* in 1953.

2. François Dagognet, *Une épistémologie de l'espace concret. Néo-géographie*, Paris, 1977, p. 124.

3. For an overview of this metageographical literature, see Christian Jacob, "Dédale géographe. Regard et voyage aériens en Grèce," *Lalies* III, Paris, 1984, pp. 147–64.

4. For a discussion of this question see the works of Pierre Hadot: "La terre vue d'en haut et le voyage cosmique," in Jean Schneider and Monique Léger-Orine, *International Colloquium, Frontiers and Space Conquest*, Dordrecht and Boston, 1988, pp. 31–40; and *What is Ancient Philosophy?*, Cambridge, Mass., 2002, p. 314.

5. Plato, *Theaetetus*, 173c–176a; Aristotle, *Nicomachean Ethics*, X, 7–9.

6. See Jean-Marc Besse, *Voir la terre. Six essais sur le paysage et la géographie*, Arles, 2000; and *Le Spectacle du monde. Jardins, fêtes, géoramas*, Paris, in press.

7. Ola Söderström, *Des images pour agir. Le visual en urbanisme*, Lausanne, 2000, and Lucia Nuti, *Ritratti di città: visione e memoria tra Medioevo e Settecento*, Venice, 1996.

8. Louis Marin, *Utopics: Spatial Play*, trans. Robert A. Vollrath, Atlantic Highlands, NJ and London, 1984, pp. 207–8.

9. For a detailed analysis of geographers' methods of visualizing the landscape, see the article by Marie-Claire Robic, "Interroger le paysage? L'enquête de terrain, sa signification dans la géographie humaine moderne (1900–1950)," in Claude Blanckaert (ed.), *Le terrain des sciences humaines. Instructions et enquêtes (XVIIIe–XXe siècle)*, Paris, 1996, pp. 357–88.

10. See the accounts and analyses collected in the catalogue *Autour du Monde: Jean Brunhes, regards d'un géographe, regards de la géographie*, Boulogne, Musée Albert Kahn, 1993.

11. Letter from Emmanuel de Margerie to Jean Brunhes, 26 January 1912, quoted in *Autour du Monde*, p. 181.

12. For a study of Poidebard's work, see Raymond Chevallier, *La photographie aérienne*, Paris, 1971.

13. Olivier Lugon, *Le style documentaire. D'Auguste Sander à Walker Evans. 1920–1945*, Paris, 2001, pp. 214–40.

14. Olivier Lugon, *Le style documentaire*, p. 236.

15. Marvin W. Mikesell, "Landscape," *International Encyclopedia of the Social Sciences*, vol. 8, New York, 1968, reprinted in *Man, Space and Environment*, eds. Paul Ward English and Robert C. Mayfield, Oxford, 1972, p. 13.

16. Albert Demangeon, "Contribution de l'aviation à l'étude des terroirs et des paysages rureaux," *Premier congrès de*

géographie aérienne. Comptes rendus des séances, Paris, 1938, p. 267.

17. Emmanuel de Martonne, *Géographie aérienne*, Paris, 1948.

18. Paul-Henry Chombart de Lauwe, *Découverte aérienne du monde*, Paris, 1948, introduction by Emmanuel de Martonne.

19. Antoine de Saint-Exupéry, *Wind, Sand and Stars*, trans. Lewis Galantière, London and Toronto, 1939, p. 57.

20. Eric Dardel, *L'homme et la terre*, Paris, 1952 (repr. 1990), p. 35.

21. Pierre Deffontaines and Mariel Jean-Brunhes Delamarre, "Nouvelle visions de la terre par avion," in *Atlas aérien de la France*, vol. 1, Paris, 1955, p. 7.

22. Pierre Marthelot, "La terre et la vie," in *Découverte aérienne du monde*, 1948, p. 149.

23. Pierre Deffontaines and Mariel Jean-Brunhes Delamarre, "Nouvelles visions de la terre par avion," p. 8.

24. Lucien Febvre, review of *Atlas aérien de la France*, in *Annales*, 1956, p. 261.

25. Paul Henry Chombart de Lauwe, "La photographie aérienne et les civilisations disparues," in *Découverte aérienne du monde*, p. 249.

26. "Man's remains are so mixed with the earth that they fuse together and their history becomes that of the earth." From Paul Chombart de Lauwe, "La photographie aérienne et les civilisations disparues," p. 245.

27. Antoine de Saint-Exupéry, *Wind, Sand and Stars*, pp. 57–58.

28. Le Corbusier, *Carnet* J 37, vol. 3 (337).

29. Pierre Deffontaines and Mariel Jean-Brunhes Delamarre, "Nouvelles visions de la terre par avion," p. 7.

30. The literature on this subject is extensive. Useful works include W. J. T. Mitchell (ed.), *Landscape and Power*, Chicago and London, 1994, and Trevor J. Barnes and James S. Duncan (eds.), *Writing Worlds: Discourse, Text and Metaphor in the Representation of Landscape*, London, 1992.

31. Mariel Jean-Brunhes Delamarre, quoted in *Autour du Monde: Jean Brunhes, regards d'un géographe, regards de la géographie*, p. 207.

32. Jean Brunhes, *Human Geography. An Attempt at a Positive Classification, Principles and Examples*, trans. I. C. Le Compte, Chicago and New York, 1920, p. 47.

33. Jean Brunhes, *Human Geography*, pp. 48–51.

34. Pierre Deffontaines, *Atlas aérien*, Paris, vol. 4, 1962, p. 7.

35. Back in 1935, Le Corbusier wrote: "We desire to change something in the present world. For the bird's-eye view has enabled us to see our cities and the countries which surround them and the sight is not good.... The airplane is an indictment. It indicts the city. It indicts those who control the city." From "Frontispiece to Pictures of the Epic of the Air," in *Aircraft: the New Vision*, New York and London, 1935.

BIBLIOGRAPHY

BY THE AUTHORS

BESSE, Jean-Marc, *Voir la Terre. Six essais sur le paysage et la géographie*, Arles, 2000

BESSE, Jean-Marc, *Les Grandeurs de la Terre. Aspects du savoir géographique au seizième siècle*, Lyons, 2003

BESSE, Jean-Marc, *Le Spectacle du monde. Atlas, jardins, géoramas*, Paris, in press

BESSE, Jean-Marc, *Les Grandeurs de la Terre. Aspects du savoir géographique au seizième siècle*, Lyons, in press

BESSE, Jean-Marc and BOISSIÈRE, A., *Précis de philosophie*, Paris, 1996 (4th edition, 2003)

BESSE, Jean-Marc and ROUSSEL, Isabelle, (eds.), *Environnement : représentations et concepts de la nature*, Paris, 1997

CORNER, James (ed.), *Recovering Landscape: Essays in Contemporary Landscape Architecture*, Princeton, 1999

CORNER, James and MACLEAN, Alex S., *Taking Measures Across the American Landscape*, New Haven and London, 1996

MACLEAN, Alex S., CAMPOLI, Julie, and HUMSTONE, Elizabeth, *Above and Beyond: Visualizing Change in Small Towns and Rural Areas*, Chicago, 2002

MACLEAN, Alex S. and MCKIBBEN, Bill, *Look at the Land: Aerial Reflections on America*, New York, 1993

TIBERGHIEN, Gilles A., *Land Art*, New York, 1995

TIBERGHIEN, Gilles A., *Land Art Travelling*, Valence, 1996

TIBERGHIEN, Gilles A., *Nature, Art, Paysage*, Arles, 2000

FURTHER READING

ARENDT, Hannah, "The Conquest of Space and the Stature of Man" (1963), in *Between Past and Future: Eight Exercises in Political Thought*, New York, 1968

ARENDT, Hannah, "The Archimedean Point," *Ingenior*, Spring 1969, pp. 4–9, 24–26

ARENDT, Hannah, *The Human Condition*, Chicago, 1985

ARTHUS-BERTRAND, Yann, *The Earth from the Air*, New York and London, 1999

AUJAC, Germaine, *La Sphère, instrument au service de la découverte du monde*, Caen, 1993

BUISSERET, David (ed.), *Envisioning the City: Six Studies in Urban Cartography*, Chicago and London, 1998

CHOMBART DE LAUWE, Paul Henry, *Découverte aérienne du monde*, Paris, 1948

COMMENT, Bernard, *The Painted Panorama*, trans. Anne-Marie Glasheen, New York, 2000

CONZEN, Michael P., (ed.) *The Making of the American Landscape*, Boston and London, 1994

CORBOZ, André, *Looking for a City in America: Down these Mean Streets a Man Must Go*, Santa Monica, 1992

COSGROVE, Denis E., "Contested Global Visions: One-World, Whole-Earth, and the Apollo Space Photographs," in *Annals of the Association of American Geographers*, 84 (2), 1994, pp. 270–94

Cosgrove, Denis E. (ed.), *Mappings*, London, 1999

Cosgrove, Denis E., *Apollo's Eye: A Cartographic Genealogy of the Earth in the Western Imagination*, Baltimore and London, 2001

Dardel, Eric, *L'Homme et la Terre: nature de la réalité géographique*, Paris, 1990 (1st edition 1952)

Deffontaines, Pierre and Jean-Brunhes Delamarre, Mariel, "Nouvelles visions de la Terre par avion," in *Atlas aérien de la France*, vol. 1, Paris, 1955

Gerster, Georg, *Flights of Discovery: the Earth from Above*, New York and London, 1978

Gibson, Walter S., *Mirror of the Earth: The World Landscape in Sixteenth-Century Flemish Painting*, Princeton and London, 1989

Hadot, Pierre, "La Terre vue d'en haut et le voyage cosmique," in Schneider, Jean and Léger-Orine, Monique (eds.), *Frontiers and Space Conquest: the Philosopher's Touchstone*, Dordrecht and Boston, 1988, pp. 31–39

Jackson, John Brinckerhoff, *The Necessity of Ruins and Other Topics*, Amherst, 1980

Jackson, John Brinckerhoff, *Discovering the Vernacular Landscape*, New Haven and London, 1984

Jackson, John Brinckerhoff, *A Sense of Time, a Sense of Place*, New Haven and London, 1994

Jacob, Christian, *L'Empire des cartes. Approche théorique de la cartographie à travers l'histoire*, Paris, 1992

Koolhaas, Rem, Boeri, Stefano, et al., *Mutations*, Barcelona, 2000

Kostof, Spiro, *The City Shaped: Urban Patterns and Meanings Through History*, London and Boston, 1992

Le Corbusier, *Aircraft: the New Vision*, New York and London, 1935

Lipsky, Florence, *San Francisco: the Grid meets the Hills*, trans. Cynthia Schoch, Marseilles, 1999

Marin, Louis, *Utopics: Spatial Play*, trans. Robert A. Vollrath, Atlantic Highlands, NJ and London, 1984

Martonne, Emmanuel de, *Géographie aérienne*, Paris, 1948

Oettermann, Stephan, *The Panorama: History of a Mass Medium*, trans. Deborah Lucas Schneider, New York and London, 1997

Pinchemel, Philippe and Clergeot, Pierre, *La Terre écrite*, Paris, 2001

Réclus, Onésime, *A Bird's-Eye View of the World*, trans. Malvina Antoinette Howe, Boston, 1892

Turri, Eugenio, *Il paesaggio come teatro. Dal territorio vissuto al territorio rappresentato*, Venice, 1998

Varnedoe, Kirk, *A Fine Disregard: What Makes Modern Art Modern*, New York, 1990

ACKNOWLEDGMENTS

While I take pictures flying alone, no one knows better than I that it would not be possible without the love and support of family and friends as well as the support I have received from clients, suppliers, academicians and institutions over the past 30 years. My work is the result of collaboration with others who have influenced and informed my pictures. I would like to remember those who are no longer alive, J.B. Jackson, Tim Anderson and Jack Robinson. Among the many others are those with whom I have collaborated on book projects: James Corner of the University of Pennsylvania, Bill McKibben, Julie Campoli of Terra Firma Design and Beth Humstone of the Vermont Forum on Sprawl, John Repps, Anne Whiston Spirn, and Richard Sexton.

I will always appreciate having had the opportunity to work with Odile Fillion on the Mutations Exhibition in Bordeaux, not only for her energy and creativity but also for her many introductions in France.

For this book project I want to thank Dominique Carré for his vision in shaping and getting this book into print along with Elizabeth Henry, Gilles Tiberghien, Jean-Marc Besse, Marianne Théry, Luce Penot, Rémi Babinet, and the staff of Thames & Hudson.

For recent commissions I am grateful to Bill Stern and the Rice Design Alliance in Houston, Texas, Daniel Serda and the Kansas City Design Center, Armando Carbonell of the Lincoln Institute of Land Policy, John Fowler and Holliday Fenoglio Fowler LP, Robert Davis and the Seaside Institute, Bill Pressley and Pressley Associates, Inc., Ken Bassett and Sasaki Associates, Inc, and Dolores Hayden and Yale University, and Jamie Sayen of the Northern Appalachian Restoration Project. I would like to also thank the National Endowment for the Arts and the Graham Foundation for Advanced Studies in the Fine Arts for their continuous generous support.

I will always be grateful for the freedom that I have had to move about in American air space and for the many flight controllers who have looked after my safety and the safety of others. I would like to thank mechanic Mike Dupont of American Air Services as well as my flight instructor Skip Freeman who introduced me to flying.

I have had important help from many people that have worked at Landslides. Recent contributors from Landslides on this project are Eric Greimann, Laurie Ensley, Robyn Nuzzolo, and Natalie MacLean. I would also like to thank my brother Paul MacLean for his input when I started Landslides as well as his contribution to this book.

Most important has been the love of friends and family over time, especially my mother and father, daughters Eliza and Avery and my wife Kate.